KU-035-622

Visible Exports / Imports

UNIVERSITY
OF
GLASGOW
LIBRARY

Visible Exports / Imports:
New Research on Medieval and Renaissance European Art and Culture

Edited by

Emily Jane Anderson, Jill Farquhar and John Richards

Visible Exports / Imports:
New Research on Medieval and Renaissance European Art and Culture,
Edited by Emily Jane Anderson, Jill Farquhar and John Richards

This book first published 2012

Cambridge Scholars Publishing

12 Back Chapman Street, Newcastle upon Tyne, NE6 2XX, UK

British Library Cataloguing in Publication Data
A catalogue record for this book is available from the British Library

Copyright © 2012 by Emily Jane Anderson, Jill Farquhar and John Richards and contributors

All rights for this book reserved. No part of this book may be reproduced, stored in a retrieval system, or transmitted, in any form or by any means, electronic, mechanical, photocopying, recording or otherwise, without the prior permission of the copyright owner.

ISBN (10): 1-4438-3997-3, ISBN (13): 978-1-4438-3997-6

For Joe and Henry

TABLE OF CONTENTS

LIST OF ILLUSTRATIONS

Fig. 1-1. Giorgio Vasari, *Six Tuscan Poets*, oil on panel, 1544, 132.08 x 156.53 cm, Minneapolis Institute of Arts. Photo: Minneapolis Institute of Arts, The William Hood Dunwoody Fund.

Fig. 1-2. Tomb of Bavarino de'Crescenzi, marble, 1346, Verona, San Pietro Martire. Photo: author.

Fig. 1-3. Giacomo Filippo Tomasini, *Petrarcha redivivus*, 2nd edition, 1650, pl. VI. Photo: Rare Book and Manuscript Library, University of Pennsylvania.

Fig. 1-4. Altichiero, *Dream of King Ramiro, Council, Battle of Clavigo* (part), fresco, 1376-9, c.6.5 x 3.7 m. Padua, Basilica del Santo, Cappella di San Felice (formerly San Giacomo). Photo: Centro Studi Antoniani, Padua.

Fig. 1-5. Altichiero, detail of *Council*, fresco, 1376-9, Padua, Basilica del Santo, Cappella di San Felice (formerly San Giacomo). Photo: Centro Studi Antoniani, Padua.

Fig. 1-6. Altichiero, detail of *Dream of King of King Ramiro*, 1376-9. Padua, Basilica del Santo, Cappella di San Felice (formerly San Giacomo). Photo: Centro Studi Antoniani, Padua.

Fig. 2-1. Giotto di Bondone, *Crucifix*, 430 x 303cm, tempera on panel. Rimini, Chapel of Isotta degli Atti, Tempio Malatestiano (formerly San Francesco). Photo: Tempio Malatestiano, Rimini, Italy/The Bridgeman Art Library.

Fig. 2-2. Giotto di Bondone, *Crucifixion*, tempera on panel, 45 x 43.7 cm, Munich, Alte Pinakothek. Photo: Bayerische Staatsgemäldesammlungen - Alte Pinakothek München.

Fig. 4-2. Antonio Ghini, Altar of the *Madonna delle Grazie*, 1474, marble. Cathedral of S. Lorenzo, Grosseto. Reproduced by permission of the Ministero per i Beni e le Attività Culturali. Photo: Soprintendenza BSAE di Siena e Grosseto.

Fig. 4-3. Detail of the northern wall of the cathedral with the traces of the former chapel of the *Madonna delle Grazie*. Photo: author.

Fig. 4-4. Matteo di Giovanni, *Madonna and Child Enthroned with Saints Sebastian, William of Malavalle, Mary Magdalene, Lucy and Six Angels,* c.1490, tempera on panel. Church of S. Niccolò, Montepescali. The arms of the commune of Montepescali are depicted at the sides of the predella. Reproduced by permission of the Ministero per i Beni e le Attività Culturali. Photo: Soprintendenza BSAE di Siena e Grosseto.

Fig. 4-5. Antonio Ghini? Altar of St Sebastian, church of Ss. Stefano e Lorenzo, Montepescali. Formerly in the church of S. Niccolò. The arms of the commune are carved at the base of the pilasters. Reproduced by permission of the Diocese of Grosseto, Ufficio Beni Culturali Ecclesiastici. Photo: author.

Fig. 5-1. Orvieto Cathedral Façade. Photo: author.

Fig. 5-2. Preparatory drawing *"disegno monocuspidale,"* stylus and brown ink on parchment, c.1290 (19th century photographic copy), 101 x 74 cm. Orvieto, Museo dell'Opera del Duomo. Photo: reproduced by permission from the Museo dell'Opera del Duomo, Orvieto.

Fig. 5-3. *Genesis, Tree of Jesse, Stories from the New Testament, Last Judgement,* sculpted reliefs on façade pilasters, 1310-1330. Orvieto, Orvieto Cathedral. Photos: author.

Fig. 5-4. *King David,* detail of *Tree of Jesse,* sculpted reliefs on façade pilaster, 1310-1330. Orvieto, Orvieto Cathedral. Photo: author.

Fig. 5-5. *Adam,* detail of *Stories from the New Testament,* sculpted reliefs on façade pilaster, 1310-1330. Orvieto, Orvieto Cathedral. Photo: author.

Fig. 7-1. Plan and key of Magdalen Cycle, Santa Maria Maddalena, Cusiano. Original drawing by author.

Fig. 8-4: Anonymous artist, *Praxis de Nautis, (St Nicholas saves the ship from a tempest)*, fresco, c. 1320, Thessaloniki, St Nicholas Orphanos. Photo: the author, reproduced with the permission of the IX Ephorate of Byzantine Antiquities in Thessaloniki.

Fig. 8-5: Anonymous artist, *Praxis de Tribus filiabus, (The Generosity of St Nicholas)*, fresco, c. 1320, Thessaloniki, St Nicholas Orphanos. Photo: the author, reproduced with the permission of the IX Ephorate of Byzantine Antiquities in Thessaloniki.

Fig. 9-1. *Man of Sorrows and the Symbols of the Passion, Passional of Abbess Cunegund*, NKČR XIV.A.17, fol. 10r, parchment, 1312, 30 x 25cm. National Library of the Czech Republic, Prague. Photo: reproduced courtesy of the National Library of the Czech Republic, Prague.

Fig. 9-2. *Dedication illustration, Passional of Abbess Cunegund*, NKČR XIV.A.17, fol. 1v, parchment, 1312, 30 x 25cm, National Library of the Czech Republic, Prague. Photo: reproduced courtesy of the National Library of the Czech Republic, Prague.

Fig. 9-3. *Arma Christi, Passional of Abbess Cunegund*, NKČR XIV.A.17, fol. 3r, parchment, 1312, 30 x 25cm, National Library of the Czech Republic, Prague. Photo: reproduced courtesy of the National Library of the Czech Republic, Prague.

Fig. 9-4. *Parable of the Invincible Knight, Passional of Abbess Cunegund*, NKČR XIV.A.17, fol. 3v, parchment, 1312, 30 x 25cm, National Library of the Czech Republic, Prague. Photo: reproduced courtesy of the National Library of the Czech Republic, Prague.

Fig. 9-5. *Christ with Lance and Supplicating Nun, Passional of Abbess Cunegund*, NKČR XIV.A.17, fol. 7v (detail), parchment, 1312, 30 x 25cm, National Library of the Czech Republic, Prague. Photo: reproduced courtesy of the National Library of the Czech Republic, Prague.

Fig. 10-1. The Duchy of Bavaria in the fifteenth century. Source: author.

FOREWORD

This interdisciplinary publication brings together new research on Medieval and Renaissance art, culture and the critical history by established scholars, early career academics and postgraduate students from the University of Glasgow, Queen's University Belfast, University College Cork, the University of Aberdeen and the University of Warwick. The majority of articles featured are based on papers given at *Gloss*, a postgraduate conference on Medieval and Renaissance art and culture, held at the University of Glasgow, 29 June 2007 and organised by Emily Jane Anderson with Sandra Cardarelli and Joanne Anderson, and/or at the International Medieval Congress, University of Leeds (sessions 218, 318 and 518 organised by Emily Jane Anderson and Dr. Jill Farquhar), 9-12 July 2007. Additional papers by John Richards (University of Glasgow) and Flavio Boggi (University College Cork) which were not given in Glasgow or Leeds, have been added. An introduction to the papers is provided by Robert Gibbs, Emeritus Professor of Pre-Humanist Art History and Codicology at the University of Glasgow, who moderated one of the Leeds sessions, as did John Richards.

The papers are historical and art historical in focus and concern art production (wall and panel painting, sculpture, architecture, manuscript illumination and textiles), material and visual culture and literature in various European cities and locales in the 14th and 15th centuries and later criticism associated with these subject areas. There is an emphasis on the transmission and translation of workshop style, the traditional concept of artistic centres and peripheries, the consideration of art works in context, art production and the workshop system, the Medieval city, notions of progression and transition pertaining to Medieval and Renaissance art production, Petrarch and Humanism, Panofsky and the critical history, art theory and practice, patronage, commerce, religion and politics.

Emily Jane Anderson (University of Glasgow)
Jill Farquhar (Independent, Belfast)
John Richards (University of Glasgow)

ACKNOWLEDGEMENTS

Firstly we would like to thank the individual contributors who have made this book possible and have shown great patience throughout the publication process.

Many thanks to the University of Glasgow and to the University of Leeds who hosted, respectively, *Gloss* and the International Medieval Congress 2007, the contexts in which this publication was first conceived and at which most of the papers included here were first aired.

Thanks to the staff at Cambridge Scholars Publishing for their patience and assistance throughout the preparation of this publication.

Special thanks are due to Andrea Campbell, Catherine Lawless, Debra Strickland, Graeme Small, Tom Tolley and John Bonehill for their contributions to the preparation of the volume. We would also like to thank Dr Ian Gill, Katy Gill, Margaret Sweet and Alistair Sweet for their invaluable assistance and support.

Emily Jane Anderson (University of Glasgow)
Jill Farquhar (Independent, Belfast)
John Richards (University of Glasgow)

INTRODUCTION

This volume celebrates a distinctive moment in the study of Medieval and Renaissance art history in the UK, and particularly in the historic Scottish universities, that brought together a generation of older historians like myself with a strong commitment to the visual and connoisseurship traditions of British art history and younger teachers and scholars attuned to the increasing challenges to established views of the subject's aims and methods. It also involved scholars from other disciplines in these and other institutions with which we had strong associations. All four art history departments in Scotland were, and remain, strongly staffed in these areas; in 2007 they were particularly notable for having several specialists in Italian art concerned with the Northern regions rather than the traditional Anglophone love of Tuscany and Rome. This distinctive perspective is evident in several of these contributions ranging from Rimini up to the Trentine Alps. The conferences in Glasgow and Leeds where some of these papers saw their first discussion already marked a flourishing decade for us in which a former postgraduate of mine, Flavio Boggi, now head of art history at Cork, had brought the art-historical activity there to a similarly flourishing level, and he made an important contribution to those conferences not only with his experience but an extensive knowledge of the art of Tuscan centres neglected in the English-language world, particularly Lucca and Pistoia, the latter directly connected to my own Bolognese interests through the activity of Lippo di Dalmasio in Pistoia itself. The dialogue between the artists of the Val Padana, Rimini and Bologna with Florence and Tuscany, and the most celebrated of Florentine painters, Giotto, likewise runs through these studies, and it is from a Paduan perspective that John Richards approaches Giotto and his admirer, Francesco Petrarca. This tour round later medieval Europe does not stop at the Alps. Perhaps unusually for British departments our studies continued to Bavarian patronage and the first major work of 14th century Bohemian art before reaching once more the less unfamiliar territories of France and Burgundy.

Our vision of the arts is comprehensive, and the range of concerns and approaches are very varied. The cults of saints and of Christ's Passion are represented in the papers by Joanne Anderson on Mary Magdalene, by Anastasia Kanellopolou on St. Nicholas and by Jenny Schurr on the Man

of Sorrows and the Symbols of the Passion. The royal abbess of the St. George convent at the heart of Prague had a very personal manuscript richly illustrated that focused from the outset on a highly distinctive treatment of the *Arma Christi*/Arms of Christ, splattered with Christ's blood, that long lost-sight-of rather daunting aspect of the current modish fashion for personal heraldry. Also up a hill, but one far less politically crucial than Hradčanská, is the church of S. Maria Maddalena at Cusiano in which the life of that saint is represented with extraordinary thoroughness in a region where her cult is generally remarkably prominent. As saints go the Magdalene is surely among the most personally approachable, and Anderson explores this particular display in the chancel of a church with no resident priest of its own of a saint more generally associated with the mendicants outside this region. The exporting and importing, forcibly and otherwise, of not only saints' relics but the imagery associated with the second saint in the Venetian hierarchy of cults, St. Nicholas, from Thessaloniki are perhaps central to the Byzantine intricacies of Venice's aspirations to take over the Eastern empire, as argued convincingly in Kanellopolou's paper.

In several cases it is the invisible nature of the subjects that is paramount, at least for the modern viewer. For Petrarch's appearance, for which there is an extensive imagery, and for his panel by Giotto that is the subject of one of the most celebrated comments of the time upon Trecento art, we are left with posthumous and much later echoes. Richards succeeds in drawing a remarkably closely focused account of Petrarch and his intimate and political contacts who require a more central position in our view of the Renaissance. For Burgundian tapestry most of our specific knowledge is from documents recording a lavish but almost entirely lost world, though Katherine Wilson's study is very appropriate for Glasgow whose Burrell Collection is one of the richest holders of the remnants of this luxurious expression of power and privilege in most of the courts and palaces of Europe.

We have panel paintings once more reflecting Giotto's impact, though here on the very much extant work of the Riminese artists (Jill Farquhar), and the very different culture of the Quattrocento Sienese painter Matteo di Giovanni (Sandra Cardarelli), and we have the spectacular sculpture of the marble and mosaic façade of Orvieto Cathedral (Pippa Salonius). Salonius argues that this exceptional display, despite having spectacular Romanesque forbears such as Modena's own cathedral, remained too exceptional in Italy not to reflect the papal politics that involved Orvieto, and of the contemporary theological disputes taking place at the University of Paris. From what remains today Rimini established a major tradition of

panel painting at a remarkably early date, and Farquhar explores the role of Giotto in the furnishing of the Franciscan church (to become the celebrated Malatesta Temple at the expense of most of this) as an influence and inspiration for that school. Flavio Boggi's study of the Madonna of Humility incorporates the visible exports of several Emilian artists into a full-blown Pistoiese iconographic tradition rather later in the century. He explores the workings of civic and guild authority in Pistoia and the significant locations of the Humility Madonna representations in the city.

Cutting across these particular works of art are the broader political issues of patronage, as at Orvieto and notably in Cardarelli's exploration of the relationships between the local civic patronage of the towns of the Maremma and controlling hand of Siena in the background. For the dukes of Upper Bavaria no such tensions were allowed in their use of architectural space and heraldic enrichment to mark their territory around Munich, as did the rest of the local aristocracy. The dukes' patronage of the Frauenkirche also reflects their diplomatic relationship to the civic authorities, issues explored by Andreas Dahlem and illustrated with his characteristically incisive photography. Much of our conference involved such historical issues. Katherine Wilson discusses the remarkable tapestries commissioned by the Dukes of Burgundy recording a couple of battles and the Council in Constance in which they were involved; why were they commissioned and what were their intentions? The Battle of Roosebeeke was a potent enough image to upset the Duke of Lancaster at the negotiations of 1393. Wilson reminds us that some of the most lavish and potent creations of European art are essentially unknown to us despite their immense importance. We move on to Neil Murphy's study of the even more ephemeral yet very public and political creations for the triumphal entries of the kings of France, mindful perhaps of the very real military overtones of such occasions in recent French history Louis XI's entries into the towns of the Somme recovered by purchase from the Burgundians are studied in some detail, the political implications, the theatre and costume of the occasions. Here too the visual arts played a vital presence that can today only be imagined from the vestiges of such documentation.

All these papers are effectively framed by one of the earliest and most self-conscious of cultural historians, Petrarch, and at the other end by perhaps the most celebrated of all the art-historians of the last century, Erwin Panofsky. With the publication of Susie Harries' immense biography of Nikolaus Pevsner Dan Keenan's exploration of Panofsky's pursuit of 'scholarly objectivity' has acquired a particular resonance, not

least because both scholars refused to allow their work to be defined by the racial stereotypes of either the Nazis or the Zionists. But whereas for Pevsner Englishness became a concern that echoed his devotion to German culture and expressed in his monumental survey of the English built environment, for Panofsky, Keenan argues, the driving force was the concept of humanism, not merely in the specific Renaissance sense but as an approach to history governed by the broader philosophical principles of 'rationality and freedom' reconciled with 'fallibility and frailty' producing 'responsibility and tolerance'. These papers take us through the world of later 'Medieval' art to the heart of the ideals of the 'Renaissance', as defined by Panofsky in particular (we medievalists have perhaps a less specific view of the term!). Both their range of subject and method demonstrate the richness of research into these fields currently being undertaken while frequently reminding us of the crucial role of all our histories in giving our contemporary society a balanced and informed view of where it is and where it might be going.

Robert Gibbs
University of Glasgow

SECTION I

THE IDEAL OF FLORENCE
AND THE IMAGE OF GIOTTO

CHAPTER ONE

PETRARCH AND GIOTTO IN PADUA: IDENTITY AND FRIENDSHIP

JOHN RICHARDS

Vasari's *Six Tuscan Poets* (oil on panel, 1544, 132.08 x 156.53 cm., Minneapolis Institute of Arts, The William Hood Dunwoody Fund; fig. 1-1) articulates one of the most persistent conflicts of reputation in European literary culture. Against a backdrop of four figures identified by Vasari in his account of the painting as Cino da Pistoia, Guittone d'Arezzo, Boccaccio and Guido Cavalcanti, (Vasari 1906, 7:673-4) are displayed the key players in this literary debate - Petrarch and Dante.[1] Vasari's commission, from the Florentine Dante enthusiast Luca Martini, was driven by the sixteenth-century debate around the relative value of the two poets, and especially in relation to the arguments in favour of the Petrarchan vernacular advanced in Pietro Bembo's *Prose della lingua volgare* of 1525. As Deborah Parker has observed, Vasari's picture forms "part of a wider Florentine effort to qualify [the Venetian] Bembo's championing of Petrarch" (Parker 1998, 52).

Dante's supremacy is established by his seated position and his physical dominance of the foreground, access to which is prohibited to the other *dramatis personae* by his outstretched arms. The gesture of his right arm, ostensibly drawing Petrarch into the discussion, actually bars him from the focal area of the composition and from the instruments of knowledge displayed on the table. These are implicitly part of Dante's realm, not Petrarch's. Also pointedly denied to Petrarch is the volume of Virgil which Dante holds up for Cavalcanti's attention. This all leaves Petrarch excluded from the conversation, awkwardly forcing himself forward in search of attention. Where Dante commands, Petrarch importunes. This is Dante's seminar.

Vasari's visual format is derived from the established iconographies of transmitted authority. Parker suggests a basis in recent Renaissance examples, such as Raphael's *Pope Leo X with Cardinals Giulio de'Medici*

and Luigi de'Rossi (oil on panel, c.1518-19, 154 x 119 cm., Florence, Uffizi), of which Vasari had made a copy for Ottaviano de'Medici a few years earlier (Parker 1998, 49; Vasari 1906, 7:662). But the more explicitly didactic setting of the *Six Tuscan Poets* also reflects an older pedagogical iconography, pervasive in the tombs of thirteenth and fourteenth – century Italian jurists and educators, in the legal imagery associated with their practice and across a wider spectrum of images of learning and authority (fig. 1-2).[2] Vasari's painting applies a Mannerist gloss to the gestural language of the debate, responding in kind to Bembo's dialogue form.[3] But the image's generic affinities with the iconography of teaching, here in what one might call its post-doctoral version (four of the six participants are laureates), are clear. And the inherent structure of this iconography, drawn from the medieval imagery of power-transference, itself looking back to the *Traditio legis* and its own imperial sources, underlines the superiority of Dante over Petrarch in Vasari's picture.

Books play a conspicuous role in this little drama. Vasari has engineered a physical separation of Petrarch's and Dante's volumes which is as extended as the limits of the composition will allow. Petrarch's luxury copy of his own *Canzoniere* (closed, inactive), identified by the profile portrait of Laura on the binding, is also contrasted with Dante's well-thumbed pocket Virgil (open, in use). Petrarch had just as much right as Dante to involvement in any Virgilian seminar, but the emphasis of Vasari's painting reminds us that Petrarch was by the time of its execution seen almost exclusively as the author of the *Rime sparse*, as he was even by Bembo, for whom the Dante/Petrarch *paragone* was largely a matter of the *volgare* and the two poets' respective uses of it. The humanist Petrarch, the later Petrarch, the Petrarch of his own self-valuation, hardly figures here. Instead, we have a reflection of the radically incomplete view of him which dominated late- and post-Renaissance culture.

Vasari claimed that his likenesses were taken "delle teste antiche." (Vasari 1906, 7:674) While this is hard to confirm in the case of his back row, the portrait of Dante clearly conforms to an established norm. Dante's is, with whatever level of historical accuracy, an easily recognisable face, especially in profile. In all essentials Vasari's version conforms to the type derived from the supposed ur-portrait in the chapel of the Bargello in Florence, long attributed to Giotto and accepted by Vasari as such (Gombrich 1979; Vasari 1906, 1:372).

Vasari's Petrarch reflects a more generalised format for the poet's appearance which served as a norm from the sixteenth century onwards. He is distinctly fleshy. The fresco portrait added to the *stanza delle visioni*

in Petrarch's former house in Arquà a few years after Vasari's picture conforms to this format.[4] It shows a Petrarch even plumper than Vasari's and afflicted with an unsteady and rather disturbing cross-eyed glare. This really is the "fat faced Frankie" of Ezra Pound's jibe (Pound 1952, 263). The generally uninspired and uninspiring qualities of cinquecento representations of the poet (and of later portraits dependent on them) also characterise his several appearances in the frescoes of the central room of the house. These offer a visual commentary on the long 'metamorphosis' canzone *Nel dolce tempo della prima etade*, number 23 in the *Rime sparse*. Giacomo Filippo Tomasini's *Petrarcha redivivus*, published in Padua in 1635, includes a number of illustrations of this same poem which are derived from these frescoes. Plate 6 (fig. 1-3) of the second edition of 1650 is representative, illustrating lines 72-4 of the poem:

> "Questa che col mirar gli animi fura
> m'aperse il petto el'cor prese con mano,
> dicendo a me: 'Di ciò non far parola.'"

In response to this the illustration offers a depressingly literal visual equivalent. A muscular Laura, clearly well used to this sort of thing, steadies the ineffectually flapping Petrarch with one hand while she thrusts forward the other and expertly rips his heart out. It is an image which almost comically fails to rise to the challenge of finding a visual correlative to Petrarch's verse.

The point of this critique is not to lambast particular artists but rather to draw attention to what seems to me a general difficulty faced by Petrarch's illustrators in matching a portrait tradition drawn from a set of images based on the older Petrarch with the erotic and 'narrative' requirements of the endlessly popular *Rime sparse*.[5]

The contrast between *Rime* text and image is perhaps best considered in a broader context, as symptomatic of an expanding gulf between Petrarch and Petrarchism, of a general failure (by no means confined to the cinquecento) to make

> "the significant distinction between the well known (but not entirely understood) superficial presence of Petrarch in the Europe-wide and centuries-long phenomenon of Petrarchism, on the one hand, and, on the other, his less known but equally important deep presence in western culture, in literature and beyond." (Scaglione 1975, 22)

It is a recognition of precisely this "deep presence" for which one searches in vain through so much of Petrarchan illustration.[6]

For all the shortcomings of its illustrations, the text of *Petrarcha redivivus* is commendably sensitive to the needs of a fully rounded literary portrait of Petrarch. As Stocchi observes, Tomasini offers

> "il primo tentativo coerente (dopo le tendenze cinquecentesche a concentrare l'attenzione critica sopratutto sul Canzoniere) di ricomporre l'unità dell'opera del Petrarca." (Stocchi 2006, 540)

Tomasini printed two portraits of Petrarch in the first edition of his book, a profile frontispiece ultimately derived from Altichiero's grisaille portrait in Lombardo della Seta's 1379 presentation copy of the *De viris illustribus* (Paris, Bibliothèque Nationale de France, MS Lat. 6069F; 320 x 230 mm.),[7] and an *all'antica* profile in a medallion border on p.180. Like Vasari, Tomasini claimed of them that they were derived from "vetustis tabellis" (Tomasini 2004, 2). He discusses these sources carefully in a *Praeloqium*, and in the main body of his text he shows himself familiar with the surviving fragment of a votive scene which came from Petrarch's house in Padua and which shows the poet kneeling in prayer (Tomasini 2004, 169). The portrait (detached fresco, c.1400, 50 x 60 cm., Padua, Palazzo Vescovile) was presumably painted after Petrarch's death to commemorate his residence among his fellow canons; indeed, there is documentary evidence that Petrarch's previous association with the house remained one of its salient features as it changed hands in the ensuing years.[8] The portrait is not perhaps of a quality which justifies some of the attributions which have come its way (Nante 2006, 411) but it is recognisably close to a number of other Paduan images which reflect direct contact with the living Petrarch.

In vita: Pandolfo Malatesta and Enrico Capra

Two of Petrarch's letters offer a revealing context for the early portrait tradition. In a letter of 1362, describing an event of late 1356 (*Rerum senilium libri*, I.6), Petrarch recalls the occasion on which he sat for his portrait at the behest of his friend Pandolfo II Malatesta (1325-73), *condottiere* and lord of Pesaro.[9] The ostensible tone of this letter (to Francesco Bruni) is one of sustained self-deprecation, a rhetorical posture familiar to any student of Petrarch's letters. Demurring from Francesco's extravagant praise and declaring himself a mere "squatter in the academy (*achademicus advenus*)",[10] Petrarch steers his argument to the opinions of Pandolfo, the man of action. Bruni, Petrarch says, is to believe anything Pandolfo says "about war, strategy and especially the qualities of a leader"

but when it comes to Pandolfo's fulsome praise of Petrarch: "seek someone else to believe." As proof that his friend's judgemental faculty was clouded by affection, Petrarch recalls the two occasions on which Pandolfo sent a painter to make a portrait of him. The first of these preceded the friends' initial meeting. Pandolfo, "attracted just by reports of my fame", wanted to see "the longed-for face of an unknown man." (Petrarch 1992, 1:28)

Petrarch says that the unnamed artist of the second portrait was already a close friend of his and one of the best painters of his time.[11] Wrapped in a cloud of references to Zeuxis, Apelles *et al.*, the admission of friendship is perhaps the most tantalising element of Petrarch's account, and several attempts have been made to identify the artist. It clearly cannot have been Simone Martini (d. 1344), as is suggested by the letter's most recent translators (Petrarch 1992, 1:29). Pier Giorgio Pasini, though (rather disconcertingly) judging an explicit connection to be "forse impossibile", points to the apparent affinities between Petrarch's description of the portrait's setting and Altichiero's work in Padua (Pasini 1983, 22). Anna Falcioni notes the known association between Altichiero's collaborator Jacopo Avanzi and the Malatesta and develops an argument for the second of Pandolfo's images of Petrarch as "chiaramente umanistica" in character on the basis of her belief that "Petrarca fu effigiata seduto tra i suoi libri" (Falcioni 2007, 89). The analogy which both Pasini and Falcioni are suggesting must be with the rather battered fresco portrait of Petrarch in the *Sala dei Giganti* in Padua, all that survives of Francesco da Carrara's *Sala virorum illustrium*, and which shows Petrarch at work "tra i suoi libri" (fresco, c.1370-1380).[12]

But Petrarch's account does not really allow for so specific a reconstruction of Pandolfo's lost portrait. He says that Pandolfo "enjoyed seeing me among my books, as he said, in my own place," and that the painter "took the liberty of sitting down with me as I was reading" as "he stealthily did something or other with a pen" (Petrarch 1992, 1:29). While his book-loving friend's appreciation of him in his natural surroundings rings true, Petrarch provides no further evidence of the actual nature of the image. Nor should we expect it to do so, for the anecdote is not produced for its own sake, but in support of Petrarch's prosecution of one of his most persistent themes, that of the ideal relationship between culture and power. Falcioni notes what she sees as historiographic vacillation between Pandolfo "condottiere e uomo di Stato" and Pandolfo the patron of learning (Falcioni 2007, 89). But for Petrarch there was no such necessary discrepancy; it was a constant of his thought that power and literary patronage enjoyed a necessary symbiotic relationship, that poet and prince

needed each other for the proper fulfilment of their respective destinies and for a process of mutual affirmation. The letter displays *in nuce* his approach to these issues. The point is also made in a sonnet addressed to Pandolfo (*Rime* 104). The interlinked themes of fame, friendship, virtue, memory and art which are central to Petrarch's philosophy of culture solidify round the assured preservation of Pandolfo's reputation in Petrarch's verse. Pandolfo is placed in the company of Caesar, Scipio and others, whose reputations survive because paper monuments are more lasting than those made of marble:

> "Pandolfo mio, quest'opere son frali
> al lungo andar, ma 'l nostro studio è quello
> che fa per fama gli uomini immortali." (Petrarch 1951, 143)

The memory of Petrarch is inextricably linked with that of Pandolfo and with that of their friendship, to which letter and sonnet and portrait are all monuments.

The second letter to be considered here (*Rerum familiarum libri* 21: 11) is dated October 15, 1359 and refers to Petrarch's visit to Bergamo in that year. His host there was the goldsmith Enrico Capra, "a man with little literary knowledge, yet with a sharp intellect." Enrico, like Pandolfo, "was immediately attracted by my reputation and seized with a burning desire to win my friendship" (Petrarch 1985, 189). He had, we are told, been asking Petrarch to visit him for many years. Eventually Petrarch "yielded despite objections from my more exalted friends who believe his humble condition unworthy of such honor" (Petrarch 1985, 190). Capra, having already abandoned his craft in pursuit of a new passion for learning, showed (Petrarch says) symptoms of acute anxiety "for fear the many [other] invitations would tempt me." Once these perils had been averted and Petrarch was securely billeted for the night, the intensity of Capra's happiness was such that his friends were frightened in case "he might fall ill or become mad...or die." Inside Capra's house Petrarch found further expression of this mania in

> "elaborate preparations, a dinner more suited to royalty than to an artisan or philosopher, a gilded bedroom, a plush bed in which he solemnly swore no one else had slept, or ever would, and an abundance of books, not those of an artisan but of a scholar and true lover of literature." (Petrarch 1985, 190)

This abundance already included many of his own works, to which Petrarch afterwards made additions. The tone of the letter establishes very

clearly the social gulf that lay between Enrico Capra and someone like Pandolfo Malatesta. This allowed Petrarch to do something quite openly with Capra which he was only able to suggest obliquely in the case of Pandolfo and his other lordly patrons: to imply that Enrico's role in history was to acquire fame because of, and here only because of, his association with Petrarch. It was on the basis of his enthusiasm that Capra would "be deserving of a place in some part of my work" (Petrarch 1985, 190). There his memory would be preserved - which is exactly what happened.

The extent and longevity of this enthusiasm was most strikingly confirmed by its visual expression:

> "Long before [Capra] had begun spending a sizeable portion of his patrimony in my honor, displaying the bust, name and portrait of his new friend in every nook of his house and imprinting his image even more deeply in his heart (*signum nomen imaginem novi amici in omnibus domus sue angulis, sed in pectore altius insculptam habere*)." (Petrarch 1985, 189; Petrarch 1955, 998)

This interesting passage has attracted little comment. On the most obvious level it suggests that a cult of the living Petrarch was already supported by the provision of easily secured or readily available likenesses, a state of affairs requiring rather delicate handling by their object. Petrarch was entirely familiar with the Roman literature of portraiture, and part of his self-deprecation may reflect an uncomfortable awareness of sources such as Pliny's scornful account of people who

> "decorate even their own anointing rooms with portraits of athletes of the wrestling-ring, and display all round their bedrooms and carry about with them likenesses of Epicurus [and] offer sacrifices on his birthday, and keep his festival..." (Pliny 1952, 262-3)

Though it is a matter of scholarly consensus that Petrarch had no access to the letters of the younger Pliny, his account is strangely reminiscent of Pliny's letter relating the suicide of Silius Italicus, who

> "not only kept by him but even treated with a sort of veneration...the busts of Virgil, whose birthday he kept up far more scrupulously than he did his own." (Pliny, *Epistle* 3. 7).

If it is a coincidence that so striking a precedent for Capra's veneration was unknown to Petrarch, whose identification with Virgil is well known, and who dated his Bergamo letter to Virgil's birthday, it is certainly an intriguing one.[13]

The elder Pliny's contempt hinges on a contrast between the ancient practice of commemorating ancestors and what he regarded as the degenerate culture of artistic consumption which obtained in his own time. Petrarch echoed this in 'Reason's' critical assault on a taste for sculpture in the *De remediis utriusque Fortune*: "once statues were the hallmarks of virtue; now, they are attractions for the eyes" (Petrarch 1991, 1:133). But 'Reason' goes further than Pliny and condemns the entire culture of ancestral images: "the madness of smoke-begrimed portraits in your hall, broken busts of your ancestors, and the family shrine full of worm-eaten titles" (Petrarch 1991, 3:5). This hostility stems from one of the central tenets of Petrarch's thought, the superiority of virtue over received status, but it leads to no condemnation of memorial portraiture as such. The commemoration of the virtuous dead in art had an accepted exemplary role, and Petrarch often referred to the moralising experience of exposure to the image or memory of some great figure of the past.[14] Even so, images of the living, still more of himself, were obviously harder for Petrarch to assimilate very comfortably within such a culture of exemplarity.

The Malatesta and Capra portraits were only two of many which seem to have been commissioned during or shortly after Petrarch's lifetime. The young Leonardo Bruni (1370-1444), as he recalls in his *Commentarius rerum suo tempore gestarum*, was first awakened to his humanist vocation by an encounter with a portrait of Petrarch (Garin 1970, 2-3). He saw it on a wall in the castle at Quarata, a villa of the commune of Arezzo, in which Bruni was briefly imprisoned in 1384. It is impossible to determine whether this portrait had been painted while Petrarch was still alive, but the depiction of Arezzo's greatest son in a building associated with the commune is unsurprising either way; indeed, there seems to have been a flourishing cult of Petrarch's memory there and elsewhere during the poet's lifetime.

In *Rerum senilium libri* 13: 3, which has some affinities with the Bergamo letter, Petrarch responds to the request of Giovanni Fei of Arezzo, who was seeking his friendship ("a sterile thing", says Petrarch) and asking for

> a letter, if only one, which you promise to save like a treasure or sacred relic, for the lasting glory not only of yourself, as you say, but of your posterity as well. (Petrarch 1992, 2:483)

Petrarch takes the opportunity to tell of the occasion in 1350 when a group of Aretine nobility took him - "to my amazement and ignorance" - to see the house in which he had been born. They told him that the then owner had been forbidden to extend the house "lest anything be changed from

how it looked when [I] entered this wretched, toilsome life across that threshold." (Petrarch 1992, 2:484). Bruni himself repeated this story in his biography of Petrarch (Thompson and Nagel 1972, 78).

A portrait of Petrarch was recorded in the new Visconti palace at Pavia (Mardersteig 1974, 256-7), and Vasari (1906, 3:633) says there was another in Cansignorio della Scala's palace in Verona. Both can be dated to the 1360s.[15] Neither survives.

To this group we should add the rather unprepossessing image in Nardo di Cione's *Last Judgement* in Florence (fresco, 1350-1357, dimensions unknown, Florence, Santa Maria Novella, Cappella Strozzi). Petrarch's inclusion, in close proximity to Dante, may reflect the climate of esteem which underpinned at least two attempts on the part of Petrarch's Florentine followers to remind him of his Florentine origins and persuade him to take up residency there.[16]

In morte: the Paduan portraits

Nowhere is there so significant a body of extant trecento likenesses of Petrarch as in Padua, home of his last signorial patron, Francesco 'il vecchio' da Carrara;

> "a man of vast wisdom [who] loves and honors me as though he were my son, not my lord, and who feels this way both for himself and in memory of his magnanimous father [Giacomo II da Carrara, d.1350], who loved me as a brother." (Petrarch 1992, 2:572-3)

All but one of the Paduan portraits are securely dated to the period shortly after Petrarch's death, and it is probable that the portrait in the present *Sala dei giganti* was also posthumous. Four of them can be associated with Altichiero, whose dates comfortably allow for him to have seen his subject in person.[17] It is quite possible that Altichiero had worked in direct contact with Petrarch on the planning of Francesco's *Sala virorum illustrium*.

Of the Paduan portrait cluster the one which must be accorded benchmark status in terms of identification is located in the presentation volume of Petrarch's *De viris illustribus*, completed by his friend and amanuensis Lombardo della Seta on January 25th 1379. The portrait, a grisaille profile bust, is located on the verso of the flyleaf directly above the title, which also refers to Francesco da Carrara's patronage.[18] Below this is Lombardo's list of those sections of the Carrara version of the *De viris* which Petrarch had managed to complete. Following the portrait on f. 1r is a grisaille image of the *Triumph of Fame*.[19] The first section of the text ends on f. 142r. with the *explicit* of the life of Caesar and a note of

Petrarch's death.[20] The bottom of f. 142v. has a word square on the text "INCLITOFRANCESCODECARARIA" and a blank half-page above which may have been intended for the addition of another portrait. On f. 143r. begins Lombardo's supplement, the 12 lives which he wrote himself after Petrarch died.[21] The organisation of this volume clearly underlines the collaborative nature of the enterprise. Three people were responsible for the book: Petrarch, Lombardo and Francesco da Carrara, and they implicitly share with the 36 heroes of the *De viris* the triumph of fame depicted on f. 1r.

Closely related to the circumstances of this manuscript's production is the fresco showing Petrarch at work in his study which was retained from the trecento decoration of the *Sala virorum illustrium* (the present *Sala dei Giganti*) after a fire in the early sixteenth century. Petrarch's identity is established by a painted titulus. On the other side of the window is a portrait of Lombardo in another (or part of the same) study, also identified by a titulus and looking towards Petrarch. The scholarly setting is derived from a long tradition of author portraits, and the paired format establishes a quasi-pedagogical context, rather like that of Tomaso da Modena's chapter house Dominicans in Treviso (fresco, 1351-2, Treviso, San Nicolò) and which was later adopted for Martino da Verona's paired Church Fathers on the San Fermo pulpit in Verona (marble and fresco, 1396, Verona, San Fermo Maggiore).[22] Lombardo's portrait has been repainted, but the preservation of the two portraits together underlines Lombardo's importance in respect of Petrarch's legacy. The arrangement also suggests that the portraits were painted after Petrarch's death, for Lombardo's role is unlikely to have seemed so significant while Petrarch was still alive and hoping to complete the *De viris illustribus*, on which the *Sala* frescoes were based.[23] The detailed portrait of Petrarch's study may have additional personal meaning in this context, for Petrarch was at pains to point out that Francesco had "often" visited him there (Kohl and Witt 1978, 51).

The attribution of the Paris and *Sala dei Giganti* portraits of Petrarch to Altichiero, though undocumented, is entirely persuasive. The other two portraits in this Paduan group are included in works securely documented as his: the fresco cycles in the Cappella di San Giacomo (subsequently rededicated to San Felice, but referred to hereafter as San Giacomo) in the Santo and in the nearby Oratorio di San Giorgio. The San Giorgio frescoes were completed in 1384, but the San Giacomo paintings belong to exactly the same period as the Paris profile. Final payment for them was made to Altichiero in November 1379. Neither of these posthumous portraits are identified as such *in situ* or in the documentation, but their affinities with

the other portraits in this group are such that there need be no doubt that they represent Petrarch, as is further confirmed by the repeated use of these images as sources for author portraits of Petrarch in subsequent manuscripts and incunabula.[24] Both show him as witness to a narrative scene in the life of the respective chapels' dedicatees.

The San Giacomo portrait is found in the penultimate scene of the narrative cycle of the martyrdom and miracles of St James which runs round the upper and middle bands of the chapel walls. The cycle culminates on the east wall with three linked scenes (fresco, c.1376-9, c.6.5 x 3.7 m; fig. 1-4), showing the appearance of St James to King Ramiro (or Charlemagne), the council in which he tells of his dream, and the ensuing battle of Clavigo (or Pamplona).[25] In the *Council* scene, Petrarch sits beside the monarch's throne, holding a large book (fig. 1-5). With his left hand Petrarch points to a figure who appears again beside him in the San Giorgio fresco and who was identified by Giovanni Mardersteig as Lombardo (Mardersteig 1974, 269). In the absence of the original *Sala virorum illustrium* portrait of Lombardo, this identification must remain speculative, though the circumstantial evidence for it is persuasive.[26]

Petrarch's appearance here is entirely compatible with the Paris and *Sala* portraits, displaying the same arched nose, creases at the corners of the mouth, and a double chin not quite concealed by the hood (which does hide his grey hair).[27] The face is warm in colour and comparatively unlined for a man who died two days short of his 70th birthday, seemingly confirming Leonardo Bruni's later assertion that "[Petrarch] was very attractive in appearance and his handsomeness lasted throughout his life." (Thompson and Nagel 1972, 75). Of course, Bruni's remark was only a reflection of what he had read or heard (and perhaps of the Quarata portrait), but what he says about the durability of Petrarch's good looks is supported by the testimony of Giovanni Conversini, who saw him only months before his death.[28]

In his 1366 'grand climacteric' letter to Boccaccio (*Rerum senilium libri* 8:2) Petrarch says that

> "...I was convinced that, although the number of years is usually inscribed on the face itself by Nature's fingers, in my case a certain liveliness and lifestyle far removed from youthful debauchery would make a beholder consider me younger than I would have had the nerve to claim by shameless lying." (Petrarch 1992, 1:263)

Four years later, in a letter to Giovanni Dondi (*Rerum senilium libri* 12:1), Petrarch again comments on the excellent state of his health until a recent

illness. He cites the judgement of another friend, Tommaso del Garbo, who

"...in the presence of a crowd of nobles...swore that he had never seen a stronger body than mine – I use his own word – or a healthier one, or a finer constitution." (Petrarch 1992, 2:442)

Only in his sixties, according to the *Posteritati*, did old age begin to "[invade] my body, which had been very healthy in every age..." (Petrarch 1992, 2:672). Of this decline there is little sign in any of Altichiero's portraits. Petrarch's clothes allow for no very detailed assessment of his figure, but they suggest a certain bulkiness which seems to have been confirmed by the recent analysis of his skeleton and which is rather at odds with the insistence on frugality which we find in the *Posteritati* and elsewhere.[29]

The exhumation of Petrarch's remains in 2004 might also have given a definitive answer to the question of Petrarch's actual appearance. But the discovery in his tomb of a skull which was not his (some 200 years older than the other bones and almost certainly female) dashed this hope.[30] Failing the reacquisition of the original skull, which must have been stolen in one of several raids on Petrarch's bones over the years, we will have to continue relying on Altichiero's four portraits as the most authentic visual record of his appearance.

One further portrait in the *Council* scene can be tied to its subject with certainty, that of the chapel's patron Bonifacio Lupi, Marchese di Soragna. He sits on the far right, in profile, displaying on his hat his motto: *amor*. Though many of Mardersteig's suggestions must be treated with considerable caution, his identification of the two men standing behind and to the left of Petrarch as Francesco 'il vecchio' da Carrara (dark hood, white beard) and his son Francesco Novello da Carrara (in profile, dark beard) is persuasive and has been widely accepted.[31] The same two figures appear prominently and together in the San Giorgio cycle.[32] For all the problems of establishing individual identities it is clear that the *Council* scene represents a cross section of what Benjamin Kohl has called the "Carrara affinity" (Kohl 1998, 167-204) in what Margaret Plant has styled

"an allegory of contemporary politics, reflecting issues of crucial importance in the history of Padua in the 1370's and views of the nature of the state." (Plant 1981, 410)

Bonifacio Lupi, arguably the most important man in Padua after the Carraresi themselves, was tied to them by marriage, by historical

circumstances and by long service.[33] He was closely acquainted with Lombardo, who drew up the initial contract for the building of the chapel. There is also evidence that he had known Petrarch quite well and that he remained in contact with the poet's family after 1374.[34] Like Petrarch, he was long acquainted with the emperor Charles IV, to whom the Carraresi owed their ducal rank.[35] Bonifacio's prominence is signalled both by the splendour of his chapel, and by its location, filling the whole width of the south transept and facing Padua's most important pilgrimage site, the shrine of St Anthony of Padua.

The fresco also reflects the specific political context of the Paduan-Venetian conflict which rumbled on, with intermissons, between 1353 and the first fall of the Carraresi in 1388. Padua's ally Louis of Hungary (possibly the model for Altichiero's figure of the king) played a major role in this conflict, which had, at the time of the frescoes' completion, seemingly turned in Padua's favour, and during the course of which Petrarch had mediated with the Venetians on Francesco da Carrara's behalf.[36] It had been in response to the peace partly brokered by Petrarch in September 1373 that Francesco had adopted his own motto: *memor* (Kohl 1998, 103, 126-7). The war was also reflected in the iconography of Altichiero's allegorical frontispiece for the *compendium* of the *De viris illustribus*, a potted version of the full text which was begun by Petrarch at the specific request of Francesco da Carrara, finished by Lombardo, and written out by him in a volume which he completed on December 9th 1380 (Paris, Bibliothèque Nationale de France, MS Lat. 6069G).[37] The frontispiece shows the bull of Padua (home to the remains of St Luke) turfing the lion of St Mark into the sea.[38]

The iconography of the *Council* is derived from some of the same sources as Vasari's *Six Tuscan Poets,* but the composition more explicitly recalls a format developed by Giotto and his followers for such scenes of authority and conclave, and it is here set in a three-bay box of unequivocally Giottesque type.[39] The action is less pronounced than Vasari's; this is a strikingly grave council which communicates by hand signals. It might remind one of Petrarch's observation that a friend's language has the characteristic that "I truly understand [it] as though it were my own, and not merely his speech but his silence and his gestures" (Petrarch 1985, 56).[40] The most significant gesture here is the king's. The index finger of his right hand stretches out towards Petrarch, seated in the place of honour at the right hand of the throne. Towards Petrarch, too, are inclined the king's head and his glance.[41] Petrarch's prominence in this scene, the sense in which he is as pivotal here as he is edgily excluded from the centre of Vasari's picture, is clear. Petrarch, in turn, points to the

supposed Lombardo, as does the standing figure between Petrarch and Lombardo, the supposed Francesco da Carrara. The three men form a stable triangle at the centre of this side of the scene.

There are no overt sartorial dimensions to Petrarch's prominence. Here, as in the Paris and *Sala dei giganti* portraits, he wears a plain hood and gown, with no elements suggesting affiliation to any university or vocation. Although there are local traditions that he was buried wearing either the red, "amictu rubeo" (Tomasini 2004, 174), proper to his Paduan canonry or (less likely) the robe given him by King Robert for his coronation as laureate in 1341,[42] the dignified plainness of Petrarch's dress surely reflects both the way he was remembered and the way he actually dressed.[43]

Books play as significant a role in this composition as they do in Vasari's. Petrarch's right hand rests on a large green volume bound with clasps and studs. Given the gesture towards 'Lombardo' and the broader context of this image as a memorial to Petrarch's association with the Carrara court, it is surely most likely that the book is to be understood as the *De viris illustribus* in its Carrara version. It is very unlikely to be the *Canzoniere*. The *De viris* was the most tangible and permanent token (according to Petrarch's understanding of the superior staying power of the written word) of the last of Petrarch's relationships with a man of power,[44] the last example of his projection of humanist learning with the purpose of educating a ruler in the most valuable lessons of Roman virtue and the last-but-one of his gifts to a princely patron. It was also, as the paired portraits of the *Sala virorum illustrium* suggest, the thing that bound Francesco da Carrara and Lombardo together in a common memory of Petrarch.

It should be remembered at this point that the years immediately following Petrarch's death were really Lombardo's golden time. His authority in Padua as Petrarch's *de facto* literary executor and his friendship with the poet's family gave him a control over the written legacy which was effectively total.[45] During these years he completed the *De viris illustribus* in both the long and short versions, produced a variant volume of the earlier 'all-ages' version of the text (Paris, Bibliothèque Nationale de France, MS Lat. 6069I), as well as copies of other books by Petrarch for Francesco da Carrara. This enterprise was funded by another prominent member of the Carrara 'affinity' and a close associate of Bonifacio Lupi, Checco (Francesco) da Lion.[46]

There is a second book in the *Council* scene, held above Petrarch's head by the supposed Francesco da Carrara. It is small and plainly bound, but it is prominently displayed. It is hardly fanciful to think that this may

he the *compendium* of the *De viris*, designed specifically for use in conjunction with the frescoes of the *Sala virorum illustrium* and which was, in a very particular sense, Francesco's book.

The date of the San Giacomo portrait is significant, for it belongs to a moment which is unique in the trajectory of Petrarch's fame. As Kohl observes, the few years immediately following Petrarch's death represent a peak of his reputation as a whole: "never again would the appraisal of [his] stature be so unambiguously acknowledged" (Kohl 1975, 351). This is the reported state of his reputation which Leonardo Bruni puts into the mouth of the young Niccolò Niccoli in his *Dialogus II*:

> "When, as I said before, I had travelled to Padua to transcribe the books of our Petrarca, not many years after his death, I often met those men who were his good friends while he was alive. From them I obtained such an acquaintance with his character that it was almost as if I had seen him myself.....They all, then, declared that in Petrarca there had been many things worthy of praise, but three especially; for they said that he had been very handsome, and wise, and the most learned man of his age." (Thompson and Nagel 1972, 49)

This handsome sage is the Petrarch of the San Giacomo portrait, surrounded by his friends and admirers, captured just before his reputation underwent a process of extensive critical revision, especially beyond Padua.[47] The ensuing reappraisal tended to undermine the early consensual belief in the value of Petrarch's work as a whole and led to the fragmented and contentious reputation which was embodied in Vasari's painting and which obtains, to some extent, to this day.

The *Council* is one of a number of commemorations initiated by those who had known Petrarch. These mainly comprised literary memorials of various kinds. But with them must also be counted what was in effect a state funeral, as well as other formalised memorials like the observance for many years of the date of Petrarch's death by the canons of Padua Cathedral, an observance probably connected with the votive portrait formerly in his residence behind the cathedral.[48] On one level the *Council* uses Petrarch as a kind of trophy, though in a very different context from that of Enrico Capra's veneration. It also shows him as the familiar of princes, a status which he certainly merited and a role which was formally reflected in his appointment as Count Palatine and counsellor to Charles IV and which, for all his protests, he still recorded very clearly for posterity.[49] The *Council* should be seen as a kind of epideictic display cabinet, presenting the Carrara court in an idealised light as a proper context for the reception of Petrarch while he was alive and for the

perpetuation of his memory after he was dead, evoking a particularly Petrarchan ideal of *amicitia* in a courtly setting. Petrarch's presence is here preserved as a central emblem of Paduan court identity, held in place, as it were, by both *amor* and *memoria*.

This is surely appropriate. Like Cicero, Petrarch had given long thought to the nature of "every degree of genuinely or overtly amicable relations" that comprised the broad term *amicitia* (Brunt 1965, 20).[50] Friendship was one of his lifelong themes, particularly the friendship between men who may have been socially or politically unequal, but who could meet as equals on the cultural field of play.[51] This attention coloured virtually all his relationships with the people whom we rather loosely refer to as his patrons,[52] and it was rooted in a clearly articulated distinction between true friendship and that most pernicious feature of court life, flattery.[53]

It is testimony to Petrarch's adroit handling of his own status that he managed to bypass many of the accepted structures of patronage and obligation which ordinarily characterised attendance at a court. One need only compare the conditions of Petrarch's court career with those of the poet Francesco di Vannozzo, scratching out a living on the fringes of the Carrara court and constantly keeping an eye on the meagre favours which might come his way, or Giovanni Conversini da Ravenna, eventually chancellor of Carrarese Padua but whose duties as a newcomer to court had included rubbing Francesco da Carrara's legs.[54] Petrarch steadfastly refused jobs which would involve him in formal subordination to any immediate authority, preferring to draw his income from undemanding church benefices,[55] and when he lived in proximity to courts he managed to keep himself to some degree remote from them. Accession to any regal or signorial demand was easily explained by him in terms of friendship rather than coercion. Petrarch was thus never really a courtier, and still less, in any of the usual senses, a court poet.

He understood, of course, that men of power were to be handled with care, not least because of his fundamental conviction that between poet and prince there existed a necessary culture of exchange which had to be nurtured. Petrarch's formulation of his own position may have absolved him from the more mechanical aspects of gift giving at courts, what Brigitte Buettner calls "that mute but persuasive grammar made of objects, words and gestures that ceaselessly spoke of rank and status" (Buettner 2001, 616). But he was no proponent of *lèse-majesté*, approving (in *Rerum senilium libri* 1:5.) the assertion of Valerius Maximus that "someone who did not know how to respect our leading men would rush into any villainy." (Valerius Maximus 2000, 2:219)

Petrarch's gifts to such men were necessarily restricted in worldly terms, because his recipients were unlikely to be "in need of anything" (Mommsen 1957, 79) and because the donor was in no position to "give anything great." (Petrarch 1992, 2:117) [56] Instead, Petrarch targeted his gifts very carefully in a context of mutual and significant personal exchange. Thus to his old patron Giacomo Colonna Petrarch had hoped to give a portion of the *Africa*, [57] as well as his laurel crown, because

"long before his simply hearing of it [the laurel] from a distance had afforded him occasion for great delight, expressed in a very elegant gift, a personally composed poem." (Petrarch 1975, 211)

And when he received from Charles IV's chancellor Jan ze Středa the diploma appointing him Count Palatine, Petrarch returned the great gold seal that came with it because, although "I accept unusual gifts, in particular your patronage" and "I...need for his favour and your benevolence, I am not in need of gold in the same way" (Petrarch 1985, 167).

What Petrarch gave most readily was advice. To Francesco da Carrara this was delivered in the exemplary form of the *De viris illustribus* and its visual pendant the *Sala virorum illustrium*, and in the long letter on the subject of good government, *Rerum senilium libri* 14:1. Advice was integral to the most significant and lasting gift Petrarch thought a poet could give to a prince, fame, whose relationship with virtue was central to Petrarch's sense of himself and of the poet's value. This was expressed via the reiteration of a number of favourite literary and historical connections: between Achilles and Homer, Augustus and Virgil, Scipio and Ennius. The inclusion of Ennius in Scipio's triumph and the addition of a statue of Ennius to the façade of the Scipios' tomb were, for Petrarch, the clearest signs of the poet's historical significance.[58] Wrapped around the core of these poet/prince relationships was Petrarch's self-justifying belief that the commemoration of a leader by his association with a poet could turn out to be the most persuasive basis for that leader's fame:

"For what can the thirty-five tribes of the Roman people or the forty-four legions of warriors...have bestowed upon [Augustus], compared to what Virgil alone contributed to his eternal fame?" (Petrarch 1992, 2:551)

This gave sanction to Petrarch's habitual hobnobbing with men of power, for, as he rather extraordinarily said, "I stayed with them in a way that they were, so to speak, my guests." (Petrarch 1992, 2:673).

Sometimes the prince's receipt of a scholar's gift might be his truest claim to fame:

> "Amonicus Serenus is remembered as having a library containing 62,000 books all of which he left to Gordian the Younger who was then emperor and a disciple of his, a matter that made him no less famous than the empire." (*Rerum familiarium libri* 3:18. Petrarch 1975, 159-160)

This legacy may remind us of the most famous of Petrarch's gifts, the panel of the Madonna and Child by Giotto which he left to Francesco da Carrara in his will of 1370.

The terms in which Petrarch couched this bequest, distinguishing between the contrasting understanding of artistic beauty shown by the *ignorantes* and the *magistri*, have long been central to a critical understanding of the *rapprochement* between humanism and the visual arts, not least to that of Vasari, who quoted from the will in his 1568 life of Giotto (Vasari 1906, 1:401-2). Of the significance of the gift and of Petrarch's wording in this context there is no doubt, though the distinction he made between the informed and merely instinctive reception of art was hardly new.[59] But Petrarch's real purpose here was to use Giotto, the first designated 'classic' of modern art history, to articulate the common ground on which poet and prince could meet. Just as all his moral advice to rulers would be redundant, "fanning dead ashes to no purpose" (Kohl and Witt 1978, 40), unless the prince had the spark of virtue already in him, so the gift of Giotto would be robbed of half its meaning were Francesco da Carrara not the sort of enlightened ruler who could be relied upon to get the point. Francesco's reception of the Giotto, a gift whose value transcended the monetary and the conventionally devotional, would cement for all time his connection with Petrarch. The remembrance of Giotto, Petrarch and Francesco were thus united in mutual affirmation and common identity. This is a very special class of gift, as Paula Findlen has observed:

> "Petrarch clearly saw his prized Giotto...as belonging to a separate category of goods that he would not bequeath to his family but hope to pass on to posterity." (Findlen 1998, 93)

Despite a long-held Paduan belief that a panel in the cathedral was Petrarch's Giotto, it seems certain that the painting itself is lost.[60] Perhaps it went to Pavia with the Carrara Petrarch manuscripts when Padua was lost to GianGaleazzo Visconti in 1388. But we may not have lost all visual touch with it. In the San Giacomo *Dream* scene the king sleeps soundly in

his bed. On the back wall of the bedroom hangs a small painting of the Madonna and Child in a round-arched frame (fig. 1-6). Such 'domestic' icons were probably a common enough feature of wealthy households; indeed, we know that Altichiero painted one in 1384 for a kinswoman of Bonifacio, Margareta di Corradino Lupi.[61]

The fictive panel retains some of the gilding which would have allowed it to glitter in the darkness of the chapel, and although it has shared the various disasters which have afflicted the San Giacomo frescoes, its fundamentally Giottesque character is still clear. The format resembles small Giotto Madonnas like the one in Washington (tempera on panel, c.1320-30, 85.5 x 62cm., Washington, National Gallery of Art, Samuel H. Kress Collection). This is hardly surprising, given the enduring veneration of Giotto in Padua and Altichiero's own debt to him (perhaps Altichiero was one of the "magistri" alluded to in Petrarch's will), but it is possible to wonder whether the affinities may not be more specific in this context, whether this might not be a memorial 'portrait' of Petrarch's gift to Francesco da Carrara. At the very least one could argue that this is exactly where one might expect to meet such a memorial, in a milieu coloured by a Petrarchan rhetoric of commemoration and friendship and characterised by the commemorative efforts of Petrarch's friends and followers, efforts typified by Coluccio Salutati's reminder to himself that his actions should always be guided by the knowledge that "the name and fame of [Petrarch] will be in your hands." (Murphy 1997, 93).[62]

Notes

[1] For the identification of the background figures, especially the two non-laureates to the left, see Parker (1998, 50-1). Boccaccio was Bembo's preferred model for vernacular prose, as Petrarch was for verse. See Kennedy (1994, 83)

[2] For which see Gibbs (1990) and Grandi (1982).

[3] For Kennedy (1994, 86) Bembo's *Prose* "dramatizes a humanist's anxieties about linguistic fragmentation and about the possibility of reconstituting a lost language; it records the anguish of an entire generation about Italy's political fragmentation and the possibility of renewing or inventing a shared culture; and it advocates a paradoxical program that endorses literary dismemberment as a way to recuperate an authentic understanding of cultural discourse."

[4] The frescoes were added by Paolo Valdezocco, then owner of the Casa Petrarca, around 1550. Paolo was also responsible for the addition of the bronze portrait head to Petrarch's sarcophagus. See Magliani (2003).

[5] Wilkins notes "more than 130 editions" in the 16th century (Wilkins 1955d, 284).

[6] Petrarchism has an extensive literature. For two general assessments see Wilkins (1955d) and Guss (1974).

[7] Lombardo's manuscript was no longer available in Padua after 1388, having entered the Visconti library in Pavia.

[8] Bellinati (2006, 41-42) publishes a document of 1388 recording the second transfer to have taken place after Petrarch's death of the house "vacanti per mortem domini Francischi Petrarche olim canonici, in qua nunc habitat dominus Henrucus Gallettus…"

[9] For the letter's date, see Wilkins (1960, 94), and, for the events described, Wilkins (1961, 153-4).

[10] Latin text of *Rerum senilium libri* I.6 at http://www.bibliotecaitaliana.it/xtf/ view?docId=bibit000342/bibit000342.xml&chunk.id=d3814e242&toc.depth =1&toc.id=d3814e126&brand=default

[11] Though he adds the deflating caveat that he was "a great artist as they go nowadays" (Petrarch 1992, 29). The original text goes: "[Pandolfo] misit ergo quam potuit: magnum prorsus artificem ut res sunt."

[12] For the *Sala virorum illustrium* portrait see Mommsen (1952, 99-100) & Richards (2000, 117-123). An unusually legible photograph of the fresco is published by Magliani (2003, 16).

[13] I am very grateful to Luke Houghton of the Department of Classics at the University of Glasgow for alerting me to the Silius analogy. Petrarch's ignorance of Pliny's *Epistles* is very strange, for they were sufficiently well known in the early Trecento for Geri d'Arezzo (c.1270-1339) to imitate them, as was known by the Florentine Coluccio Salutati in 1395 (Witt 2000, 224-7). They, or at least Books I-VIII, were certainly available in the Biblioteca Capitolare in Verona, where they were known to Giovanni de Matociis (d.1337), who first established the separate identities of the two Plinies in his *Brevis adnotatio* (Avesani 1976, 120) and to Petrarch's Veronese friend Guglielmo da Pastrengo (1290-1362), who included Pliny the Younger in his *De viris illustribus* (Pastrengo 1991, 184). For the terms of Petrarch's access to the Capitolare, see Billanovich (1997, 158).

[14] E.g. *Rerum familiarium libri* VI, 4 (Petrarch 1975, 314-317).

[15] For Petrarch and the Scaligeri, see Richards (2007, 5-6).

[16] A first attempt, in which Petrarch was to be offered an academic post, was made in 1351. The Florentines tried again in 1365, this time offering a canonry. For these, and Petrarch's refusals, see Wilkins (1961, 99 and 107).

[17] Altichiero's career is documented between 1369 and April 1393, by which time he was already dead. His time in Padua working for the Lupi is well documented, though it is unclear exactly when (between 1369 and c.1376) he moved from Verona to Padua to take up work on the *Sala virorum illustrium*.

[18] "Francisci Petrarce Poete laureati quorundam clarissimorum heroum epithomatis, ad generosissimum Patavi Dominum Franciscum de Carraria, rubrice." Ferrante (1934, 466).

[19] For the *Triumph of Fame* see Shorr (1938), Gilbert (1977) and Richards (2000, 123-133).

[20] "His gestis Caesaris cum instaret, obit ipse vates celeberrimus Franciscus Petrarca, millesimo trecentesimo septuagesimo quarto, decimonono, julii Arquade. Francisci Petrarce poete laureati explicit epithoma ad inclitum Franciscum de Cararia Patavi Dominum." Ferrante (1934, 466).

[21] For Lombardo's additions, see Ferrante (1934, 465-74).

[22] For the pulpit, see Aliberti Gaudioso (1996, 48-49).

[23] For the Sala virorum illlustrium, see Mommsen (1952) and Richards (2000, 104-34).

[24] The first modern scholar to identify the San Giacomo portrait as Petrarch was Andrea Moschetti, director of the Museo Civico in Padua (Moschetti 1904 and 1929).

[25] For a variant reading, in which the monarch is Charlemagne and the battle Pamplona, see Plant (1981, 419-420), Richards (2000, 152-153) and Bourdua (2004, 118-120).

[26] The portrait of Lombardo in the *Sala dei giganti* is a complete repaint. But the markedly square head does resemble that of the figure in Altichiero's two frescoes. Perhaps the 16th-century artists attempted to retain something of the look of the original.

[27] For which see *Rerum familiarium libri* VI, 3: "...I had grey hair considerably before my twenty-fifth year." (Petrarch 1975, 303). Mardersteig (1974, 268) suggests that Petrarch's face was at least partly repainted during a restoration of 1771. The frescoes have been restored again since Mardersteig's time and all later additions have been removed.

[28] Kohl & Day (1974, 24). Giovanni's text reads: "De senecte incommodis taceo, quorum ille adeo vixit immunis, ut ad decrepitudinem ipsam non solum corporis mundiciam verum iuvenilem quoque referret florem." Mardersteig (1974, 275) cites the description of Petrarch in Boccaccio's *De vita et moribus domini Francisci Petracchi de Florentia*. Though the biography was first drafted before Boccaccio and Petrarch became friends, Wilkins (1963, 82) suggests that the description included in the second part of Boccaccio's text depended on an accurate account given him by someone who knew Petrarch well. Wilkins (1963, 84) suggests 'Laelius' (Angelo di Pietro Stefano dei Tosetti). Boccaccio's description reads: "Statura quidem procerus, forma venustus, facie rotunda atque decorus, quamvis colore etsi non candidus, non tamen fuit obscurus, sed quadam decenti viro fuscositate permixtus. Oculorum motus gravis, intuitus lctus et acuta perspicacitate subtilis; aspectu mitis, gestibus verecundus quamplurimum; risu letissimus, sed numquam cachino inepto concuti visus..." (Boccaccio 2004, 82 and 84), with which compare the description in the *Posteritati*: "Corpus iuveni non magnarum virium sed multe dexteritatis obtigerat. Forma non glorior excellenti, sed que placere viridioribus annis posset: colore vivido inter candidum et subnigrum, vivacibus oculis et visu per longum tempus acerrimo..." (Petrarch 1955, 2).

[29] Wilkins (1961, 258).

[30] Caramelli et al. (2007).

[31] E.g. Mardersteig (1974, 269), Plant (1981, 414), Kohl (1998, 181), Richards (2000, 149)

[32] In the scene of *St Lucy before Judge Pascasio*.

[33] For Bonifacio Lupi and his chapel see Richards (2000, 138-158). The dedication of his chapel to St James the Great may reflect Carrara history, for the family celebrated the saint's feast day as the anniversary of their first real step towards

absolute power in Padua with the election of Giacomo 'Grande' da Carrara as Captain General in 1318. This was commemorated, by statute, with a *palio* every 25th of July. Kohl (1998, 42).

[34] As an example of the close relationship between Lombardo and Bonifacio in a Petrarchan context there is the occasion of the legitimisation of Lombardo's son Pellegrino in 1389. This took place in Bonifacio's house in Padua and was recorded by his notary, Andrea Codagnelli. See Ferrante (1934, 455) and Billanovich and Pellegrin (1964, 230-1). The late Benjamin Kohl has suggested (verbal communication) that the boy was named in memory of Petrarch, who styled himself "peregrinus ubique" in one of his *Epistole metriche* (3:19, 16): "incola ceu nusquam, sic sum peregrinus ubique." (Petrarch 1951, 798). See also Wilkins (1955c) for Bonifacio and Petrarch. A Paduan document of 1378 relating to Bonifacio's hospital of S. Giovanni Battista in Florence was witnessed by Francescuolo da Brossano, Petrarch's son-in-law and heir (Sartori 1963, 323).

[35] Bonifacio received consistent support from the emperor in his attempts to reclaim his ancestral lands and rights from Visconti control. In 1355 he accompanied Charles to Pisa and was described as being "in gran modo nella confidenza di Carlo" (Pezzana 1971, 1:39), a confidence confirmed by his appointment as Charles's *consigliere* in 1366. Bonifacio's cousin Raimondino, the patron of the Oratory of San Giorgio, had fought with the young Charles at the battle of San Felice in 1332, and was knighted by him on the battlefield. When Francesco da Carrara went to meet the emperor at Udine in 1368, he took Petrarch with him, and when Charles later arrived in Padua, Petrarch was evidently there too.

[36] For the war see Kohl (1998, 103-131 & 205-242. For King Louis as model for Ramiro/Charlemagne, see Plant (1981).

[37] For the *Compendium* see Mommsen (1952, 106) and Martellotti (1983, 50-66).

[38] For the frontispiece see Richards (2000, 133) and Minazzato (2006).

[39] For the 3-bay box see Gibbs (2000), and, for the significance of Altichiero's use of the format, Richards (2000, 24-32; 154-155).

[40] *Rerum familiarium libri* XVIII, 8.

[41] The movement is, I think, clearly towards Petrarch rather than, as Plant (1981, 414) suggests, "towards the [Carrara] princes."

[42] Zardo (1887, 226) discusses both traditions.

[43] I am very grateful to Dr. Jane Bridgeman for her comments.

[44] "The memory of men is unstable; paintings are transitory; statues are perishable, and among the invention of mortals nothing is more stable than letters." *Rerum familiarium libri* VII, 15 in Petrarch (1975, 376).

[45] For Lombardo's activities in the years 1374-88, see Billanovich (1947, 301-335) and for his Petrarch manuscripts, Martellotti (1983, 90-106).

[46] For which, see Billanovich and Pellegrin (1964, 222). For a summary description of the interconnected web of acquaintance around Bonifacio and Lombardo, see Richards (2000, 205-6).

[47] Baron (1966, 254-6).

[48] Kohl (1975) discusses a variety of responses to Petrarch's death.

[49] Wilkins (1961, 152-153). Petrarch discussed the diploma making him Count Palatine in *Rerum familiarium libri* XXI, 2.

[50] Cited in Hunter (1985, 483).

[51] The literature on Petrarch and friendship is extensive; there is probably no account of him that wholly omits it. For a recent discussion, see Wojciehowski (2005), and for a useful summary of Petrarch's position, see *Rerum familiarium libri* III, 11 (Petrarch 1975, 143-144).

[52] In the *Posteritati* (*Rerum senilium libri* XVIII,1), Petrarch discusses these relationships with some care: "such love for freedom was implanted in me that I studiously avoided anyone whose very name seemed incompatible with it." (Petrarch 1992, 2:673).

[53] E.g. *Rerum familiarium libri* XVIII, 8, citing Cicero's *De amicitia* (Petrarch 1985, 56-59).

[54] For Francesco see Levi (1908), and for Giovanni, Kohl (1998, 156).

[55] Wilkins (1955b).

[56] *Rerum senilium libri* 4, 1, to Luchino dal Verme. See Richards (2007, 79).

[57] Petrarch says (*Rerum senilium libri* XVI,1) that Giacomo Colonna had been attracted to his youthful self: "he had been charmed by my appearance, without knowing yet who I was or where from" (*meo delectatus erat aspectu, ignarus adhuc quis aut unde essem.*) (Petrarch 1992, 2:601; Latin from http://www.bibliotecaitaliana.it/xtf/view?docId=bibit000342/bibit000342.xml). This intense engagement with the visual aspects of identity and memory surfaces repeatedly in Petrarch's writing, e.g. *Rerum familiarium libri* III, 12 to Marco Genovese: "From when I first saw you I fixed your image indelibly deep in my heart like a faultless diamond which no time can remove, nor any place." (Petrarch 1975, 147).

[58] See Richards (2007, 95-98).

[59] Book IX of Quintilian's *Institutio Oratoria* deals at length with the intellectual foundations of art, and Petrarch's oppositional terms surely reflect such observations as: "The learned therefore know the principles of Composition, but even the unlearned know its pleasures (Ideoque docti rationem componendi intelligunt, etiam indocti voluptatem)". Quintilian (2001, 4:224-225). Compare Petrarch's reference to his panel "...cuius pulchritudinem ignorantes non intelligunt, magistri autem artis stupent." (Mommsen 1957, 78-80). Though the full text of Quintilian was only discovered by Poggio Bracciolini in 1416, Petrarch knew most of it, for which see Nolhac (2004, 2:83-94).

[60] For this panel, see Grossato (1974, 97).

[61] For which see Bourdua (2002).

[62] "Ecce, Francisci nomen et fama in manibus tuis erit." Murphy's translation is of Salutati's *Epistolario* 4.5, which refers to Salutati's receipt of the long awaited *Africa*.

References

Aliberti Gaudioso, Filippa M., ed. 1996. Pisanello: *I luoghi del gotico internazionale nel Veneto*. Milan: Electa.

Avesani, Rino. 1976. "Il preumanesimo Veronese." In *Storia della cultura veneta: Il trecento*, edited by Gianfranco Folena, 19-110. Vicenza: Neri Pozza.

Baron, Hans. 1966. *The Crisis of the Early Italian Renaissance: Civic Humanism and Republican Liberty in an Age of Classicism and Tyranny*. Revised one-volume edition. Princeton: Princeton University Press.

Baxandall, Michael. 1971. *Giotto and the Orators: Humanist observers of painting in Italy and the discovery of pictorial composition 1350-1450*. Oxford: Oxford University Press.

Bellinati, Claudio. 2006. *Identità e spiritualità di Francesco Petrarca, canonico della cattedrale di Padova (1349-1374)*. In Mantovani, *Petrarca e il suo tempo*, 27-42.

Benati, Daniele. 1992. *Jacopo Avanzi nel rinnovamento della pittura padana del secondo '300*. Bologna: Grafis edizione.

Bernardo, A.S. 1955. "Petrarch's Attitude toward Dante." *PMLA* 70 (3): 488-517.

Billanovich, Giuseppe. 1947. *Petrarca letteratto. Lo scrittoio del Petrarca*. Rome: Edizioni di storia e letteratura.

—. 1997. "Petrarca e i libri della cattedrale di Verona." In *Petrarca, Verona e l'Europa: Atti del convegno internazionale di studi (Verona, 19-23 sett. 1991)*, edited by Giuseppe Billanovich and Giuseppe Frasso, 117-178. Padua: Editrice Antenore.

Billanovich, Giuseppe and Elizabeth Pellegrin. 1964. "Una nuova lettera di Lombardo della Seta e la prima fortuna delle opere del Petrarca." In *Classical, Medieval and Renaissance Studies in Honor of Berthold Louis Ullman*, edited by Charles Henderson, vol.2, 215-236. Rome: Edizioni di storia e letteratura.

Boccaccio, Giovanni. 2004. *Vita di Petrarca*. Edited with Italian translation of the *De vita et moribus domini Francisci Petrarcchi de Florentia* by Gianni Villani. Rome: Salerno editrice.

Bourdua, Louise. 2002. "Altichiero's 'Anchona' for Margareta Lupi: A Context for a Lost Painting." *Burlington Magazine* 144 (1190): 291-293.

—. 2004. *The Franciscans and Art Patronage in Late Medieval Italy*. Cambridge: Cambridge University Press.

Brunt, P.A. 1965. "Amicitia in the late Roman Republic." *PCPS* 11: 1-20.

Buettner, Brigitte. 2001. "Past Presents: New Year's Gifts at the Valois Courts, ca. 1400." *Art Bulletin* 83 (4): 598-625.

Caramelli, David et al. 2007. "Genetic analysis of the skeletal remains attributed to Francesco Petrarca." *Forensic Science International* 173: 36-40.

Falcioni, Anna. 2007. "Malatesta (de Malatestis), Pandolfo." In *Dizionario biografico degli Italiani*, vol.68. Rome: Istituto della Enciclopedia Italiana.

Ferrante, Giuseppina. 1934, "Lombardo della Seta umanista Padovano (?-1390)." *Atti del reale iIstituto Veneto di scienze, lettere ed arti* 93 (2): 445-87.

Findlen, Paula. 1998. "Possessing the Past: The Material World of the Italian Renaissance." *American Historical Review* 103 (1): 83-114.

Foresti, Arnaldo. 1977. "La gita del Petrarca a Bergamo il 13 ottobre 1359." In *Aneddoti della Vita di Francesco Petrarca*, edited by Antonia Tissoni Benvenuti with a preface by Giuseppe Billanovich, 379-404. Padua: Editrice Antenore.

Garin, Eugenio. 1970. "Ritratto di Leonardo Bruni Aretino." *Atti e memorie della accademia Petrarca di lettere, arti e scienze* 40: 1-17.

Gibbs, Robert. 1990. "Images of Higher Education in Fourteenth-Century Bologna." In *Medieval Architecture and its Intellectual Context: Studies in Honour of Peter Kidson*, edited by Eric Fernie and Paul Crossley, 269-281. London: Hambledon Press.

—. 2000. "The three-bay (or five-bay) interior and the apsidal interior from Giotto to van Eyck: a Westminster episode." In *England and the Continent in the Middle Ages: studies in memory of Andrew Martindale, Harlaxton medieval studies VIII, proceedings of the 1996 Harlaxton symposium*, edited by John Mitchell & Matthew Moran, 175-188. Stamford: Shaun Tyas.

Gilbert, Creighton. 1977. "The Fresco by Giotto in Milan." *Arte Lombarda* 47: 31-72.

Gombrich, Ernst. 1979. "Giotto's Portrait of Dante?" *Burlington Magazine* 121 (917): 471-483.

Grandi, Renzo. 1982. *I monumenti dei dottori e la scultura a Bologna 1267-1348*. Bologna: Istituto per la storia di Bologna.

Grossato, Lucio, ed. 1974. *Da Giotto al Mantegna*. Milan: Electa Editrice. Published in conjunction with the exhibition "Da Giotto al Mantegna" shown at the Palazzo della Ragione, Padua, 9 June – 4 November 1974.

Guss, Donald L. 1974. "Petrarchism and the End of the Renaissance." In Scaglione, *Francis Petrarch, Six Centuries Later*, 384-401.

Hunter, Richard L. 1985. "Horace on Friendship and Free Speech." *Hermes* 113 (4): 480-490.

Kennedy, William J. 1994. *Authorizing Petrarch.* Ithaca: Cornell University Press.

Kohl, Benjamin G. 1975. "Mourners of Petrarch." In Scaglione, *Francis Petrarch, Six Centuries Later*, 340-352.

—. 1998. *Padua under the Carrara 1318-1405.* Baltimore: Johns Hopkins Press.

Kohl, Benjamin G. and James Day. 1974. "Giovanni Conversini's Consolatio ad Donatum on the Death of Petrarch." *Studies in the Renaissance* 21: 9-30.

Kohl, Benjamin G. and Ronald G. Witt. 1978. *The Earthly Republic: Italian Humanists on Government and Society.* Manchester: Manchester University Press.

Konstan, David. 1995. "Patrons and Friends." *Classical Philology* 90 (4): 328-342.

Levi, Ezio. 1908. *Francesco di Vannozzo e la lirica nelle corti Lombarde durante la seconda metà del secolo XIV.* Florence: Galleti & Cocci.

Magliani, Mariella, ed. 2003. *La Casa di Francesco Petrarca ad Arquà.* Milan: Skira.

Manazzato, Marta. 2006. "Francesco Petrarca: *Compendium virorum illustrium*." In *Petrarca e il suo tempo,* 411-413.

Mantovani, Gilda P., ed. 2006. *Petrarca e il suo tempo.* Published in association with the exhibition "Petrarca e il suo tempo" shown at the Musei Civici agli Eremitani, Padua, 8 May – 31 July 2004. Milan: Skira. Mardersteig, Giovanni. 1974. "I ritratti del Petrarca e dei suoi amici di Padova." *Italia medioevale e umanistica* 17: 251-280.

Martellotti, Guido. 1983. *Scritti Petrarcheschi.* Padua: Editrice Antenore.

Mommsen, Theodor E. 1952. "Petrarch and the Decoration of the Sala Virorum Illustrium in Padua." *Art Bulletin* 34: 95-116.

—. 1957. *Petrarch's Testament.* Ithaca: Cornell University Press.

Moschetti, Andrea. 1904. "Per un antico ritratto del Petrarca." In *Padova a Francesco Petrarca nel VI Centenario alla nascita,* 8-10. Padua: Comitato per le onoranze al Petrarca.

—. 1929. "Due ritratti antichi di F. Petrarca." *Atti e memorie della Reale Accademia Petrarca di Scienze Lettere ed Arti in Arezzo* 7: 5-12.

Murphy, Stephen. 1997. *The Gift of Immortality: Myths of Power and Humanist Poetics.* Cranbury, NJ: Associated University Presses.

Nante, Andrea. 2006. "Pittore attivo a Padova: Francesco Petrarca in preghiera." In Mantovani, *Petrarca e il suo tempo,* 409-411.

Nolhac, Pierre de. 2004. *Pétrarque et l'Humanisme*. Reprint of the 1907 edition. Geneva, Slatkin Reprints.

Parker, Deborah. 1998. "Vasari's Portrait of Six Tuscan Poets: A Visible Literary History," in *Visibile Parlare*: Dante and the Art of the Italian Renaissance," edited by Deborah Parker, special issue, *Lectura Dantis* 22-23 (Spring and Fall): 45-62.

Pasini, Pier Giorgio. 1983. *I Malatesti e l'arte*. Bologna: Cassa di Risparmio.

Pastrengo, Guglielmo da. 1991. *De viris illustribus et De originis*. Edited by Guglielmo Bottari. Padua: Editrice Antenore.

Petrarch (Francesco Petrarca). 1951. *Rime, trionfi e poesie latine*. Edited by Ferdinando Neri, Guido Martellotti, Enrico Bianchi and Natalino Sapegno. Milan: Riccardo Ricciardi Editore.

—. 1955. *Prose*. Edited by Guido Martellotti, Pier Giorgio Ricci, Enrico Carrara and Enrico Bianchi. Milan: Riccardo Ricciardi Editore.

—. 1975. *Rerum familiarium libri I-VIII*. Translated by Aldo S. Bernardo. Albany: State University of New York Press.

—. 1982. *Letters on Familiar Matters: Rerum familiarium libri IX-XVI*. Translated by Aldo S. Bernardo. Baltimore: Johns Hopkins Press.

—. 1985. *Letters on Familiar Matters: Rerum familiarium libri XVII-XXIV*. Translated by Aldo S. Bernardo. Baltimore: Johns Hopkins Press.

—. 1991. *Petrarch's Remedies for Fortune Fair and Foul; A Modern English Translation of De remediis utriusque Fortune*. Edited and with commentary by Conrad H. Rawski. 5 vols. Bloomington: Indiana University Press.

—. 1992. *Francis Petrarch, Letters of Old Age:. Rerum senilium libri I-XVIII*. Translated by Aldo S. Bernardo, Saul Levin and Reta A. Bernardo. 2 vols. Baltimore: Johns Hopkins University Press.

—. 2004. *Epystole seniles*. http://www.bibliotecaitaliana.it/xtf/view ?docId=bibit000342/bibit000342.xml

Pezzana, Angelo. 1971. *Storia della città di Parma*. 5 vols. Reprint of original edition of 1837-59. Bologna: Forni.

Plant, Margaret. 1981. "Portraits and Politics in Padua: Altichiero's Frescoes in the S. Felice Chapel, S.Antonio." *Art Bulletin* 63: 406-425.

Pliny (Gaius Plinius Secundus). 1952. *Natural History, Books XXXIII-XXXV*. Edited and translated by Harris Rackham. Loeb Classical Library 394. Cambridge MA: Harvard University Press.

Pound, Ezra. 1952. *Guide to Kulchur*. Norfolk, CT: New Directions.

Quintilian (Marcus Fabius Quintilianus). 2001. *Institutio Oratoria*. Edited and translated by Donald A. Russell. 4 vols. Loeb Classical Library 124-7. Cambridge MA: Harvard University Press.

Richards, John. 2000. *Altichiero: An Artist and his Patrons in the Italian Trecento*. Cambridge: Cambridge University Press.

—. 2007. *Petrarch's Influence on the Iconography of the Carrara Palace in Padua: The Conflict between Ancestral and Antique Themes in the Fourteenth Century*. Lewiston, NY: Edwin Mellen Press.

Sartori, P.Antonio. 1963. "Nota su Altichiero." *Il Santo* 3 (3): 291-326.

Scaglione, Aldo, ed. 1975a. *Francis Petrarch, Six Centuries Later: A Symposium*. Chicago: Department of Romance Languages, University of North Carolina, Chapel Hill and The Newberry Library.

—. 1975b. "Petrarca 1974: A Sketch for a Portrait." In Scaglione, *Francis Petrarch, Six Centuries Later*, 1-24.

Schubring, Paul. 1898. *Altichiero und seine Schule: ein Beitrag zur Geschichte der oberitalienischen Malerei im Trecento*. Leipzig: K.W. Hiersemann.

Shorr, Dorothy. 1938. "Some Notes on the Iconography of Petrarch's Triumph of Fame." *Art Bulletin* 20: 100-107.

Stocchi, Manlio Pastore. 2006. "Giacomo Filippo Tomasini: *Iacobi Philippi Tomasini Episcopi Æmoniensis Petrarcha redivivus*." In Mantovani, *Petrarca e il suo tempo*, 540-541.

Tomasini, Giacomo Filippo. 2004. *Petrarcha Redivivus*. Facsimile of the 1st edition of 1635, edited and with an introduction by Massimo Ciavolella and Roberto Fedi, with Italian translation by Edoardo Bianchini and Tommaso Braccini. Pistoia: Libreria dell'Orso.

Thompson, David and Alan F. Nagel. 1972. *The Three Crowns of Florence: Humanist Assessments of Dante, Petrarca and Boccaccio*. New York: Harper & Row.

Trapp, J.B. 2003. "The Iconography of Petrarch in the Age of Humanism." In *Studies of Petrarch and His Influence*, 1-117 London: Pindar Press.

Valerius Maximus. 2000. *Memorable Doings and Sayings*. Edited and translated from the *Factorum et dictorum memorabilium libri novem* by D. R. Shackleton Bailey. 2 vols. Loeb Classical Library, 492-493. Cambridge MA: Harvard University Press.

Vasari, Giorgio. 1906. *Le Opere*. Edited by Gaetano Milanesi. 9 vols. Florence: Sansoni.

White, Peter. 1978. "Amicitia and the Profession of Poetry in Early Imperial Rome." *Journal of Roman Studies* 68: 74-92.

Wilkins, Ernest Hatch. 1955a. *Studies in the Life and Works of Petrarch*. Cambridge, MA: The National Academy of America.

—. 1955b. "Petrarch's Ecclesiastical Career." In Wilkins, *Studies in the Life and Works of Petrarch*, 3-32.

—. 1955c. "Petrarch and Giacomo de' Rossi." In Wilkins, *Studies in the Life and Works of Petrarch*, 273-279.

—. 1955d. "A General Survey of Renaissance Petrarchism." In Wilkins, *Studies in the Life and Works of Petrarch*, 280-299.

—. 1960. *Petrarch's Correspondence*. Padua: Editrice Antenore.

—. 1961. *Life of Petrarch*. Chicago: University of Chicago Press.

—. 1963. "Boccaccio's Early Tributes to Petrarch." *Speculum* 38, 1 (January), 79-87.

Witt, Ronald G. 2000. *In the Footsteps of the Ancients: The Origins of Humanism from Lovato to Bruni*. Leiden: Brill Academic Publishers.

Wojciehowski, Dolora Chapelle. 2005. "Francis Petrarch: First Modern Friend." *Texas Studies in Literature and Language* 47 (4): 269-298.

Zardo, Antonio. 1887. *Il Petrarca e I Carraresi*. Milan: Ulrica Hoepli.

Zetzel, J.E.G. 1972. "Cicero and the Scipionic Circle." *Harvard Studies in Classical Philology* 76: 173-179.

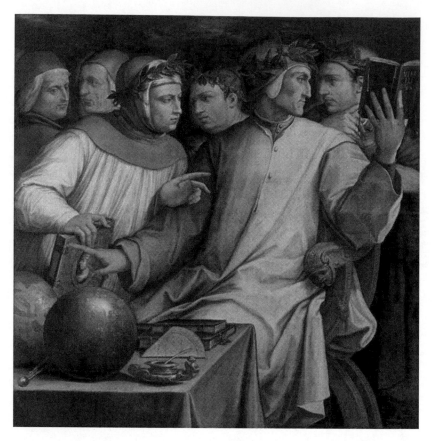

Fig. 1-1. Giorgio Vasari, *Six Tuscan Poets*, oil on panel, 1544, 132.08 x 156.53 cm, Minneapolis Institute of Arts, The William Hood Dunwoody Fund. Photo: Minneapolis Institute of Arts.

Fig. 1-2. Tomb of Bavarino de'Crescenzi, marble, 1346, Verona, San Pietro Martire. Photo: author.

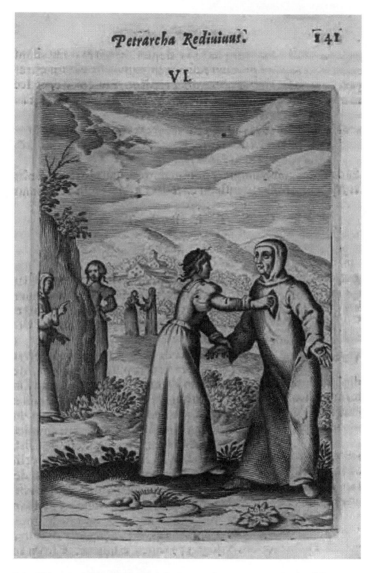

Fig. 1-3. Giacomo Filippo Tomasini, *Petrarcha redivivus*, 2nd edition, 1650, pl. VI. Photo: Rare Book and Manuscript Library, University of Pennsylvania.

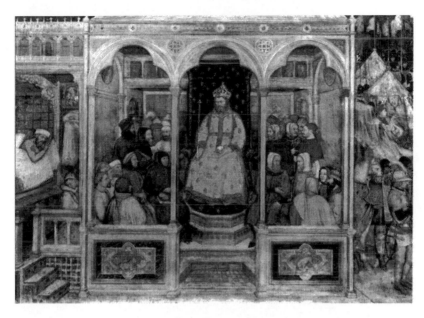

Fig. 1-4. Altichiero, *Dream of King Ramiro, Council, Battle of Clavigo* (part), fresco, 1376-9, c.6.5 x 3.7 m. Padua, Basilica del Santo, Cappella di San Felice (formerly San Giacomo). Photo: Centro Studi Antoniani, Padua.

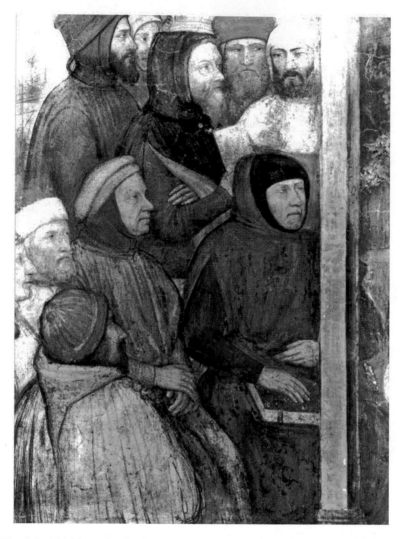

Fig. 1-5. Altichiero, detail of *Council*, fresco, 1376-9, Padua, Basilica del Santo, Cappella di San Felice (formerly San Giacomo). Photo: Centro Studi Antoniani, Padua.

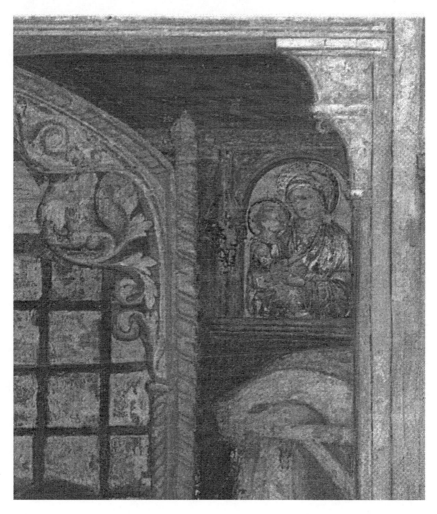

Fig. 1-6. Altichiero, detail of *Dream of King of King Ramiro*, 1376-9. Padua, Basilica del Santo, Cappella di San Felice (formerly San Giacomo). Photo: Centro Studi Antoniani, Padua.

CHAPTER TWO

A FLORENTINE IN ROMAGNA:
GIOTTO AND THE DECORATION
OF THE CHURCH OF SAN FRANCESCO, RIMINI

JILL FARQUHAR

The early fourteenth-century programme of decoration for the church of San Francesco in Rimini survives only in fragments. The church itself was substantially rebuilt as the Tempio Malatestiano by Sigismondo Pandolfo Malatesta (1417–1468) in the middle of the fifteenth century. This rebuilding enclosed parts of the earlier church but obliterated almost all of the trecento decoration.[1] While small fragments of fresco remain, the most prominent survival is the large painted cross, attributed to Giotto, which still hangs in the Tempio, in the Chapel of Isotta degli Atti (fig. 2-1). This essay will investigate the role of Giotto in the trecento programme at San Francesco and attempt to securely associate a group of Giotto's panels, now scattered across Europe, with the high altar in the same church.

The presence of Giotto in Rimini, in the early Trecento, is attested to by various commentators and historians of varying periods and varying reliability. The resulting body of information is therefore vague and, at times, conflicting.

The first account of Giotto's presence in the city is supplied by the chronicler Riccobaldo Ferrarese who states that there were works executed by him in the churches of the Franciscans in Assisi, Rimini, and Padua, and in the church of the Arena in Padua (Ferrariensis 2000, 218-219).[2] This account appears to date to 1312 or 1313 and certainly no later than 1319 and serves as a terminus ante quem for Giotto's activity at Rimini (Davies and Gordon 1988, 32-34).

Vasari's descriptions of Giotto's activity are perhaps the most wordy but also, perhaps, the most unreliable. Vasari ascribed many works to

Giotto's hand which had previously been unmentioned and were soon removed once again from his catalogue.[3] For this reason it is necessary to treat Vasari's comments on Giotto's activity in Rimini with extreme caution. Moreover his comments on the patronage of Giotto by the Malatesta family are imprecise and rather puzzling.

"Finita quest'opera, [at Gaeta] non potendo cio negare al signor Malatesta, prima si trattenne per servigio di lui alcuni giorni in Roma, e di poi se n'andò a Rimini, della qual città era il detto Malatesta signore; e lì, nella chiesa di San Francesco, fece moltissime pitture: le quali poi da Gismondo, figliuolo di Pandolfo Malatesti, che rifece tutta la detta chiesa di nuovo, furono gettate per terra e rovinate." (Vasari 1906, 392)

The inference here seems to be that at least some of the works ascribed to Giotto in San Francesco at Rimini were integral to the fabric of the building, suggesting they were fresco cycles such as those cited by Vasari in the cloister. The comments however do not rule out, by any means, the presence of painted panels by the artist such as an altarpiece or painted cross.[4]

The length of time Giotto is supposed to have remained in Rimini is not commented on and so this can give us no idea of extent of any programme he may have executed. On the other hand Vasari clearly states that Giotto painted "moltissime pitture" in the church of San Francesco indicating that he believed Giotto to be responsible for a large extent of the interior decoration (Vasari 1906, 392).

This statement, even allowing for Vasari's notorious unreliability, must be qualified further. The works of the Riminese artists of the first half of the Trecento have, at various periods, been confused by commentors with works of Giotto himself. Vasari himself ascribes a work by the Riminese school in San Francesco in Ravenna to Giotto and notably in the 19th and early 20th century works of the Riminese artists were occasionally exported as works of the Florentine master (Vasari 1906, 388). It is therefore very possible that works existing in the church of San Francesco by the Riminese School could have been confused with works of Giotto at an early point in their history.

For these reasons Vasari's account is unhelpful in an assessment of the extent of Giotto's activity in Rimini. Riccobaldo's more basic comments, with their historical proximity to the period in question are far more likely to be reliable, written most probably within two decades of Giotto's supposed visit.

An idea of the form and scale of the church of San Francesco would be a useful tool in assessing which types of decoration may have been present. Various excavations have revealed foundations relating to earlier building campaigns on the site. The original arrangement of the east-end is difficult to establish. Fragments of foundations of three eastern chapels have been discovered beneath the nave of the present church; all three are rectangular in plan, the central one being wider and deeper than the others and this arrangement does seem to reflect early Franciscan plans in its simplicity and austerity (Hope 1992, 55). The situation is complicated by the more recent discovery of the foundations of a semi-circular apse further to the east of these chapels however this structure is likely to have belonged to the earlier church on the site (Santa Maria in Trivio), the apse reflecting the Byzantine origins of that building.

Our knowledge of the church of San Francesco is enhanced dramatically due to the fact that Alberti's Tempio did not simply replace the older building, but instead encased it, retaining large sections of the existing fabric in the new structure.

As Hope has indicated, the current ground plan of the Tempio is related to that of the earlier church (Hope 1992, 53-56). Fabric from San Francesco survives in several of the chapels on the right of the nave, indicating that some of these chapels were in an identical position. The chapel nearest the high altar, dedicated to St. Jerome, appears to have been the same size in both San Francesco and the Tempio (Hope 1992, 53). The pattern of surviving fabric also suggests that the right hand exterior wall of San Francesco was located on the line of the interior wall of these right hand chapels in the present church (Hope 1992, 56). The present entrance wall is also, substantially, a survival from the older church.[5]

Assuming that the foundations of the rectangular chapels represent the pre-Tempio arrangement of the church then these survivals suggest two possible basic floor plans for San Francesco.[6] Either the church was originally rectangular in plan (without transepts), or the current Chapel of St. Jerome represents the right transept (rather than a flanking chapel) which reflected an analogous structure on the opposite side of the church. Either way we are looking at a relatively small and basic space, approximately 40 metres in length, and therefore substantially smaller than the current structure.

It is now necessary to turn to the most obvious piece of evidence remaining at the Tempio Malatestiano, the painted cross which still hangs in the church. The cross, which has generally been attributed to Giotto or

to his shop throughout its history, is no longer complete; it has been shorn at all four ends ridding the present structure of the usual lateral imagery.[7]

In terms of style there is no doubt that the Tempio cross relates strongly to other works by Giotto, most particularly the crosses painted for Santa Maria Novella in Florence, the Scrovegni Chapel, and the Ognissanti, Florence. The former two are securely associated with the name of Giotto while the latter is more problematic. All three however, offer useful clues to the nature of the Tempio example.

The first of the crosses, that from Santa Maria Novella, has been associated with the first years of the Trecento and is formally quite distinct from the latter two examples in that it retains the rectangular terminal panels, which, as we will see, were superseded in the Riminese example. The Santa Maria Novella cross is, however, set apart from its Duecento predecessors by the realistic depiction of Christ's body, hanging weightily from the cross. This realistic depiction was to be continued, albeit in a less exaggerated manner, in the crosses at Rimini, Padua and the Ognissanti, although their structure and profiles are very different.

The crosses from the Scrovegni Chapel and the Ognissanti have an unusual and elaborate silhouette, enhanced by the barbed quatrefoils of the terminal panels and the "lobes" added around the central section. In the Riminese cross similar "lobes" are present, and this indicates that cross originally had a similar outline. This is confirmed by the shape of the detached Redeemer panel which, like the other examples, is based on the barbed quatrefoil. Moreover, the Scrovegni and Ognissanti crosses appear to be elaborations of the Riminese cross. The latter lacks the additional lobes, present at the level of Christ's knees, which are present in the former two. This suggests that the Scrovegni and Ognissanti crosses are later elaborations of the Riminese cross, which was therefore the first to be executed.

It is the Scrovegni Cross however, which forms the closest parallel to the Tempio example. Although on a much smaller scale, the Scrovegni cross is remarkably similar especially in the way that the anatomy is defined by strong light and shade. Also analogous is the diaphanous loincloth which is arranged almost identically in both crosses.

On the other hand, between the crosses there are small but significant differences in the execution. The emphatic, yet detailed, rendering of the muscles of Christ's torso is somewhat weaker in the Riminese cross, and the rib cage and pectoral muscles are picked out in a more linear, and perhaps, less accomplished fashion. The result is a level of stylisation absent in the figures at Padua.

A plausible explanation for this is that the Riminese cross relied heavily or entirely on the participation of assistants for its completion. We know that Giotto worked at various times in his career with a large workshop, and in fact many of the works signed by him appear to be entirely workshop projects. It seems therefore highly likely that the stylisation of the anatomy is due to a less skilled interpretation of Giotto's design by assistants working, either in collaboration with the master, or within his own workshop.

Another issue which needs to be addressed is that of location. The Tempio cross immediately presents a problem of scale: even in its diminished state it measures 430cm by 303cm, and is therefore an extremely large panel for a church of the size of San Francesco.[8] The cross can however, be likened to that in the nearby Augustinian church of Sant'Agostino which, in a similarly damaged state, measures 427cm by 335cm.[9] The church of Sant'Agostino has been substantially altered since the medieval period but its ground plan still reflects the layout of the trecento church, and it can be seen that both Riminese churches were similar in layout and scale (both had three rectangular chapels at the east end). The Sant'Agostino cross however, does not offer a straightforward parallel to the Tempio cross, as it was obviously heavily influenced by the former. This influence may extend to scale as well as style and format, particularly as houses of rival mendicants were prone to competition in such matters, and this would suggest that the scale of the Tempio cross dictated the scale of the latter. By comparison to the Florentine cross then, the Tempio cross is on an exceptionally large scale for a church of the size of San Francesco and this raises the question of where it was accommodated within the church.

The original placing of the painted crosses of the Duecento and Trecento is still much debated: few examples remain in situ, and many were designed for churches which have now changed substantially. It seems certain however, that the majority would have been situated in a prominent position either above a rood screen or *tramezzo*, or sited within the choir, suspended above or behind the high altar.

At Santa Maria Novella the trapezoidal foot of the painted cross strongly suggests that it was designed to stand upon a surface rather than be suspended from the ceiling and the only reasonable site for this would have been upon a substantial rood screen, such as that reconstructed by Hall for the trecento church (Hall 1974, 157–173).[10] Likewise, the Scrovegni Cross, with its similar trapezoidal foot, probably stood above a screen or similar structure within the chapel. This idea is supported by the

fact that the rear side is painted and was therefore clearly intended to be visible.

These examples suggest that the Tempio cross was located in a similar position within San Francesco, and indeed the foundations of a structure possibly representing a rood screen (or combination of rood screen and choir screen) have been located half-way along the present nave of the church (Hope 1992, 54).[11] Pasini, in his reconstruction of the trecento interior of Sant'Agostino, places the painted cross above a screen straddling the nave, even though, like the Tempio cross, the Sant'Agostino cross appears to have been exceptionally large for such a visibly accessible location (Pasini 1998, 48).

The alternative possibility: that the cross was located within the choir, suspended by chains from the ceiling, seems more likely for reasons of scale but is problematic in other respects. Firstly there is the issue of the duplication of imagery. As we will see, it is possible that the high altarpiece of San Francesco had a central Crucifixion scene. If the cross was located within the choir, it would then be seen directly above the parallel image below, a seemingly superfluous duplication of iconography. In addition, it appears that the cross was, at some stage in its history, within close reach of human contact. There is substantial and localised damage to Christ's feet, suggesting a case of "pious vandalism" as discussed (with reference to other crosses) by Mognetti (2002, 354 – 369).[12] If this damage occurred while the cross was in its original location at San Francesco, then a position above the choir is not feasible. However, it is just possible that, given the scale of the church, a painted cross resting on a screen may have been accessible to the laity.[13]

The evidence seems to suggest then, that despite its scale, the Tempio cross was originally located above the screen in the nave of San Francesco. In such a position it must have appeared extremely imposing, and it is therefore unsurprising perhaps that it exerted such an influence on the painted crosses of Rimini and the surrounding areas. Not only do the majority of crosses by the Riminese artists follow closely both its style and structure, but the high proportion surviving in the area suggests that the painted wooden cross, as a piece of church furniture, had become extremely popular.

Neither the cross in the Tempio Malatestiano or the Sant'Agostino cross are signed and their dates are uncertain. Giovanni da Rimini's signed and dated cross in the church of San Francesco in Mercatello sul Metauro, signed and dated to 1309 (or 1314, the inscription is damaged), is more obviously in debt to the Tempio example. It therefore provides a convincing *terminus ante quem* for the Tempio Cross.[14]

There is another work which has been associated with Giotto's visit to Rimini. This is represented by the group of seven panels now scattered over several locations including the National Gallery in London. The panel in London represents The Pentecost and is probably the last in the sequence of seven. The rest of the sequence consists of *The Nativity/ Adoration of the Magi* (New York, Metropolitan Museum), *The Presentation in the Temple* (Boston, Isabella Gardner Museum), *The Last Supper* and *The Crucifixion* (fig. 2-2), both in the Alte Pinakothek, Munich, *The Entombment* (Settignano, I Tatti, Berenson Collection) and *The Descent into Limbo*, also in the Alte Pinakothek, Munich.[15]

Their arrangement was for a while a matter of debate however technical evidence now suggests that the panels were originally arranged horizontally in a single row. This is indicated by the positions of the batons which would once have supported the structure and by the gesso lip on the left edge of the Nativity and right edge of the Pentecost implying that they were originally the outer two panels of the sequence (Bomford et al, 1989, 66-68).[16] The original structure therefore would have been reasonably low and wide (at least 320cm) and would have resembled a dossal rather than a polyptych proper.

The presence of St. Francis at the foot of the cross in *The Crucifixion* and the use of Christological narratives allows the assumption that the panels once resided in a Franciscan church but otherwise the provenance is unclear. Gordon discusses two theories as to the original location of the panels (Gordon, 1989, 528-531). The first of these associates the panels with those mentioned by Vasari as being brought to Arezzo from San Sepolcro in 1327 and which he described as "a panel by Giotto's hand containing small figures which later fell to pieces" (Vasari 1906, 30). The second theory which Gordon proposes is that the panels originally belonged to the church of San Francesco in Rimini (Gordon 1989, 528-531).

Gordon supports this theory by discussing various elements which tie both the iconography and the format of the dossal to the area around Rimini (Gordon 1989, 528–531). The most obvious of these is the low format of the structure itself and its content; a sequence of Christological narratives. These are unusual features in the context of Tuscan panels within Giotto's period of activity but are a characteristic of several Riminese panels.

The other elements are predominantly iconographical. Gordon points out that the conflation of the Nativity and the adoration of the Magi occurs in several instances within the body of Riminese panel painting (Gordon 1989, 528). A notable example would be the panel by Giovanni Baronzio

now in the Courtauld Institute Galleries in London where several events are included such as the bathing of the Christ child and the annunciation to the shepherds as well as the arrival of the Magi. The swooning Madonna of the Munich *Crucifixion* is, Gordon has observed, also a common trait of the Riminese Crucifixion scenes and, in particular, the way the Madonna is supported under the shoulders by her female companions is repeated in various instances around Rimini (Gordon 1989, 528–531).[17] Finally, the inclusion of the scene of the descent into Limbo is significant as this is by no means a common scene in the early years of the Trecento, however it is also a scene which is repeated several times in the extant body of Riminese painting, usually, as in the dossal discussed, as part of a sequence of Christological narratives (Gordon 1989, 528).

The second of the two theories is, I think, far more persuasive and yet hardly conclusive. However there are several other characteristics, so far overlooked, which connect the panel to the "Riminese School" of the early Trecento.

First of all the central Crucifixion scene of the dossal has other affinities with Riminese versions of the same scene. The composition itself is relatively simple, consisting of Christ's cross, flanked on the left hand side (Christ's right) by the Holy Women and the swooning Madonna, and on the right hand side by St. John the Evangelist. Behind St. John we see a figure characterised as Jewish (rather than Roman) and behind him another male figure, only just visible. In addition there are the three kneeling figures around the foot of the cross; St. Francis himself and the two donors.

This basic composition is an elaboration of the basic Byzantine Crucifixion in its simplest form, which consists simply of Christ flanked by the Madonna and St John. The scene retains the simplicity and symmetry of this format yet enhances the "temporal" and narrative qualities of the scene by the introduction of extra characters and activity. As we will see, in Tuscan painting St. John was far more frequently placed to the left of Christ (our left) amongst the group of Christ's followers rather than to the right, the area reserved for those unable to recognise Christ's divinity or "the unseeing mass". In this example, however, and the majority of Riminese Crucifixion scenes, St. John remains in his position opposite the Madonna on the right side of the cross.

This is not to say however, that this feature of Riminese Crucifixion scenes derives from the Munich panel but rather that Riminese iconographical tradition remained tied to Byzantine prototypes long superseded in Tuscan painting, a situation which is unsurprising due to Rimini's position as a port on the Adriatic with trading links with Venice

and Dalmatia. In this sense the Munich Crucifixion may follow an existing
Riminese tradition rather than actually setting it.[18]

On the other hand there are at least three Riminese scenes which
appear to be directly reliant on the Munich Crucifixion. The first of these
belongs to the panel now in the Pinacoteca Comunale in Ravenna and
attributed to the so called Maestro del Coro degli Scrovegni. The panel
consists of a central Madonna and Child flanked by four scenes of Christ's
life.[19] As his title suggests the painter of this panel was strongly influenced
by Giotto's frescoes at the Scrovegni Chapel yet, while the scenes of the
Nativity and the Adoration of the Magi are essentially copies of the
versions in the chapel, it is not the frescoed Crucifixion which he uses as a
source. Instead the image is far closer to the Munich panel.[20] This pattern
is repeated in the panel by Giovanni da Rimini in Rome [21] and on the tiny
panel by Baronzio in Venice where the figure behind St. John is now
characterised as the Centurion (fig. 2-3).[22] In this latter example the figure
of St. John is clearly reliant on the analogous figure in the Munich
Crucifixion.

It is noteworthy that all three of these examples occur as one image
within in a sequence of Christological narratives. Like the panels
attributed to Giotto, the former two skip straight from scenes of Christ's
infancy to his Passion.

Gordon has already pointed out that the drinking figure in the Munich
Last Supper is repeated by Pietro da Rimini in the frescoed *Wedding at
Cana* in the Capellone of San Nicola in Tolentino (Gordon 1989, 528).
This figure is repeated again in the *Last Supper* by Giovanni Baronzio, an
image which appears at least partly indebted to the Munich version in
other ways, notably the visibility of the bench to the right of the table, and
the attempt to construct both a convincing "room" and spatially coherent
arrangement of the occupants around the table.[23]

Another feature which the Riminese artists seem to have adopted is
derived from the *Descent into Limbo* also in Munich. In this panel Christ's
robe is distinctively coloured. These pale robes with gold striation are
repeated at least twice by Riminese artists most strikingly by Giovanni da
Rimini in the panel, discussed above, in Rome.[24]

Perhaps the most convincing argument for a provenance of San
Francesco in Rimini is provided by the polyptych signed and dated by
Giovanni Baronzio to 1345, now located in the Galleria Nazionale delle
Marche in Urbino and originally from Macerata Feltria. This polyptych is
highly unusual in its combination of narrative scenes, standing saints and a
Madonna and Child all within the main register.[25] Again the four
narratives begin with episodes from the infancy of Christ before skipping

immediately to the Passion. It is the second of these scenes, *The Presentation of Christ in the Temple*, which is important here as the five figures depicted are directly taken from the Presentation in Boston. The similarity extends not only to the poses but also to the arrangement of the robes of the adult figures and to the general coloration.[26] The closeness of the figures in this scene implies that Baronzio must have been familiar with the Boston *The Presentation of Christ* and thus with the Giottesque dossal.

Finally, the physical structure of the dossal seems to follow the Riminese tradition in the presentation of panels and altarpieces. Technical evidence has shown that the seven scenes do not seem to have been divided from one another by internal framing elements but were divided by incised lines, which are still visible in the Presentation, and probably gold or patterned bands (Bomford et al. 1989, 67). This lack of internal articulation is typical of Rimini where narrative scenes are usually divided by gold or patterned bands which do not project forward of the picture surfaces. Baronzio's altarpiece divided between a private collection and the Galleria Nazionale d'Arte Antica in Rome is a good example of this as are two triptychs depicting the life of Blessed Clare of Rimini.[27] Even when the Riminese artists adopt a more typically Tuscan, gabled structure the internal divisions often remain discrete, such as in Baronzio's Macerata Feltria polyptych.

The above observations, along with those of Gordon, strongly support the theory that the panels divided between Settignano, Munich, New York, London and Boston, were indeed designed for the Church of San Francesco in Rimini. There seems little doubt that several of the Riminese painters active in the first half of the Trecento were familiar with the panels, and the content, iconography and structure of the "dossal" all fit in with the artistic tradition current in Rimini and its surrounding areas at this period.

If this is the case then several problems still remain. Firstly, what was the function of the group of panels? If they did indeed form an altarpiece, was this for the high altar of the church or for a side chapel? Alternatively, did they form part of a funerary monument as Gordon has suggested (Gordon 1989, 530)? If the donor figures can be identified, as has been suggested, with Malatesta di Verucchio (d. 1312) and either his sister Imiglia, or his wife, Margherita, then this would perhaps support the interpretation that the panels belonged to a funerary chapel.[28] On the other hand, the width of the seven reconstructed panels (at least 320cm) suggests that it could have formed a high altarpiece rather than that of a lateral chapel.

This latter theory is supported by the presence of gesso and paint on the rear side of several of the panels (Bomford et al. 1989, 67). This paint, which seems to be original, imitates a porphyry surface and indicates that the panels were almost certainly visible, to some degree, from the rear. This would almost certainly not be the case if the panels were part of wall monument, or if they belonged to a side chapel. The small scale of the eastern chapels (the central chapel is only around four metres wide), as well as the polychromy on their reverse, indicates that the altarpiece would have been set forward of the eastern chapels, in the centre of the choir.

A further problem raised by the panels is that of attribution and of their relationship to the other work ascribed to Giotto in San Francesco; the painted cross. From the quality of the panels and the proximity in style to the Scrovegni Chapel frescoes, it seems unlikely that Giotto did not have some role in their production. Various scholars have noted differing areas of quality in the panels suggesting that perhaps Giotto was responsible for the design and the some of the painting of the panels, but that large areas were left to assistants. The influence that both the painted cross and the dossal appear to have exercised over subsequent painting in Rimini, and the strongly derivative nature of the Riminese painted crosses in particular, raises the question of whether the Riminese painters were themselves involved with the early fourteenth century programme of decoration at San Francesco. If we can clearly see workshop participation in both the dossal and the cross, could this participation have been partly represented by local Riminese painters drafted into the workshop on a temporary basis? This is particularly likely if the project at Rimini was as large as Vasari suggested, and perhaps also incorporated fresco decoration.[29]

The dating of Giotto's work in Rimini remains an issue. If we assume that the altarpiece and painted cross belong to the same project, which seems likely as none of the sources suggest more than one visit by Giotto, then we need to place this project in relation to Giotto's other work around the first decades of the Trecento.[30] We know that Giotto was present in Padua, executing the Scrovegni Chapel frescoes in the very early years of the Trecento. Giotto's project in Rimini then, must have been executed between 1300 and 1314, either before or shortly after the Scrovegni Chapel project, with an earlier date the more likely. It probably consisted of a dossal with narrative scenes for the high altar and a large painted cross for the screen across the nave (although we cannot exclude the presence of fresco decoration).

The inclusion of specifically Riminese characteristics in the dossal suggests that the project was most likely executed with extensive workshop participation, and that local painters may have been drafted into

the workshop on a temporary basis. This situation may explain one mechanism by which Giottesque traits tempered by Riminese iconographical traditions become characteristic of the Riminese panels produced over course of the following forty years. The position of the panels in a prominent place in the most prestigious Franciscan church in the region suggests the operation of another mechanism of transmission: Franciscan (or indeed other mendicant) patrons requesting similar decorations for their own houses. Both mechanisms may help to explain the remarkable consistency and distinctiveness of the panels produced by the Riminese painters in the first half of the Trecento.

Notes

[1] For an analysis of the early buildings on the site see Hope (1992, 51-154). San Francesco itself was built on the site of an earlier church, Santa Maria in Trivio which appears to have been given for the use of the Franciscans on their arrival in Rimini. Hope reports that some fresco painting from the trecento church seems to have survived on the underside of a Gothic arch in the Chapel of St. Jerome (1992, 53).

[2] "Zotus pictor eximius Florentinus agnoscitur; qualis in arte fuerit testantur opera facta per eum in ecclesiis Minorum Assisii, Arimini, Padue, ac per ea que pinxit palatio Comunis Padue et in ecclesia Arene Padue". (Ferrariensis 2000, 218-219).

[3] A good example, relevant to Rimini is Vasari's description of a fresco cycle in the cloister of San Francesco at Rimini which he ascribes to Giotto. "Fece ancora nel chiostro di detto luogo, all'incontro della facciata della chiesa, in fresco, l'istoria della Beata Michellina; che fu una delle più belle ed eccellenti cose che Giotto facesse giammai, per le molte e belle conziderazioni che egli ebbe nel lavorla." (Vasari 1906, 392). In fact, as Maginnis has pointed out, this fresco could not have been executed by Giotto as Michellina did not die (and could therefore not have been beatified) until 1356 (Maginnis 1997, 82).

[4] In addition, Vasari mentions another project carried out by Giotto whilst in Rimini, an image of Saint Thomas Aquinas outside of the door of the Dominican church of San Cataldo, apparently executed for a Florentine prior then at the convent (Vasari 1906, 393-394). This work, along with the convent to which it belonged, no longer survives and it is therefore not possible to verify Vasari's remarks.

[5] The central axis of the older church was slightly to the right of the present axis, as was demonstrated by the round window, revealed within the fabric of the facade after the Allied bombing raids of 1943-44 (Hope 1992, 56). The window was 12.83 metres from the ground and 52 centimetres right of the current axis of the church.

[6] These basic floor plans would, however, by the fourteenth century have been disrupted and augmented by additional chapels. For the chapels endowed in the Trecento see Campana (1951, 17-37).

[7] Presumably, this would have consisted, to the left and right, of busts of the Madonna and Saint John the Evangelist, and at the top, the Redeemer. (It is unclear what, if anything, may have been depicted at the lowest end of the vertical axis.) A Redeemer panel formerly in the Jekyll Collection in London has been associated with this cross. I have been unable to establish the present location of this panel. Its earlier presence in Jekyll Collection was noted by Zeri (1957, 75-87).

In its present form the cross has the following dimensions: 430 x 303cm. The surface is damaged in several areas notably around the feet and where the end panels have been removed. A large section of the paint is missing in the area below the feet. The condition is otherwise reasonably good.

[8] The trecento church was likely around 40 metres in length (Davies 1992, 54). By comparison Giotto's painted cross for the church of Santa Maria Novella in Florence is much larger at 578cm by 406cm, but was designed for a church over three times the length of the Riminese church.

[9] This cross, is strongly reliant on the Tempio cross and has also lost its terminal panels (Pasini 1998, 48).

[10] Bellosi, however, asserts that the cross was suspended from the ceiling, in the vicinity of the high altar (Bellosi 2002, 153).

[11] Hall has demonstrated that in Santa Maria Novella the rood screen (or tramezzo) and the choir screen (which sectioned off the area around the high altar) were separate and distinct structures. The smaller scale of San Francesco in Rimini suggests that perhaps the structure located in the nave could have been a combination of rood and choir screen, although more investigation is needed on this topic (Hall 1974, 157 – 173).

[12] Mognetti has discussed the instance of localised damage to a cross in the Petit Palais in Avignon. In this case the damage is almost identical to that in the Tempio Cross.

[13] Alternatively, had the tramezzo in San Francesco been of a similar type to those in Santa Maria Novella and Santa Croce in Florence, and permitted the friars access to a raised platform above the nave, the damage could have been caused by the friars themselves who would have had very close access to the cross.

[14] Conti and Canova have both suggested that the figures of Christ, the Virgin and the Evangelist, in a miniature signed and dated by Neri da Rimini to 1300 are derived from the figures on the termini of the painted cross (Conti 1981, 96), (Canova 1992, 166). This theory suggests that the cross must have been painted before 1300. If correct this would place the date of Giotto's visit to Rimini between his activity in Rome before the turn of the century, and his execution of the frescoes in the Scrovegni Chapel. This is also firmly within the period of Rimini's domination by Malatesta di Verucchio and shortly after the Malatesta family's final suppression of their rivals for control of the city, the Parcitade, in 1295. It is questionable, however, whether the similarities between the miniature and the Redeemer from the Tempio cross are great enough to make 1300 a secure terminus ante quem for the latter.

[15] For a detailed technical analysis of the Pentecost panel and discussion of the relationship of all seven panels see Bomford (1989, 64–71). The Pentecost panel is also discussed by Gordon (1989, 524–531). The panels are of similar size except

the Last Supper which has been planed down at both the upper and lower edges. X-radiographs have revealed that all were cut from the same piece of wood and that no panels appear to be missing from the sequence. In addition to this the panels all share the unusual feature of having the gold leaf of the gilded areas laid down onto "terre verde", or green earth, rather than the red bole which was far more usual (Bomford et al. 1989, 69). All of these features confirm that the panels belonged to a single structure.

[16] A letter of 1807 exists which appears to mention the Giotto panels although here the total number is described as twelve, incorporating, in addition to the Passion scenes, scenes from the life of the Virgin. If we can take this description at face value, then it appears that the original dossal may have been arranged over two registers, one incorporating scenes of the life of the Virgin and Christological narratives. This also raises the possibility of a missing central iconic panel. Such a reconstruction, however, partially contradicts the technical evidence, and the question is also raised about the whereabouts of the missing five narrative panels (Tartuferi 2000, 174–177).

[17] Additional examples include the *Crucifixion* panel in the Musée des Beaux-Arts, Strasbourg (55 x 31cm) attributed to the Maestro di Verucchio and that in the Thyssen-Bornemisza Collection in Madrid by Giovanni Baronzio.

[18] This idea is supported by the *Crucifixion* panel in the Pinacoteca Civica, Faenza (35 x 28cm) dating from the last few decades of the thirteenth century and which has a similar composition although the figures are constructed differently. Interestingly, the figure behind St. John in this example is St. Peter.

[19] Panel measures 56 x 85cm. This panel was obviously Franciscan in origin as both St. Francis and St. Louis of Toulouse are represented in small scale beneath the throne of the Virgin. This is in addition to the figure of Anthony of Padua who appears within the *Crucifixion* scene. The other three scenes consist of the *Nativity*, the *Adoration of the Magi* and the *Resurrection*.

[20] The composition is identical with the exception that the kneeling figures around the cross are omitted (St. Francis is represented elsewhere on the Ravenna panel) and the robed male figure behind St. John is substituted for the figure of St. Anthony of Padua.

[21] The panel which includes five other scenes of Christ's life is located in the *Galleria Nazionale d'Arte Antica*, Rome. (Dimensions: 52.5 x 34.5cm.)

[22] Located in the Gallerie dell'Accademia, Venice (16.9 x 14.8cm). The panel belongs to a group of 12 Christological narratives now spread over three locations. Six belong to the *Accademia*, five to the *Staatliche Museen*, Berlin and the last to a private collection in Rome. In the Venice *Crucifixion* the figure is Christ is particularly close to that of the painted cross of the Tempio Malatestiano.

[23] The construction of the bench with seated apostles at the front of the picture space is a device used by Giotto both in the Scrovegni Chapel and in the Munich Last Supper although Baronzio has eschewed Giotto's asymmetrical placement of Christ.

[24] See also Giovanni Baronzio's *Descent into Limbo* panel in the *Pinacoteca Nazionale* in Bologna (51 x 35cm).

[25] Above this register the structure is completed by gables containing half-length saints, the Virgin and angel of the Annunciation and a central Crucifixion. The polyptych originally belonged to the refectory of the Franciscan house in Macerata Feltria, and this location is attested to by the presence of St. Francis and of St. Louis of Toulouse (Volpe 1965, 82).

[26] The main difference is in the setting and this can be explained in terms of the format; in the Boston version the picture field is almost square allowing the tall ciborium to be included between the figures. In the low rectangular format of Baronzio's image the setting is instead suggested by an architectural backdrop intended to represent the Temple interior.

[27] The first of the Blessed Clare triptychs is located in the Museo Fesch, Ajaccio (inv. 176) and the second, of which only two panels remain, is split between the Lowe Art Gallery, Miami, (inv. 61.18; Kress 1084) and the National Gallery of Art, London, (inv. 6503). See Zeri, (1950, 247 – 251) and Gordon (1986, 150-153).

[28] The identity of the two donors is a problematic issue. It is possible that the two donor figures beneath the cross in the Munich *Crucifixion* represent Malatesta di Verucchio (d.1312) and either his sister Imiglia, with whom he asked to be buried in her tomb in San Francesco, or his third wife Margherita. However, Oertel (1961, 11) noted that the male donor was dressed as a deacon while the female donor was dressed as a nun. A close look at the scene reveals that the male donor does indeed appear to be wearing the dress of a deacon, and is tonsured. The female donor, on the other hand, is not wearing the dress of a female religious. If the male figure is in clerical garb then he cannot be identified with Malatesta di Verucchio.

[29] If we accept an early date for Giotto's presence in Rimini, then collaboration with local painters seems more likely, as the master may have needed to augment a small workshop.

[30] There are two possibilities: either the panels were painted just before the Scrovegni project, or shortly after it. Suggestions by scholars that the narrative panels date to around the period of the Peruzzi frescoes, seem to me to be based in little substance, although perhaps the only way to resolve this problem of dating is by a future technical analysis of the painted cross in the Tempio. The dossal panels have several distinct characteristics in terms of the materials and techniques used in their execution: the use of terre verde beneath the gilding being the most obvious. If the same techniques or materials can be detected in the Tempio cross than this would imply that both of the works were probably executed by the same workshop at around the same time and that both must pre-date the Mercatello cross.

References

Bellosi, L. 2002. "The Function of the Rucellai Madonna in the Church of Santa Maria Novella." In *Italian panel painting of the Duecento and Trecento*, edited by V. M. Schmidt, 147-159. Washington: National Gallery of Art, Washington/Yale University Press.

Benati, D. ed. 1995. *Il Trecento Riminese: Maestri e botteghe tra Romagna e Marche*, Milan: Electa.

Bomford, David, Jill Dunkerton, Dillian Gordon and Ashok Roy. 1989. *Art in the Making: Italian Painting Before 1400*, London: National Gallery of Art.

Campana, A. 1951. "Per la storia delle capelle Trecentesche della Chiesa Malatestiana di S. Francesco." *Studi Romagnoli* 2:17-37.

Canova, G.M. 1992. "La miniatura degli ordini mendicanti nell'arco adriatico all'inizio del Trecento." *Arte e spiritualità nell'ordine agostiniano, Atti del Convegno*, Tolentino. 165-184.

Ciatti, M. 2002. "The Typology, Meaning and Use of some Panel Paintings from the Duecento and Trecento." In *Italian panel painting of the Duecento and Trecento*, edited by V. M. Schmidt, 15-29. Washington: National Gallery of Art, Washington/Yale University Press.

Conti, A. 1981. *La Miniatura Bolognese. Scuole e botteghe, 1270 –1340*. Bologna: Alfa.

Davies, M. and Dillian Gordon. 1988. *Catalogue of the Early Italian Schools before 1400*. London: National Gallery.

Ferrariensis, Riccobaldi. 2000. "Compilatio Chronologica." In *Fonti per la Storia dell'Italia Medievale, Rerum Italicarum Scriptores 4*, edited by A.T.Hankey, Rome.

Gordon, D. 1986. "The Vision of the Blessed Clare of Rimini." *Apollo* 124: 150-153.

—. 1989. "A dossal by Giotto and his workshop: some problems of attribution, provenance and patronage." *Burlington Magazine* 131: 524-531.

Hall, M.B. 1974. "The 'Ponte' in S. Maria Novella : the problem of the Rood screen in Italy." *Journal of the Warburg and Courtauld Institutes*. 37: 157-173.

Hope, Charles. 1992. "The early history of the Tempio Malatestiano." *Journal of the Warburg and Courtuald Institutes* 55: 51-154.

Lombardi, F.V. 1988. "Due opere di Giovanni Baronzio e Carlo da Camerino da Macerata Feltria a Urbino." In *Il Convento di San*

Francesco a Macerata Feltria (Atti del convegno di studi 30 agosto 1981), 113-133. San Leo: PS.

Maginnis, Hayden. 1997. *Painting in the Age of Giotto; a Historical Reevaluation*, Pennsylvania: Pennsylvania State University Press.

Mognetti, E. 2002. "Marks of Devotion: Case Study of a Crucifix by Lorenzo di Bicci." In *Italian panel painting of the Duecento and Trecento*, edited by V. M. Schmidt, 354–369. Washington: National Gallery of Art, Washington/Yale University Press.

Oertel, R. 1961. *The Munich Pinakothek: Italian Painting from the Trecento to the End of the Renaissance*. Munich: Alte Pinakothek

Pasini, P.G. ed. 1998. *Medioevo Fantastico e Cortese: Arte a Rimini fra Comune e Signoria*, Rimini: Musei Comunali.

Schmidt, V.M. ed. 2002. *Italian panel painting of the Duecento and Trecento*. Washington: National Gallery of Art, Washington/Yale University Press.

Tartuferi, A. ed. 2000. *Giotto. Bilancio critico di sessant'anni di studi e ricerche*. Florence: Giunti.

Vasari, Giorgio. 1906. *Le Opere*. Edited by Gaetano Milanesi. 9 vols. Florence: Sansoni.

Volpe, A. 2002. *Giotto e i Riminesi*. Milan: Motta Federico

Volpe, C. 1965. *La Pittura Riminese del Trecento*. Milan: Mario Spagnol Editore.

Zeri, F. 1957. "Due appunti su Giotto." *Paragone*. 85: 75-87.

—. 1950. "Triptychs of the Beata Chiara of Rimini." *Burlington Magazine* 92: 247–251

Fig. 2-1. Giotto di Bondone, *Crucifix*, 430 x 303cm, tempera on panel. Rimini, Chapel of Isotta degli Atti, Tempio Malatestiano (formerly San Francesco). Photo: Tempio Malatestiano, Rimini, Italy/ The Bridgeman Art Library.

Fig. 2-2. Giotto di Bondone, *Crucifixion*, tempera on panel, 45 x 43.7 cm, Munich, Alte Pinakothek. Photo: Bayerische Staatsgemäldesammlungen - Alte Pinakothek München.

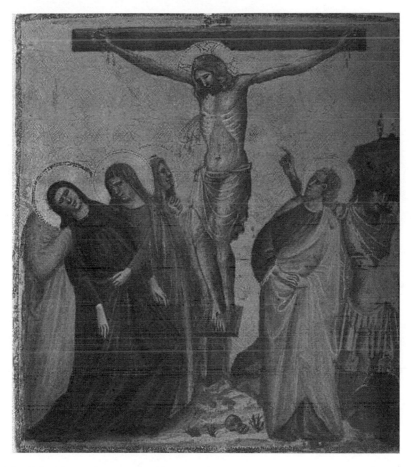

Fig. 2-3. Giovanni Baronzio, *The Crucifixion*, tempera on panel, 16.9 x 14.8cm. Venice, Accademia Galleries. Photo: reproduced by permission of the Ministero per i Beni e le Attività Culturali.

Section II

Commission, Context and Commerce

CHAPTER THREE

LIPPO DI DALMASIO,
THE MADONNA OF HUMILITY AND PAINTING
IN PISTOIA IN THE LATE TRECENTO

FLAVIO BOGGI

Scholars have traditionally defined Italian, and especially Tuscan, trecento painting through distinctions between the artistic practices of Florence and Siena.[1] Conventionally, their assessments have compared and contrasted the qualities of illusionistic space and form, perceived to be so central to the art of Giotto and his Florentine followers, with the expressive handling of colour and line, seen to characterise the work of Duccio and his Sienese heirs.[2] It may fairly be concluded that such approaches have gone some way to supporting an investigation of the visual culture of these major city-states and their respective contributions to the history of the region's art. Yet this long historiographical tradition has often discouraged an evaluation of the creativity of the smaller urban communities that filled the map of Tuscany, where the promotion of local artistic conventions frequently resulted in a unique sense of civic identity. Indeed, as Enrico Castelnuovo stressed in his introduction to a revisionist account of late medieval Italian painting, any scrupulous examination of the art of the peninsula in the 1300s ought to look beyond Florence and Siena, to what is now considered the periphery, so as "to recover the extraordinary variety of regional and local cultures."[3]

Pistoia is one of Tuscany's centres of artistic activity to have suffered neglect as a result of the inherited processes of assessment and interpretation. A near neighbour of Florence on the flat plains of the middle Arno valley, the Pistoiese Commune fell permanently under Florentine political hegemony in 1351, but only after repeated attempts to resist its subordination to the bigger state located beyond its south-eastern frontier.[4] Given these and other political circumstances, Florentine pictorial traditions were identified in the older literature on the city's arts as the principal forces affecting Pistoiese painting through the fourteenth

century, especially after 1351. Over the past several decades, however, art historians have challenged the view that the cultural subjugation of the town to Florence was absolute. Among the first scholars to do so was Pier Paolo Donati, who instigated the systematic study of Pistoia's native painters at work in the trecento.[5] Adopting a fresh analytical framework that was less reliant on the old historiographical premises, he revealed a vibrant and distinctive artistic milieu that did not conform to the familiar Florentine paradigm and to Giotto's models. Admittedly, Pistoia and its institutions provided a significant source of patronage for Florentine craftsmen—Alesso d'Andrea, Bonaccorso di Cino, Taddeo Gaddi and Niccolò di Tommaso, to name but a few—in the course of the century, a phenomenon that historians of art have explored in some detail, starting off in 1810 with the publication of Sebastiano Ciampi's pioneering archival research on the Opera di San Jacopo.[6] Less understood are the artistic interrelationships that existed between Pistoia and Emilia, which have been insufficiently assimilated into accounts of Tuscan painting of the period. As Ludovico Frati (1910) and Pèleo Bacci (1941-42) were the first to discover, the Bolognese painters Dalmasio di Jacopo degli Scannabecchi (doc. 1342-73) and Lippo di Dalmasio (b. ca.1353; d. 1410), father and son, migrated between their native town and Pistoia in the search for commissions during the early years of the Florentine domination of the Pistoiese Commune. But they were not the only Emilian artists to have been employed at this time in Pistoia to judge from Paolo Serafini's *Madonna of Humility* (fig. 3-1) in the town's eponymous basilica (Boskovits 1975, 152).

The present essay will focus on Pistoia as a site where local pictorial conventions met and coalesced with Emilian, specifically Bolognese artistic customs through the later half of the fourteenth century. Special attention will be paid to the Pistoiese career of Lippo di Dalmasio, the most richly documented Bolognese painter active in the city, as well as to the diffusion of the Madonna of Humility theme, which seems to have emerged in the 1340s in Avignon and parts of Italy, becoming prominent in the devotional images of Pistoia after 1350.[7] In addition, this contribution is intended to offer some little studied material to the broader debates surrounding the rich network of artistic exchange within and between the urban centres of trecento Italy.

Histories of Pistoiese trecento art

As is well known, the preferential status given by art historians to Florentine culture emerges in the earliest accounts of Italian art. This is especially true of Giorgio Vasari's *Le Vite de' più eccellenti pittori, scultori ed architettori* (1568), in which Pistoia and its late medieval painters receive short shrift. Local artists Giovanni Cristiani and Antonio Vite, undeserving of a *vita* of their own, are relegated to the following of outsiders: the Roman Pietro Cavallini in the case of the former (1:542) and the Florentines Gherardo Starnina and Lorenzo Monaco in the case of the latter (2:8; 2:26); the frescos by "Dalmasio" in the *cappella maggiore* of San Francesco, meanwhile, are ascribed to Puccio Capanna, one of Giotto's most important Florentine pupils according to the Aretine author (1:403). Other influential writers on Italian art subsequently took up Vasari's erroneous claims as historical fact, among them Filippo Baldinucci (1768, 220, 257, 316) and Luigi Lanzi (1809, 1:50, 2:12-13). By the eighteenth century, however, local historians and antiquarians had already begun to comb Pistoia's archives and to scrutinise the town's surviving monuments in an effort to secure reliable information on the history of the city's arts. Even though it remained in unpublished manuscripts, the historical research undertaken by Baronto Tolomei, Bernardino Vitoni and Innocenzo Ansaldi laid the foundations for Ciampi's seminal *Notizie inedite* of 1810 and Francesco Tolomei's comprehensive *Guida di Pistoia* of 1821, both of which offer the reader a trustworthy catalogue of the names of Pistoiese medieval craftsmen gleaned from documents and artefacts.[8] Ciampi's thorough and thoughtful research in particular set a new standard, paving the way for the synthetic accounts of Pistoiese trecento painting of recent decades.[9]

Informed comment on the interactions between Bolognese and Pistoiese artists emerged in the scholarly literature only after the archival discoveries of the early twentieth century. Yet some recognition of the question tentatively appeared in Joseph Archer Crowe and Giovanni Battista Cavalcaselle's second volume of *A New History of Painting in Italy* (1864, 228-30), where remarks about Pistoiese art were attached to the tail end of a chapter devoted to the "progress of painting" at Bologna, Modena and Ferrara. Unfortunately, reasons supporting this unexpected configuration of cities and local schools of painters from both sides of the Apennines were not offered to the reader. In 1874, meanwhile, the Modenese antiquarian Pietro Bortolotti gave a clearer statement on the Tuscan town's connections with Emilia in his study of Fra Paolo da Modena, claiming that the miraculous *Madonna of Humility* in the

Pistoiese sanctuary (fig. 3-1) was the model for the Modenese painting of the same subject in the Galleria Estense. As flawed as some of Bortolotti's conclusions turned out to be, his contribution had the merit of focusing attention on the Humility Virgin, a theme to be found in surviving paintings from both regions. Admittedly, his analysis of the style of the picture in Pistoia had certain shortcomings. More effective, though, was Adolfo Venturi's rigorous method of Morellian connoisseurship. In 1907 (948) the scholar ascribed the *Madonna of Humility between Four Angels* in Pistoia's Palazzo Comunale (fig. 3-6) to Lippo di Dalmasio, the first serious attempt to associate one of the city's surviving pictures with the Bolognese artist. This attribution, published by Venturi, a Modenese art historian, generated some disagreement in Tuscany.[10] Nevertheless, it instigated further debate on the extent of Lippo's Pistoiese activity, as well as the search for other works by the Bolognese artist possibly lost among the many uncertainties then hovering over the local tradition of painting.

The discovery of mural paintings in San Domenico, Pistoia, offered scholars an opportunity to study fresh visual evidence from the trecento.[11] Responding to these finds, Mario Salmi (1931, 459-60) attributed to the Bolognese school frescos of the *Madonna* and *Saint Dominic* from the nave of the church. Without any reliable point of reference for Dalmasio's style, Salmi (1931, 460) nevertheless wondered if the Bolognese master might have been the creator of the *Madonna*. But both saints are certainly examples of Pistoiese painting that in more recent times have been plausibly assigned to the local Master of Popiglio (Neri Lusanna 1993a, 86), even though Salmi's attribution is still supported by some (Cortesi and Giaconi 2008, 176). Quite different and possibly Emilian is *A Group of Six Figures* in fresco, whose dense modelling and spirited faces betray the recognisable traits of the Bolognese school, as Salmi (1931, 461-62) himself noted. Most convincing of all was the scholar's suggestion that Dalmasio's son Lippo may have been responsible for the *Madonna of Humility* in the cloister (fig. 3-2). Concluding that the grace and sweetness of the figures were most in keeping with Tuscan taste, Salmi (1931, 456-59) decided against this attribution, despite having offered compelling arguments in favour of a Bolognese iconography for the figure of Mary.

Salmi's conclusions epitomise the ambiguity of Lippo's current standing: the painter's early activity, largely centred on Pistoia, has been neglected because his pictures for the Tuscan town are unsigned, undated and mixed up with the products of such local artists as Antonio Vite and Giovanni Cristiani. In fact, scholars have preferred to concentrate on the period of Lippo's maturity, from his return to Bologna in 1390 and after, thereby leaving a significant gap in our understanding of the earlier stages

of his career.[12] But the confusion surrounding Lippo's Pistoiese work has much to do with entrenched misunderstandings about the mutual influences between Emilian and Tuscan artists in Pistoia, as recent efforts to address the problems of the painter's origins have demonstrated (Boggi and Gibbs 2010, 31-55). The question of Lippo's connection with Pistoia, then, requires careful consideration.

In search of Lippo di Dalmasio in Pistoia

Vasari may have unwittingly stumbled upon the work of Lippo di Dalmasio in Pistoia, for in his life of the mysterious Lippo Fiorentino—a conflation of many artistic identities, as Gaetano Milanesi (1906, 2:11n1) and Paul Barolsky (1991, 46-48), among others, have observed—the reader will encounter a painter of the same name, born in 1354, who executed a panel in Pistoia and "molte cose" in Bologna.[13] More reliable sources for locating our artist in the Tuscan town are the archival discoveries published in this century and the last. These make it abundantly clear that both Lippo and his father had a presence in Pistoia over many years. Dalmasio is mentioned as a resident of the city both in 1359 (Bacci 1941-42, 106), when he decorated a marble tabernacle of the Virgin for San Giovanni Fuorcivitas, and in 1365 (Filippini and Zucchini 1947, 59-60), the year he entrusted his affairs in his native town to the painter Simone dei Crocefissi, his brother-in-law. Earlier contact with Pistoia cannot be discounted if, as is generally agreed, he was responsible for the frescos in San Francesco, dated by Mellini (1970, 41) to the period of the 1343 dedicatory inscription. Lippo, meanwhile, is documented as a resident of Pistoia in 1377 (Filippini and Zucchini 1947, 153), when he was a legal minor, and is last mentioned there in 1390 (Boggi and Gibbs 2010, 94), the year his name appears in a list of seventeen men selected to take part in the Commune's General Council. It is very likely, therefore, that Lippo's artistic education took place in Bologna and Pistoia, the two cities in which his father was active during his childhood and adolescence. Furthermore, following the death of Dalmasio in or shortly after 1373, all the available evidence indicates that Lippo took up his father's practice in Pistoia while keeping his personal and business affairs open in Bologna, including the maintenance of a house near Simone's in the parish of San Domenico. Certainly, the important and busy highway known as the "via de Collina", or the "strata Sambuce," which led out of Pistoia to Sambuca and over the Apennines to Bologna, would have facilitated the necessary travel between his adopted home in Tuscany and the town of his birth in

Emilia.[14] In short, Lippo's professional activity up to 1390 appears to reflect the patterns of work and divided nature of Dalmasio's career.

The years that Lippo spent in Pistoia were important to the town's artistic life and critical to his own development as a painter. Although the course of his Pistoiese career is reasonably well documented, it is impossible to tie any of his extant work in the city to a known record. The altarpiece depicting the *Virgin between Saints Benedict, Andrew, John the Baptist and Paul* is now lost; it was commissioned after 2 May 1381 by the testamentary executors of madonna Stella di Grandino for the chapel of Saint Benedict in Santa Maria dei Servi (Bacci 1941-42, 108-09). Transferred to the side of the sacristy in 1518 to make way for a new picture of the *Annunciation* by Gerino da Pistoia (Rogers Mariotti 1996, 156), the altarpiece might well have been the painting on panel, mentioned above, that Vasari assigned to Lippo Fiorentino. Surviving works in Pistoia that may be attributed to Lippo di Dalmasio today—the detached frescos in San Domenico (fig. 3-2), San Paolo (fig. 3-3) and the Palazzo Comunale (fig. 3-6), as well as the homeless *Virgin and Child* from the Casa Landini (fig. 3-8) (Boggi and Gibbs 2010, cat.1, 2, 3, 32)—depict the theme of the Madonna of Humility (a subject that is particularly prominent in his later Bolognese oeuvre too). In these paintings both Mary and her Son are characterised by a gentle air that betrays their creator's origins in an impassioned and intimate Bolognese pictorial culture. In the *Humility Virgin* of San Domenico, the best-preserved picture of the group, we encounter an artist with meticulous craftsmanship and a notable inventiveness as far as design and iconography are concerned. However, in these other Pistoiese frescos, coarsely torn from their original context and crudely disfigured by subsequent retouching, the intensity of expression typical of Lippo's own signed paintings of later years is less easy to discern.

Lippo's Pistoiese sojourn was also crucial to his development as a communal official, which earned him an elevated place within his society. These early experiences in Tuscany prefigure the known successes of his later life in Bologna, where his public career grew in status and probably came to overshadow his artistic identity (Pini 1998, 471-74). From 1385 to 1390 Lippo was elected to the General Council of the Commune of Pistoia to represent the Porta Guidi in the Borgo San Paolo for at least one term of office in each year (Boggi and Gibbs 2010, 89-94). It appears inescapable that Lippo, a painter of Bolognese lineage who kept his affairs alive in Emilia while residing in Tuscany, was awarded Pistoiese nationality; without it he surely could not have presumed to participate in the Tuscan city's government, even during the 1380s when Florentine interference in

Pistoiese communal structures was rife. Lippo's involvement in the town's public life is likely to have led to artistic commissions through contacts that he would have made while engaged in the affairs of the council. A case in point is the *Madonna of Humility* from the Sala Guelfa (fig. 3-6) in the very same civic palace where our painter attended to his duties as a member of the *consiglio generale*. But this setting would also have allowed for fruitful exchanges with the city's other artists, many of whom participated in the same public assembly, representing either the very same *porta* or a neighbouring one within the Borgo San Paolo, the *società* or district to which Lippo and most of Pistoia's artisans and commercially minded citizens belonged. Among the town's local painters to be elected to the body were Giovanni Cristiani,[15] his son Bartolomeo di Giovanni,[16] Antonio Vite,[17] Andrea di Guido,[18] Filippo di Lazzaro[19] and his brother Jacopo di Lazzaro.[20] Late medieval Pistoia had a compact urban fabric that must have allowed for the cross-fertilisation of ideas among its artists and patrons. Thus, even outside the meeting halls and debating chambers of the Palazzo Comunale, in the narrow streets and small squares of the Borgo San Paolo, Lippo and Pistoia's local painters would have encountered one another on a regular basis. The proximity and concentration of craftsmen within the city's walls inevitably engendered competition in the market place, so there is little doubt that patrons were cognisant of the range of artistic innovation and the different pictorial traditions available to them.

Presumably Lippo was a member of a guild structure in Pistoia; without such an affiliation he surely could not have operated as an independent artist there. Reason to believe that he was may be found in the decision to nominate the shoemaker Jacopo di Marco his procurator in 1389 (Bacci 1941-42, 111), for shoemakers and painters joined the same guild in trecento Pistoia (Herlihy 1967, 173). As is well known, guilds fostered a sense of community in their members, inasmuch as the artisan's skills were rigorously regulated, and the quality of the product was scrupulously appraised by peers or clients. In this regard, Pistoia resembles most other late medieval Italian city-states whose prosperity was closely bound up with commerce and industry (Gai 1984). Like the painters of his day enrolled in the Pistoiese guild, Lippo would also have attended to minor tasks, such as the commission he received in 1384 from the Opera di San Jacopo to paint forty *aste* (candlesticks or torches) to surround the bier of ser Jacopo di ser Jacopo Sandri in San Francesco for the sum of two pounds.[21] For Lippo, then, guild membership would have involved adapting the Bolognese practices and procedures of his family training to the standards and customs of Pistoiese craftsmen and their clientele. This

may well account for his appropriation of certain Tuscan pictorial conventions—from goldwork and altarpiece structures to figure compositions and facial types—during his Pistoiese sojourn, traces of which may still be discerned in his later Bolognese activity (Boggi and Gibbs 2010, 57-78; Massaccesi 2010-11, 112-14).

The bureaucracy of fourteenth-century Pistoia offers the historian scattered notices regarding Lippo's domestic affairs and his day-to-day dealings with other urban dwellers. These records also testify to the Bolognese painter's successful integration in Pistoiese society. Evidently Lippo's network of business and private contacts extended beyond the confines of the artisan class in the Borgo San Paolo, for in 1384 he guaranteed a substantial loan of a hundred gold florins (Bacci 1941-42, 111) to madonna Antonia, daughter of Bartolomeo de' Cancellieri of the leading family in the neighbouring Borgo San Giovanni; a son of Taviano Bracciolini, another member of Pistoia's patriciate, was also in attendance. This last document confirms that Lippo's Pistoiese base was in the *cappella* of San Bartolomeo, immediately adjacent to the *cappella* of San Leonardo in the Borgo San Paolo. The latter parish was home to the painter Antonio Vite (Bacci 1911, 5) who, like Lippo, represented the Porta Guidi on the General Council. But perhaps the most convincing sign that the Bolognese painter was accepted into Pistoiese society was his marriage to a local woman named Antonia, daughter of Paolo Sali who served for the Porta Guidi on the General Council (Bacci 1941-42, 110). While the date of the marriage is unknown, it is likely to have taken place in Pistoia in the 1380s (Pini 1998, 485), but certainly before 1390 when Lippo is last documented in Tuscany. To judge from the will that she made in Bologna in 1429 (Frati 1910, 212), Antonia outlived our painter by many years. So, memories of Pistoia and its distinctive traditions must have been kept alive in Bologna through the 1390s and early 1400s owing to Antonia's presence in the family home in the *cappella* of San Domenico.

Locating the work of Lippo di Dalmasio in Pistoia

While the known documentary evidence may confirm Lippo's connections with Pistoia were deep rooted and long standing, the same records offer no help in verifying Lippo's authorship of the *Madonna of Humility* in San Domenico (fig. 3-2). The most typical and the most Bolognese of his works in Pistoia, it is also the most disputed. Yet the Bolognese iconography of the tent or pavilion as tabernacle, the most striking feature of the fresco, as well as aspects of its style and technique,

make it one of the finest of Lippo's pictures (Boggi and Gibbs 2010, 37-48).

The *Madonna of the Pavilion*, as the fresco in San Domenico might be called, was formerly located in the cloister. A reliable description of the sacred image as it appeared in around 1500, before it was hidden from view, is preserved in the *Obituario di San Domenico*.[22] But Innocenzo Taurisano (1923, 91-92), who rediscovered the painting in the early twentieth century after reading of its existence in the latter text, considered it an example of Sienese craftsmanship. Viewed as a distinct attributional challenge, the work was subsequently ascribed to a local artist by the majority of critics. As mentioned above, Salmi (1931, 456-59) supposed Lippo might have been its author. On reflection, though, he decided against the tentative suggestion, favouring instead an unknown Pistoiese master because of the fresco's gracefully characterised figures. For similar reasons other scholars, including Bacci (1941-42, 112) and Millard Meiss (on the advice of Richard Offner) (1936, 438n17), arrived at the same conclusion. Giulio Valiani (1932, 232), meanwhile, tied the picture to Giovanni Cristiani, a most unlikely attribution that was nevertheless supported by Vasco Melani (1970, 165) and Eugenio Marino (1977-78, 252-54).

Far more popular with critical opinion was Miklós Boskovits's proposal that a young Antonio Vite under the influence of Paolo Serafini was the creator of the *Madonna of the Pavilion*.[23] This attribution had the merit of clearly signalling the work's unambiguous connections with Emilia, which Salmi had previously acknowledged in his comments about the Bolognese iconography of the Virgin. After all, Vite is generally known to have appropriated a number of Bolognese pictorial motifs and conventions.[24] Some features of his frescos in the vaults of the chapter house at San Francesco in Pistoia (late 1380s or early 1390s) are characteristic of Bolognese art: the sumptuous vegetation of the settings and the representation of the Mass in the scene of the *Institution of the Crib at Greccio*, as well as, more generally, the intense naturalism and spirited narrative. The generic similarities between the works of Lippo and Antonio may perhaps be explained by a process of mutual exchange dating to the period when both craftsmen resided in the Porta Guidi in the late 1370s and 1380s. Yet, in spite of these affinities, Vite's general approach belongs within a Tuscan Giottesque idiom (Boggi and Gibbs 2010, 38-39), displaying stylistic connections with the work of Niccolò di Tommaso (Boskovits 1975, 149n260) and the local Master of 1336 (Feraci 2006-07, 31). Most telling of all, as will be discussed in greater detail below, Vite's

more certain depictions of the Madonna of Humility are clearly distinguished from Lippo's treatment of the theme.

Finally, Ugo Feraci (2006-07, 29) has recently reattributed the *Madonna of the Pavilion* to Paolo Serafini, the Modenese artist whom Boskovits claimed was the author of the famous *Madonna of Humility* in the Pistoiese sanctuary (fig. 3-1). The proposal, accepted by Nicoletta Lepri (2011, 53), is noteworthy insofar as it points to an Emilian rather than a Pistoiese author, even though Emilian painters working in Pistoia were prepared to learn from local masters, and vice versa. On balance, however, Paolo Serafini cannot have painted both the *Madonna of the Pavilion* and the *Humility Virgin* of the shrine because the two compositions are far removed from each other in style—Mary's well rounded face with pointed chin in the latter fresco, for example, is absent from the former (Boggi and Gibbs 2010, 50)—and iconography.

Tuscan and Emilian versions of the Madonna of Humility in Pistoia

As the above review of the critical literature may have demonstrated, a web of attributions links Lippo di Dalmasio, Antonio Vite and Paolo Serafini with paintings of the Madonna of Humility in Pistoia. But closer inspection of all the surviving examples reveals differences in the artists' treatment of the theme. First of all, Serafini's *Humility Madonna* in the eponymous sanctuary (fig. 3-1) and the four pictures attributed to Lippo—the *Virgins* of San Domenico (fig. 3-2), San Paolo (fig. 3-3), the Palazzo Comunale (fig. 3-6) and the Casa Landini (fig. 3-8)—form part of a consistent Emilian or northern Italian tradition inasmuch as they all depict the Child on the viewer's left, generally suckling his Mother's right breast.[25] This arrangement appears in the earliest dated example of the theme, Bartolomeo da Camogli's picture of 1346 in Palermo's Galleria Regionale della Sicilia. On the other hand, the majority of the versions executed by Tuscan artists—from Siena, Florence, Lucca and Pisa—depict the Infant on the other side of the Virgin, often feeding from her left breast, as is the case in the early Simonesque painting in Berlin's Gemäldegalerie.[26] A similar pattern is repeated in renderings of the *Madonna del Latte* or enthroned *Maria lactans* in Emilia[27] and Tuscany.[28] But in the *Madonna of Humility* in Pistoia's San Bartolomeo in Pantano (fig. 3-4), a work that is generally assigned to Vite without hesitation, the standard Tuscan figural arrangement prevails.[29] Furthermore, the Baby reappears on the right in Vite's other autograph pictures of the Virgin

nursing her Child, the same format being adopted by Sano di Giorgio (see fig. 3-5), Vite's Pistoiese disciple and collaborator.[30]

Leaving aside the question of the position of the Infant, Lippo's *Madonna of the Pavilion* (fig. 3-2) and Serafini's *Humility Virgin* (fig. 3-1) each present a very different treatment of the theme. Most important of all, Serafini's work is characterised by a closed group of figures, a composition that is also to be found in Bartolomeo da Camogli's earlier picture. Lippo's fresco, meanwhile, exhibits a more upright and frontal figure of the Mother, an arrangement that is repeated in all of his surviving examples of the subject in Pistoia. Such a pose was probably copied from Tomaso da Modena (Gibbs 1992, 173), who in turn may have borrowed it from Vitale da Bologna (Gibbs 1989, 291), but a more erect and frontal figure also appears in the art of Lippo's uncle Simone (Boggi and Gibbs 2010, 22, 49). The vertical emphasis of the *Madonna of the Pavilion*, then, is distinguished from the smoothly contoured and streamlined entity of the fresco in the basilica of Santa Maria dell'Umiltà, as Neri Lusanna (1993a, 76) has also observed. But other compositional and iconographic differences may be noted. Serafini's *Virgin*, which displays the attributes of the sun, moon and stars of the Woman of the Apocalypse (Revelation 12:1), is framed by two fictive colonnettes and is placed beneath a lobed arch—as is the case in the Palermo panel and many other examples besides—while Lippo's fresco in San Domenico presents Mary surrounded by a giant sun and with a pavilion upheld by angels. A luminous yellow disc and prominent rays appear in all four of Lippo's frescos of the *Madonna* in Pistoia, but these motifs take on an elliptical form in the works from the Palazzo Comunale (fig. 3-6) and the Casa Landini (fig. 3-8). A large round sun recurs in signed examples of the theme from his later career, such as those in Santa Maria della Misericordia and the Pinacoteca Nazionale, both in Bologna (Boggi and Gibbs 2010, cat.10, 14), and the National Gallery, London (Gordon 2011, 276-83). So, even ignoring the formal differences in painting style or technique, and despite the passage of time and the damaged condition of the group of frescos, Lippo's pictures of the Mother seated on the ground can be distinguished from Serafini's fresco on the basis of body language, gesture, shape and setting.

Antonio Vite and his followers seem to be responsible for disseminating another variant of the Madonna of Humility theme, which presents a rival type in Pistoia and neighbouring territory in the late trecento. The group of pictures portrays Mary and her Child in a very upright and frontal position (even more than in Lippo's versions of the subject). In addition, the Infant stands upon his Mother's knees instead of

nestling in her lap,[31] engaging attendant saints or blessing the beholder as opposed to suckling. Among the surviving examples attributed to Vite in the city are frescos in San Francesco, the Palazzo Comunale (fig. 3-7) and Santa Maria a Ripalta.[32] Evidently this composition spread to Pisa and Prato, but the arrangement is also reflected in the work of the next generation of Pistoiese painters to judge from the career of Sano di Giorgio.[33] As Feraci (2006-07, 31) has already revealed, Vite's designs of the Humility Virgin combine aspects of an Emilian iconography of the theme with the extreme frontality of Florentine versions of the subject. In fact, as Meiss (1936, 447-48) was the first to note, there developed in Florence in the late trecento a composition featuring an erect Virgin raised high above the ground plane, emotionally detached and physically removed from her Child who is rarely shown feeding. But this group of images, in line with the overwhelming majority of early Florentine Madonnas of Humility (Meiss 1936, 464), does not contain the Apocalyptic symbols of the sun, moon and stars. Yet in Vite's new arrangement, as may be seen in the fresco in Pistoia's communal palace (fig. 3-7), one will encounter the frontal pose of the Florentine group combined with the Apocalyptic motifs—an elliptical sunburst and oval or mandorla-like golden sun—of Lippo's *Madonnas* in the Palazzo Comunale (fig. 3-6) and the Casa Landini (fig. 3-8). So it would appear that Vite succeeded in creating a uniquely Pistoiese variant of the Humility Virgin based upon his own experience of Florentine and Emilian pictorial conventions.[34]

Although Vite's design exemplified the new trend of Humility Madonna in Pistoia at the start of the fifteenth century, the more triangular composition of Serafini's fresco returned to favour after 17 July 1490, the date at which a miracle increased the latter's importance (Gai 2004). The painting was originally commissioned for the old church of Santa Maria Forisportam, possibly for the Chapel of the Purification that is known to have been decorated in 1383 (Rauty 1993, 34-37). But in 1579 it was translated to the high altar of the purpose-built shrine of the Madonna dell'Umiltà (Cipriani 1993, 10), where it served as the focal point for an ever-expanding Marian cult. Among the surviving copies dating from the late quattrocento and after, all archaizing in appearance, are pictures by Niccolò di Mariano, il Sollazzino and Bernardino del Signoraccio.[35] The diffusion of Serafini's image at such a late date testifies to the enduring popularity of the theme in the Tuscan city. At the same time, the painting's subsequent transformation into a cult object casts light upon the changing attitudes and shifting devotional practices of the faithful in early modern Pistoia.[36]

The placement and function of the Madonna of Humility in Pistoia

As Meiss (1936, 438) made clear in his classic study of the subject, and as Iacopo Cassigoli (2009, 91) has reiterated more recently, the Humility Virgin was particularly prominent among the devotional images of Pistoia. The surviving versions attributed to Lippo di Dalmasio and Paolo Serafini, probably painted in the 1380s, were not the first of the city's pictures to portray the theme. In fact, the earliest known example, now lost, dates from before 1362: on 27 December of this year, Corrado di ser Lippo di Dato made a testamentary bequest to the Augustinian community attached to San Lorenzo allowing for a lamp to be kept alight in front of an already existing painting of the *Madonna of Humility* (Pappagallo 1994, 27-28). The circumstances of Corrado's legacy suggest that the *Virgin* of San Lorenzo had a protective function, being a focal point for public devotion given Mary's power of intercession. But his bequest was made in a funerary context, from which background many of Pistoia's pictures of this type later emerged.

Almost all of Pistoia's surviving depictions of the theme have been removed from their original physical locations, thereby preventing a full appraisal of their intended function and viewing conditions. And yet the initial placement of the *Madonna of the Pavilion* (fig. 3-2) is known, a detail that helps to define the significance that the work possessed for its maker and users. Taurisano, as we know, discovered the painting in the cloister of San Domenico, a site that had accommodated the tombs of lay members of the city's elite families since the early 1300s.[37] The fresco commemorates two such individuals: praying donors, a man and woman (husband and wife?), are memorialised in the act of being presented to the Virgin and Child by Saints Dominic and Catherine of Alexandria. Since the *Obituario* confirms that the cloister's painted decoration—the *Madonna of the Pavilion* included—was tied to the area's tombs,[38] one can safely conclude that the fresco was principally connected with a funerary function. In fact, it appears to follow in the tradition of the early examples of the subject in Avignon and Naples, which, as Beth Williamson (2009, 148) has recently examined, have a commemorative purpose. This is an essential element of other Pistoiese versions of the theme, including the picture in the basilica of Santa Maria dell'Umiltà (fig. 3-1).[39] Both the *Madonna of the Pavilion* and the miracle-working fresco in the shrine highlight Mary's intercessory and protective powers, drawing attention to her special role as the Mother of Christ and procurer of grace. The hopeful messages of mercy and salvation encoded in these images would have

been perfectly suited to a personal monument designed with the final redemption of the soul in mind.[40]

In Pistoia the Madonna of Humility theme also appeared in the decoration of the town's seats of secular and ecclesiastical power, the Palazzo Comunale and the Palazzo dei Vescovi (subsequently renamed the Casa Landini), unexpected sites for the image.[41] In these surroundings the Virgin took on the role of the supreme patron and powerful defender of the citizens and the faithful of Pistoia, protecting the entire population rather than caring for a particular person or a single family. Lippo's *Humility Madonna with Angels* (ca.1380s) from the Sala Guelfa (fig. 3-6) and the *Humility Virgin between Saints Zeno and James* (1397-98) in a niche on the ground floor (fig. 3-7), recently attributed to Vite (Feraci 2006-07, 21), are among the examples to have survived in the Civic Palace. But these are not the earliest manifestations of the civic cult of Mary in Pistoiese public art. Such themes had been central to the city's political imagery since the thirteenth century, and Mary was prominently represented in the painted embellishments for the network of buildings associated with the communal government (Boggi 2007). She is often found in the company of the apostle James the Greater and Bishop Zeno—as is the case in the fresco attributed to Vite—patrons respectively of the town and church of Pistoia and regularly invoked together as the Commune's *defensores* (Webb 1996, 78-81). Both Lippo and Vite would have been intimately aware of these customs insofar as they were elected members of Pistoia's General Council. Their *Humility Madonnas*, executed in the closing decades of the trecento, perpetuated earlier traditions of promoting the Mother of Christ as the Commune's exalted advocate and heavenly protector. Indeed, both the stone *baldacchino* of Lippo's composition and the fabric pavilion or tent of Vite's fresco convey a strong sense of the civic ceremonial and ritual associated with the procedures of honouring a dignitary.[42] The pavilion in the latter painting, a compositional device perhaps inspired by the earlier *Madonna* in San Domenico (fig. 3-2), is an effective allusion to her role as Queen of Heaven. It is equally appropriate as a symbolic contrast to the humility through which she earned her place as *Regina coeli*, as was argued by Meiss (1936, 462). In Lippo's painting, the *baldacchino* inspired by the mid-trecento cupola project for Florence's Santa Maria del Fiore is surely not without significance. It is just possible that an image that had come to typify Pistoiese devotion was being subtly adjusted for the seat of government in order to accommodate Pistoia's political ties with Florence, an alliance strongly supported by the Panciatichi, the powerful Pistoiese family whose members and followers backed "Florenizing" policies in the late trecento (Herlihy 1967, 203-5).

The implied enthronement in both frescos (in Vite's work Mary rests upon two cushions) and the musical accompaniment in Lippo's mural belong to the practices of government spectacle enacted in and around the images in the Palazzo Comunale. In short, both *Humility Madonnas* are firmly embedded in a Pistoiese civic ideology that celebrates the Mother of Christ as the city's greatest supporter, relying on her special function as universal mediatrix.

During the period in which the *Humility Virgins* for the Palazzo Comunale were being painted, another two frescos depicting the same theme were also being executed in the nearby Episcopal Palace. The latter are believed to have been commissioned by Andrea Franchi (1335-1401), Pistoia's bishop from around 1381 and prior of the city's Dominican convent in 1370.[43] One of these paintings was located on the main façade overlooking the Piazza del Duomo, and the other was situated inside. Though lost, they are described in the writings of the chronicler Pandolfo Arferuoli and the Dominican friar Giuseppe Maria Guidi.[44] As is discussed elsewhere (Boggi and Gibbs, 2011, 75-76), the homeless Casa Landini *Madonna* (fig. 3-8), attributed to Lippo, is likely to be one of the two works cited in the texts. On the testimony of the Episcopal Chancellor, Guidi made the claim that the *Humility Madonnas* in the Palazzo dei Vescovi were so admired by Franchi that he commissioned the artist who had designed them to execute a similar picture, including the suckling motif and the Apocalyptic symbol of the moon, for Santa Maria Forisportam (fig. 3-1).[45] Admittedly, there is no firm evidence for Franchi's connection with the painting for the latter church. Yet, as the most important member of the Pistoiese Dominicans, he may have been involved in the commissioning of the *Madonna of the Pavilion* for San Domenico (fig. 3-2), and hence with the diffusion of the Madonna of Humility in the city.[46] After all, and as Meiss and other scholars have noted, the theme has strong associations with the Dominican Order.[47] Be that as it may, the lost frescos from the Bishop's Palace provide another prominent demonstration of Pistoia's desire to celebrate the protection of the Mother of Christ and her saintly companions.

Conclusion

The introduction to this essay began with a call to considering the artistic scene of late trecento Pistoia on its own terms rather than Florentine ones. The painted evidence discussed in the foregoing pages supports the view that Pistoiese, Bolognese and Modenese craftsmen created a remarkable cross-fertilisation among Pistoia's artistic workshops.

From this milieu emerged a variety of depictions of the Madonna of Humility, a theme so favoured by local patrons that, by the end of the fourteenth century, the type could be viewed in the city's parish churches, mendicant convents, Civic Hall and Bishop's Palace. Indeed, it would be impossible to establish with any degree of certainty where religious fervour ended and civic patriotism began in the mind of a late medieval Pistoiese citizen gazing upon the *Madonna* in the Sala Guelfa of the government palace (fig. 3-6). While Florentine customs may have had a small part to play in this trend, the episode as a whole adds to our understanding of the creative interconnections that existed between Tuscany and Emilia, raising questions about interregional artistic exchange.[48] But as Enrico Castelnuovo and Carlo Ginzburg (1979, 326-28) made clear in their seminal contribution to the dynamics of centre-periphery relationships across the peninsula, the minor centres of medieval Italy could sometimes become sites that actively promoted resistance to the values of the cultural centre. Adopting this notion, Pistoia's artistic relationships with Bologna might be seen to be a form of resistance to Florentine cultural and political hegemony. Perhaps these and related factors account for Lippo's successful career in the Tuscan town that included, as we have seen, election to the Pistoiese Commune's General Council. All the same, our painter repaid his debt to Pistoia upon his return to Bologna: from 1390 until his death in 1410, Lippo executed pictures for Emilian patrons that make known his connections with the pictorial traditions of Tuscany. And this is especially true of his most complete work on panel to survive in his native city, the signed altarpiece in the Pinacoteca Nazionale, which, as Roberto Longhi (1950, 17) observed, proclaims Lippo's close ties with the artistic culture of Pistoia.

Notes

[1] For a perceptive assessment of the literature, albeit with a view to highlighting a bias towards Florence rather than Siena, see Maginnis (1997, 7-63).

[2] On this point see, for instance, White (1979, 9-16).

[3] "... per il Trecento il problema principale fu quello di riscoprire la straordinaria varietà delle culture regionali e locali, di restituire la fisionomia diversificata di una miriade di centri, di seguire le differenti tendenze e proposte fino a leggerne i successi e gli scacchi ..." (Castelnuovo 1986, 8).

[4] The Pistoiese Commune was under Florentine hegemony between 1328 and 1343. Following the demise of Walter of Brienne in 1343, Florentine involvement in the government of Pistoia weakened, leading to factional feuds among the city's patrician families and culminating in Florence's seizure of Pistoia in March 1351. The town lost the last vestiges of its independence in 1401/02, after which it

became part of the Tuscan territorial state controlled by Florence. For these events and their repercussions, see Herlihy (1967, 214-31), Altieri Magliozzi (1978), Gai (1981), Neri (1999). For Pistoia's links with the Florentine artistic scene in this period, see Gai (1978).
[5] The scholar wrote important articles on two local artistic personalities, the Master of 1310 (Donati 1974) and the Master of 1336 (Donati 1976). Unfortunately, his study of Pistoiese painting from the second half of the trecento was never published. For this period, however, see the fundamental contribution of Boskovits (1975, 147-52).
[6] In his "Dissertazione III. Della Pittura," Ciampi (1810, 93-95) revealed that Alesso d'Andrea and Bonaccorso di Cino decorated the Chapel of Saint James in Pistoia Cathedral in 1347 (destroyed in 1786 but a few fragments survive today). For a recent contribution on the activity of these painters, see Feraci (2006). Taddeo Gaddi's altarpiece (early 1350s) for San Giovanni Fuorcivitas is *in situ* (Ladis 1982, 159-66). Niccolò di Tommaso is known to have completed work on another high altarpiece for the same church in 1372 (Ladis 1989), the year he is also recorded in the accounts of the Opera di San Jacopo as restoring an altarpiece in the cathedral's sacristy, as well as working on the decoration of the Chapel of Saint James (Gai 1970, 78-79). For Niccolò's largely intact frescos (ca.1372) in the former convent chapel of Sant'Antonio Abate, see Carli (1977). Finally, Niccolò may have been involved in retouching a fresco, attributed to "Dalmasio," on which see most recently Feraci (2006-07, 28). But the work of some prominent Sienese painters was once to be found in Pistoia too: altarpieces by Pietro Lorenzetti and Lippo Memmi were recorded in San Francesco, on which see Neri Lusanna (1993b, 86-87).
[7] In an important essay, Meiss (1936, 436) made a case for the theme's central Italian origins, identifying Simone Martini as its inventor. For a useful review of his thesis, including an appraisal of the supporting arguments made in subsequent years by other scholars, see Williamson (2009, 16-22). However, critics such as Longhi (1953, 6), Bologna (1969, 302-03), Castelnuovo (1962, 87, 152), Leone de Castris (1986, 409; 2003, 310) and Guarnieri (2006, 100) have preferred to locate the Humility Madonna's origins in Avignon, where Simone was active from 1335/36; for a succinct overview of the main points, see Williamson (2009, 23-25). Finally, Bolzoni and Ghezzi (1983, 294n11) suggested that the theme was in circulation in Avignon prior to Simone's arrival in France, since Opicinus de Canistris, a cleric and illuminator from Pavia based in Avignon, recorded a vision of the Virgin that was evidently inspired by an image of the Madonna of Humility. On 15 August 1334 he noted: "Hac nocte vidi in sompnis virginem Mariam cum filio in gremio tristem sedentem in terra..." For a recent response to the source, see Feraci (2006-07, 45n130), Williamson (2009, 68), Guarnieri (2011, 21).
[8] For the published lists of painters, see Ciampi (1810, 117-18) and Tolomei (1821, 151-218). Baronto's important manuscript *Memorie riguardanti le belle arti in Pistoia* is now lost but frequent reference to it can be found in the guidebook published by his son Francesco (Tolomei 1821). The manuscripts of Vitoni (*Il forestiere istruito in Pistoia* [1810-11]; *Diario* [1778-79]; *Guida del forestiere in Pistoia* [1779-82; 1783-1810]; *Viaggi in campagna* [1793 and 1806-10]) and

Ansaldi (*Descrizione delle pitture, sculture e architetture della città di Pistoia* [after 1773]; *Descrizione fatta in confuso delle pitture esposte al pubblico nella città di Pistoia* [before 1773]) were published by di Zanni and Pellegrini (2003). But the studies of Ciampi and Tolomei also took account of the earlier histories of the city compiled by such local erudites as the Servite friar Michelangelo Salvi (1656-62), the Capuchin friar Giuseppe Dondori (1666) and the nobleman Jacopo Maria Fioravanti (1758).

[9] See Bonacchi Gazzarrini (1969), Bacchi (1986), Neri Lusanna (1995), Carofano (1998), Neri Lusanna (1998), Neri Lusanna and D'Afflitto (1999).

[10] Bacci (1941-42, 112) considered it the work of a local Pistoiese master influenced by the Sienese school. The fresco is generally attributed to Lippo, for which see Boggi and Gibbs (2010, 131-32), although Luciano Bellosi (in De Marchi 1986, 55n5) and Pisani (1997, 78) have made a case for Nanni di Jacopo, while Neri Lusanna and D'Afflitto (1999, 367) have preferred to reattribute it to an artist in Antonio Vite's circle.

[11] Among the most recent studies of the frescos, see Santolamazza (2008, 43-75) and Lepri (2011, 15-56).

[12] The following have made valuable additions to the better known pictures, albeit with a focus on the painter's activity from 1389 to 1410: Berenson (1968, 214-15), Boskovits (1975, 252n271), Benati (1992, 129n107), Massaccesi (2010-11, 106-17).

[13] "Avendo poi molte cose lavorato in Bologna, et in Pistoia una tavola che fu ragionevole, se ne tornò a Fiorenza ..." (Vasari in Milanesi 1906, 11).

[14] But a second, more circuitous route to Bologna existed: the "strata de Fonte Taonis." This took travellers from Pistoia's Porta Guidi over the Monte La Croce, through the upper valley of the Bisenzio, and over the pass at Montepiano to Bologna. A third Apennine pass connected Pistoia to Modena via Popiglio, Mammiano, San Marcello and Abetone. For Pistoia's six major highways, see Herlihy (1967, 19-26).

[15] Giovanni di Bartolomeo Cristiani is listed as a member of the General Council under the Porta Caldatica from 1368 to 1401. For 1368-69, see Boggi (2007, 259). For the subsequent years see the unpublished references in the Archivio di Stato, Pistoia (hereafter cited as ASP), Comune di Pistoia: Consigli, Provvisioni e Riforme (hereafter cited as Consigli) 15, fol. 107 (20 June 1371); 16, fol. 44 (28 April 1374); 19, fols. 73v (23 April 1379), 87 (21 June 1379), 171 (29 Oct 1380); 20, fols. 42v (19 Oct 1383), 51v (18 Dec 1383); 21, fol. 9 (16 May 1385); 22, fol. 9v (4 Nov 1387); 23, fol. 61v (15 May 1390); 24, fol. 55 (27 June 1393); 25, fol. 14v (22 Dec 1396); 26, fols. 34v (28 April 1397), 49v (20 June 1397), 171v (29 Oct 1399); 27, fol. 54 (29 Oct 1401). Giovanni was also among the six citizens elected to represent the Borgo San Paolo on the more prestigious Council of Twelve: ASP, Consigli 26, fols. 23v (26 Feb 1397), 171v (29 Oct 1399).

[16] Bartolomeo di Giovanni Cristiani is listed as a member of the General Council under the Porta Caldatica from 1387 to 1422: ASP, Consigli 21, fol. 88 (17 June 1387); 22, fols. 15v (20 Dec 1387), 42v (18 Dec 1388), 44 (28 Dec 1388); 24, fol. 10 (29 Oct 1392); 25, fols. 7 (29 Oct 1396), 14 (22 Dec 1396); 26, fol. 133 (29 Oct 1398); 27, fols. 54 (29 Oct 1401), 168 (28 June 1404), 204v (28 June 1405); 29,

fol. 27 (28 June 1410); 32, fol. 298 (29 Aug 1422). He obtained membership of the more prestigious College of the Anziani in 1390: ASP, Consigli 23, fol. 94 (1 Nov 1390). In addition, he was among the six citizens elected to represent the Borgo San Paolo in the Council of Twelve: ASP Consigli 26, fol. 22v (27 Feb 1397); 29, fol. 18v (28 April 1410). Finally, he was elected to serve as a tax administrator (*impositor*) for the Porta Caldatica: ASP, Consigli 27, fol. 178 (8 Oct 1404); 27, fol. 217 (27 Oct 1405).

[17] Antonio Vite is listed as a member of the General Council under the Porta Guidi (Lippo's *porta*) from 1379 to 1406. For 1379-80, 1382, 1386-87 and 1406, see Gai 1970, 92-94. For the other years see the unpublished references in ASP, Consigli 23, fol. 131v (28 April 1391); 24, fols. 43v (28 April 1393), 114v (11 March 1394); 26, fols. 35 (28 April 1397), 50 (20 June 1397); 27, fols. 20 (28 April 1401), 160 (18 April 1404), 168 (28 June 1404). He obtained membership of the more prestigious Council of Twelve, representing the Borgo San Paolo, in 1404: ASP, Consigli 27, fols. 167v (28 June 1404), 170 (1 July 1404).

[18] Andrea di Guido is listed as a member of the General Council under the Porta Guidi in 1399 and 1402-03: ASP, Consigli 26, fol. 152v (28 April 1399); 27, fols. 87v (29 Oct 1402), 136v (29 Oct 1403), 145v (31 Dec 1403). He obtained membership of the more prestigious Council of Twelve in 1402-03: ASP, Consigli 27, fols. 76v (1 Sep 1402), 98 (26 Jan 1403).

[19] Filippo di Lazzaro was listed under the Porta Lucchese and the Porta Caldatica between 1349 and 1392 (Boggi 2007, 259).

[20] Jacopo di Lazzaro was listed under the Porta Lucchese and the Porta Guidi between 1345 and 1390 (Boggi 2007, 259).

[21] Bacci (1941-42, 109-10) gave the year as 1383 but Lucia Gai has identified it as 1384 in Boggi and Gibbs (2010, 88). It is of interest to note that on 26 August 1383 one otherwise unspecified "Filippo dipintore" is paid eight *soldi* for the painting of "torchi" or processional candleholders (ASP, Patrimonio ecclesiastico: Congregazione de' Preti della SS. Trinità G411, fol. 22); it is tempting to conclude that this might be a reference to Lippo di Dalmasio rather than the local artist Filippo di Lazzaro.

[22] Pistoia, Biblioteca Forteguerriana, MS B 76: "Iuxta dictam sepulturam olim cuiusdam Arrighi teutonici cum pulchris figuris desuper videlicet beatae virginis cum filio, beati Dominici, beatae Katerinae cum papilione cum duobus angelis." The excerpt was published by Orlandi (1957, 53). For a recent discussion of the manuscript and its compilers, see Giaconi (2010, 13-14).

[23] See Boskovits (1975, 253n275) as well as Neri Lusanna (1993a, 85), Lapi Ballerini (1996, 68), Neri Lusanna and D'Afflitto (1999, 367), Cortesi and Giaconi (2008, 179).

[24] Among the recent contributions to the question, see, for example, Neri Lusanna (1993a, 85), Neri Lusanna (1993b, 112, 153), Neri Lusanna and D'Afflitto (1999, 367), Feraci (2006-07, 28-31), Cassigoli (2009, 121, 138-40).

[25] See, for example, Lippo's later versions, of which some are signed (Boggi and Gibbs 2010, pl. 5 and figs. 22, 26), as well as the work of Simone dei Crocefissi (Meiss 1936, fig.4), Fra Paolo da Modena (Meiss 1936, fig. 7), Giovanni da Bologna (Meiss 1936, fig. 14), Tomaso da Modena (Gibbs 1992, figs. 1-2) and

Lorenzo Veneziano (Guarnieri 2006, cat. 6, 11, 12, 21, 33, 37). But see also Gordon (2011, 311) who has most recently observed that "north Italian painters show the Child on the [viewer's] left." Christ resting on the Virgin's right is also a largely standard feature of the early Humility Virgins in the Marche (Marcelli 2004, figs. 42-44) and southern Italy (Williamson 2009, pls. 1, 3, 6 and fig. 18).

[26] For the Sienese examples, see, for instance, Van Os (1969, figs. 46, 50, 53, 57, 64-71, 75). For Florence, see Boskovits (1975, pls. 93, 102 and figs. 131, 161, 216, 231, 308, 493, 558), but noting that there are some important exceptions, for which see Williamson (2009, pl. 2 and figs. 32, 37). For Pisa, see Carli (1994, figs. 141, 142); and for Lucca, see Filieri (1998, figs. 44, 225).

[27] For Emilian versions of the Virgin feeding Christ on her right, see, for instance, Lippo's own signed Rusconi-Clerici *Madonna*, as well as the *Virgins* from San Colombano and the van Marle Collection (Boggi and Gibbs 2010, cat. 15-16, 28); Simone dei Crocefissi's *Madonna del Latte* in San Martino, Bologna (D'Amico 1985, fig.1); Tomaso da Modena's *Madonna* of Villa Felissent (Gibbs 1989, p.54); and Barnaba da Modena's Virgin *Lactans* in Pisa (Carli 1994, fig. 140).

[28] For Sienese versions of the Virgin feeding Christ on her left, see, for instance, Cassigoli (2009, figs. 2.7, 2.19). For Florentine examples, see Boskovits (1975, pls. 48, 58, 114, 125 and figs. 50, 57, 75, 323, 347, 393, 437, 465). For early surviving versions in Pisa, see, for example, Cassigoli (2009, figs. 1.4, 1.5); and for Lucca, see Filieri (1998, figs. 124, 135, 148, 192 and cat. 14, 16).

[29] Described by Meiss (1936, 438) as being "of local origin," the *Madonna* in San Bartolomeo was ascribed plausibly by Boskovits (1975, 283) to Antonio Vite, an attribution most recently endorsed by Feraci (2006-07, 29, 31) and Lepri (2011, 52).

[30] See Vite's fresco of the *Madonna of Humility between Saints Francis, James, Anthony Abbot and Bartholomew* in the Museo Civico (from Santa Maria Maddalena al Prato) in Pistoia and the *Madonna of Humility between Saints Augustine and John the Baptist* in Sant'Agostino in Prato (Feraci 2006-07, 15-16, 20 and figs. 14, 22). For Sano di Giorgio see also the *Madonna* in the Confraternita della Misericordia (from Santa Maria Mater Jacobi) in Pistoia (Cassigoli 2009, 104 and fig. 3.9).

[31] For the Christ Child standing on his enthroned Mother's lap and blessing, see Shorr (1954, 26-29), who notes that the motif is prominent in Sienese painting. For a useful overview of the iconography of the standing Infant, see Trotzig (2004).

[32] For the *Madonna* (late 1300s) at the Sanmarini altar in San Francesco, see Neri Lusanna (1993b, pl. xxiv), and for the *Madonna of Humility* (early 1400s?) in Santa Maria a Ripalta, see Neri Lusanna and Ruschi (1992, fig. 46).

[33] For example, see Vite's *Humility Virgin with a Donor* (early 1400s) formerly in Pisa's San Paolo a Ripa d'Arno (destroyed but illustrated in Lapi Ballerini [1996, fig. 15] and Pisani [2007, 84-85]) and a fresco associated with Vite's immediate circle in Prato's San Michele (Lapi Ballerini 1996, fig. 17). But see also Sano di Giorgio's *Madonna* in Pistoia's Palazzo Comunale (Neri Lusanna 1993b, fig. 133).

[34] For Vite's activity in the city of Florence itself, see Boskovits (1975, 151) and, more recently, Feraci (2006-07, 7 and 14-15).

[35] See, for instance, Niccolò di Mariano's signed altarpiece of 1492 (Sant'Andrea, Pistoia), il Sollazzino's signed *gonfalone* of 1509 (Nuovo Museo Diocesano, Pistoia) and works by Bernardino del Signoraccio, including a signed altarpiece of 1493 (Santa Maria dell'Umiltà, Pistoia) and a later picture now in Avignon (Musée du Petit Palais); D'Afflitto et al. (1996, 60, 125-27, 144-45) and Cassigoli (2006, 27). Also derived from Serafini's example, though totally over-painted, are the frescos of the *Virgin of Humility* (1500s?) within a tabernacle on the north wall of the cathedral (Acidini Luchinat 2003, 110-11) and the *Madonna del Soccorso* in Santa Liberata (from the church of the Gesuati). This last picture portrays the Humility Madonna between two figures whose identity is difficult to discern, especially given the extent of the overpainting, which Feraci (2006-07, 46n136) suggests may have taken place in the late fifteenth century. Finally, the Virgin in Bernardino Detti's *Madonna della Pergola* (1523) in the Museo Civico in Pistoia is more loosely related to Serafini's prototype (D'Afflitto et al. 1996, 224-26).

[36] The protective powers of the *Madonna* were evidently felt in 1643 when the city was saved from a papal military attack, on which see Cipriani (1989).

[37] See Giaconi 2008, 88. Furthermore, the *Obituario di San Domenico* confirms that sixty-seven tombs, including frescos and family arms, were situated on all four sides of the cloister by the late fifteenth century (Giaconi 2008, 93).

[38] The *Obituario di San Domenico* lists the *Madonna of the Pavilion*—"beatae virginis... cum papilione"—as lying close to the tomb of a certain Arrigo *teutonico* who died in 1493 (Giaconi 2008, 90). Given the year of death, Arrigo cannot have commissioned Lippo's painting, so the tomb belonging to the donors depicted in the fresco must have been reassigned to Arrigo in the late fifteenth century. In fact, thirty of the sixty-seven tombs mentioned in the *Obituario* lay empty by the late 1400s (Giaconi 2008, 93-94).

[39] In Serafini's picture an unidentified woman is kneeling in prayer on the bottom left. Other Pistoiese examples of the theme with a commemorative purpose include Vite's San Bartolomeo *Madonna* (fig. 3-4), in which the praying hands of a penitent survive on the right of the fresco, as well as the incomplete inscription "Qui reverenter vidit ..." ("He who looks with reverence ..."); and Sano di Giorgio's *Madonna del Rastrello* (fig. 3-5), in which a tonsured donor dressed in white kneels on the bottom left.

[40] Meiss (1936, 460) was careful to discuss the meaning of the Madonna of Humility in the context of Mary's role as "compassionate, maternal intercessor for humanity before the impartial paternal justice of Christ or God the Father." But the scholar (1936, 460-61) also observed that the *Madonna* for Giovanna d'Aquino's tomb in Naples carries the inscription *Mater omnium* (Mother of all). On this last picture and its funerary context, see the more recent comments of Bock (2005).

[41] As Williamson (2009, 148-65) has made clear in her investigation of the uses of the early surviving Italian examples of the type, the Humility Madonna appears in ecclesiastical or domestic contexts as the focus of public or private devotion, including painted cenotaphs, tombs, altarpieces and portable panels of small size. Instead, the frescos in Pistoia's Palazzo Comunale were viewed in the secular and public context of government chambers. Their original audience consisted of civic officials who gathered in oligarchical councils and *ad hoc* committees to take

decisions on government policy. This use of the image in Pistoia highlights the Virgin's religio-political role while maintaining the concept of her intercessory powers.

[42] At an earlier date, Simone Martini included a great canopy in his magnificent mural of the *Maestà* in the Sala del Consiglio in Siena's Palazzo Pubblico, the ritual significance of which was made clear by Norman (2006). Furthermore, it should be noted that the pose of the Child in Vite's fresco in Pistoia's Palazzo Comunale is similar to that of the Infant in Simone's *Maestà*, among the early examples in painting to show the Baby Christ standing on his Mother's knee in the act of blessing the viewer (Shorr 1954, 26-29).

[43] For his life and career, see Guidi (1839) and Taurisano (1922).

[44] In 1628 Arferuoli mentioned that Bishop Franchi "fece dipingere la Madonna con alcuni Santi sopra la porta del vescovado, rasente il tetto, dove detto monsignor vescovo è ritratto inginocchioni... Fece dipingere nel salone di sopra con il Cenaculo, dove è ancor lui ritratto, l'anno 1395, insieme con quella Madonna detta, nel salon basso, di mezzo a S. Zeno e a S. Niccolao." (Pacini 1994, 120). In 1714 Guidi wrote that Franchi "fe' dipingere in alto sopra la porta del palazzo [vescovile] la gran Madre di Dio, che corteggiata da molti Santi, tiene in braccio, ed allatta il suo vezzoso Bambino, quasi che ad essi, come ai padroni, raccomandasse la custodia del vecchio e nuovo edificio... su la parete del salone da basso, fe' dipingere altra immagine della beatissima Vergine, cui fanno ossequioso corteggio S. Pietro, S. Pavolo, S. Niccolò da Bari, e S. Tommaso d'Aquino, esistenti sopra d'un quasi Altare..." (Guidi 1839, 34).

[45] "Il riflettere che queste due Immagini, di sopra la porta, e del primo salone, sono simili in tutto a quello della Madonna dell'Umiltà, sì nelle fattezze del Volto, sì nella positura della persona, sì nello scorcio di dar la poppa al Bambino, sì nel tenere sotto del piede la luna, dette giusto motivo a molti devoti di credere, che piaciute in estremo al nostro buon Prelato quelle due belle figure della Regina del Cielo, ordinasse al sopradetto pittore, che ne colorisse una simile nel tabernacolo di quel muro, che sosteneva il campanile di santa Maria Forisporta; quale poi per il miracoloso sudore tramandato nel 1490 dal fronte, fu trasferita nella suntuosa Basilica dell'Umiltà." (Guidi 1839, 34-35).

[46] It is tempting to think that Franchi would have known, or at least have heard of, the Avignonese examples of the Madonna of Humility through his brother Bartolomeo, who went to Avignon in 1372; Arferuoli in Pacini (1994, 120).

[47] Meiss (1936, 451-52) observed that the religious and devotional interests of the Order facilitated the diffusion of the composition. Among the other scholars who have made broadly similar claims, see, for example, Rolfs (1910, 41), Leone de Castris (1986, 409), Gibbs (1989, 165), Guarnieri (2006, 100; 2011, 21).

[48] The concept has recently yielded fresh insights into the visual culture of renaissance Italy; see Campbell and Milner (2004).

References

Acidini Luchinat, Cristina. 2003. *La cattedrale di San Zeno a Pistoia.* Cinisello Balsamo: Silvana.

Altieri Magliozzi, Ezelinda. 1978. "Istituzioni comunali a Pistoia prima e dopo l'inizio della dominazione fiorentina." In *Egemonia fiorentina ed autonomie locali nella Toscana nord-occidentale del primo Rinascimento: Vita, arte, cultura,* 171-205. Pistoia: Centro italiano di studi di storia e d'arte.

Bacchi, Andrea. 1986. "Pittura del Duecento e del Trecento nel pistoiese." In *La pittura in Italia: Il Duecento e il Trecento,* edited by Enrico Castelnuovo, 1:315-24. Milan: Electa.

Bacci, Pèleo. 1911. "Il pittore pistoiese Sano di Giorgio discepolo di Antonio Vite." *Bullettino storico pistoiese* 13: 197-207.

—. 1941-42. "Notizie sui pittori bolognesi Dalmasio di Jacopo Scannabecchi e Lippo di Dalmasio a Pistoia." *Le Arti* 3: 106-13.

Baldinucci, Filippo, 1768. *Notizie de' professori del disegno da Cimabue in qua.* 1681-1728. Edited by Giuseppe Piacenza. Vol. 1. Turin: Stamperia reale.

Barolsky, Paul. 1991. *Why Mona Lisa Smiles and Other Tales by Vasari.* University Park, PA: The Pennsylvania State University Press.

Benati, Daniele. 1992. *Jacopo Avanzi nel rinnovamento della pittura padana nel secondo '300.* Bologna: Grafis.

Berenson, Bernard. 1968. *Italian Pictures of the Renaissance: A List of the Principal Artists and their Works with an Index of Places.* Vol. 3.1, *Central Italian and North Italian Schools.* Rev. ed. London: Phaidon.

Bock, Nicolas. 2005. "Una Madonna dell'Umiltà di Roberto d'Oderisio: titulus, tema e tradizione letteraria." In *Le chiese di San Lorenzo e San Domenico: gli ordini mendicanti a Napoli,* edited by Serena Romano and Nicolas Bock, 145-71. Naples: Electa.

Boggi, Flavio. 2007. "The Maestà of the Palazzo Comunale in Pistoia: Civic Art and Marian Devotion in the Pistoiese Commune of the Fourteenth Century." *Mitteilungen des Kunsthistorischen Institutes in Florenz* 51: 251-66.

Boggi, Flavio, and Robert Gibbs. 2010. *The Life and Career of Lippo di Dalmasio, a Bolognese Painter of the Late Fourteenth Century.* Lewiston, New York: Mellen.

—. 2011. "Lippo di Dalmasio e la *Madonna del Padiglione* in san Domenico a Pistoia." In *Tracce di arte e di spiritualità in San Domenico di Pistoia,* edited by Alberto Coco and Alessandro Cortesi, 57-78. Florence: Nerbini.

Bologna, Ferdinando. 1969. *I pittori alla corte angioina di Napoli, 1266-1414, e un riesame dell'arte nell'età fridericiana.* Rome: Bozzi.

Bolzoni, Giuseppina, and Teresa Ghezzi. 1983. "Una Madonna veneziana del 1400 nella Pinacoteca di Brera: una ricerca." *Arte cristiana* 71: 291-94.

Bonacchi Gazzarrini, Giuliana. 1969. *Corso di storia civile, politica ed economica, arte e cultura di Pistoia.* Vol. 1, *La pittura pistoiese dal XIII al XIV secolo.* Pistoia: Assessorato alla Pubblica Istruzione.

Bortolotti, Pietro. 1874. "Fra Paolo da Modena: ignoto pittore trecentista domenicano." *Atti e memorie delle RR. Deputazioni di storia patria per le provincie modenesi e parmensi* 7: 383-456.

Boskovits, Miklós. 1975. *Pittura fiorentina alla vigilia del Rinascimento, 1370-1400.* Florence: Edam.

Campbell, Stephen, and Stephen Milner, eds. 2004. *Artistic Exchange and Cultural Translation in the Italian Renaissance City.* Cambridge: Cambridge University Press.

Carli, Enzo. 1977. *Gli affreschi del Tau a Pistoia.* Florence: Edam.

—. 1994. *La pittura a Pisa dalle origini alla "bella maniera."* Ospedaletto, PI: Pacini.

Carofano, Pierluigi. 1998. "Pistoia." In *Enciclopedia dell'arte medievale*, edited by Angiola Maria Romanini, 9:445-47. Rome: Istituto della Enciclopedia Italiana.

Cassigoli, Iacopo. 2006. "Dalla *Grande Madre* alla *Maria Lactans*: Iconografia e culto del latte a Pistoia." *Il Tremisse pistoiese* 31: 26-28.

—. 2009. *Ecce Mater: La Madonna del latte e le sante galattofore; Arte, iconografia e devozione in Toscana fra Trecento e Cinquecento.* Florence: Nicomp L.E.

Castelnuovo, Enrico. 1986. "Mille vie della pittura italiana." In *La pittura in Italia: Il Duecento e il Trecento*, edited by Enrico Castelnuovo, 1:7-24. Milan: Electa.

—. 1962. *Un pittore italiano alla corte di Avignone: Matteo Giovannetti e la pittura in Provenza nel secolo XIV.* Turin: Einaudi.

Castelnuovo, Enrico, and Carlo Ginzburg. 1979. "Centro e periferia." In *Storia dell'arte italiana.* Part 1, *Materiali e problemi.* Vol. 1, *Questioni e metodi*, edited by Giovanni Previtali, 283-352. Turin: Einaudi.

Ciampi, Sebastiano. 1810. *Notizie inedite della Sagrestia pistoiese de' belli arredi del Campo Santo pisano e di altre opere di disegno dal secolo XII al XV.* Florence: Molini, Landi & Co.

Cipriani, Alberto. 1989. *L'assalto dei Barberini a Pistoia nel 1643.* Pistoia: Società pistoiese di storia patria.

—. 1993. "Quel 'prodigioso licore': il miracolo dell'Umiltà nella turbolenta Pistoia del XV secolo." In *Centenario del miracolo della Madonna dell'Umiltà a Pistoia (Pistoia 5-26 maggio 1992)*, edited by Alessandro Andreini and Marco Gori, 3-19. Pistoia: Società pistoiese di storia patria.

Cortesi, Alessandro, and Elettra Giaconi, eds. 2008. *Arte e storia nel convento San Domenico di Pistoia.* Florence: Nerbini.

Crowe, Joseph Archer, and Giovanni Battista Cavalcaselle. 1864. *A New History of Painting in Italy: From the Second to the Sixteenth Century.* Vol. 2. London: John Murray.

D'Afflitto, Chiara, Franca Falletti and Andrea Muzzi, eds. 1996. *L'età di Savonarola: Fra' Paolino e la pittura a Pistoia nel primo Cinquecento.* Venice: Marsilio.

D'Amico, Rosalba. 1985. "Nuovi appunti per il Trecento bolognese. La 'Madonna col Bambino' di Simone de' Crocefissi in S. Martino." *Strenna storica bolognese* 35: 97-115.

De Marchi, Andrea. 1986. "Il 'Maestro del 1310' e la fronda anti-giottesca: intorno ad un 'Crocifisso' murale." *Prospettiva* 46: 50-56.

Di Zanni, Lisa, and Emanuele Pellegrini, eds. 2003. *Pistoia inedita: la descrizione di Pistoia nei manoscritti di Bernardino Vitoni e Innocenzo Ansaldi.* Pisa: Edizioni ETS.

Donati, Pier Paolo. 1974. "Per la pittura pistoiese del Trecento: il Maestro del 1310." *Paragone* 25: 4-26.

—. 1976. "Per la pittura pistoiese del Trecento: il Maestro del 1336." *Paragone* 27: 3-15.

Dondori, Giuseppe. 1666. *Della pietà di Pistoia.* Pistoia: Fortunati.

Feraci, Ugo. 2006. "Precisazioni su Bonaccorso di Cino e sulla pittura toscana di metà Trecento." *Arte cristiana* 94: 89-104.

—. 2006-07. "Antonio Vite e la pittura tardogotica pistoiese." *Proporzioni* 7-8: 7-48.

Filieri, Maria Teresa, ed. 1998. *Sumptuosa tabula picta. Pittori a Lucca tra gotico e rinascimento.* Leghorn: Sillabe.

Filippini, Francesco, and Guido Zucchini. 1947. *Miniatori e pittori a Bologna. Documenti dei secoli XIII e XIV.* Florence: Sansoni.

Fioravanti, Jacopo Maria. 1758. *Memorie storiche della città di Pistoja.* Lucca: Benedini.

Frati, Ludovico. 1910. "Dalmasio e Lippo de' Scannabecchi e Simone dei Crocefissi." *Atti e memorie della Deputazione di storia patria per le provincie di Romagna* (3rd ser.) 27: 209-24.

Gai, Lucia. 1970. "Nuove proposte e nuovi documenti sui maestri che hanno affrescato la cappella del Tau a Pistoia." *Bullettino storico pistoiese* 72: 75-94.

—. 1978. "Rapporti fra l'ambiente artistico pistoiese e fiorentino alla fine del Trecento ed ai primi del Quattrocento. Riesame di un problema critico." In *Egemonia fiorentina ed autonomie locali nella Toscana nord-occidentale del primo Rinascimento: Vita, arte, cultura*, 325-58. Pistoia: Centro italiano di studi di storia e d'arte.

—. 1981. *L'ultimo periodo dell'autonomia comunale pistoiese*. Pistoia: Società pistoiese di storia patria.

—. 1984. "Artigiani e artisti nella società pistoiese del basso Medioevo. Spunti per una ricerca." In *Artigiani e salariati: Il mondo del lavoro nell'Italia dei secoli XII-XV*, 225-91. Pistoia: Centro italiano di studi di storia e d'arte.

—. 2004. "La Madonna dell'Umiltà a Pistoia." In *Colloqui davanti alla Madre. Immagini mariane in Toscana tra arte, storia e devozione*, edited by Antonio Paolucci, 61-69. Florence: Mandragora.

Giaconi, Elettra. 2008. "Il chiostro-cimitero nel convento San Domenico di Pistoia." In *Arte e storia nel convento San Domenico di Pistoia*, edited by Alessandro Cortesi and Elettra Giaconi, 77-120. Florence: Nerbini.

—. 2010. *L'aristocrazia della morte nella chiesa di San Domenico a Pistoia*. Florence: Nerbini.

Gibbs, Robert. 1989. *Tomaso da Modena: Painting in Emilia and the March of Treviso, 1340-80*. Cambridge: Cambridge University Press.

—. 1992. "*Pulchrior Aurora*: A new *Madonna of Humility* by Tomaso da Modena." *Apollo* 135: 171-73.

Gordon, Dillian. 2011. *The Italian Paintings Before 1400: National Gallery Catalogues*. London: National Gallery Co.

Guarnieri, Cristina. 2006. *Lorenzo Veneziano*. Cinisello Balsamo: Silvana.

—. 2011. "Lorenzo Veneziano e l'ordine dei predicatori: nuove riflessioni critiche attorno alle tre tele con la *Madonna dell'umiltà*." In *Lorenzo Veneziano: Le* Virgines humilitatis*; Tre Madonne "de panno lineo": Indagini, tecnica, iconografia*, edited by Chiara Rigoni and Chiara Scardellato, 19-41. Cinisello Balsamo: Silvana.

Guidi, Giuseppe Maria. 1839. *Vita del beato fra Andrea Franchi dell'ordine di S. Domenico, vescovo di Pistoia. Scritta dal lettore fra Giuseppe Maria Guidi del medesimo ordine nell'anno 1714*. Pistoia: Tipografia Cino.

Herlihy, David. 1967. *Medieval and Renaissance Pistoia: The Social History of an Italian Town*. New Haven: Yale University Press.

Ladis, Andrew. 1982. *Taddeo Gaddi: Critical Reappraisal and Catalogue Raisonné*. Columbia: University of Missouri Press.

—. 1989. "A High Altarpiece for San Giovanni Fuorcivitas in Pistoia and Hypotheses about Niccolò di Tommaso." *Mitteilungen des Kunsthistorischen Institutes in Florenz* 33: 3-16.

Lanzi, Luigi. 1809. *Storia pittorica della Italia dal risorgimento delle belle arti fin presso al fine del XVIII secolo*. 6 vols. 3rd rev. and exp. ed. Bassano: Remondini.

Lapi Ballerini, Isabella. 1996. "Pitture murali fra Tre e Quattrocento nella chiesa di San Paolo." *Pistoia Programma* 33-34: 59-72.

Leone de Castris, Pierluigi. 1986. *Arte di corte nella Napoli angioina. Da Carlo I a Roberto il Saggio, 1266-1343*. Florence: Cantini.

Lepri, Nicoletta. 2011. "Di alcuni affreschi tre-quattrocenteschi staccati e conservati nel refettorio vecchio del convento di S. Domenico." In *Tracce di arte e di spiritualità in San Domenico di Pistoia*, edited by Alberto Coco and Alessandro Cortesi, 15-56. Florence: Nerbini.

Longhi, Roberto. 1950. "La mostra del Trecento bolognese." *Paragone* 1: 5-44.

—. 1953. "Frammento siciliano." *Paragone* 4: 3-44.

Maginnis, Hayden. 1997. *Painting in the Age of Giotto: A Historical Reevaluation*. University Park, PA: The Pennsylvania State University Press.

Marcelli, Fabio. 2004. *Allegretto di Nuzio, pittore fabrianese*. Fabriano, AN: Tipolitografia fabrianese.

Marino, Eugenio. 1977-78. "Iconologia del Ciclo 'Via Paradisi' di Giovanni di Bartolomeo Cristiani: 'Penitenza' e 'Sogno di Dio' tra Medioevo e Umanesimo." *Memorie domenicane* 8-9: 249-340.

Massaccesi, Fabio. 2010-11. "Lippo di Dalmasio: una *Croce* nelle Collezioni Comunali d'Arte di Bologna e altre aggiunte." *Arte a Bologna. Bollettino dei Musei Civici d'Arte Antica* 7-8: 106-17.

Meiss, Millard. 1936. "The Madonna of Humility." *The Art Bulletin* 18: 435-64.

Melani, Vasco. 1970. *Itinerari pistoiesi*. Pistoia: Tellini.

Mellini, Gian Lorenzo. 1970. "Commento a 'Dalmasio.'" *Arte illustrata* 27-29: 40-55.

Milanesi, Gaetano, ed. 1906. *Le Vite de' più eccellenti pittori, scultori ed architettori* by Giorgio Vasari. 1568. Vol. 2. Florence: Sansoni.

Neri, Francesco. 1999. "Società ed istituzioni: Dalla perdita dell'autonomia comunale a Cosimo I." In *Dentro lo Stato fiorentino: Dalla metà del XIV alla fine del XVIII secolo*, edited by Giuliano Pinto, 1-80. Vol. 3 of *Storia di Pistoia*. Florence: Le Monnier.

Neri Lusanna, Enrica. 1993a. "L'affresco della Madonna dell'Umiltà: filologia e iconografia." In *Centenario del miracolo della Madonna dell'Umiltà a Pistoia (Pistoia 5-26 maggio 1992)*, edited by Alessandro Andreini and Marco Gori, 71-86. Pistoia: Società pistoiese di storia patria.

—. 1993b. "La pittura in San Francesco dalle origini al Quattrocento." In *San Francesco: La chiesa e il convento in Pistoia*, edited by Lucia Gai, 81-164. Pisa: Pacini.

—. 1995. "Pistoia, Lucca, Arezzo." In *Pittura murale in Italia: Dal tardo Duecento ai primi del Quattrocento*, edited by Mina Gregori, 82-91. Bergamo: Bolis.

—. 1998. "Le arti figurative a Pistoia." In *L'età del libero Comune: Dall'inizio del XII alla metà del XIV secolo*, edited by Giovanni Cherubini, 275-316. Vol. 2 of *Storia di Pistoia*. Florence: Le Monnier.

Neri Lusanna, Enrica, and Chiara D'Afflitto. 1999. "Le arti figurative." In *Dentro lo Stato fiorentino: Dalla metà del XIV alla fine del XVIII secolo*, edited by Giuliano Pinto, 357-431. Vol. 3 of *Storia di Pistoia*. Florence: Le Monnier.

Neri Lusanna, Enrica, and Pietro Ruschi. 1992. *Santa Maria a Ripalta. Aspetti della cultura artistica medievale a Pistoia*. Florence: Edam.

Norman, Diana. 2006. "'Sotto uno baldachino trionfale': The Ritual Significance of the Painted Canopy in Simone Martini's *Maestà*." *Renaissance Studies* 20: 147-60.

Orlandi, Stefano. 1957. *I Domenicani a Pistoia fino al sec. XV*. Florence: "Il Rosario."

Pacini, Alfredo. 1994. *La chiesa pistoiese e la sua cattedrale nel tempo. Repertorio di documenti (a.255-a.1450)*. Pistoia: CRT.

Pappagallo, Giorgio. 1994. "La ex chiesa di San Lorenzo: Apparati decorative e pratiche devozionali nel XIV secolo." *Il Tremisse pistoiese* 19: 25-32.

Pini, Raffaella. 1998 (1999). "Per una biografia del pittore bolognese Lippo di Dalmasio (1353 ca.-1410)." *Atti e memorie: Deputazione di Storia Patria per le Provincie di Romagna* (new ser.) 49: 451-530.

Pisani, Linda. 1997. "Il 'Maestro della cappella Bracciolini:' proposte per l'attività giovanile e precisazioni sulla cronologia." *Antichità viva* 36: 72-81.

—. 2007. "Echi pisani di Lorenzo Monaco." In *Intorno a Lorenzo Monaco. Nuovi studi sulla pittura tardogotica*, edited by Daniela Parenti and Angelo Tartuferi, 76-87. Leghorn: Sillabe.

Rauty, Natale. 1993. "Tracce archivistiche per l'antica chiesa di Santa Maria Forisportam." In *Centenario del miracolo della Madonna*

dell'Umiltà a Pistoia (Pistoia 5-26 maggio 1992), edited by Alessandro Andreini and Marco Gori, 21-40. Pistoia: Società pistoiese di storia patria.

Rogers Mariotti, Josephine. 1996. "Su Gerino da Pistoia." In *L'età di Savonarola: Fra' Paolino e la pittura a Pistoia nel primo Cinquecento*, edited by Chiara D'Afflitto et al., 77-97. Venice: Marsilio.

Rolfs, Wilhelm. 1910. *Geschichte der Malerei Neapels*. Leipzig: Seemann.

Salmi, Mario. 1931. "Per la storia della pittura a Pistoia e Pisa (A proposito degli affreschi scoperti in San Domenico di Pistoia)." *Rivista d'Arte* 13: 451-76.

Salvi, Michelangelo. 1656-62. *Historie di Pistoia e fazioni d'Italia*. 3 vols. Rome: de' Lazari (vol. 1); Pistoia: Fortunati (vol. 2); Venice: Valuasense (vol. 3).

Santolamazza, Lisa. 2008. "Ricostruzione della decorazione pittorica della chiesa di San Domenico di Pistoia. Metodologia per un grafico alla luce di un manoscritto quattrocentesco." In *Arte e storia nel convento San Domenico di Pistoia*, edited by Alessandro Cortesi and Elettra Giaconi, 43-75. Florence: Nerbini.

Shorr, Dorothy C. 1954. *The Christ Child in Devotional Images in Italy during the XIV Century*. New York: Wittenborn.

Taurisano, Innocenzo. 1922. *Il beato Andrea Franchi vescovo di Pistoia (1335-1401)*. Roma: Collegio Angelico.

—. 1923. "I domenicani in Pistoia. La loro chiesa e il loro convento." *Bullettino storico pistoiese* 25.3: 85-94.

Tolomei, Francesco. 1821. *Guida di Pistoia per gli amanti delle Belle Arti, con notizie degli Architetti, Scultori, e Pittori pistoiesi*. Pistoia: Bracali.

Trotzig, Aina. 2004. "The Iconography of the Enthroned Virgin with the Christ Child Standing in her Lap." In *Images of Cult and Devotion: Function and Reception of Christian Images in Medieval and Post-medieval Europe*, edited by Søren Kaspersen, 245-53. Copenhagen: Museum Tusculanum Press.

Valiani, Giulio. 1932. "Opera di restauro in S. Domenico." *Bullettino storico pistoiese* 34: 230-34.

Van Os, Hendrik. 1969. *Marias Demut und Verherrlichung in der sienesischen Malerei 1300-1450*. The Hague: Staatsuitgeverij.

Vasari, Giorgio. 1568/1878-85. *Le Vite de' più eccellenti pittori, scultori ed architettori*. Edited by Gaetano Milanesi. 9 vols. Florence: Sansoni.

Venturi, Adolfo. 1907. *Storia dell'arte italiana*. Vol. 5, *La pittura del Trecento e le sue origini*. Milan: Hoepli.

Webb, Diana. 1996. *Patrons and Defenders: The Saints in the Italian City-States*. London: Tauris.

White, John. 1979. *Duccio: Tuscan Art and the Medieval Workshop*. London: Thames and Hudson.

Williamson, Beth. 2009. *The Madonna of Humility: Development, Dissemination and Reception, c.1340-1400*. Woodbridge: Boydell Press.

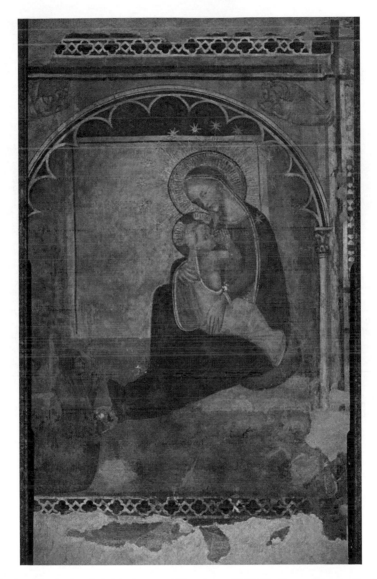

Fig. 3-1. Paolo Serafini, *Madonna of Humility*, c.1383 (?), fresco. Pistoia, Basilica della Madonna dell'Umiltà. Photo: Diocesi di Pistoia (Prot. aut. 35/08).

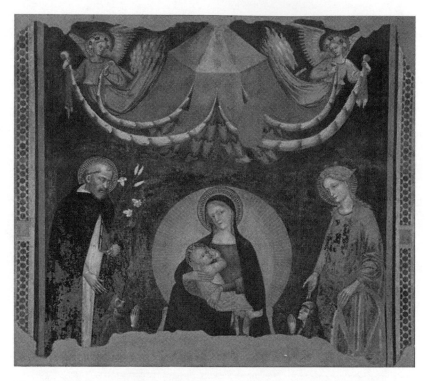

Fig. 3-2. Lippo di Dalmasio, *Madonna of Humility with Saints Catherine and Dominic* (*Madonna of the Pavilion*), c.1380, fresco, 2.10 x 2.40m. Pistoia, San Domenico. Photo: author.

Fig. 3-3. Lippo di Dalmasio, *Madonna of Humility*, c.1380s, fresco, 66 x 84cm. Pistoia, San Paolo. Photo: Diocesi di Pistoia (Prot. aut. 35/08).

Fig. 3-4. Antonio Vite, *Madonna of Humility*, c.1380s, fresco. Pistoia, San Bartolomeo in Pantano. Photo: Diocesi di Pistoia (Prot. aut. 35/08).

Fig. 3-5. Sano di Giorgio, *Madonna of Humility*, c. early 1400s, fresco. Pistoia, San Giovanni Battista al Tempio. Photo: Diocesi di Pistoia (Prot. aut. 35/08).

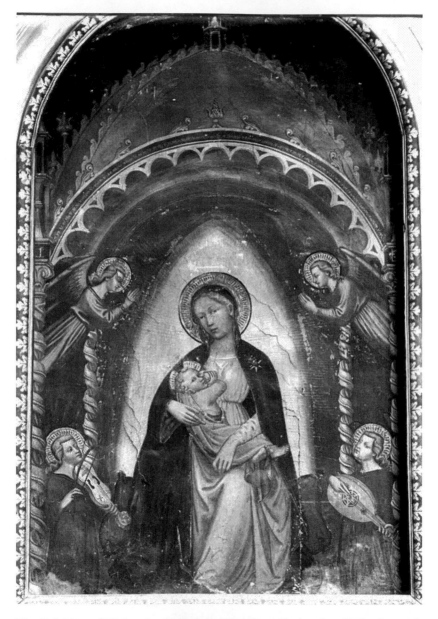

Fig. 3-6. Lippo di Dalmasio, *Madonna of Humility with Angels*, c.1380s, fresco, 2 x 2.91m. Pistoia, Palazzo del Comune, Sala Maggiore. Photo: author.

Fig. 3-7. Antonio Vite, *Madonna of Humility between Saints Zeno and James*, 1397-98, fresco. Pistoia, Palazzo del Comune, Sale Affrescate. Photo: Museo Civico di Pistoia.

Fig. 3-8. Lippo di Dalmasio (?), *Madonna of Humility*, c.1380s (?), fresco. Formerly Pistoia, Casa Landini. Photo: author.

CHAPTER FOUR

MATTEO DI GIOVANNI AND THE CIVIC PATRONS OF SOUTHERN TUSCANY

SANDRA CARDARELLI

This paper investigates some fifteenth-century civic commissions for the cathedral of Grosseto and the church of S. Niccolò in Montepescali.[1] A third, speculative case, regarding an altarpiece intended for the church of S. Leonardo in Ravi, will also be considered. The commissions for these churches, all part of the southern Tuscan diocese of Grosseto, were carried out by the Sienese artist Matteo di Giovanni.[2] It will argue that these paintings were likely to have been part of a wider pattern of civic patronage in support of the consolidation of local civic authorities.

These towns became part of the Sienese *contado* at different times in history, either by war or pacts of allegiance.[3] In both cases, modes of taxation and reciprocal expectations in the provision of goods or services varied according to the needs of the moment and the strategic and economic importance of the communities involved (Bowsky 1981, 1-22).[4] This varied relationship was reflected also in the artistic output of these communities. In this regard I shall argue that the choice of subject represented and the iconography of the works examined here was substantially independent from Siena and responded to local devotional practices related to the cult of patron saints.

Fifteenth-century commissions in this area, known as the Maremma, show significant involvement of local civic institutions in the commissioning of religious art. Surviving works suggest that their subject matter and intended function suited local needs and traditions, and were pivotal to the rituals connected to the celebration of local patron saints. These rituals also held a strong political significance, as they were used to reinforce territorial unity and common interests through the renewal of the pacts of allegiance.[5] Ritual celebrations of patron saints constituted a crucial component in the creation of the identity of these communities and

involved both the religious and civic realms, as emerges from the medieval statutes of these cities.[6]

The commissions in Grosseto, Montepescali and Ravi should not be viewed as isolated examples, but rather as typical practices of local governments, whereby many of the artworks produced for local churches were funded by the commune.[7] This phenomenon was by no means restricted to Siena or Tuscany, but rather took place in several communes of central Italy between the twelfth and fifteenth centuries.[8]

The churches of the diocese of Grosseto preserve a number of altars and altarpieces that pertain predominantly to the second half of the fifteenth century. The representation of locally renowned saints in the works examined shows that each centre maintained its own traditions and cherished local cultural heritage. Moreover, the evidence available suggests that there was sharing of cultural models between Siena and the Maremma.[9] It will be argued that the style developed by Matteo di Giovanni in Siena was adapted to suit the specific purposes and requirements of the local patrons and the intended audience. As we shall see later, this was the case for the altarpiece known as the *Madonna delle Grazie*, painted by Matteo di Giovanni around 1475.

Although Matteo is renowned as one of the most prolific talents of the Sienese *quattrocento*, only two of his works survive in the Maremma. These are an Assumption of the Virgin known as *Madonna delle Grazie* hosted in the cathedral of Grosseto, and a large altarpiece representing the *Madonna and Child enthroned with Sts. Sebastian, William,*[10] *Mary* Magdalen*e, Lucy and six angels* in the church of S. Niccolò in Montepescali. There may also have been a third altarpiece, unfortunately now lost and originally pertaining to the church of S. Leonardo in Ravi, for which only excerpts from records of payments made to Matteo remain in an article published in 1904 (Zdekauer 1904, 140-150).

I suggest that these three altarpieces were part of a precise policy of the civic governments of Grosseto, Montepescali and probably Ravi that aimed to consolidate their power and authority by enhancing the cult of locally highly venerated figures. The medieval statutes of southern Tuscan cities record that local civic governments implemented civic rituals based on the common veneration of saintly figures in which the clergy, members of the ruling class, and the population took part.[11]

Although no direct primary source related to these commissions seems to have survived, some hypotheses can be made on the basis of the visual analysis of the first two works, the statutes of the towns, the ecclesiastical visitation of Bishop Francesco Bossi (1576), the visit of the Sienese

auditor Bartolomeo Ghcrardini (1676), and the records of the chancellor of the curia of Grosseto, Francesco Anichini (1752). [12]

The *Madonna delle Grazie* and other fourteenth-century commissions in the cathedral of Grosseto: civic patronage for the community

Although the *Madonna delle Grazie* that is displayed in the cathedral of Grosseto is not dated, a comparison with other works produced by Matteo di Giovanni suggests that this altarpiece dates from between c. 1470 and 1475 (Fig. 4-1). [13] The issue of its patronage has been the object of scholarly research in recent years, as it is an essential element for our understanding of its function (Fumi Cambi Gado 1996); (Buricchi 1998); (Israëls 2003). Although a possible involvement of the resident Bishop Giovanni Agazzari in the commission for this altarpiece was hypothesized on the basis of previous clerical commissions in the cathedral, there is no evidence of this in the patronage of the *Madonna delle Grazie* (Fumi Cambi Gado 1996, 45). On the contrary, as pointed out by Buricchi and Israëls, the coat of arms of the commune of Grosseto, the *Opera*—the civic institution that was responsible for the maintenance and decoration of the church—and the *Operaio*—a civic official, a kind of worker in chief—carved in the marble altar in which the painting is displayed, [14] suggest that the *Operaio* was involved in the commissions for both the altar and the altarpiece (Fig. 4-2). [15] Moreover, the inscription on the altar shows that this was carved by Antonio Ghini in 1474, thus around the date suggested by the majority of scholars for the completion of the *Madonna delle Grazie*.

The red and white marble slabs that were inserted inside the niche of the altar-frame during the refurbishments of the 1860s, may have induced scholars to believe that this space was originally conceived to host a large altarpiece with a rounded top or lunette, thus sparking doubts on the original size of the *Madonna delle Grazie* and its pertinence to the altar. However, documentary evidence shows that the marble panels that originally lined the altar-frame were damaged by water infiltration and that some of them were replaced already in 1644. On the same occasion the Sienese painter Francesco Pericciuoli was employed to re-touch the damaged painting of the *Madonna delle Grazie*. [16] Traces of the original position of both altar and altarpiece of the Assumption are left on the exterior buffered arch of the north wall. [17] This corresponds to the first bay of the left aisle, where Bossi witnessed the altar of the Assumption in 1576 (Fig. 4-3). [18] In this location the Assumption painted by Matteo di

Giovanni was displayed in a small chapel that was later demolished, and that projected towards the outside (Israëls 2003, 154).

The Statutes of the city of 1421 acknowledge that the *Opera* of Santa Maria, the institution that built, maintained, and decorated the cathedral of Grosseto, was under the control of the commune.[19] The commune, through the Priors, elected the *Operaio* and controlled his actions.[20] It is difficult to ascertain whether and to what extent the *Operaio* was only the manager of the financial resources granted by the commune for the decoration of the cathedral, or whether he had personal financial input in commissions such as that for the *Madonna delle Grazie*. As such, he may have exercised his personal taste in the choice of iconography, subject represented and material used in the commissions given. Nonetheless, the presence of the arms of the commune on the altar gives us a strong indication of the importance and influence of the civic authorities in shaping the appearance of the cathedral space.

Other commissions that display the arms of the commune in the cathedral include the baptismal font, which was completed by Antonio Ghini in 1470, only a few years before the altar of the *Madonna delle Grazie*, and the stained glass windows attributed to Benvenuto di Giovanni (second half of the fifteenth century). These works are a visual testimony of the commune's active engagement in the decoration of the cathedral in the second half of the fifteenth century. Moreover, the ecclesiastical visitation of Bishop Francesco Bossi of 1576 highlights that according to an ancient tradition, the altar of the Assumption was maintained by the *Operaio*, who also elected the chaplain.[21]

The Statutes of Grosseto of 1421 show that the Commune was involved in the celebration of the patron saints of the city: Sts Lawrence (10th August), Cyprian (16th September), and the Virgin of the Assumption on 15th August each year. The feast for the Assumption entailed a procession to the cathedral where, during the celebration of mass on the high altar, the officials of the commune offered large wax candles to honour the Virgin.[22]

The veneration of the Virgin of the Assumption in Grosseto dated back further than Sienese dominance in the area, as a parish church dedicated to Mary of the Assumption was already recorded in 1015 (Kurze 1982, 2: 113-114). When the bishop's see was moved from the nearby town of Roselle to Grosseto in 1138, a new cathedral was built, and this was dedicated to St. Lawrence, the titular saint of the cathedral in Roselle. Yet, the Virgin continued to benefit from strong devotional focus in Grosseto, and more generally in the diocese, in the following centuries.

According to Pecci (post-1759, 137-139), in 1465 Grosseto experienced the devastation of plague that decimated the population. Further injury was caused by the insalubrious water drunk by both the population and the cattle. Sienese attempts to re-populate the city in the following years failed, and ad-hoc provisions to relieve local citizens from the tax burden proved to be of little help to the destitute community. The commission of the Assumption from Matteo di Giovanni was probably devised by the local commune as a pledge for protection at a time of particular hardship. The painting might have been popularly re-named *Madonna delle Grazie* once this was thought to have a special intercessory power with the divine, as the numerous *ex-votos* recorded by Bossi in his visitation to the cathedral suggests.[23]

There are strong indications that this might have been a consolidated practice, and thus that the format of the panel was explicitly required to fulfil a dual function, both as an altarpiece and as a movable icon. The small dimensions of the Madonna in Grosseto suggests that this sacred image was probably used as a processional icon in the annual celebrations of the Virgin of the Assumption organized by the commune of Grosseto on 15th August.[24] Archival records show that the practice of taking the *Madonna delle Grazie* in procession is documented at least from 1558.[25]

The half-length representation of the Assumption painted by the Sienese painter Domenico di Bartolo for the church of the Refugio in Siena (known as the *Madonna Orante*) may have been the reference model for the *Madonna delle Grazie*.[26] Nonetheless, the panel in Grosseto maintains original features such as the presence of the six angels unusually squeezed around the Virgin, whereas these are not present in Domenico di Bartolo's Assumption. The Assumption in Grosseto shows a close-up view, where the focus is on the Virgin and surrounding angels, estranged from the traditional elements that were used in Sienese iconography of this subject at the time. Matteo di Giovanni used this traditional format in his other two surviving Assumptions painted for the church of S. Agostino in Asciano (1475, tempera and gold on panel, 331.4 x 173.9 cm. National Gallery, London), and for the church of S. Maria dei Servi in Sansepolcro (1489, tempera on panel, 324 x 166 cm.). The *mandorla* of cherubs and seraphim that typically lift the Virgin to heaven, and St. Thomas and the crowd waiting for the gift of the girdle in front of an empty sarcophagus, are all missing in the Grosseto panel. This choice suggests that Matteo had to take into account two major requirements when depicting the panel for Grosseto: its ritual function, and the awareness of the iconographic elements that made the subject immediately recognizable to the intended audience.[27]

The records available suggest that the altarpiece was intended from the onset for the marble altar carved by the sculptor Antonio Ghini in 1474.[28] As noted above, four years earlier, Ghini had also carved a marble baptismal font, and both works bear the arms of the commune of Grosseto, the *Opera* and the *Operaio*.[29] This ensemble reminded the population that the civic authorities had a privileged relationship with the divine, and that their power was justified and protected by this sacred tie. The relationship between sacred setting and temporal power reached its peak during the ritual celebration of the patron saints of the city: St. Lawrence on the 10th August, and the Virgin of the Assumption on the 15th of the same month. It is likely that during the celebrations for the Assumption, the *Madonna delle Grazie* was temporarily moved to the main altar to be displayed for the devotion of the population and to receive the offering of wax candles by the civic authorities, following the example of contemporary civic rituals in Siena and other cities.[30] It has been shown that the panel was screened from view by a silk curtain that was removed only on special occasions and in accordance with an ancient tradition.[31]

No study has ever been carried out on the establishment and development of such rituals in the Maremma, and on whether these were only a derivative of the Sienese model. As the medieval statutes of other cities suggest, such rituals were developed over a lengthy period of time and were widespread throughout the Tuscan region and beyond.[32] It is therefore likely that, in the diocese of Grosseto, they were established at the time of the feudal lordship of the Aldobrandeschi family, well before the commune of Siena took over in the area.[33]

The commission from an artist such as Matteo di Giovanni for the altarpiece of the *Madonna delle Grazie* underscores the importance that the city of Grosseto held in the area, and the recognition of its cathedral as a major centre for devotion, drawing in devotees from other parts of the Maremma (BCG, Anonimo 1759, passim).

Iconam habens pulcram: civic patronage and Williamite influence in the church of S. Niccolò in Montepescali

The second altarpiece that Matteo di Giovanni painted in the diocese of Grosseto is displayed in the church of S. Niccolò in the town of Montepescali (Fig. 4-4). This shows the Madonna and Child enthroned with Sts. Sebastian, William of Malavalle, Mary Magdalene and Lucy.

According to the records of the chancellor of the curia Francesco Anichini, Montepescali had two parish churches: S. Niccolò and Ss. Stefano e Lorenzo.[34] Parish churches were the only churches where

baptism could be dispensed, and Anichini recorded that in Montepescali they were both under the patronage of the commune (AVG, Anichini 1752, 2:122). Matteo's altarpiece was originally intended for the church of S. Niccolò and it is currently displayed there, but as I will later discuss, the other parish church of the town played an important role in the history of this painting.

On the basis of stylistic analysis, most scholars agree that this altarpiece was produced towards the end of Matteo's artistic career, between the late 1480s and 1495 (Trimpi 1987, 160; Buricchi 1998, 77; Paardekooper 2002, 28). We shall see that the visual evidence, the history of the church, the statutes of the town, and Bossi's records, provide enough circumstantial evidence to suggest that this was a civic commission. The first saint who is depicted on our left is St. Sebastian, the saint traditionally invoked in times of plague. During his visit to the church of S. Niccolò Bossi recorded that an altar had been dedicated to this saint about eighty years earlier by the commune as an ex-voto.[35] This altar was tentatively attributed to Antonio Ghini—the same artist who was responsible for the carving of the altar of the *Madonna delle Grazie* in Grosseto—by the Soprintendenza, and is now displayed in the church of Ss. Stefano e Lorenzo.[36]

Grottanelli (1876, 2:64), was the first to suggest that the patron of this altarpiece was the commune of Montepescali on the basis of the coat of arms painted on its frame, at the sides of the predella. Paardekooper (2002, 28) found compelling evidence for the civic patronage of both painting and altar, by looking at the visual evidence, the statutes of the city of 1427, and the records of the Sienese auditor Bartolomeo Gherardini (1676). Furthermore, Pardekooper showed that the dimensions of the altarpiece are compatible with those of the empty niche of the altar-frame.[37] The first recognizable symbol of civic involvement is represented by the arms of the commune of Montepescali painted at the sides of the predella. The same coat of arms is repeated at the base of the pilasters of the altar-frame that hosted Matteo's painting and now stands, devoid of its sacred image, in the church of Ss. Stefano e Lorenzo (fig. 4-5). The coats of arms underscore the civic patronage of these works, and the records of Bishop Bossi provide further indication of this. In the early 1490s an outbreak of plague obliged the commune to instruct the resident population over welfare issues (Grottanelli 1876, 2:19), and it is likely that the altar dedicated to St. Sebastian was established by the commune on this occasion as a pledge to the saint.

Two female saints take pride of place in the foreground of this altarpiece: Mary Magdalene and Lucy. They both carry the attributes of

their sainthood: the ointment jar for Mary Magdalene, whose dress in gold brocade and red cloak symbolize her weaknesses, later overcome by penitence. St. Lucy holds her eyes on a golden tray with her left hand, and the sword, symbol of her martyrdom, in the other.

St. William of Malavalle is represented here with the crutch in one hand to symbolise his status as a hermit but also to remind the viewer of his victory over the dragon that supposedly lived in the marshes around Castiglione della Pescaia, a town on the coast close to Montepescali. He holds rosary beads in his other hand, and wears metal bands around his ankles as a reminder of his ascetic practices.[38] The representation of St. William and St. Mary Magdalene suggests the strong connections between Montepescali and the Williamite order that originated in the nearby town of Castiglione della Pescaia. This bond seems to be strengthened by the fact that both saints look directly at the viewer.

The commission for the altar of St. Sebastian and the altarpiece painted by Matteo represents a further sign of the control and influence of the local commune in the establishment and development of the religious cult.[39] This was independent from Sienese influence and relied on long-standing local traditions. As far as the cult of St William is concerned, he represents a good example of a saint who was greatly venerated in the Maremma and whose cult was later exported to Siena. Gigli even records William as a "Sienese saint" as late as 1723, and writes that the Augustinians in Siena used to celebrate his feast by displaying his relics on February 20 (Gigli 1723, 1:62). The Great Union of the Williamites with the Augustinians ordered by Pope Alexander IV in 1256 might have contributed to a growth in devotion for the saint beyond the boundaries of the Maremma, when he became a highly venerated figure also in Siena.[40]

It is also important to contextualize the commission for this altarpiece within the ritual celebrations organized by the commune, and the presence of the Williamites in the territory around Montepescali. As shown by Paardekooper (2002, 28), the name of St. Sebastian is engraved in the left pilaster of the altar, and according to Bossi (ASV, Bossi 1576, f. 51v), the right of patronage pertained to the commune.[41] The striking display of the altarpiece and the altar as an ensemble, with the arms of the commune prominently painted and carved, indicates the influence and commitment of the civic government of Montepescali to the religious life of the town. The participation of the commune of Montepescali in the maintenance of the altar of St. Sebastian is also reported by Gherardini, who pointed out the custom of celebrating the saint with a choral mass and a procession.[42] The civic statutes of 1427 dedicate the last rubric to the celebration of the patron saints of these churches, protectors of Montepescali. As in

Grosseto, the annual celebrations entailed processions towards the two churches that ended with the ritual offering of wax candles.[43] In addition to the celebrations and ritual offerings of wax candles to honour the Annunciation and the patron saints of the town, Saints Niccolò and Stefano, ritual offerings were also presented to the church of S. Guglielmo in the town of Castiglione della Pescaia, where the commune of Montepescali offered two wax candles of twelve pounds each year.[44] St. William of Malavalle was a particularly venerated figure in the Maremma as well as being the inspirational figure behind the foundation of the Williamite order, one of the most important eremitic Orders in central Italy. This was approved by a Papal document in 1211, although William was never canonized.[45]

In the Maremma, William held particular significance for the people of Montepescali, and Anichini stated that the church of S. Niccolò was held by Williamite monks.[46] According to Gherardini (1676, 4:231) and Anichini (1752, 2:128), the influence of the order in the area was further emphasized by the presence of a hermitage near Montepescali, and a fourteenth-century document shows that a road named after St. William connected the village with the hermitage and church dedicated to St. Mary Magdalene (Mazzini 1997, 76). Gherardini (1676, 4:231) describes a church and hermitage dedicated to Mary Magdalene as located outside the city walls. Curiously, according to his records, the resident hermit was elected by the commune and it was customary to celebrate twelve masses there each year and have a feast on St. Mary Magdalene's day on 22nd of July.[47] However, by the time of Anichini, in 1752, the hermitage was already abandoned, and by 1760 it was destroyed (AVG, Anichini 1752, 2:128). This event may have corresponded to the progressive disintegration of the Order from the late sixteenth century onwards. Mary Magdalene's connection with the Williamites is suggested by the hagiographic texts that portray her as a model of penitence resorting to the life of a hermit in the last years of her existence.[48] The discipline of the Williamites required total detachment from the secular world in secluded locations so as to enhance repentance, and included ascetic practices such as the use of iron chains, hairshirts and sleeping on the bare earth. A place name of St. Lucy is still mentioned in the maps of the area, although I have not been able to trace a link between this location and the Williamite order.

The churches of S. Niccolò and Ss. Stefano e Lorenzo were partially funded by the income from the land and properties attached to them, and partially with the alms and donations of the population and the commune itself. The Statutes of the city of 1427 confirm that the commune

administered and controlled this income and that the maintenance of the churches was overseen by two *Operai,* who were elected every year by the Priors of the commune.[49] The commune also ensured that the celebrations of the patron saints of the city and titular saints of the two churches were carried out, and that two *doppieri* and eight *falcole* of wax were offered.

This second altarpiece painted by Matteo di Giovanni in the diocese of Grosseto should therefore be viewed in the context of the ritual celebration of patron saints supported by the commune. It also suggests a complex network of relationships between the civic authorities, the local clergy, a prominent religious Order, and the population. This pool of local forces had as an ultimate goal the reinforcement of their identity as part of the community by sharing the veneration of deeply-rooted saintly models. The altarpiece commissioned from Matteo di Giovanni for S. Niccolò also implies that the presence of the Williamites in the area was still an integral component of the community at the end of the fifteenth century, and that St. William acted as the catalyst for local beliefs and values.

The lay and civic patronage of a long-lost altarpiece in the church of S. Leonardo in Ravi: some considerations

The last case that is explored here is purely speculative, as the painting in question has long been lost. This altarpiece, if ever accomplished, was intended for the church of S. Leonardo, in the town of Ravi. The only records that we have about it refer to some payments made to Matteo in 1472 for the completion of an altarpiece begun by another Sienese artist: Sano di Pietro.[50] These are contained in an old article published by Lodovico Zdekauer (1904, 11:140-150), and are based solely on the personal records of a local lord, Cione di Urbano, who noted the commission for this altarpiece in his diary.[51]

Zdekauer hypothesized that the cost of the painting provided by Cione's records implied that the commission was not exclusively due to Cione himself.[52] Further payments are noted on behalf of Sano di Pietro and later Matteo di Giovanni in the following two years. Although in this case documentary evidence and visual analysis cannot provide us with clues about the other party involved in the commission, the statutes of Ravi of 1447 may suggest that the second patron was the commune. Ravi became part of the Sienese *contado* in 1438. The civic statutes written in 1447 show that Cione di Urbano, the local feudal lord, still retained considerable influence and authority in the village. He was involved in the election of the ruling board and conserved significant privileges in the management of the village resources, so that Sienese control appears only

to have been a formal arrangement.[53] This highlights his unique position as a powerful local figure, and suggests that on this occasion he might have sponsored the enterprise of the altarpiece together with the commune of Ravi. As is the case in Grosseto and Montepescali, the statutes of Ravi also regulated the celebration of the patron saints of the village: the Virgin of the Assumption and St. Leonard. On these occasions, two large wax candles of five pounds of wax for the value of 40 *soldi* were offered on behalf of the commune.[54] Gherardini reported that the patronage of the church pertained to the commune, and that there were only two altars there (BCG, Gherardini 1676, 4:298). Later, Anichini recorded the civic patronage in the church (AVG, Anichini 1752, 2:72).

The precise date of construction of the church is unknown as S. Leonardo is not listed in the *Rationes Decimarum* of 1276-1277 and 1303.[55] Sigismondo Tizio, in his *Historiae Senenses*, records that during the Aragonese invasion of the Maremma region in 1447, Cione di Urbano made a vow to the *edicula* of S. Leonardo.[56] As the Statutes of Ravi were written in the same year and they contain a rubric on the election of the *Operaio* for that church, the word *edicula* may refer to the church building, which was probably erected between 1303 and 1447.[57]

Bossi's description and records regarding the churches of Ravi are notably less detailed and therefore inconclusive. Nonetheless, he acknowledges the presence of two altars in the church of S. Leonardo, including the major.[58] The second altar was dedicated to the Annunciation and according to Bossi (ASV, Bossi 1576, ff. 343r-344v) pertained to a consorority. It has been impossible to establish whether the consorority made use of the altar of the Annunciation as an established practice. However, the statutes of the town detail the celebrations of the Virgin and St Leonard, in which the officials of the commune took part. This may provide an indication that the altarpiece commissioned by Cione and the commune, was intended for the main altar.[59]

Conclusion

Matteo di Giovanni left examples of his work in two outstanding altarpieces commissioned by the civic governments of the cities of Grosseto and nearby Montepescali, in southern Tuscany. The altarpieces examined here represent highly venerated saintly figures, whose celebrations were pivotal to the ritual re-affirmation of the power and authority of the local civic governments. Although both works share the same artist and the same typology of patrons, they present also some important differences.

As we have seen in the case of the *Madonna delle Grazie* in Grosseto, the form and composition of this altarpiece stands as a strikingly original representation of the Assumption. The magnified view of the Virgin, centrally placed, is not lifted to heaven with the traditional *mandorla* of seraphim and cherubs, but she is surrounded by six lateral angels unusually and tightly compressed against the central figure. It was likely conceived in this new format so that the population could see the figure of the Virgin better, as the panel went in procession around the city. If Domenico di Bartolo's panel for the church of the Refugio in Siena acted as inspirational model for the altarpiece in Grosseto, the latter shows peculiar compositional elements that may have been suggested by the patrons to fulfil specific devotional and ritual functions. Its dimensions suggest that the altarpiece was used in the ritual celebration of the Assumption enacted by the commune, the clergy and the population on the 15th August each year. As one of the patron saints of the city of Grosseto, the icon of the Virgin embodied both the justification of power held by the civic authorities, as well as her role as protectress and intercessor with the divine in times of hardship.

The large altarpiece commissioned from Matteo di Giovanni for the church of S. Niccolò in Montepescali about a decade later, further enhances the connection between civic power and religious life in local, rural communities. The representation in the altarpiece of the figure of St. William, and other locally renowned saints connected to the Williamite Order, suggests that the Williamites were an important part of the community and a deeply rooted presence in the area. The impact of the Williamites on the life of local communities and the patronage of their churches has seldom been addressed, and would certainly deserve further investigation.

The saints shown in Matteo's altarpiece in Montepescali were part of ritual celebrations that entailed processions to the various churches and the hermitage of the city that culminated with the celebration of sung masses. These rituals were enacted by the commune, the clergy and the population of Montepescali, and continued to take place over the following centuries, as the records of Gherardini and Anichini make clear.

The documentary evidence available for the case of the lost altarpiece commissioned for the church of S. Leonardo in Ravi suggests that this too was commissioned under the aegis of local civic institutions. Although there are no surviving primary source documents referring to these works, the visual analysis of the altarpieces in Grosseto and Montepescali, the statutes of Grosseto, Montepescali and Ravi and the records of Bossi, Gherardini and Anichini, are all elements that support the hypothesis of

significant civic patronage in the area. The commissions that involved Matteo di Giovanni in the Maremma show that they were developed and shaped by the requirements and financial input of the local civic authorities and that they were likely to be part of a larger programme of church decoration that entailed the representation of highly venerated saints. Through these commissions the commune exercised its authority by shaping civic rituals and religious practices enacted by the population.

Notes

[1] An earlier version of this paper was presented at the International Medieval Congress, University of Leeds, 9-12 July 2007. I would like to thank the University of Aberdeen and the AHRC for generously sponsoring my research in the Diocese of Grosseto, Dr. Tom Nichols, Dr. Louise Bourdua and Prof. Andrea Campbell for providing useful feedback, and the editors for their guidance and valuable suggestions.

[2] Matteo di Giovanni di Bartolo (active between 1452 and 1495) was one of the most prominent and prolific artists in fifteenth-century Siena who worked for a variety of religious, civic and lay patrons. For an overview of Matteo's *oeuvre* see: Trimpi (1987); Buricchi (1998); Paardekooper (2002); and the two recent exhibition catalogues, Alessi and Bagnoli eds. (2006); Syson et al. (2007).

[3] Grosseto was finally conquered by Siena in 1336, after a string of rebellions had occurred in 1224, 1259, 1266 and 1334. Montepescali was the first town of the area to pay the *census* to Siena in 1147, but the Aldobrandeschi family remained feudal lords until Montepescali became commune in 1225. It was submitted to Siena in 1300. Ravi signed pacts of allegiance from 1262, but it continued to be controlled by families who exercised feudal rights over the town until this became part of the Sienese *contado* in 1438.

[4] On the institutional relationship of Siena with the cities of the *contado* see Marrara (1961, passim).

[5] This aspect is discussed at length in my PhD thesis. See Cardarelli (2011). Subject communities took part in the celebrations for the Assumption in Siena on 15th August each year. On that occasion, the annual payment of the *census* by means of wax candle offerings sealed the renewal of the pacts of allegiance with the dominant commune. The statutes of Grosseto of 1421 show that the communities in the environs of Grosseto were also due to pay the *census* to that commune on the occasion of the celebrations of St. Lawrence, main patron saint of the city, on 10th of August each year. See *Lo statuto del comune di Grosseto del 1421*, (1: xxxix).

[6] *Lo Statuto del Comune di Grosseto del 1421*; *Statuti di Montepescali del 1427*; *Lo Statuto di Ravi di Maremma del 1447*.

[7] On the patronage of churches in the diocese of Grosseto see Archivio Vescovile di Grosseto (hereafter AVG) Anichini, vols 1-2, 1751-52.

[8] For the civic patronage of cathedrals in Italy see *Opera: Carattere e ruolo delle fabbriche cittadine fino all'inizio dell'Età Moderna* (1996).

[9] The appropriation by Siena of the cult of saintly figures from the *contado* became an integral part of its identity as a state, as is evident in the veneration of St. William of Malavalle, who was acknowledged as Sienese, although evidence shows that he never travelled to Siena and the development of his cult was peculiar to the Maremma.

[10] The saint venerated in the Maremma is known as Guglielmo di Malavalle (1157†), named after the insalubrious area near Castiglione della Pescaia where William lived and where the first monastery of the order was built after his death. See *Bibliotheca Hagiographica Latina* 1900, 2: 1283-88.

[11] Studies on these rituals show that these were by no means limited to Siena and its *contado*, but that it was a phenomenon that was replicated by many communes of central and north-east Italy. See Vauchez (1986, 64-66) and Webb (1996, 95-134).

[12] Archivio Segreto Vaticano, Congreg. Vescovi e Reg., *Visita Apostolica* 60 (hereafter ASV), Bossi 1576; Biblioteca Chelliana, Grosseto (hereafter BCG), Gherardini, vol 4, 1676; AVG, Anichini, vols 1-2, 1751-52.

[13] This hypothesis was agreed by most scholars. See: Gengaro (1934, 150); Carli (1964, 37); Fumi Cambi Gado (1996, 53); Buricchi (1998, 58); Paardekooper (2002, 28).

[14] The arms of the *Opera* and the commune of Grosseto are carved in the spandrels that flank the arch of the altar-frame. The coat of arms of the *Operaio* is carved at the base of each of the two pilasters of the altar-frame.

[15] See Buricchi (1998, 58). The same hypothesis was made more recently by Israëls (2003, 154-156). As I have argued elsewhere, although it has been suggested that the *Madonna delle Grazie* could have been moved to the cathedral of Grosseto at a later date, this hypothesis is untenable. There are strong indications that the altarpiece was in fact commissioned for Grosseto and that it has always been displayed in the altar with the same dedication (Cardarelli 2006, chapter 2; 2009, 187-193). On the hypothesis of different provenance of the *Madonna delle Grazie* see Carli (1964, 37).

[16] BCG, F. Anichini, *Indice generale dei libri e carte esistenti nell'Archivio Comunale di Grosseto* (1750), (hereafter *IGACG*), f. 37r: "Madonna delle Grazie ritoccata da M[agistro] Francesco Pericciuoli pittore, fu fatta fare la Stella d'argento che tiene in petto, e rimutati alcuni pezzi di marmo nella fodera della cappellina perchè l'acqua vi faceva danno. Rincontro dell'Operaio. f. 11, 1644."

[17] On the basis of the remaining buffered arch structure Garzelli (1967, 47), hypothesized that a chapel dedicated to the Assumption might have been part of the original 13th century structure of the cathedral.

[18] In the course of the centuries the altar was moved at least once, from the first bay of the left aisle, to the chapel on the left of the transept. For a detailed history of the movements of the altar and the *Madonna delle Grazie* see Cardarelli (2009, 187-198).

[19] The *Opera* of the cathedral of Grosseto was established between the end of the twelfth and the beginning of the thirteenth century. At least since the fourteenth century the *Opera* was under the jurisdiction of the commune.

[20] *Lo statuto del Comune di Grosseto del 1421*, (I, XVIII; XX).

[21] ASV, Bossi 1576, f. 16r: "Prope portam que est in eadem navi invenit altare Assumptionis Divae Mariae [...] Quod altare licet scripturis non constet ut dixit operarius, esse dotatum per antiquam tamen consuetudinem operarii omnes retinet in eo cappellanum amovibilem, qui missa celebret, et lampadem continuo curet." (Published in Israëls 2003, 219).

[22] *Lo Statuto del Comune di Grosseto del 1421*, (I, XXXIIII): "[...] in solemnitate Assumptionis supradicte gloriosissime Virgini de mense Augusti, fieri faciat quatuor dopleria cere cum staggioli ponderis otto librarum cere pro quolibet, que offerri debeant in mane quando major missa apud maius altare maiori ecclesia celebrantur per dominum Potestatem, Priores et Camerarium et alios offitiales comunis [...]."

[23] ASV, Bossi 1576, f. 15v: "[...] altare Assumptionis Dive Marie lapideum, et ornatum rebus omnibus necessariis preter crucem, et cum icona que est post altare in muro condita cum ornatu marmoreo perpulcra, et magne devotionis, ut etiam apparere videbatur ex tabulis votivis, que muro affixe prope dictum altare pendebant."

[24] Some scholars have argued that the altarpiece was cut down at a certain point in history. See Carli (1964, 38); Mazzolai (1967, 101; 1980, 141); Paardekooper (2002, 28); Israëls (2003, 154). Trimpi (1987, 145-146) expressed a doubtful position. As I have fully discussed elsewhere (Cardarelli 2006, chapter 2; 2009, 190-191; 2011, 147-150), the iconography and the visual examination of the panel show that this is in its original format.

[25] BCG, Anichini, *IGACG*, (1750), f. 37r: "[1558] Madonna delle Grazie portata in processione e spesa di lire 4 in velo per coprirla, Libro dell'Opera, set. A dal 1552 al 1560, f. 130".

[26] A comparison between the *Madonna delle Grazie* and Domenico di Bartolo's *Madonna Orante* was made by Hartlaub (1910, 73). For a recent study of Domenico di Bartolo's panel see Ladis (2001, 169).

[27] The inscription in the halo (ASSUMPTA EST MARIA), her seated position with the hands clasped in prayer, and the white mantle with the pomegranate pattern, were all elements typical of the Assumption according to the tradition passed by the *Golden Legend* (1993 ed. 2:77-97). On the issue of development of the iconography of the Assumption in Siena see Syson (2007, 106-107; 132).

[28] Bossi (1576, ff. 13v; 15v) is the first known source to mention the altar with this dedication, thus acknowledging that the *Madonna delle Grazie* provided the *titulus* of the altar. On altars and their dedication see Durand (1995, 1: iii, 26-27, 31).

[29] Little is known about this artist. The chronology of his works shows that Ghini worked on the monumental fountain in the main square of Asciano, near Siena, in 1472, and on an inlaid marble slab for the cathedral of Lucca in 1475, therefore a year after the completion of the altar in Grosseto. Both commissions involved patronage of the commune.

114 Chapter Four

[30] On the civic celebrations in Siena see Nevola, (2000, 171-184). For a sociological analysis of these rituals in Siena see the study of Bram Kempers, (1994, 89-136).
[31] See above, n. 25. See also Cagnola (1906, 6:109).
[32] Extensive descriptions of the celebrations of patron saints are contained in the statutes of Arezzo (1327), Florence (1325) and Montepulciano (1337). In the Maremma, the town of Campiglia maintained the ritual celebration of local patron saints after the shift of power from the commune of Pisa to that of Florence. See the study of Isidoro Falchi (1880, 201). See also above n. 11.
[33] Unfortunately the only remaining statutes pertaining to the period of dominance of the Aldobrandeschi in the Maremma belongs to the castle of the Triana and Montagutolo, which pertains to the diocese of Sovana, adiacent to that of Grosseto. However, they highlight that as early as the 13th century patron saints were called upon to protect the cities and their population, and they constituted an essential part of the identity of these communities. See the statutes of the castles of Triana and Montagutolo (Piccolomini 1905); (Polidori 1863).
[34] AVG, Anichini 1752, 2:124. These had previously been recorded in the list of the *Rationes Decimarum* of 1275-1276.
[35] ASV, Bossi 1576, f. 51v: "Altare Sancti Sebastiani, a dextris aditus ecclesiae est longum, et latum ut decet, sed eius mensa est inequalis. Iconam habens pulcram et deest crux. Dectum altare, est sub cura et patrocinio Communitatis predicti castri, quae celebrare facit missam singulis diebus Mercurii, quod prestatur a Plebano, cum mercede trium librarum in singulos annos. Curat etiam dicta Communitas celebrari festum Sancti Sebastiani, cum missa adhibito cantu, solutis duobus caroleniis cuilibet sacerdoti, qui eo ad celebrandum convenit, erogat etiam eadem Communitas libras duodecim cere, in usum dicti altaris illuminandum, et predicta omnia dicta Communitas prestitit, iam fere .80. annis citra, quo tempore ex voto dictum altare construxit. [...]"
[36] There is a history of alternating fortunes and because the church of S. Niccolò fell into ruin, part of its internal decoration had to be accommodated in the church of Ss. Stefano e Lorenzo.
[37] The altarpiece measures 276 x 200.5 cm. The altar niche 338 x 220 cm. Both measurements in Paardekooper (2002), Appendix, 15.
[38] On the iconography of St. William of Malavalle see Scaramucci (2001).
[39] On this see Grottanelli (1876, 2:64).
[40] *Dizionario degli Istituti della Perfezione* (1977, 4:1480).
[41] See above, n. 35.
[42] BCG, Gherardini, 1676, 4: 229.
[43] *"Statuti di Montepescali del 1427"*, IXXL.
[44] *"Statuti di Montepescali del 1427"*, IXXL: "Ne la festività dei gloriosi apostoli Jacomo et Filippo, el primo dì di Maggio, a la chiesa di Sancto Guglielmo, ne la corte di Castiglioni, si offeriscano due doppieri di cera del peso di libre dodici."
[45] *Dizionario degli Istituti della Perfezione* (1977, 4: 1479-1481). For a history of the Order see Elm (1962).
[46]AVG, Anichini 1752, II:114: "La Pieve di Monte Pescali, di cui non vi è memoria dell'innalzamento della sua fabbrica [...] riportata da Giovanni Bollando al tomo secondo degli atti de' Santi, come deppendente dai monaci Guglielmiti."

Cf. Bolland (1658, Feb. II: 480), who records: "Fuerunt in eadem provincia sequentes prepositurae [...] Montis Piscalis, cum cura." Also in Elm (1962, 99). The pertinence of the parish church of S. Niccolò to the Williamite monks has been questioned in an article by Ceccarelli-Lemut and Sodi, (1995 [1997], 102: 409-410). However, it should be emphasized that Bossi records an altar of St Sebastian in S. Niccolò, but not in S. Stefano.

[47] BCG, Gherardini 1676, 4:231.

[48] For an hagiography of the saint see *The Golden Legend* (1993 ed. 1:380).

[49] *"Statuto del Comune di Montepescali del 1427"*, (I, XIV).

[50] Two entries refer to "Matteo dipintore". Zdekauer (1904, 11:149) believed that these refers to Matteo di Giovanni: ""A dì 30 di Genaio [1472] uno fiorino largo [...] a Matteo, dipintore, per lo quadro", and later, in July 1473: "ducati cinque larghi per me a Matteo, dipintore, per resto di ducati sei del quadro di nostra donna [...]".

[51] A tentative search for Cione di Urbano's personal book of records in the Archive of the Monte dei Paschi di Siena, where Zdekauer saw it in 1904, did not produce any results. I would like to thank the director of the archive, Dr Florio Bianconi for his help in the search.

[52] Zdekauer (1904, 11:148): "Et al dì 24 [Dicembre 1471] libre 20 per me a Maestro Sano, dipintore, resto di libre 48 per la mia metia de la tavola d'altare per la chicsa di Ravi."

[53] *"Lo statuto di Ravi di Maremma del 1447"*, 324-391.

[54] *"Lo Statuto di Ravi di Maremma del 1447"*, xxviii: "Dell'offerte da farsi per sancta Maria et per sancto Leonardo rubrica. Anco providdero et ordinaro che per la festa della gloriosa vergine Madonna sancta Maria del mese d'agosto et per la festa del beato messer sancto Lonardo ogni anno s'offerisca per lo Comune di Ravi due ceri ad ogni solennità el suo di valuta di soldi quaranta di denari, ^di peso di libre .v. di cera per ciascuno cero^ pena al Camarlengho e Priori che contra facessero soldi .x. per ciascuno et ciascuna volta".

[55] In the *Rationes Decimarum* of 1276-77 (1932, 1:143), the church of S. Andrea is recorded as the only church present in the village. Bishop Bossi (1576, ff. 343r-345v) describes the parish church of S. Leonardo and only briefly refers to the old church of S. Andrea, suggesting that the latter was in decline by then.

[56] Tizio, (ante 1528), 1998, 3:248: "Verum ad divum Leonardum [Cione] conversus et votum emictens (nam in Ravio edicula Leonardo constituta erat)".

[57] See *"Lo Statuto di Ravi di Maremma del 1447"*, xi: "Anco providdero e ordinaro chel Camarlengo e Priori del mese di dicembre ogni anno eleghino due buoni et leali huomini e quali sieno Operai della chiesa del beato misser sancto Leonardo di Ravi [...]".

[58] ASV, Bossi 1576, f. 331v. The present arrangement of the church, with six lateral chapels and four altars is notably different from that described by Bossi, Gherardini and Anichini. This was probably the result of the extensive refurbishment carried out in the 1830s.

[59] *"Lo Statuto di Ravi di Maremma del 1447"*, xxviii.

Bibliography

Alessi Cecilia, and Bagnoli Alessandro eds. 2006. *Matteo di Giovanni: Cronaca di una strage dipinta*, exhibition catalogue. Siena: Ali edizioni.

Anichini, Francesco. 1750. *Indice generale dei libri e carte esistenti nell'Archivio Comunale di Grosseto*, MS, Biblioteca Chelliana, Grosseto.

—. 1751-52. *Storia Ecclesiastica della Città e Diocesi di Grosseto*, 2 vols, MS, Archivio Vescovile, Grosseto.

Anonimo. 1759. *Relazione della Miracolosa Immagine di Maria Santissima detta delle Grazie che si venera nella chiesa cattedrale di Grosseto e della solenne coronazione della medesima seguita il dì VI Maggio MDCCLIX*. Siena: Per Francesco Rossi.

Bibliotheca Hagiographica Latina. 1949. 2 vols. Bruxells: ed. Socii Bollandiani.

Bolland, Jean. 1658. *Acta Sanctorum Mensis Februarii*. 3 vols, Antwerp: apud Iacobum Meursium.

Bossi, Francesco. 1576. Congreg. Vescovi e Reg., *Visita Apostolica 60*, Archivio Segreto Vaticano.

Bowsky, William. 1981. *A Medieval Italian Commune: Siena under the Nine, 1287-1355*. Berkeley: University of California Press.

Buricchi, Susanna. 1998. *Matteo di Giovanni, opere in Toscana*. Città di Castello: Tipolitografia Peruzzi.

Cagnola, Guido. 1906. "Una gita a Grosseto" *Rassegna d'Arte*, 6:109-111.

Cardarelli, Sandra. 2006. *Matteo di Giovanni in Southern Tuscany: New Hypotheses on the Madonna delle Grazie in the Cathedral of Grosseto*. M.Litt. diss. University of Aberdeen.

—. 2009. "Matteo di Giovanni nella Diocesi di Grosseto: Nuove Ipotesi e Spunti di Riflessione" in *Contributi per l'Arte in Maremma. Arte e Storia nella Maremma Antica*, edited by O. Bruschettini, 187-198. Arcidosso: Edizioni Effigi.

—. 2011. *Siena and its Contado: Art, Iconography and Patronage in the Diocese of Grosseto from c. 1380 to c. 1480*. Ph.D. thesis, University of Aberdeen.

Carli, Enzo. 1964. *Arte senese nella maremma grossetana*. Grosseto: Grafiche "La Commerciale".

Ceccarelli, Maria, L. and Stefano Sodi. 1995 (1997). "Storia generale e storia locale. Osservazioni metodologiche su una recente controversia relativa alla storia antica e medievale della diocesi di Roselle-Grosseto", *Bullettino Senese di Storia Patria*, 102:395-410.

de Voragine, Jacobus. 1993. *The Golden Legend.* Translated by W. Granger Ryan, 2 vols, Princeton, NJ: Princeton University Press.

Della Valle, Guglielmo. 1786. *Lettere Sanesi.* 3 vols, Venice: Pasquali.

Durand, William. 1995. *Rationale Divinorum Officiorum,* edited by A. Davril and T. M. Thibodeau. Turnhout: Brepols.

Elm, Kaspar. 1962. *Beitrage zur geschicte des Wilhelmitenorderns.* Köln: Bölhau.

Falchi, Isidoro. 1880. *Intrattenimenti popolari sulla città di Campiglia Marittima.* Prato: Tipografia Aldina Alberghetti.

Frey, Carl. 1892. *Il codice magliabechiano. Contenente notizie sopra l'arte degli antichi e quella de' fiorentini da Cimabue a Michelangelo Buonarroti, scritte da Anonimo Fiorentino.* Berlin: Grote.

Fumi Cambi Gado, Francesca. 1996. "Opere d'arte del secolo XV nella cattedrale di Grosseto". In *La cattedrale di San Lorenzo a Grosseto,* edited by L. Martini and C. Gnoni-Mavarelli, 45-58. Milan: Silvana Editoriale.

Gengaro, Maria L. 1934. "Matteo di Giovanni," *La Diana,* IX:149-185.

Gherardini, Bartolomeo. 1676. *Visita fatta nell'anno 1676 alla città e castella della città di Siena dall'illustrissimo Signor Bartolomeo Gherardini,* 4, MS 185, Biblioteca Chelliana, Grosseto.

Gigli, Girolamo. 1723. *Diario sanese.* 2 vols. Lucca: Venturini.

Grottanelli, Lorenzo. 1873-76. *La Maremma Toscana.* 2 vols. Siena: Gati.

Hartlaub, Gustav. 1910. *Matteo da Siena und seine Zeit,* Strasbourg: Heitz.

Kempers, Bram. 1994. "Icons, Altarpieces and Civic Ritual in Siena Cathedral, 1100-1530". In *City and Spectacle in Medieval Europe,* edited by Barbara A. Hanawalt and Kathryn L. Reyerson, 89-136. Minneapolis and London: University of Minnesota Press.

Kurze, Wilhem. 1982. *Codex Diplomaticum Amiatinum.* 3 vols, Tubingen: Niemeyer.

Israëls, Machtelt. 2003. *Sassetta's Madonna della Neve: An Image of Patronage.* Leiden: Primavera Pers.

Ladis, Andrew. 2001. "The Music of Devotion Image, Voice and the Imagination in a Madonna of Humility by Domenico di Bartolo". In *Visions of Holiness: Art and Devotion in Renaissance Italy,* edited by A. Ladis and S. E. Zuraw. 163-177. Athens: Ga.

Lo Statuto del Comune di Grosseto del 1421. 1995. Edited by Maura Mordini. Grosseto: Biblioteca Comunale Chelliana.

"Lo statuto di Ravi di Maremma (1447)". 1994. Edited by Mario Brogi, *Bullettino Senese di Storia Patria,* IC:324-399.

Marrara, Danilo. 1961. *Storia istituzionale della Maremma senese.* Siena: Meini.

Mazzini, Vanessa. 1997. "Le chiese di Montepescali". In *Montepescali: storia, arte e archeologia*, 53-78, edited by Maria S. Fommei. Grosseto: I Portici.

Mazzolai, Aldo. 1967. *Maremma: Storia e Arte,* Florence: Editoriale Olimpia.

—. 1980. *Storia ed arte della Maremma,* Grosseto: Bonari.

Milanesi, Gaetano. 1854. *Documenti per la storia dell'arte senese,* 3 vols. Siena: Torrini.

Nevola, Fabrizio. 2000. "Cerimoniali per santi a metà quattrocento in Siena". In *Siena e il suo territorio nel Rinascimento,* edited by Mario Ascheri. 3 vols, 171-185. Siena: Edizioni "il Leccio".

Opera: Carattere e ruolo delle fabbriche cittadine fino all'inizio dell'Età Moderna. 1996. Edited by Margaret Haines and Lucio Riccetti, Florence: Leo S. Olschki.

Paardekooper, Ludwin. 2002. "Matteo di Giovanni e la tavola centinata". In *Matteo di Giovanni e la pala d'altare nel senese e nell'aretino: 1450-1500*, edited by Davide Gasparotto and Serena Magnani, 19-48. Montepulciano: Le Balze.

Piccolomini, Paolo, ed. 1905. *Lo statuto del Castello della Triana,* Siena: Lazzeri.

Polidori, Luigi, ed. 1863. *Statuti Senesi scritti in volgare nei secoli XIII e XIV.* Bologna: G. Romagnoli.

Rationes Decimarum Italiae nei secoli XIII e XIV. 1932-42. Ed. Pietro Guidi. 2 vols. Città del Vaticano: Biblioteca Apostolica Vaticana.

Rocca, Giancarlo. 1977. *Dizionario degli Istituti della Perfezione.* Vol. 4, Rome: Edizioni Paoline.

Romagnoli, Ettore. facsimile 1835. *Biografia cronologica de' bellartisti senesi, 1200-1800*, 13 vols, Florence: Edizioni S.P.E.S.

Scaramucci, Sara. 2001. *Iconografia di S. Guglielmo di Malavalle e l'ordine dei Guglielmiti.* Tesi di Laurea, Università di Siena, Facoltà di Lettere e Filosofia.

"Statuti del commune di Montepescali del 1427". 1995. In *Statuti e regolamenti. Statuti del commune di Montepescali*, Pisa: ed. Litografia Felici.

"Statuto del comune di Montagutolo dell'Ardinghesca 1280-1297" in *Statuti Senesi scritti in volgare nei secoli XIII e XIV.* 1863. Edited by Luigi Polidori, 1-66. Bologna: G. Romagnoli.

Syson, Luke, Fabrizio Nevola, Alessandro Angelini and Philippa Jackson. 2007. *Renaissance Siena: Art for a city.* Exhibition catalogue, London: The National Gallery.

Tizio, Sigismondo. ante 1528 (1998 ed.). *Historiae Senenses,* edited by Grazia Tomassi Stussi, Manuela Doni Garfagnini and Petra Pertici. 3 vols. Rome, Istituto Storico Italiano.

Trimpi, Erica S. 1987. *Matteo di Giovanni: Documents and a Critical Catalogue of his Panel Paintings.* Ph.D. thesis, University of Michigan.

Vauchez, André. 1986. "Patronage des Saints et religion civique dans l'Italie communale a la fine du Moyen Age". In *Patronage and Public in the Trecento,* edited by Vincent Moleta, 59-80. Florence: Olschki.

Webb, Diana. 1996. *Patrons and Defenders. The Saints in the Italian City-States.* London and New York: I. B. Tauris Publishers.

Zdekauer, Lodovico. 1904. "Sano di Pietro e Messer Cione di Ravi, Conte di Lattaia (1470-1473)". *Bullettino Senese di Storia Patria,* 11:140-150.

Fig. 4-1. Matteo di Giovanni, *Virgin of the Assumption*, also known as *Madonna delle Grazie*, c. 1470-75, tempera and gold on panel, 98 x 60 cm. Cathedral of S. Lorenzo, Grosseto. Reproduced by permission of the Ministero per i Beni e le Attività Culturali. Photo: Soprintendenza BSAE di Siena e Grosseto.

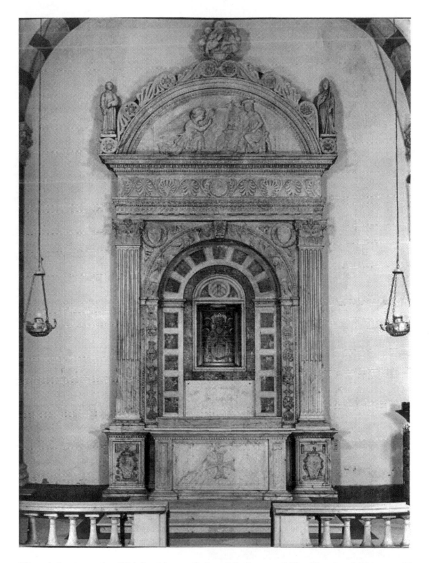

Fig. 4-2. Antonio Ghini, Altar of the *Madonna delle Grazie*, 1474, marble. Cathedral of S. Lorenzo, Grosseto. Reproduced by permission of the Ministero per i Beni e le Attività Culturali. Photo: Soprintendenza BSAE di Siena e Grosseto.

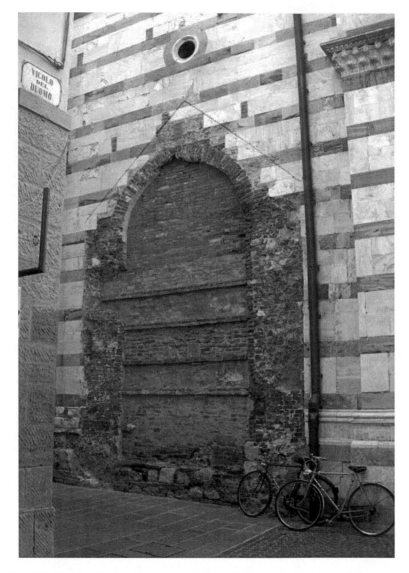

Fig. 4-3. Detail of the northern wall of the cathedral with the traces of the former chapel of the *Madonna delle Grazie*. Photo: author.

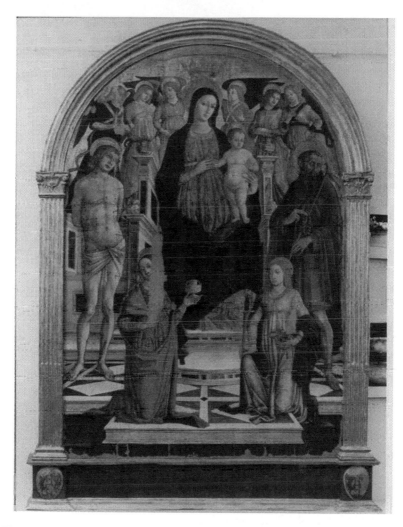

Fig. 4-4. Matteo di Giovanni, *Madonna and Child Enthroned with Saints Sebastian, William of Malavalle, Mary Magdalene, Lucy and Six Angels*, c.1490, tempera on panel. Church of S. Niccolò, Montepescali. The arms of the commune of Montepescali are depicted at the sides of the predella. Reproduced by permission of the Ministero per i Beni e le Attività Culturali. Photo: Soprintendenza BSAE di Siena e Grosseto.

Fig. 4-5. Antonio Ghini? Altar of St Sebastian, church of Ss. Stefano e Lorenzo, Montepescali. Formerly in the church of S. Niccolò. The arms of the commune are carved at the base of the pilasters. Photo by author. Reproduced by permission of the Diocese of Grosseto, Ufficio Beni Culturali Ecclesiastici.

CHAPTER FIVE

THE CATHEDRAL FAÇADE:
PAPAL POLITICS AND RELIGIOUS
PROPAGANDA IN MEDIEVAL ORVIETO

PIPPA SALONIUS

The immense surface areas covered with sculpted narrative reliefs on the lower level of the façade decoration at the cathedral of Orvieto have few comparable models in Italian cathedral design (fig. 5-1). Although comprehensive fields of 'sculpted sermons' were commonly found framing the entrances of the great Gothic cathedrals in France, we find only rare precedents in Italian Romanesque church façade decoration.[1] Precursory Italian models portraying similar subject matter in the same manner as the Orvieto façade reliefs are best exemplified by Wiligelmo's narrative panels now flanking the main portal of the cathedral of Modena, sculpted before 1110 and those on both sides of the west porch of San Zeno Maggiore in Verona, signed by Nicholaus and Guglielmus towards the middle of the same century.[2] Moreover, this innovative use of extensive relief sculpture on Orvieto cathedral's great western front appears to have had little success as a decorative trend on the Italian peninsula. No trace of such lengthy narrative executed in low relief remains in the façade designs of the contemporary Italian cathedral projects of Florence and Siena. This article is a consideration of the façade decoration of the cathedral in Orvieto and is an attempt to demonstrate that its unique nature was a natural consequence of the extraordinary social circumstances in which it was produced.

Orvieto was a place of popes in the second half of the thirteenth century. Urban IV, Gregory X, Martin IV, Nicholas IV and Boniface VIII all held court there (Paravicini Bagliani 1988, 163). The pope and his numerous entourage made what was essentially a modest hill top town of artisans and feudal nobility a magnet for men of wealth and culture (Waley 1985, 14-18). During the second half of the thirteenth century Orvieto

hosted two kings: Edward I, king of England and Charles I, ruler of the Angevin Kingdom of Sicily and Naples. On his journey homewards from the Holy Land, Edward stopped off in Orvieto to visit the new pope Gregory X.[3] One of the foremost matters of discussion between the pope and the future king must have been the murder of Edward's cousin Henry of Almain by Guy de Montfort at Viterbo on 13 March 1271 (Powicke 1950, 2:606). Both men attended Henry of Almain's funeral, held in the church of San Francesco in Orvieto and a large bronze bell was ordered by Edward as a gift for the church to commemorate the occasion (Piccolomini Adami 1883, 147). Charles I was a regular visitor at the papal court in Orvieto where his longest stay was during the residency of Pope Martin IV and lasted from the summer of 1281 until January 1282 (Durrieu 1886-1887, 2:187; Waley 1985, 77). The Angevin king's elder brother, Louis IX of France was canonised by Pope Boniface VIII at the church of San Francesco in August 1297 (Fumi [1884] 1997, 398). The 'red count' Ildebrandino Aldobrandeschi also specified in his will that Orvieto's Franciscan church was to be his final resting place.[4] Aldobrandeschi is defined by Powicke as "the most powerful man in southern Tuscany" (Powicke 1950, 2:608). In addition to the eminent members of the papal court, kings and palatine counts, the city was also home to the mendicant scholars and future saints, Thomas Aquinas and Bonaventure of Bagnoregio. Thomas Aquinas was lector at the Dominican convent in Orvieto for four years beginning in the autumn of 1261 (Walz 1966, 323; Weisheipl 1994, 153, 159; Rubin 1991, 187; Lansing 1998, 165). The Franciscan Minister General Bonaventure of Bagnoregio is known to have given two sermons to the papal curia in Orvieto in December 1262 and an ulterior sermon before the General Consistory in the summer of 1264 (Bonelli 1958, 54).

Orvieto was also the seat of the *Studium curiae* during extended periods of papal occupancy.[5] This was the research institution which accompanied the papal court and functioned as a sort of high level academy for its members and their entourage.[6] Some of the greatest theologians and experts in canon and civil law of the Middle Ages were to teach there (Paravicini Bagliani 1996b, 183). A letter from Pope Nicholas IV at the papal court in Orvieto addressed to a Professor of Civil Law, Conte da Orvieto, provides further evidence of the erudite environment which must have pervaded the city during periods of papal residency. In his missive Nicholas IV informs the academic that the bishops, abbots and other members of the clergy who followed his lessons had papal dispensation to do so.[7] This scholarly encouragement on the part of the

Franciscan pope was in contradiction to an earlier decree issued by Pope Honorius III which forbade all ecclesiastics from studying civil law.[8]

It is clear that in the second half of the thirteenth century – at least while the papal court was present – Orvieto was a centre of culture and learning. The first surviving documents referring to the city's new cathedral project also date to this period, and scholars tend to agree that the more detailed of the two surviving preparatory drawings for the cathedral façade was also executed at the end of the same century (fig. 5-2).[9] The decorative sequences on the pilasters of this drawing indicate that the figurative decoration of the cathedral's great western front was already under consideration at the time it was drawn up.

How then should one read this extensive narrative, for which preparation began in the late thirteenth century, sculpted in low relief over the four pilasters on the lower level of the cathedral façade in Orvieto? The dialogue is bipartite, with the central axis positioned at the main entrance of the cathedral (fig. 5-1). In the tympanum above the central portal sit the Virgin and Christ child enthroned. This is fitting as the cathedral is dedicated to Santa Maria della Stella, mother of God, who together with her son were the two most powerful intercessionary figures that could be invoked in prayer. "Respice stellam, voca Mariam", was the repetitive refrain of a sermon praising the Virgin by the Cistercian reformer Bernard of Clairvaux.[10]

Two trees of swirling acanthus are used to frame circular figurative scenes on the pair of central pilasters flanking the main portal (fig. 5-3). On the external pilasters beside them larger narrative episodes of the Genesis and Last Judgement are separated respectively by ivy and grape vine. The choice of plant types was by no means casual. Ivy is an evergreen and was a recurring medieval motif symbolising eternal life and resurrection. Its function in partitioning the Orvietan Genesis scenes is to contradict the representation of the Fall of Man, offering a note of future hope and promise to the medieval observer (de Vries 2004, 327). The eucharistic grape vine is used on the Last Judgement pilaster in reference to the bloody sacrifice Christ made to save Mankind.[11]

The Tree of Jesse and its counterpart framing the entrance on the cathedral façade at Orvieto recall the peopled acanthus scrolls which were common decorative motifs on public monuments of the Roman Empire during the Flavian period (69 – 96 AD) and the Flavian Renaissance under Emperor Settimius Severus (193 - 211 AD) and his successors.[12] The motif was later included in the Romanesque sculptural repertoire in Pisa and Lucca, where it can be found on the columns flanking the east portal on the Baptistery of Pisa and the central portals of the cathedrals of Pisa

and Lucca. In Siena, patria of Lorenzo Maitani, Giovanni Pisano employed the same motif at the end of the thirteenth century on the columns flanking the central portal on the city cathedral (Seidel 2003, 293).

The classical Roman examples of the motif distinguish themselves from its later Italian versions in the choice of surface area the decoration was applied to. In monumental classical art, acanthus was sculpted in relief onto the flat surfaces of pilasters and its application to the curved surface of columns such as those at the cathedrals of Pisa, Lucca and Siena was almost unheard of (Siedel 2003, 304). Two important classical precedents of the motif in church architecture, which were visible in the Middle Ages and may have determined Lorenzo Maitani's deliberate citation of the classical model in Orvieto, are the pilasters dating to the second century AD now located in the apse of the church of San Giovanni Maggiore in Naples and the five pilasters of Pope John VII's oratory situated on the interior wall of the façade of the old basilica of Saint Peter's in Rome (fig. 5-4).[13]

Other late thirteenth-century examples of the use of peopled acanthus scrolls in decorative programmes besides Giovanni Pisano's sculpted columns for the Sienese cathedral façade, are found in the Roman basilica of Santa Maria Maggiore and in the upper church of the basilica of San Francesco in Assisi (Seidel 2003, 332-334). Both of these churches were favoured by the patronage of the Franciscan Pope Nicholas IV, whose redecorative campaign included the peopled acanthus scroll adorning the triumphant arch at Santa Maria Maggiore (Cooper 2003, 32-33n8; Seidel 2003, 334). This mosaic edition of the motif closely echoed the earlier Assisi paintings of the same subject matter in the Vault of the Saints, located in the third bay of the nave, above the Saint Francis cycle commissioned of Giotto by Nicholas IV, in the upper church of the basilica of San Francesco in Assisi.[14]

It is apparent that the peopled acanthus scroll sculpted under the direction of Lorenzo Maitani on the flat surfaces of the Orvieto cathedral pilasters was a deliberate citation of the classical tradition rather than a continuation of the Romanesque adaptation of the model. Moreover, its choice was likely to have originated as a visual reference to Rome, capital of the western Roman Empire and city of the papacy. Knowledge of the motif was certainly common to both the designers of the apse mosaics commissioned by Nicholas IV for the Roman papal basilica of Santa Maria Maggiore and those responsible for articulating the stories sculpted in relief on the central pilasters on the façade of the cathedral at Orvieto, which the same pope had specified was to be built "…ad instar Sancte Marie maioris de Urbe" (Fumi [1891] 2002, 248).

The narrative reads from left to right across the façade like the open pages of a giant two columned medieval manuscript (fig. 5-3). To the left of the main portal the two pilasters illustrate the Genesis and Stories of Prophets from the Old Testament. The New Testament is presented to the observer on the pilasters to the right of the entrance in Stories from the New Testament and the Last Judgement. Middeldorf Kosegarten suggests that the figure at the base of the Tree of Jesse framework on the New Testament side of the façade is not in fact Jesse but Adam the first man, in which case this second Tree on the cathedral of Orvieto may well represent an Italian development of the Tree of Jesse iconography in the preliminary phase of its metamorphosis into the extremely popular fourteenth century iconography of the *Lignum Vitae* (Middeldorf Kosegarten 1996, 54) (fig. 5-5). This hypothesis linking the iconography of the Tree of Jesse to that of the Tree of Life is further supported by the existence of an early fourteenth century Italian representation of the Lignum Vitae, which is painted in monumental dimensions on the interior wall of the façade at the parochial church of San Giovenale in Orvieto.[15]

If it is indeed Adam represented at the base of the Tree on the south side of the central portal in Orvieto, the iconography was likely to have been inspired by an episode narrated in the *Legenda aurea*. The story tells of Seth, the son of Adam, who in viewing the Tree of Life had a vision of a newborn child amongst its branches. Seth was then given some seeds by a guardian angel and instructed to bury them together with the body of his father at his death. Three trees grew from the body of Adam and eventually centuries later amalgamated to one. This single tree in its turn became timber for the cross erected at Adam's gravesite on Golgotha and was used to crucify Christ (Iacopo da Varazze 1998, 344-345). Seth's vision is a prophesy of the salvation of Man. In Orvieto, it is used as a precursory reference to Man's salvation illustrated in the Last Judgement on the fourth pilaster, which concludes the sculpted relief narration on the lower level of the city cathedral's façade. According to the *Legenda aurea* the acanthus tendrils sprouting above Adam's belly in Orvieto can be identified with the tree of Seth's prophesy.[16] Another Roman precedent for the visual association of acanthus vine with the wood of the holy cross exists in the early twelfth century apse mosaics at the Church of San Clemente (Riccioni 2006, 37, 41-47).[17]

What is curious on the Orvieto cathedral façade is the unusual mirroring of the Tree motif on either side of its main portal (fig. 5-3). Was this double iconographic motif of particular pertinence to the city itself? In order to address this question we must return to the abovementioned climate of erudition predominant in Orvieto during its extended periods of

papal occupancy. The gradual thirteenth century acceptance of all Latin translations of Aristotle's works as appropriate texts for university students meant that by 1260-1270 Aristotelian thought permeated almost every area of university education (Le Goff 2007, 122). All students at the arts faculty of a *Studium generale* "followed a common course, which largely consisted of Aristotle's logic and natural philosophy" (Grant 2005, 16). After completing an arts degree they could then proceed to a graduate degree in theology, law or medicine. It is evident then that all late thirteenth century theologians, lawyers and physicians had a reasonable knowledge of logic and natural philosophy. This implies that any lector at the *Studium curiae* and a great many members of the papal court present in Orvieto necessarily had a solid grounding in natural philosophy.

A key concept, central to Aristotle's natural philosophy, was that of the eternity of the world, which posed a direct threat to the biblical version of God creating it as narrated in the Genesis (Grant 2005, 26). Already in the mid-twelfth century Peter Lombard had warned of the conflict natural philosophy posed to theology concerning the Eucharist at the beginning of Distinction 10 of Book Four of the *Sentences* (Sylla 1975, 361). Approximately one hundred years later the Dominican Thomas Aquinas and the Franciscan Bonaventure of Bagnoregio discussed the question of the eternity of the world in their commentaries on Peter Lombard's *Sentences* at the University of Paris during the early 1250s (Dales 1990, 86). Both of these mendicant scholars and future saints, as previously mentioned, lived and taught in Orvieto while the papal court was there in residence.

It is significant then, that in reading Bonaventure's *Collationes in Hexameron*, a series of lectures held at the University of Paris in summer 1273, one discovers that the Franciscan believed the,

> "Old and New Testaments were related to each other as 'tree to tree; as letter to letter; as seed to seed. And as a tree comes from a tree, a seed from a seed, and a letter from a letter, so one Testament comes from the other Testament'." (Ratzinger 1989, 12)

Middeldorf Kosegarten has already stressed the unusual nature of the parallel trees represented on the pilasters of the Orvieto cathedral façade and suggested that it is best compared to Pacino di Buonaguida's near contemporary wooden panel painting now in the Academia of Florence illustrating the metaphoric parallel of the *Lignum vitae* and the *Lignum crucis*.[18] The art historian suggested in general terms that the parallel use of the tree motif was to be considered as a visual response to Bonaventure's meditations on the life of Christ (Middeldorf Kosegarten

1996, 60-61). This identification of the parallel tree motif with the works of Bonaventure of Bagnoregio is clearly confirmed by the Franciscan's own words cited above.

Bonaventure was receptive to Joachim of Fiore's historical understanding of the Bible in which,

> "the Old and New Testaments appear as two halves of historical time ... and Christ appears as the turning point of time. He is the centre and the turning point of history." (Ratzinger 1989, 105-106) [19]

Evidently, due to its dedication to the Virgin, the Orvieto cathedral façade extends this central position occupied by Christ also to the woman who brought him into the world; to his mother Mary. Bonaventure's historical schema appears to have been well known to those responsible for the iconographic programme of the cathedral façade at Orvieto. Rosalind Brooke's observation that Nicholas IV, who was a generous supporter of the Orvieto cathedral and long term Orvietan resident, "... was (also) a close student of Bonaventure's writings. While he was Minister General he actually added three paragraphs to the Leggenda Major..." supports the theory that the designers responsible for the façade programme at Orvieto may well have been members of his court (Brooke 2006, 442).

The second mendicant scholar Thomas Aquinas, present in Orvieto at the beginning of the 1260s, has been attributed with the authorship of the Roman liturgy of the *Corpus Christi* feast (Rubin 1991, 185; Lansing 1998, 165). The liturgy's extensive use of Aristotelian terminology to articulate the eucharistic statements in support of the Real Presence is considered remarkable (Rubin 1991, 188; Lansing 1998, 165). As conventual lector of the Dominicans in Orvieto, Thomas was a member of a select group of scholars and administrators who advised the pope, and Urban IV is thought to have commissioned the Roman liturgy for the Corpus Christi feast from him towards the end of this period (Walz 1966, 337-339; Rubin 1991, 187; Lansing 1998, 165). Urban IV's patronage is illustrated in one of the enamelled panels decorating the Reliquary of the Corporal kept in the chapel of the Corporal of the Cathedral of Orvieto.[20] The scene shows Thomas Aquinas kneeling at the pope's feet and offering him the liturgy written on a scroll (Rubin 1991, 188; Freni 2000, 125; Harding 2004, 26). It is the last episode narrating the story of the Holy Corporal, in which the Host miraculously transformed to bleeding flesh in the hands of a Bohemian priest in the church of Santa Cristina at Bolsena. The object was immediately brought before Pope Urban IV and his court in Orvieto, where it remained as the city's most precious relic (Harding 2004, 19).

Carol Lansing brings to notice a later sermon written in either Paris or Rome by Thomas Aquinas after leaving Orvieto, in which Eucharistic devotion is associated with the condemnation of heretics (Lansing 1998, 165). If, as tradition would have it, Thomas was commissioned to write the liturgy of Eucharist by Urban IV in Orvieto, could this earlier commission be associated in terms of papal response with the controversy brewing at the *Studium generale* in Paris? The scholastic application of Aristotle's logic and natural philosophy to biblical subjects such as the Eucharist was at the heart of the Parisian academic quarrel and was the object of heated debate provoking accusations of heresy throughout the second half of the thirteenth century (Dales 1994; Grant 2005, 21). Urban IV obviously kept abreast of the debate and finally became personally involved when in Orvieto on 19 January 1263 he confirmed preceding prohibitions of Aristotle's works (Walz 1966, 326; Dales 1990, 110). One of the protagonists accused of heresy in the conflict between the faculties of the Arts and Theology at the University of Paris was the master of Arts, Siger of Brabant. He had been condemned by the Bishop of Paris and was summoned before Simon Duval, the Grand Inquisitor of France in 1277. The scholar fled to Italy, where he was probably appealing to Pope Martin IV at the papal court when he was assassinated in Orvieto in 1282.[21]

The scholastic debate at the *Studium generale* of Paris continued to ferment and around 1290,

"the secular masters of theology tried to extend their right to interpret Scripture and judge the orthodoxy of university teaching and writing to include the interpretation of Martin IV's 1281 privilege for the Franciscans" (Courtenay 1989, 175).

Nicholas IV responded by sending Benedetto Caetani, future Pope Boniface VIII and Orvietan papal resident, as papal legate to Paris (Courtenay 1989, 175-176). The papal legate addressed the French secular masters in tones which brooked no argument:

"You sit in your professorial chairs and think that Christ is ruled by your reasonings...Not so, my brethren, not so! The world is committed to us, and we have to think of what is expedient for the world, not what is expedient or agreeable to you..." (Courtenay 1989, 175-176)[22]

Unrest at the *Studium generale* of Paris persisted until well after Benedetto Caetani's intervention. However this sporadic sequence of affairs illustrating the frequent interaction between the academics in Paris and the papal court residing in Orvieto clearly demonstrates that despite

the enormous distance of approximately 1140 km between the two cities, the scholastic debate was by no means limited to the University of Paris, and must also have been the object of fervent discussion in medieval Orvieto. The individuals responsible for the iconographic programme of the sculpted reliefs on the lower level of cathedral façade in Orvieto were members of this microcosm of intense intellectual life.[23] The biblical episodes etched over the front of the city's cathedral publicly presented its viewers with a carefully integrated consideration not only of the history of Man, but of the history of Man as interpreted by intellectually renowned residents of Orvieto itself.

Notes

[1] Relief sculpture narrating the Genesis and the Last Judgement can be found in the external façade decoration of the French cathedrals of Paris, Auxerre, Amiens and Lyon, amongst others. See Sauerländer (1970, 132-138, 144-145), Williamson (1995, 48-52, 141-142, 160-162) and Reynaud (1996).

[2] The Genesis is illustrated in six relief panels at Modena. See Salvini (1972, 88-119), Frugoni (1984, 440) and Quintavalle (1991, 170-194). The panels of relief sculpture in Verona represent the New Testament on the north side of the door and the Genesis on its south side. See Kain (1981, 373) and Sauerländer (1985, 77).

[3] Tedaldo Visconti and Edward were companions in Acre when news arrived of Visconti's election to the papal seat on 1 September 1271. When Edward arrived in Orvieto on 14 February 1273, he was welcomed with great ceremony by all the cardinals, who then accompanied him before the pope (Powicke 1950, 2:606; Prestwich 1997, 83).

[4] The will, dated 6 May 1284, is published by Gaspero Ciacci (Ciacci 1980, 2:261-266).

[5] For the presence of the *Studium curiae* in Orvieto, see Riccetti (2005, 165-167).

[6] Paravicini Bagliani specifies that the *Studium curiae* should not be thought of as an actual university, as its primary role was not to confer academic degrees, but rather it functioned as a sort of high level academy for members of the papal and cardinals' *familiae* and the functionaries working at the papal court (Paravicini Bagliani 1996a, 140, 143-144; Paravicini Bagliani 1996b, 183).

[7] The letter of Nicholas IV to the professor Conte da Orvieto was written in Orvieto and dated 25 October 1290 (Paravicini Bagliani 1996a, 135-136; Langlois 1886-1893, 544). Conte da Orvieto was not the first professor of civil law to receive papal dispensation to teach to members of the religious community. On 18 October 1285 Pope Honorius IV sent a letter from Santa Sabina to the Professor of Civil Law at Siena, Bindo da Siena, allowing members of the clergy to attend his lectures (Paravicini Bagliani 1996a, 135; Prou 1886-1888, 168).

[8] For a discussion of Honorius III (1216-1227) and the study of civil law see Kuttner (1952).

[9] A document published by Fumi dated 22 June 1284 records an agreement between bishop Francesco of Orvieto and the cathedral canons. It refers to an earlier convention, which indicates that plans for the new cathedral were already being made before this date (Fumi [1891] 2002, 83-84). The two preparatory drawings for the cathedral façade were executed in stylus and brown ink on parchment. The first drawing, known as the 'disegno monocuspidale', measures 101 x 74 centimetres. The second drawing, generally attributed to Lorenzo Maitani and known as the 'disegno tricuspidale' measures 120 x 87 centimetres. Neither of the two drawings, held in the Museo dell'Opera at Orvieto, is dated. For a discussion of their date of execution see Riccetti (2005, 286-289). Two nineteenth century photographic copies of each drawing are also held in the same museum.

[10] The refrain in Bernard of Clairvaux's sermon invoking the image of Mary as the guiding navigational star at a sea in tempest, translates: "Look to the star, call upon Mary" (Gilson 1949, 77-78; Saint Bernard 1953, 927-929; Leclercq 1969, 203-205, Del Bravo 1998, 75n99).

[11] In his work on English eucharistic images Eamon Duffy writes, "The central image of Christ as the mystic vine, shedding his blood to quench our thirst, is derived not only from John 15, but from Isaiah 63, with its vision of a saviour robed in red as Christ was robed in his own blood on the cross, and who declares that 'I have trodden the wine-press alone,' a passage applied in the liturgy of Holy Week directly to Christ's Passion." (Duffy 2005, 252).

[12] From the post Flavian period until the "Flavian Renaissance", peopled acanthus scrolls were no longer employed in monumental art. (Seidel 2003, 304). For a general discussion of the use of classical models in thirteenth-century religious art see Settis (2003).

[13] The semi-pilasters in Rome, which date to the Severian period (193 – 211 AD), were brought to the Basilica of Saint Peters in 706/707, where they were used to decorate the oratory built by Pope John VII (Seidel 2003, 305).

[14] The Vault of the Saints in the upper church of the Basilica of San Francesco in Assisi is generally accepted as the work of a Roman workshop executed between 1285 and 1288. (Seidel 2003, 332-334; Hueck 1967, 18). Bellosi attributes the decoration of the Vault of the Saints to Pope Nicholas IV's "favourite artist" Jacopo Torriti, the painter and probable Franciscan friar, whose workshop was also responsible for the mosaics in the apse of the basilica of Santa Maria Maggiore (Bellosi 1998, 157, 159-161; Tomei 1990, 99-125).

[15] Ferdinando Bologna dates the wall painting of the *Lignum Vitae* in the Church of San Giovenale in Orvieto to as early as c.1300, which suggests that it may predate the execution, but not the planning, of the low reliefs on the four pilasters of the cathedral façade (1310-1330) (Bologna 1969, pl.III-33; Bonelli 2003, 219).

[16] In identifying the *virga Jesse* with the wood of the holy cross Augustine probably laid the grounds which led to the first interpretative model of the *Lignum Vitae* (Manna 2001, 19, 89).

[17] For an extensive discussion of the association of the Tree of Life with the Holy Cross, see Hatfield (1990).

[18] Pacino di Buonaguida's panel of the *Lignum vitae* was commissioned for the Florentine convent of the Poor Clares at Monticelli. Middeldorf Kosegarten dates the panel 1300-1310 (Wood 1996, 179; Middeldorf Kosegarten 1996, 61).

[19] For a discussion of the historic vision of Joachim of Fiore see Da Campagnola (1971, 29-46).

[20] The Reliquary is signed by Ugolino di Vieri of Siena and dated 1338 (Lazzarini 1952, 51; Freni 2000, 119; Harding 2004, 21-24).

[21] Siger of Brabant is placed alongside Saint Thomas Aquinas and Saint Bonaventure in Dante's *Paradiso*. He also appears in a collection of sonnets attributed to Dante, in the poem *Fiore* in which "mastro Sighier" died "a ghiado nella Corte di Roma ad Orbiviedo" (Le Goff 1959, 135; Satolli 1968, 16).

[22] "Seditis in Cathedris et putatis quod vestris racionibus regatur Christus. Nam consciencia plurimorum vestris frivolis racionibus sauciatur. Non sic, fratres mei, non sic! Set quia nobis commissus est mundus, cogitare debemus non quid expediat vobis clericis pro vestro libito, set quid expediat orbi universo…"

[23] For discussions of the cosmopolitan nature of Orvietan society at the time Urban IV and his court were residents there, see Walz (1966) and Weisheipl (1994, 153-170).

References

Bellosi, Luciano. 1998. *Cimabue*. Translated by Alexandra Bonfante-Warren, Frank Daell and Jay Hyams. New York: Abbeville Publishing Group.

Saint Bernard. 1953. *Oeuvres Mystique*. Translated by Albert Béguin. Paris: Éditions du Seuil.

Bologna, Ferdinando. 1969. *I pittori alla corte angioina di Napoli 1266-1414*. Rome: Ugo Bozzi.

Bonelli, Roberto. 1958. "La Chiesa di San Francesco in Orvieto e San Bonaventura." *Doctor Seraphicus* 5: 53-65.

—. 2003. *Il Duomo di Orvieto e l'Architettura Italiana del Duecento Trecento*. 3rd ed. Perugia: Opera del Duomo di Orvieto.

Brooke, Rosalind B. 2006. *The Image of Saint Francis: responses to sainthood in the thirteenth century*. Cambridge: Cambridge University Press.

Ciacci, Gaspero. 1980. *Gli Aldobrandeschi nella storia e nella "Divina Commedia"*. 2 vols. Rome: Multigrafica editrice.

Cooper, Donal. 2003. "Pope Nicholas IV and the Upper Church at Assisi." *Apollo* 157 (492): 31-35.

Courtenay, William J. 1989. "Inquiry and Inquisition: Academic Freedom in Medieval Universities." *Church History* 58 (2): 168-181.

Da Campagnola, Stanislao. 1971. *L'angelo del sesto sigillo e l'"Alter Christus."* Rome: Ed. Laurentianum.

Dales, Richard C. 1990. *Medieval Discussions of the Eternity of the World.* Leiden: Brill.

—, 1994. "Gilbert of Stratton. An Early Oxford Defense of Aquinas's Teaching on the Possibility of a Beginningless World." *Documenti e studi sulla tradizione filosofica medievale* 5: 259-296.

Del Bravo, Carlo. 1998. "Filippino e lo stoicismo." *Artibus et Historiae* 19 (37): 65-75.

de Vries, Ad. 2004. *Elsevier's Dictionary of symbols and imagery.* 2nd ed. Revised and updated by Arthur de Vries. Amsterdam: Elsevier.

Duffy, Aemon. 2005. *The Stripping of the Altars. Traditional Religion in England 1400-1580.* 2nd ed. New Haven and London: Yale University Press.

Durrieu, Paul. 1886-1887. *Les Archives Angevines de Naples: études sur les registres du Roy Charles Ier (1265-1285).* 2 vols. Paris: Thorin.

Freni, Giovanni. 2000. "The reliquary of the Holy Corporal in the cathedral of Orvieto: patronage and politics." In *Art, Politics and Civic Religion in Central Italy 1261-1352: essays by postgraduate students at the Courtauld Institute of Art,* edited by Joanna Cannon and Beth Williamson, 117-177. Aldershot: Ashgate.

Frugoni, Chiara. 1984. "Le lastre veterotestamentarie e il programma della facciata." In *Lanfranco e Wiligelmo: Il Duomo di Modena,* edited by E. Castelnuovo, V. Fumagalli, A. Peroni and S. Settis, 422-451. Modena: Panini.

Fumi, Luigi (1884) 1997. *Codice Diplomatico della Città d'Orvieto. Documenti e regesti dal secolo XI al XV e la Carta del Popolo.* Facsimile of the 1st ed. Orvieto: Marsili.

—, (1891) 2002. *Statuti e Regesti dell'Opera di Santa Maria di Orvieto. Il Duomo di Orvieto e i suoi restauri.* Facsimile of the 1st ed., edited by and with introd. by Lucio Riccetti. Orvieto Perugia: Collezione dell'Opera del Duomo di Orvieto.

Gilson, Étienne. 1949. *Saint Bernard.* Paris: Plon.

Grant, Edward. 2005. "What Was Natural Philosophy in the Late Middle Ages?" *History of Universities* 20 (2): 12-46.

Harding, Catherine. 2004. *Guide to the Cappella del Corporale of Orvieto Cathedral.* Perugia: Quattroemme.

Hatfield, Rab. 1990. "The Tree of Life and the Holy Cross. Franciscan Spirituality in the Trecento and the Quattrocento." In *Christianity and the Renaissance: image and religious imagination in the Quattrocento,* edited by Timothy Verdon, 132-160. Syracuse: Syracuse University Press.

Hueck, Irene. 1967. "Ein Madonnenbild im Dom von Padua: Rom und Byzanz." In *Mitteilungen des Kunsthistorischen Institutes in Florenz*, 13: 1-30.

Iacopo da Varazze. 1998. *Legenda Aurea*, edited by Giovanni Paolo Maggioni, 2 vols. Florence: Sismel Edizioni del Galluzzo.

Kain, Evelyn. 1981. "An analysis of the marble reliefs on the façade of S. Zeno, Verona." *Art Bulletin* 63 (3): 358-374.

Kuttner, Stephan. 1952. "Papst Honorius III. Und das Studium des Zivilrechts." In *Festschrift für Martin Wolff. Beiträge zum Zivilrecht und internationalen Privatrecht*, edited by E. von Caemmerer, W. Hallstein, F.A. Mann and L. Raiser, 79-101. Tübingen: J.C.B. Mohr (Paul Siebeck).

Langlois, Ernest. ed. 1886-1893. *Les Registres de Nicolas IV*, Paris: Thorin.

Lansing, Carol. 1998. *Power and Purity. Cathar Heresy in Medieval Italy*. New York: Oxford University Press.

Lazzarini, Andrea. 1952. *Il miracolo di Bolsena. Testimonianze e documenti dei secoli XIII e XIV*. Rome: Edizioni di Storia e Letteratura.

Leclercq, Jean. 1969. *Recueil d'études sur Saint Bernard et ses écrits*. Rome: Edizioni di Storia e Letteratura.

Le Goff, Jacques. 1959. *Genio del medioevo*. Translated by Cesare Giardini. Milan: Mondadori.

—. 2007. *The Birth of Europe*. Translated by Janet Lloyd. Oxford: Blackwell.

Manna, Jacopo. 2001. "L' "Albero di Jesse" nel Medioevo Italiano un problema di iconografia." Banca Dati "Nuovo Rinascimento." http://www.nuovorinascimento.org/n-rinasc/iconolog/pdf/manna/jesse.pdf

Middeldorf Kosegarten, Antje. 1996. *Die Domfassade in Orvieto Studien zur Architektur und Skulptur 1290-1330*. München Berlin: Deutscher Kunstverlag.

Paravicini Bagliani, Agostino. 1988. "La mobilità della curia romana nel secolo XIII. Riflessi locali." In *Società e Istituzioni dell'Italia Comunale: l'esempio di Perugia (secoli XII-XIV). Deputazione di Storia Patria per l'Umbria* 85 (1): 155-278.

—. 1996a. "La fondazione dello «Studium Curiae»." In *Il pragmatismo degli intellettuali. Origini e primi sviluppi dell'istituzione universitaria*, edited by Roberto Greci, 125-145. Turin: Scriptorium.

—. 1996b. *La Vita Quotidiana alla Corte dei Papi nel Duecento*. Rome: Editori Laterza.

Piccolomini Adami, Tommaso. 1883. *Guida storico-artistica della città di Orvieto.* Siena: Tipografia all'Insegna di San Bernardino.

Powicke, Frederick M. 1950. *King Henry III and the Lord Edward.* 2 vols. Oxford: The Clarendon Press.

Prestwich, Michael. 1997. *Edward I.* New Haven and London: Yale University Press.

Prou, Maurice. ed. 1886-1888. *Les Registres d'Honorius IV,* Paris: Thorin.

Quintavalle, Arturo C. and Arturo Calzona eds. 1991. *Wiligelmo e Matilde. L'officina romanica.* Milan: Electa.

Ratzinger, Joseph. 1989. *The Theology of History in St. Bonaventure.* Translated by Zachary Hayes, 2nd ed. Chicago: Franciscan Herald Press.

Reynaud, J.F. 1996. "Lyon: Cathedral." In *The Dictionary of Art,* edited by Jane Turner, 19: 850-851. London: Macmillan.

Riccetti, Lucio. 2005. "La cultura artistica in Orvieto all'epoca dei papi (1260 – 1310)", "Disegno per la facciata del Duomo di Orvieto (soluzione monocuspidale). Disegno per la facciata del Duomo di Orvieto (soluzione tricuspidale)." In *Arnolfo di Cambio una rinascita nell'Umbria medievale,* edited by Vittoria Garibaldi and Bruno Toscano, 163-171, 286-289. Milan: Silvana Editoriale.

Riccioni, Stefano. 2006. *Il mosaico absidale di S. Clemente a Roma Exemplum della Chiesa Riformata.* Spoleto: Centro Italiano di Studi sull'Alto Medioevo.

Rubin, Miri. 1991. *Corpus Christi. The Eucharist in Late Medieval Culture.* Cambridge: Cambridge University Press.

Salvini, Roberto. 1972. *Il Duomo di Modena.* Modena: Artioli.

Satolli, Alberto. 1968. "Il complesso architettonico di San Giovenale e Sant'Agostino a Orvieto." *Bollettino dell'Istituto Storico Artistico Orvietano* 24: 3-69.

Sauerländer, Willibald. 1970. *Gotische Skulptur in Frankreich 1140-1270.* Munich: Hirmer.

—. 1985. "Nicholaus e l'arte del suo tempo." In *Nicholaus e l'arte del suo tempo,* edited by Angiola Maria Romanini, 1: 53-92. Ferrara: Corbo.

Seidel, Max. 2003. *Italian Art of the Middle Ages and the Renaissance Volume 2: Architecture and Sculpture.* Venice: Marsilio.

Settis, Salvatore. 2003. *"Ostentatio Potentiae, Doctrina Antiquitatis:* l'antico e l'arte «nuova», circa 1230-1260". In *Il senso della memoria. Atti dei convegni lincei* 195: 71-95.

Sylla, Edith D. 1975. "Autonomous and Handmaiden Science: St. Thomas Aquinas and William of Ockham on the Physics of the Eucharist." In

The Cultural Context of Medieval Learning, edited by John E. Murdoch and Edith D. Sylla, 349 391. Dordrecht Boston: Reidel.

Tomei, Alessandro. 1990. *Iacobus Torriti Pictor: Una vicenda figurativa del tardo Duecento romano*. Rome: Argos.

Waley, Daniel. 1985. *Orvieto Medievale*. Rome: Multigrafica Editrice.

Walz, Angelo. 1966. "La presenza di San Tommaso a Orvieto e l'ufficiatura del Corpus Domini". In *Studi eucaristici: atti della settimana internazionale di alti studi teologici e storici, Orvieto, 21-26 settembre 1964*. 321-355. Orvieto: Comitato esecutivo centrale.

Weisheipl, James A. 1994. *Tommaso D'Aquino. Vita, pensiero, opere*, edited by Inos Biffi and Costante Marabelli, translated by Adria Pedrazzi. 2nd ed. Milan: Jaca Book.

Williamson, Paul. 1995. *Gothic Sculpture 1140-1300*. New Haven: Yale University Press.

Wood, Jeraldine. 1996. *Women, Art and Spirituality. The Poor Clares of Early Modern Italy*. Cambridge: Cambridge University Press.

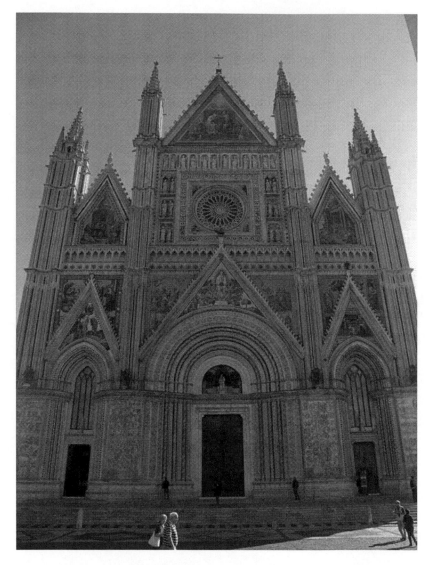

Fig. 5-1. Orvieto Cathedral Façade. Photo: author.

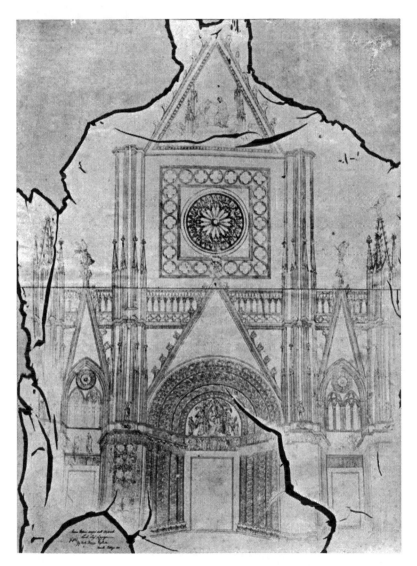

Fig. 5-2. Preparatory drawing *"disegno monocuspidale,"* stylus and brown ink on parchment, c.1290 (19th century photographic copy), 101 x 74 cm. Orvieto, Museo dell'Opera del Duomo. Photo: reproduced by permission from the Museo dell'Opera del Duomo, Orvieto.

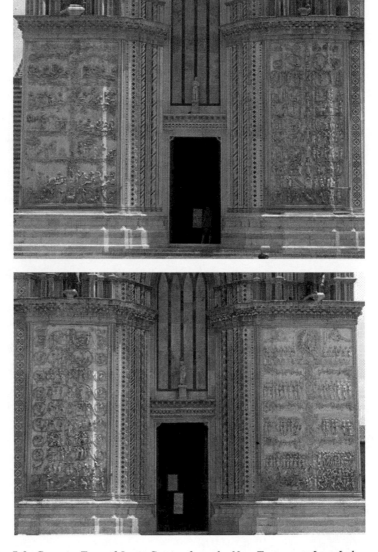

Fig. 5-3. *Genesis, Tree of Jesse, Stories from the New Testament, Last Judgement,* sculpted reliefs on façade pilasters, 1310-1330. Orvieto, Orvieto Cathedral. Photos: author.

Fig. 5-4. *King David,* detail of *Tree of Jesse,* sculpted reliefs on façade pilaster, 1310-1330. Orvieto, Orvieto Cathedral. Photo: author.

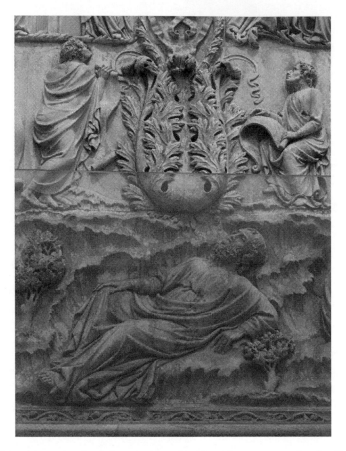

Fig. 5-5. *Adam,* detail of *Stories from the New Testament,* sculpted reliefs on façade pilaster, 1310-1330. Orvieto, Orvieto Cathedral. Photo: author.

CHAPTER SIX

POLITICAL TAPESTRIES OF PHILIP THE BOLD AND JOHN THE FEARLESS, DUKES OF BURGUNDY

KATHERINE ANNE WILSON

A highly prized luxury object of the later Middle Ages, tapestry is often described as possessing the ability to frame the ambition, achievement and power of its owner (Delmarcel 1999, Campbell 2002).[1] Tapestry was a key acquisition for the majority of late medieval rulers, a fact attested to by their accounts of daily expenditure, inventories and a few surviving pieces.[2] An examination of the daily accounts and inventories of several of the Valois dynasty, including Charles V (1338-1380), the dukes of Anjou (1339-1384), Berry (1340-1416) and Burgundy (1342-1404), reveals these individuals had amassed hundreds of tapestries during their lifetimes. Visual programmes tended to depict chivalric, classical and religious themes and corresponding subjects were often found in the collections of several Valois princes.[3] Among their tapestries, a handful which depict contemporary events stand out. Subjects including the Jousts of St Denis (1389), and those held at St Inglevert (1390) are recorded in the inventory taken at the death of Charles VI in 1422, and tapestries depicting the Battle of the Thirty (1351) and the exploits of the French military commander and constable of France, Bertrand du Guesclin were owned by the dukes of Burgundy, Berry and the French king. Less numerous than the tapestries which represent classical or religious themes, they have regularly been described as depicting "propagandist subject matter" or functioning as "political" and "portable propaganda" imposing the ambitions, accomplishments and policies of their owners upon their viewers (Campbell 2002, Chipps-Smith 1989, 29 and Belozerskaya 2005 95).[4] While it is agreed that tapestries depicting contemporary events were of considerable importance to their owners through the subjects they depicted and the uses to which they could be put, an in-depth study of

tapestries depicting contemporary political events remains an area for further exploration.

In a preliminary attempt to address these issues, three tapestries commissioned by Philip the Bold and John the Fearless will be the focus of this article, selected because they stand out from other hangings of the later Middle Ages which depicted contemporary events. Firstly, the tapestries reflected events in which their purchasers had directly been involved, and secondly, all three textiles were commissioned within five years of the event having taken place. The first tapestry, described as a *tapis de hautelice* in the ducal accounts, was ordered by Philip the Bold (1363-1404) in 1384, completed in 1386, and depicted the Battle of Roosebeke fought in 1382. The second *tapis de hautelice*, was paid for in 1411 by the son of Philip the Bold, John the Fearless (1404-1419) and represented the battle of Liège in 1408. The third *tapisserie* depicted the union of the church, and was completed in January 1419, only a few months before the murder of John the Fearless. Although these hangings do not survive, it is possible to reconstruct the political circumstances surrounding their commissioning and, from this, the possible motives for their purchase. Analysis of two categories of source can shed further light on their function and possible reception: Burgundian ducal accounts of daily expenditure and contemporary narratives which recorded their use.[5]

Function and reception of political tapestries

An essential framework for analysis of the function and reception of these tapestries is provided by recent scholarship on propaganda in general, and on Burgundian ceremonial in particular. To describe contemporary political tapestries as depicting "propagandist subject matter" or functioning as "portable propaganda" should not imply that they conveyed a central message: the legitimation or imposition of Burgundian political authority upon their viewers. Bernard Taithe has convincingly made a case for the concept of "thick" propaganda, which can be "multi-layered", and emanate from several individuals or sources, in several directions and be comprehended in different ways (Taithe 1999, 15). The concept that propaganda can be "multi layered", in its production, but particularly in its reception, is a sentiment strongly echoed in recent work on the entry ceremonies heralding the arrival of the Burgundian dukes into the towns of the Burgundian Netherlands: it has made use of the idea of "multiple meanings" and to the ambiguity of the messages communicated through these ceremonies (Arnade 1996, Lecuppre-Desjardin 2004, Brown and Small 2007, 32). This work has made clear

that Burgundian subjects were not simply passive receptors for "messages" of ducal authority (Brown and Small 2007, 26). As a result, how far ducal ceremonies actually promoted ducal authority and power has come under increased scrutiny and has prompted provocative questions about what was communicated in these ceremonies, or if the meaning of the ceremony as envisaged by their creators was fully comprehended by the audiences present (Brown and Small 2007, 26, 28, 32, 34). In their evaluation of differing contemporary interpretations of the symbolism of Philip the Good's entry into Ghent in 1458, Andrew Brown and Graeme Small are led to the conclusion that,

> "...the marvellous wealth of the city was perhaps the only message that the civic authorities could hope would make a lasting impact on the duke and his entourage" (Brown and Small 2007, 34).

Acknowledging that contemporary tapestries purchased by Philip the Bold and John the Fearless could be "multi-layered" and ambiguous in their meaning, rather than projecting a straightforward image of ducal power and authority, creates fresh ways of thinking about the functions and reception of our textiles. Considering the political context in which these tapestries were commissioned reveals that Burgundian political tapestries could provide both a space for reflection on political rule and on the ambiguity or uncertainty of political outcomes for both ruler and subject. What follows will examine each tapestry in turn, first considering the events, then the tapestry and its possible reception.

With good reason both Philip the Bold and John the Fearless are presented as men who were simultaneously concerned with increasing their power in the French kingdom and for their own Burgundian territories (Vaughan 2002, Schnerb 2005). Indeed, the battles of Roosebeke and Liège, depicted on two of the tapestries, marked important steps in, "the subjection of the Low Countries to Burgundian influence and control; each was a capital event in the military annals of Burgundy" (Vaughan 2002, 49). The tapestries of these events are then explained as manifestations of ducal desire for increased Burgundian political authority and independence, acquired and used as a means to these political ends (Jeffrey Chipps-Smith 1989, 125). However, this outcome is by no means clear from the evidence of their function and reception.[6]

The tapestry of the Battle of Roosebeke

For Philip the Bold, the battle of Roosebeke was an event where he was able to establish his power as an independent agent (Vaughan 2002, 25). His father in law, Louis of Male, had been struggling in a conflict with the town of Ghent for three years and it had become apparent that neither party could achieve victory without some outside help (Vaughan 2002, 24). In control of the French government and of King Charles VI, Richard Vaughan suggests that Philip the Bold possibly envisaged an intervention in this situation as a means to enhance his power in Flanders, in light of the fact that he was the heir of Louis of Male (Vaughan 2002, 24). When the battle of Roosebeke finally took place in November 1382, it included 1,500 men-at-arms from the Burgundian duke and the presence of Charles VI and the dukes of Bourbon and Berry, proving a commanding victory on the day for the French (Vaughan 2002, 26). Contemporary narratives were unsurprisingly eager to reinforce the glory of the achievement. Froissart notes that "the battle lasted only an hour-and-a-half from the time it was joined till the time it was won", representing a victory, "greatly to the honour and advantage of all Christendom" (Froissart 1978, 249, 250). That the battle and the outcome were of personal and political importance to Philip the Bold is clear, given the fact that Michael Bernard of Arras was paid the substantial amount of 3,600 gold francs for one *tapis de hautelice* for *l'istoire de la bataille de Roosebeke* measuring 56 ells long and 7 ells high, (approximately 5 metres high and 9 metres long) (ADCO, BO475, f° 64).[7]

Unfortunately as the tapestry no longer exists and the ducal account gives no detail on the imagery of the hanging, we can only speculate how the subject matter may have captured the success of the French army, perhaps alluding in its imagery to the claims made by chroniclers that when the French oriflamme was unfurled, the dense fog that surrounded the French army dispersed (Froissart 1978, 247). However, although the tapestry may well have been commissioned to emphasise ducal success, independent action and authority over Flanders, the textile may have also reflected the uncertainly and ambiguity of political outcomes. Here, the suggestion that Burgundian ceremonies, "'tell' of the state but do not construct it", is significant when considering our political tapestries (Brown and Small 2007, 32, translated from Lecuppre-Desjardin 2004 151, 231, 324, 302, 327). A tapestry which depicted a recent political event could claim independent action and Burgundian authority, but it does not always follow that it conveyed or fulfilled these objectives (Brown and Small, 2007, 32). In the four years that had elapsed from the

commissioning of the tapestry to its delivery, Philip had succeeded Louis of Male as Count of Flanders in 1384 and negotiated peace with the city of Ghent at Tournai in 1385 (Vaughan, 2002, 37). Although Richard Vaughan describes the battle as a "turning point" in the war against Ghent, the political aftermath was far more ambiguous (Vaughan 2002, 27). The battle took place close to winter and inclement weather ensured that there was no further campaign against Ghent (Vaughan 2002, 26). As a result, when negotiations took place at Courtrai, "the deputies of Ghent could well afford to be defiant" (Vaughan 2002, 26). They refused to buy the conditional pardon on offer for 300,000 francs as they knew that there was no way that a siege of Ghent would be attempted during the winter (Vaughan 2002, 26). No doubt, in the tapestry of the Battle of Roosebeke, ducal success, independent action and authority were reinforced within the imagery. The historical reality that the aftermath of the battle had been far less decisive than the battle itself, could have been turned to ducal advantage or simply removed from the visual narrative depicted on the tapestry.

Whatever the precise imagery depicted, it is clear that the use of the tapestry was at times contentious and problematic. When Philip the Bold met the duke of Lancaster at Calais in 1393 during peace negotiations between the English and French we are told that he exhibited the tapestry of the battle (Campbell 2002, 16). However, the duke of Lancaster apparently was unhappy with continuing discussions with the duke, because of the subject of the tapestry and requested that it be replaced with other hangings (Campbell 2002, 16). Moreover, the vast size of the tapestry appears to have affected its functionality, with implications for the coherence of its visual programme. In 1402 we find a further reference to the tapestry in the ducal accounts, where a payment was made to Colart d' Auxy *tapissier*, for dividing the hanging into three pieces (ADCO B1532, f°307, 308).

The tapestry of the battle of Liège

Just as the battle of Roosebeke had important political consequences for Philip the Bold in his future role as count of Flanders, the battle of Lèige in 1408 could be counted as another pivotal moment for the Burgundian dukes. Liège in the later Middle Ages was an imperial prince-bishopric with extensive territories (Vaughan 2002, 49).[8] The prince-bishop had been increasingly forced to share power with the clergy, nobles and the towns of the region leading to frequent power struggles. When the brother-in-law to John the Fearless, John of Bavaria, succeeded as prince-

bishop in 1390, he frequently tried to reassert his power which ended in revolts against him in 1394 and 1402 (Vaughan 2002, 50). By entering into battle with his brother-in-law against Liège, John the Fearless could potentially benefit in a number of ways. Firstly, this battle could help to consolidate his power against the house of Orléans (John having ordered the murder of the duke of Orléans in 1407) as this faction had openly supported the revolts against John of Bavaria. Secondly, it could send a decisive message of Burgundian authority to the Flemish weavers within the towns of Ghent, Bruges and Ypres who were on the edge of rebellion (Schnerb 2005, 258).

The clash between an ambiguous political reality and the desire of the dukes to emphasise independent action and political authority appear to have been key themes in the tapestry of the Battle of Liège, ordered by John the Fearless in 1410 (ADCO B1560, f°169). Rifflart Flaymal, *tapissier,* was paid for the commission of 5 *draps ou tapis de hautelice* depicting the "story of the travels that my said lord made into the land of Liège" (ADCO B1560, f°169). Fortunately, there is a detailed description of the tapestry in the ducal account dating from 1411, which provides a useful comparison with John the Fearless's own narrative of the battle written in a letter to his brother in 1408, only two days after combat had taken place (Vaughan 2002, 60-62). Each *drap ou tapis de hautelice* was to be 16 ells long and 7 ells high. All measures were in the ell of Arras and every tapestry was therefore around 11 metres by 5, in total 55m² (ADCO B1560, f°169). The ducal account also records the meticulous care taken to depict the individual figures of the lords within the weavings (ADCO B1560, f°169). The first *tapis* was described as depicting, "the entry of my said lord and lord of Hainault into the said land of Liège" (ADCO B1560, f°169), almost mirroring John's own recollections that "my brother-in-law of Hainault, and I entered the county of Liège last Thursday [20 September] with a numerous and excellent company of knights and squires" (Vaughan, 2002, 60). The visual programme of the second tapestry in the ducal accounts again closely corresponds to the ducal narrative. The account notes that the second tapestry represented the siege, "that the Lèigois had made before the town of Maastricht and the raising of the siege" (ADCO B1560, f°169), while John the Fearless wrote in his letter that,

> "we received information from certain persons that on the very day the lord of Peruwez and all the Liègois in his company had raised the siege which they had laid to Maastricht in order to come and confront us" (Vaughan 2002, 60).

The third tapestry was to depict the scene of battle, the account recording that the images portrayed exactly the point "when the Liègois came running upon and fought my said lord and my lord of Hainault and the manner by which they were chased away" (ADCO B1560, f°169). In his letter to his brother, John recalls that the battle lasted only a short time, how "in handsome and excellent order, joining battle with them and attacking them in such a way that, with the grace and help of Our Lord, the day was ours" (Vaughan 2002, 61). He further recounts that when the battle had almost come to its conclusion, a contingent of men from the town of Tongres tried to help those from Liège, but when confronted with the fact that the Liègois were losing, "turned in flight and were forthwith closely pursued by the mounted men on our side, and many of them killed" (Vaughan 2002, 61). Possibly to reinforce the significance of the battle, the third tapestry was larger than the others in the series, measuring 85m² in contrast to the others at 55m². As a viewer, one would immediately be drawn to the central scene of the battle due to its difference in form from the others.

The last two tapestries appear to depict and deal with the consequences of challenging ducal authority. The fourth tapestry portrayed the scenes of submission of the towns of Liège, Tongres, Huy, Dinant and "other towns of the said land", asking for pardon, which took place on the day after the battle as well as the surrender of those responsible for the rebellion to the duke of Burgundy (ADCO B1560, f°169). In the words of John the Fearless,

"beseeching the said brother-in-law of Liège to have pity on them and pardon them. This he did...provided that they surrendered and handed over to him all the guilty persons...to do as he pleased with." (Vaughan 2002, 60)

The final hanging reproduced the repentance of the key figures involved, and the revoking of the privileges of the towns following the sentence pronounced on Liège by John and William on the 24th of October 1408 (ADCO B1560, f°169). The conclusion to John's letter, which was written before the sentence stresses,

"All this [the pardons and sentence] has been arranged by my brother-in-law of Hainault and me, and to ensure that our decisions are obeyed, each town will give us whatever security we want." (Vaughan 2002, 60)

While the images on the tapestries, as recorded by the ducal account, may imply rather fixed representations of ducal authority and control, the

political reality faced by John the Fearless when the tapestries were commissioned in 1411 was by no means as secure as the visual programme suggested by his *tapis de hautelice*. The tapestries were commissioned at a time when strong opposition was beginning to rear its head against the duke in his struggle for the crown of France. The league of Gien had been formed in April 1410, which had declared its open hostility to John the Fearless and the intention of rescuing the king and dauphin (from Burgundian control) and restoring them to power. Composed of the dukes of Berry, Brittany and Orléans and the counts of Alençon, Clermont and Armagnac the league of Gien was not an insignificant political opposition (Vaughan 2002, 82). The tapestries of the battle of Liège, with two hangings devoted to the outcome of the battle, clearly in one sense depicted the consequences of challenging ducal authority, not only for rebellious towns under their rule, but also for those who sought to undermine the authority of John the Fearless in his struggle for the crown of France. Yet, these tapestries could also reflect political uncertainty. Members of the ducal entourage and visitors to the court would have been well aware of the political conflict between the Burgundian and Armagnac parties, which was to eventually culminate in the murder of John the Fearless in 1419. The tapestries of the battle of Liège, while intended to represent an ideal past, would surely have also been considered in light of any current political situation.

Taking into account the fact that political tapestries could reflect the ambiguity of political outcomes or even be misinterpreted, there is little doubt that purchases such as the battle of Roosebeke and Liège textiles provided their ducal owners with several distinct advantages. The form and materials of the hanging were important components of the way in which the textiles framed the dukes and contributed to their perception of magnificence in the eyes of visitors to the court. The *draps de hautelice* and *tapisserie* of the battle of Roosebeke and Liège were manufactured from the finest methods of weaving, gold and silver threads were integral to their form. What is more, all three of these textiles depicted subjects exclusive to the dukes of Burgundy. Unlike many other weavings of their time they were not reproduced for several customers.[9] As the subjects were of a unique nature they served to distinguish the duke from the rest of the court. Perhaps the best example of how battle tapestries could be used comes from a miniature of the manuscript the *Très Riches Heures* by the Limbourg brothers.[10] The miniature depicts the duke of Berry (1340-1416) feasting, surrounded by his gold and silverware, framed by a textile canopy, the room enclosed by a tapestry depicting a battle scene (Campbell 2002, 17). Even if the images or the text on the tapestry was not

readily understood by viewers, the exclusive nature of the commission and the ability of the textile to distinguish the duke was instantly recognisable by contemporaries, often reflected by the detailed description of the weave, threads and images both in the ducal accounts and in written descriptions of the Burgundian court. When Leo of Rozmital, a visitor to the court of Burgundy during the rule of Philip the Good (1419-1467) entered his great hall for the first time, his attention was immediately drawn to the person of Philip the Good because he was framed by a, "throne which was hung with cloth of gold woven with great splendour, as befitted the ducal hall" (Letts 1957, 35-36).[11]

As with the tapestry of the battle of Roosebeke there are few references to the use of the tapestries depicting the battle of Liège, most come from the later rules of the Burgundian dukes Philip the Good and Charles the Bold. We know that they were displayed during the wedding of Charles the Bold in 1468 in a room adjacent to the space where the feasts were to take place, thanks to a number of contemporary accounts. Jean de Haynin is the most detailed in his account of the tapestries, recalling that the Liège tapestry was displayed,

"In the hall where the sideboard was situated were hung the tapestries of the great battle of Liège, where duke John of Burgundy and duke William of Bavaria, count of Hainault defeated the Liegois near Othée in the year 1408..." (Brown and Small 2007, 65)

Interestingly, it is the written accounts of this wedding which perhaps best illustrates that not all contemporary viewers viewed or recalled the images in a similar manner. Describing the tapestries hung in the main feasting hall, Olivier de la Marche refers to "tapestries and hangings showing the stories of Jason, by which the beginnings of the mystery of the Golden Fleece could be understood" (Brown and Small 2007, 65). Andrew Brown and Graeme Small note that Jean de Haynin and Anthonis de Roover contradict Olivier de la Marche in his recollection, writing that the main tapestry depicted the story of Gideon and the Fleece.

It was not only recent battles, but contemporary political events that on occasion attracted specialized tapestry commissions by the duke. One in particular has been overlooked. Ordered eight months before the murder of John the Fearless in 1419, Jehanne le Gaye widow of the late Guy de Ternois was paid 4000 francs 'money royal' for the sale and deliverance of, "three pieces of tapestry 210 ells squared [with] images of archbishops, bishops and kings...of the union of the church" (Laborde 1849, 175). It was similar to the hangings of Roosebeke and Liège in that it was commissioned a few years after the end of the schism of the church. The

papal schism which had existed since the election of Urban VI in 1378, when fifteen electing cardinals had declared the election invalid claiming it had been made under fear of violence (Vaughan 2002, 210). These same cardinals had elected an alternative pope, Clement VII and the resulting confusion of allegiance and obvious diplomatic problems caused by the situation lasted until 1417 when Martin V was finally elected at the Council of Constance. Involved in the issue from the 1380s, Philip the Bold had undertaken a lengthy diplomatic trips armed with a variety of gifts, which included tapestry, no doubt in part to help pave the way for the success of the French position on the matter (Schnerb 2005, 603, ADCO B1503, f°150).[12] The resolution of the schism at the Council of Constance was of some personal importance for John the Fearless, tied as it was to the continuing political consequences of his murder of the duke of Orléans.

In fact due to the escalating Burgundian-Armagnac conflict, the Council of Constance in 1415 was concerned with more than simply the question of who should be pope. Work at the council had been frequently interrupted by the Burgundian-Armagnac dispute over the doctrines of Jean Petit. These doctrines were part of the calculated attempt by the Burgundian party to defend the murder of the duke of Orléans. The reputation of John the Fearless was undoubtedly interlinked with the reception of these documents, particularly as at this point he was effectively banished from France and any political influence (Vaughan 2002, 210, Schnerb 2005, 608). The Council of Constance therefore became a stage for the cause of John the Fearless. His ambassadors, the Bishop of Arras, Martin Porée and his councillors were tireless in their efforts towards the Burgundian cause armed as they were by the duke with plate, jewels, books and wine, which were undoubtedly to bribe the prelates of the council (Vaughan 2002, 211, Schnerb 2005, 610). In the end, their efforts were not unrewarded, the doctrines were not condemned and the reputation of the duke was upheld. Reflecting a pivotal point in the rule of John the Fearless, this tapestry was more than "propaganda" of his success of this occasion. It may well have also been commissioned to record what the duke saw as a turning point in his personal fortunes, a step on the road to future success and a reflection of his undoubted ambition to return to power in France. We can be far less certain of how it might have been viewed by contemporaries as there are no records of its use, unsurprising given the fact that John was murdered in 1419. If the tapestry had ever been displayed alongside the duke, would the hanging have reminded contemporaries the diplomatic success of the duke and his continuing influence in the face of current unfavourable circumstances? Or

did it at the same time convey a reminder of escalating Burgundian-Armagnac conflict?

The political tapestries examined in this article were undoubtedly commissioned by the dukes to reflect ducal authority and independent action. As textiles exclusive to Philip the Bold and John the Fearless they could frame the dukes and act as markers of ducal magnificence. Tapestry was *the* material of the age on which to trust such important events. Yet, these hangings did not necessarily always convey Burgundian authority or independence. Political tapestries held and communicated no single message. Depending on the political circumstances and spaces in which they were used, tapestries that portrayed political subjects could provide a place for the viewer to reflect on the ambiguity of ducal rule and action, just not necessarily in the manner that the Burgundian dukes had intended when commissioning their textiles.

Notes

[1] Tapestry and its political uses have been considered by Wolfgang Brassart in his work titled "Tapisserien und Politik" (Berlin, 1992). It has also been discussed more generally within the literature, see Delmarcel (1999) and Campbell (2002, 2007). I would like to thank the AHRC for the funding which made my research possible during my doctoral thesis and to Tom Pickles for his comments.

[2] Several inventories and accounts of late medieval rulers have been published. See Labarte (1879), Moranvillé (1889), Guiffrey (1887) and Prost (1902).

[3] Sophie Jugie has proposed that the accumulation of tapestry by Philip the Bold and his brothers, Charles V, Louis of Anjou and John of Berry reflected competition between these individuals. In her opinion the purchase of the Apocalypse tapestry by Philip the Bold (1386-1394) was primarily due to the previous purchase of a tapestry depicting the same subject by the duke of Anjou (1373-1380) (Jugie 2004, 42).

[4] When the duke helped crown Louis XI the new French king in 1461, Jeffrey Chipps-Smith considers that Philip the Good used his Gideon tapestries to such effect (ordering that his hotel d'Artois be decorated by the tapestries) making the point that the political power of Burgundy now outranked that of the kingdom of France (Chipps-Smith 1989, 125).

[5] The Burgundian ducal accounts and inventories taken on the death of a ruler provide a rich body of information to be exploited for the material culture of the Burgundian court. For Philip the Bold and John the Fearless evidence exists for the expenditure made for almost every year of their rule in the *recette générale toutes les finances*. Hundreds of payments exist for Philip the Bold and John the Fearless on the subject of repairing, transport and purpose of tapestry as well as payments made to individuals who were connected with the tapestry trade through their

professional categories. This evidence is complemented by further references to the textile in the inventories taken in 1404 on the death of Philip the Bold, in 1405 on the death of his wife Marguerite of Flanders and in 1419 on the violent death of John the Fearless. The references from the *Archives départementales de la Côte-d'Or* Dijon will be hereafter abbreviated to ADCO.

[6] As a prince of France and uncle to the Charles VI of France, Philip played an influential role in French politics, particularly during the later 1380s and 1390s. He virtually ruled in the place of the French king during his fits of insanity and on several occasions took the place of Charles on diplomatic missions.

[7] (Prost 1902, 231)

[8] These territories extended along the Meuse and included numerous towns of Liège, Huy, Dinant and Saint-Trond.

[9] The *marchant* Pasquier Grenier who became established in the town of Tournai during the fifteenth century acquired the hanging of Alexander the Great in 1459 for Philip the Good, a textile which Grenier and his sons were then able to reproduce for the Duke of Milan, Edward IV of England, Queen Isabella of Castille and the regent of the Netherlands, Margaret of Austria.

[10] The book of hours was commissioned by the duke of Berry c.1410. It is now in the Musée Condé, France.

[11] Leo recounts to the reader that, "when we arrived at the castle where the old duke resided the duke Charles dismounted and asked my lord to do the same. Then taking him by the hand he led my lord into the presence of the old duke. The duke was seated in a hall on a throne which was hung with cloth of gold woven with great splendour, as befitted the ducal hall..." (Letts 1957, 35-36).

[12] Philip the Bold made a diplomatic venture to Avignon in 1394 accompanied by a gift of tapestry aimed to persuade the then pope to resign and end the schism.

References

Arnade, Peter. 1996. *Realms of ritual: Burgundian ceremony and civic life in late medieval Ghent.* New York: Cornell University Press.

Belozerskya, Marina. 2005. *Luxury arts of the Renaissance.* London: Thames and Hudson.

Brassart, Wolfgang. 1992. *Tapisserien und Politik an den Europäischen Höfen.* Berlin: Verlag.

Brown, Andrew and Graeme Small. 2007. *Court and Civic Society in the Burgundian Low Countries c.1420-1530.* Manchester: Manchester University Press.

Campbell, Tom. 2002. *Tapestry in the Renaissance: art and magnificence.* London: Yale University Press.

—. 2007. *Henry VIII and the Art of Majesty: Tapestries at the Tudor Court.* London: Yale University Press.

—. 2007. *Tapestry in the Baroque: Threads of Splendor.* New York: Metropolitan Museum of Art Publications.

Chipps-Smith, Jeffrey. 1989 "Portable Propaganda: Tapestries as Princely Metaphors at the courts of Philip the Good and Charles the Bold." *Art Journal* 48 (2): 123-129.

—. 1998. "The Practical logistics of Art: Thoughts on the Commissioning, Displaying and Storing of Art at the Burgundian Court." In *In Detail: New studies of Northern Renaissance Art in Honor of Walter S. Gibson,* edited by L. Dixon, 27-48. Turnhout: Brepols.

Delmarcel, Guy. 1999. *Flemish Tapestry.* London: Thames and Hudson.

Froissart, Jean. 1978. *Chronicles.* Translated by Geoffrey Bereton. London: Penguin Books.

Guiffrey, Jules. 1878-85. *Histoire générale de la tapisserie.* 3 vols. Paris.

—. 1887 "Inventaire des tapisseries du roi Charles VI vendues par les Anglais en 1422." *Bibliothèque de l'École des Chartes* 48: 59-110.

Jugie, Sophie. 2004. "The dukes of Burgundy: Princes of Paris and the fleur-de-lis." In *Art from the Court of Burgundy: The Patronage of Philip the Bold and John the Fearless. 1364-1419,* edited by S. Fliegel and S. Jugie, 42-51. Dijon: Musée des beaux-arts.

Labart, Jules. 1879. *Inventaire du mobilier de Charles V roi de France.* Paris.

Le Comte de Laborde, 1849. *Les Ducs de Bourgogne études sur les lettres les arts et l'industrie pendant le XVe siecle et plus particulerement dans les pay-bas et le duche de bourgogne.* Paris.

Lecuppre-Desjardin, Elodie. 2004. *La Ville des cérémonies : Essai sur la communication politique dans les anciens Pays-Bas bourguignons.* Turnhout: Brepols.

Letts, Malcom. 1957. *The Travels of Leo of Rozmital through Germany, Flanders, England , France Spain, Portugal and Italy 1465-1467.* Cambridge: Cambridge University Press.

Moranvillé, Henri. 1889. "Inventaire de l'orfevrerie et des joyaux de Louis Ier, duc d'Anjou." *Bibliothèque de l'École des Chartes* 50: 168-179.

Prost, Bernard. 1902. *Inventaires mobiliers et extraits des comptes des ducs de Bourgogne de la maison de Valois (1363–1477.)* Paris: Leroux.

Rey, Fabrice. 2004. "Tapestry Collections." In *Art from the Court of Burgundy: The Patronage of Philip the Bold and John the Fearless. 1364-1419,* edited by S. Fliegel and S. Jugie, 123-127. Dijon: Musée des beaux-arts.

Schnerb, Bertrand. 2005. *Jean sans-Peur: Le Prince Meurtrier.* Paris: Payot.

Taithe, Bernard. 1999. "Propaganda : A Misnomer of Rhetoric and Persuasion." In *Propaganda: Political rhetoric and identity, 1300-2000,* edited by B. Taithe and T. Thornton, 1-26. Sutton: Stroud.

Vaughan, Richard. 2002. *Philip the Bold: The Formation of the Burgundian State.* London: Boydell Press.

—. 2002. *John the Fearless: The Growth of Burgundian Power.* London: Boydell Press.

Wilson, Katherine. Forthcoming. *Courtly and Urban tapestries of the Burgundian Dominions. Philip the Bold and John the Fearless and the inhabitants of Dijon and Tournai.* Turnhout: Brepols.

SECTION III

SEEING AND BELIEVING: EMBODYING DEVOTION

CHAPTER SEVEN

DEVOTIONAL AND ARTISTIC RESPONSES TO THE CULT OF MARY MAGDALEN IN TRENTINO-ALTO ADIGE, C.1300-1500: THE CASE OF CUSIANO

JOANNE ANDERSON

Like many other regions of the Italian peninsula, Trentino-Alto Adige (South Tyrol) was a locus for the devotional and visual manifestations of the cult of Mary Magdalen from the later Middle Ages onwards (Kaftal 1952-78). What designates it an area worthy of separate study, however, are the narrative cycles and votive images that include rare representations of the saint's life before the ascension of Christ and a specific development of her eremitical retreat.[1] Both aspects derive from sources additional to *The Golden Legend* a popular compendium of the lives of the saints, written by Jacobus de Voragine in c.1260 (1993, 374-83), but they have yet to receive adequate attention by art historians. Moreover, the absence of mendicant association with the churches is significant given their strong identification with Mary Magdalen as exemplar of perfect penitence.

In this paper I will present a targeted contextual overview of the Magdalen foundations in the region, highlighting these defining aspects.[2] This will lead into a case study of the most extensive fresco cycle in the western European Magdalen canon: the later fifteenth-century paintings of Santa Maria Maddalena in Cusiano, a rural parish church. I will reconsider the physical layout of the cycle, a basic element that has been poorly documented and discussed in the past, despite the implications for scene identification and narrative flow. An examination of five key scenes portraying the worldly and eremitical Magdalen, along with their accompanying inscriptions, will help us to look beyond the popular figurative style of representation to their potential iconographical sources.

Indeed, I will present these 'talking' scenes as evidence of the considered nature of the cycle and its relevance to the attendant parish community.

A Regional Survey

The church of Santa Maddalena near Mareta (South Tyrol) is the most northerly of the foundations under comparison by merit of a four-scene cycle painted on the wings of its former high altarpiece by Hans Harder of nearby Vipiteno (c.1450s) now situated to the left of the choir. On the upper panel from the left wing is a rare depiction of the conversion of Mary Magdalen through Christ, who preaches from a wooden pulpit in an interior church setting.[3] Her acceptance of the faith is conveyed through a simple but effective gesture: the crossing of her hands at the wrists, signifying contemplation and reverence (Garnier 1982, 216, 219, esp. drawing B [66]). In tandem with this exemplar for attentive devotion in church, Christ's own gesture would have 'spoken' to the viewing congregation when the altarpiece was open: by pointing to the beautifully rendered sculpture of Mary Magdalen holding her unguent vase in the central section of the triptych, he not only prophesises her future apostolic role, but also indicates her material presence as dedicatory saint and protector of this small pre-Alpine village.[4]

The position of this episode at the beginning of the cycle is a marked departure from the traditional biblical episode of conversion in the house of the Pharisee (Lk. 7:36-51). Significant for our purposes, it finds a companion in the Cusiano cycle in both its placement in the sequential ordering and the scene composition (fig. 7-2). To identify the origins of this unusual iconography, however, it is necessary to look to contemporary Magdalen drama from the German-speaking areas in addition to the traditional hagiographical literature of the saint, an aspect to which I will return below.[5]

Bolzano and its province have a relatively high concentration of Magdalen dedications, the most important being Santa Maddalena in Rencio and its late fourteenth-century cycle, which I discuss more fully elsewhere (Anderson 2009, 58-128 and 2012, ch. 2). Only two fragments survive from the ruined Santa Maria Maddalena in nearby Vadena but the separate layers of plaster provide a tantalising glimpse of a greater decorative heritage (Spada Pintarelli 1985, 63-7). The upper layer of the fragments dates from the period 1410-20. The first and larger piece bears a substantial detail from the last communion of Mary Magdalen by Bishop Maximin, attended by three angels with ceremonial candles, while the second piece, on account of the surviving architectural setting, possibly

depicted her funeral. The dividing border that separated the scenes is still visible at the left edge of the second piece and on the left side of the border is part of the decorative gable of the church from the first. On this evidence it is seems reasonable to presume that they were the final episodes of a larger, now lost, Magdalen cycle. The third and lower level, dating from 1310-20, is a fragment from the left side of the elevation of a heavily striated, hirsute Magdalen by angels. It was a common and popular reductive symbol of her eremitical life and clearly resonated with the local community living in their own challenging terrain, subject to the vagaries of nature.[6]

The small hermitage of Santa Maria Maddalena, near Riva del Garda (Trentino), is the last and most southerly foundation in this brief survey. Although now abandoned, it retains, amongst other mural paintings, two votive images from the mid-fifteenth century that present the saint in both active and contemplative roles (Codroico 2000, 366, 369 and 371; Castegnetti and Varanini 2004, 680). In the first she wears a yellow dress under her red robe and points to her principle attribute, the unguent vase, held in her left hand. Two angels are in the unusual act of crowning her while a named female donor ("*d.na Blaxia*") kneels at her feet (Codroico 2000, 373, 373n3-4). It is an important visual document for the devotion of a local secular woman, of adequate means, to an apostolic Mary Magdalen. The second painting utilises that most succinct leitmotif for her contemplative life, the elevation, but the role of the angels has been developed to create a more intense devotional image appropriate to a place of spiritual retreat. *The Golden Legend* tells us that a choir of angels raised the Magdalen to heaven seven times a day according to the canonical hours and nourished her, body and soul, with their celestial singing (Voragine 1993, 380). This event is usually given a reasonably literal interpretation in paintings with the number of angels varying but in Riva she is borne upwards on a cloth held by the lower pair, a pictorial device more typically associated with the ascension of a deceased's soul to heaven. Moreover, the liturgy of the Eucharist is implied by way of the candles held by the upper pair of angels as the saint prepares to receive the heavenly manna (Bynum 1987, 54).

The paintings and sculpture above illustrate the widespread nature of veneration to the saint in the region as well as their innovative developments of the Magdalen visual tradition with respect to her conversion and penitence. However, there is a further important commonality to consider. Without exception the host foundations here are rural parish churches or filial chapels - a significant paradigm for the study of a saint typically entrenched in urban mendicant ideology and interpretation.

The symbiotic relationship between the Magdalen and the mendicants has been well documented by Katherine Jansen, who places specific emphasis on the role of sermons and the responses to them by the laity (2001, 358). Her arguments are persuasive where the houses were numerous and the documentary evidence of them wielding great influence is ample, namely central and southern Italy, but they are less convincing when applied to this pre-Alpine region. It would appear that it did not witness the rapid expansion or influence of the religious orders, regular or mendicant, typical of the rest of the country, including those dioceses on its immediate borders. In his consideration of the relative paucity of religious houses in the diocese of Trent, Emanuele Curzel concedes a problem of surviving documentation. However he also suggests a lack of favour shown by the German bishop princes towards the religious orders and, on account of this seigneurial system, the absence of social mobility that would have provided the necessary "space" for the work and patronage of the mendicants, particularly the Franciscans (2004, 558-64). Combined with the rural character of the Magdalen churches, it seems unlikely therefore that the mendicants or their sermons were solely responsible for the content of their distinctive cycles and votive images. Overturning previous dismissal due to a lack of visual evidence (Janssen 1961, 301; Wildenberg de Kroon 1979, 137-40), we can reconsider religious theatre as a significant informant for the saint's representation, peripheral or otherwise. It is not a new point of entry for the discussion of Magdalen iconography *per se* but it has yet to be satisfactorily applied to this cross-cultural region as a whole or to the Cusiano cycle at all.[7]

The Case of Cusiano

The presbytery of Santa Maria Maddalena in Cusiano plays host to a near complete fresco cycle of thirty continuous scenes from the life of the titular saint: an astounding extension that gives license to iconographical creativity. The cycle has been dated, along with a votive image of the Magdalen on the former high altar, to the period c.1470-97 and generally attributed to Giovanni and Battista Baschenis de Averaria, members of an itinerant family of painters from Lombardy in northern Italy. Clearly responding to a competitive market in their native Averaria and nearby Bergamo, the Baschenis travelled east and came to monopolise artistic commissions in the Trentino valleys with their lively style of representation throughout the fifteenth and sixteenth centuries (Vernaccini 1989).

Located high up in the Val di Sole in Trentino, Santa Maria Maddalena was probably built before 1368, when it was mentioned in reference to an

ecclesiastical beneficiary. Later in 1573 it was described as, "*sub cura plebes*", a reference to the nearby collegiate church of San Vigilio in Ossana (Ciccolini 1936, 2; Cristoforetti 1989, 250). In terms of fabric, today the church has a single nave with pentagonal presbytery, both with ribbed vaults, an adjoining square-set sacristy and a bell tower at the western end. Originally, however, it would have had a wooden ceiling, as was common to most fourteenth-century churches in rural Trentino (Maffei and Michelangelo s.a.s 1996 and Bronzino et al. 1983, 63-7).[8] On the exterior south side is an open shrine, built towards the end of the 1400s and dedicated to Roch, who would have offered protection against the pestilence for both passing and resident supplicants.

The pastoral visitation of 1579 mentions the consecration of three altars in the church, all of which are present today (ADT, 122v and 1766, 150r). The former high altar is dedicated to the titular saint and decorated with a painted image of her elevation by two angels before a cloth of honour. The side altars are dedicated to Anthony Abbot (right) and Sebastian (left), with an early sixteenth-century representation of each on the wall behind.[9] The visitation of 1751 records a consecration of the altars on October 20 1497 (ADT, 225v). Assuming that the church was founded before 1368, it is likely that around the end of the fifteenth century the bishop was re-consecrating the altars after the completion of the presbytery stone vaulting and subsequent campaign of fresco decoration, weighting the latter's execution towards the 1490s.[10]

All paintings in the church, bar those hidden on the east wall by the sixteenth-century marble high altarpiece in the presbytery, were covered in whitewash by instruction of the *coadjutor* bishop during his visitation in 1617; complete coverage was eventually ordered by 1672 (ADT Libro 9B, 203r; 1672, 197r and v). The first restoration under the direction of the Soprintendente alle Belle Arti di Trento (1938) exposed the brightly coloured paintings with their accompanying inscriptions written in Latin and fifteenth-century local Italian vernacular.[11] A second intervention was commissioned in the 1990s, revealing more artistic works in the nave, including those behind the side altars.

Taking into account recent ecclesiastical histories, regional church survey volumes and entries in wider art-historical studies (Anderson 2009, 187-92), there are still only two works that have attempted fully to catalogue the scenes of the cycle. The journal article written by the local scholar, Quirino Bezzi (1970, 358-72) is an important documenting exercise after the completion of the first restoration but it contains many inaccuracies and omissions that imply unfamiliarity with the Magdalen legend, despite its inclusion as an appendix. George Kaftal (1978, 4:702-

24) rectified the situation eight years later as part of his larger iconographical compendium of the saints in north-east Italy, but due to constraints of format the cycle was once again summarised by a cursory list (with illustrations) that could do little to assist the reader or *in situ* observer in matters of layout and content significance.

A plan of the five relevant presbytery walls, with each individual scene of the cycle carrying a number that corresponds to a list of content (Fig. 7-1) clarifies the compositional layout. Such an approach re-inserts (after Bezzi) scene 11 in its rightful place and provides correct identification of scenes 10, 12-17 and 29-30, as well as hypotheses for the repositioned scenes 25-27.

The cycle begins at the upper lunette on the north wall and moves directly to its companion on the opposite wall before returning to the north and running along the upper register. The story continues on to the same level of the north-east, east, south-east and south walls before spiralling back round to the north wall and the middle register. It travels right round again to above the sacristy door on the south wall and then for a final time to the north wall at the level of the lower register and its three lost scenes. Symmetry with the two lunettes at the beginning is achieved when the story moves straight back over to the lower register of the south wall with its concluding scenes, 28-30. It is likely that such a compositionally complex programme relied on the planning expertise of the Baschenis workshop, but what of the content?

There is substantial damage to the lower register of the south wall due to the later insertion of the sacristy door (1591), compromising the identification of scene 30. At the outset, Bezzi did not count 28-30 as the final trio of the cycle. Instead of following the descending pattern onto the north wall as explained above, he moved directly down to the lower register of the south after scene 24 before continuing over to the lower register of the north, which he thought once depicted posthumous miracles at the tomb of the saint (1970, 362-66). Consultation of the saint's hagiography suggests that the three missing scenes were probably events occurring between the hermit's witnessing of the angels and the entombment of the Magdalen.[12] A comparison with the earlier cycles in Rencio (admittedly unavailable to Bezzi and Kaftal at the time of publication), the Magdalen chapels in San Francesco in Assisi, the Bargello in Florence and San Domenico in Spoleto and even the remains from Vadena offer possible solutions: the hermit giving his cloak to Mary Magdalen, her arrival in the crypt at Aix with the angels and the receiving of last communion from Bishop Maximin. When the cycle does in fact

return to the south wall, as I argue, it finds its logical conclusion in the saint's death, funeral and perhaps here a miracle at her tomb.

What distinguishes the content of this cycle from more canonical examples found throughout central and southern Italy is the emphasis on the two key aspects from the life of the Magdalen examined in the above survey: the process of her conversion and her retreat to the wilderness for thirty years of penance. These popular themes in fact allowed for the inclusion of some rather atypical iconography that, despite its rarity, has received inadequate consideration to date.

The first five scenes can be categorised as pre-ascension but while the *Raising of Lazarus* and the *Anointing in the House of Simon* are conventional biblical episodes (albeit with some aberrations), the other three scenes are reflective of later and diverse textual sources.[13] As I have demonstrated for the earlier cycle in Rencio (Anderson, 2012), the opening scene in Cusiano is a rare portrayal of the Magdalen's worldly life in a setting of wealth and property (fig. 7-2). It appears to follow *The Golden Legend* through a simple presentation of the Magdalen giving favour to two of her four 'suitors.' However, close inspection of the accessories of the protagonists, specifically the wreaths of red and white roses adorning the uncovered heads of the Magdalen and her maid, but perhaps also the flourished handkerchief denoting her intent to one man in particular (his companion's gesture is quite blatant in this respect), reveals an additional, overlooked source that was prevalent in this bilingual region, German religious theatre.[14]

Bram Rossano (2008) examines the saint's visualisation in literature produced during the fourteenth and fifteenth centuries (including plays) with specific reference to her wardrobe. The Magdalen's pleasure in the creation and remembrance of wearing a crown (*cranze* or *krenzlein*) as a symbol of her worldly life is noted in the fourteenth-century Vienna Passion and the c.1460 Eger Corpus Christi plays, while the more specific rose crown (*rosencranz*) appears in the later 1501 Alsfeld Passion, suggesting that it remained an enduring symbol of her vanity-led sins. I would argue that it is a convincing correlation to the painted version in Cusiano, offering us a striking contrast to the heavenly crowning the Magdalen receives in the votive painting in Riva del Garda. More broadly, Rossano observes that the flaunting of young female virginity in public, symbolised by the rose crown (*schappel*), had been harshly criticised by the thirteenth-century Franciscan Berthold von Regensburg in his sermon *von drien fürstenamten* (2008, 41; von Regensburg [1862-80] 1965). We may therefore be witnessing in the Cusiano opening scene, through a

melange of sources (religious theatre, sermons and hagiography), moral instruction to a female audience through dress and comportment.

The moment of the Magdalen's spiritual conversion occurs in the companion lunette on the south wall of the Cusiano presbytery relegating the scene of *Anointing* to third place in the cycle (fig. 7-3). Mary Magdalen, still wearing her rose crown, fine dress and necklace but with a newly acquired halo, listens attentively to Christ as he preaches from a wooden pulpit. Once again gesture is used to convey her conversion: crossed arms over chest denoting the acceptance of the words of Christ but also conforming to an established model of humility or supplication (Nash 2008, 731-4). As in Mareta, the Magdalen is a new member of the mixed-sex congregation but in Cusiano segregation of the genders is implied. Social hierarchy is also established. The Magdalen sits on a cushioned wooden chair befitting her noble status, like the lady next to her, whereas behind her are the kneeling humble veiled women (including the haloed Martha) and behind them the servants and children, who sit on the ground. The men are fewer in number but those present are seated behind the pulpit on a bench.

This variant of conversion is not found in *The Golden Legend*. However, we can once again look to late medieval religious plays, such as the fourteenth-century Frankfurt Director's Script (*Frankfurter Dirigierolle*), as a potential source for the basic subject, as was argued by Wildenberg de-Kroon, although not in reference to Cusiano (1979, 98-104). It prompts the question of whether there was a conscious decision on behalf of the likely combined religious and civic commissioning body (Anderson 2009, 196-200), along with the painters, to show the conversion of the Magdalen within the context of a sermon because it would resonate with the local population, familiar with its vivid dramatisations by travelling performers or in established locations throughout the region, including nearby Bolzano and Trent. After all, it was a medium well suited to expressing an external manifestation of an internal change (Salih 2002, 128), in this case through the presence of crown, halo and gesture. The temporary nature of the wooden pulpit in the scene of *Conversion* may also have reflected the stage furnishings during a performance of one of the source plays, as well as being redolent of actual preaching (Ben-Aryeh Debby 2002, 262-3).

The Italian vernacular inscriptions, running under all of the Cusiano scenes also suggests the influence of religious theatre on the cycle. Each commences with same words, "Here the Magdalen" (*Como la Maddalena*) as a lead into a dramatic commentary on the action depicted above. Such a repetitive and rhythmic composition suggests they were to be spoken aloud, an exegetical performance reflective of their source in combination

with the Italian hagiographical texts known to the local canons of San Vigilio in Ossana. I would therefore argue that the *Worldly Life of Mary Magdalen* and her *Conversion*, set in the expansive and visible space of the lunettes, record the transferral of popular literary tropes and stage props into two-dimensional iconographical attributes. Within the frames of these 'talking' paintings, the attributes functioned as *aide-mémoires* for the local community and passing merchants, pilgrims and clergy from both sides of the Alps with regard to their own spiritual or physical journeys.[15]

The final scene in the pre-ascension quintet is to my knowledge unique to Cusiano (5). Mary Magdalen, Martha, Lazarus and a second unidentified male without halo are presented in the act of charity under the guidance of Christ (reproduced in Jansen 2000, 83). Jansen has connected its origins to the mendicant ideals of poverty and its particular application to the saint's life made by Agostino of Ancona (2000, 82 and 86n), the Augustinian preacher (d. 1328).[16] There is certainly a real contrast between the group handing out alms to the needy and the opening scene of *luxuria* and *vanitas* in the castle of Magdala in the Cusiano cycle, but I would argue against her certitude of it being the "visual analogue" of a text written over 150 years earlier. As before, I prefer a more open, localised reading.

Firstly, Mary Magdalen and her siblings are still attired in their finery indicating a continued distinction in their status. If the iconography were truly to reflect mendicant poverty, we would expect them to renounce the external manifestations of their status as well as the veritable fruits of their wealth; thus imitating the examples of Francis, his followers and those of the other begging orders.[17] Although this scene is not found in other comparative cycles, the conversion of the Magdalen in visual programmes is always conveyed through a change in her physical attire in addition to the halo. However in Cusiano the change is a gradual process that finds completion only when she retreats from the active life (21). Secondly, there is the issue of what the protagonists are distributing and in what circumstances. At the forefront of the picture plane is a large wicker basket of apples, a fruit that was (and still is) produced in abundance in the western Trentino valleys. It functions as a local frame of reference for the layperson, where private wealth was based on cultivated land. This wealth is also distributed in the form of coins but from the hands of Lazarus, *paterfamilias*, rather than the Magdalen; this despite her own inherited property and money. With these aspects in mind, I would therefore interpret this scene not only as a simple instruction to the faithful regarding the duty and rewards of charity-as indicated by the banner in the top left corner, held like a stage prop, proclaiming, *"God is charity"*

(DEUS CARITAS EST) but also as a reflection of the appropriate masculine and feminine modes of almsgiving for the community.

In addition to the pre-ascension quintet, the cycle had an unprecedented seven scenes depicting the eremitical retreat of the saint, 21-24 on the southeast and south walls and 25-27 which once adorned the lower register of the north wall. As a group they record her 33-year physical and spiritual journey towards complete enlightenment but for the sake of brevity I shall focus on one aspect in particular - the elevation of Mary Magdalen by the angelic choir (23). For all purposes the wall scene is a straightforward depiction of *the* pivotal moment from the saint's legend and accordingly it has attracted little critical attention (fig. 7-4). However, on closer inspection we see that Cusiano has once again broken from tradition. In other cycles and votive images the saint is consistently presented as hirsute when she is raised to heaven for celestial nourishment having shed all earthly comforts over the thirty-year period. This process of renunciation is conveyed in the two previous scenes of the Cusiano cycle but during elevation she is wearing a white dress.

Sarah Salih (2002, 130) has observed that the white dress was not a "standard element" in Magdalen hagiography and definitely not represented in *The Golden Legend* (or in visual arts to her knowledge). However, within the context of *The Book of Margery of Kempe* (1430s), she notes that the bishop's order to Margery to wear the colour was an obstacle in her desire to lead a chaste life (Meech, Hope and Allen 1940, 32). White robes were worn by virgins, not newly celibate women, and so Margery worried about how she would be perceived by society. Nevertheless by obeying the order, Margery, and crucially her role model Mary Magdalen, had reached the next level of penitence because they had "renounced renunciation." In the near contemporaneous Digby Magdalen play (Baker, Murphy and Hall Jr 1982, 77) the saint is dressed by angels in a "mentyll of whyte" (line 1604) which she interprets as a "tokenyng of mekenesse" (line 1607) but Salih (2002, 131) tentatively suggests that it should not be taken as *de facto* evidence of an earlier stage Magdalen influencing the hagiography of Margery. In fact she contemplates the possibility that the Magdalen playwrights drew inspiration from "another, white clad, discontinuous holy woman," i.e. Margery. Earlier I presented a comparable example of female experience potentially informing Magdalen drama and consequently the visual arts in the form of her rose crown and so it is not inconceivable that the white dress of the elevation in the Cusiano cycle originated in a similar way.

A further interpretation of the white dress is bridal and that the now spiritually pure saint aspired to become a spouse of Christ: a status many

female mystics of this period sought after (Erler 1993, 79; Vauchez 2002, 237-42). The subject of the scene is proclaimed by a half destroyed banner with the words, "Satisfied with…"(SATIABOR CUM…) and is held by the Magdalen as she rises heavenwards for celestial communion. They accord well with the language of matrimony and its consummation, a theme reinforced by the later scene depicting the ascension of her soul (28) in which Christ receives her with the words, "Come my sweet" (UENI DILECTA MEA). It is a remarkable development of a standard Magdalen visual topos and one that perhaps reflects the female experience of affective piety, conditioned by religious theatre.

The theme of desired union with Christ is extended to the second portrayal of the elevation in the church, this time on the front of the former high altar (fig. 7-5).[18] Unlike the scene on the wall, she is finally depicted in her traditional guise as hirsute penitent but the overall significance of the episode has been developed beyond her personal experience. The elevation of Mary Magdalen was considered her highest communion with God and symbolic of her complete spiritual nourishment. As part of the high altar fabric, a unique occurrence to my knowledge, the image is given a heightened Eucharistic interpretation. Firstly, it makes a direct link between the redeemed saint and the consecration and physical consumption of the host whereby those participating in the liturgy (at least once a year) would also achieve forgiveness and salvation. Secondly, it functions as a contemplative focus for private individual, if not specifically female, devotion to Christ, a fact reflected in the altar's central placement in sacred space, surrounded by the spiritual guidance of the cycle itself.

In view of the survey and scenes discussed above, I would suggest that religious theatre from the German-speaking areas was a likely primary source alongside *The Golden Legend* for the content of the Magdalen fresco cycles of Trentino-Alto Adige. However, rather than striving for evidence of complete scene-for-scene transfer or visual analogues with surviving plays, a method found to be wanting in the past, I have proposed the idea of a general absorption or emulation of certain subjects, themes, attributes and gestures that would have transferred well to the painted medium and resonated with the clergy and laity. In the particular case of Cusiano, the rereading of its layout and the examination of selected scenes supports such new interpretations, placing the saint in a more appropriate local context.

In this light, I would like to end the paper with the open issue of audience and function, again in relation to sacred space. The cycle can be considered a didactic tool commissioned for the instruction of the laity by

an educated clergy, and given expression by an experienced artistic workshop, on account of its complex layout, vivacious imagery and memorable inscriptions. However the location of the cycle in the presbytery is both unusual and problematic. Visibility from the nave is limited and so unlike the cycle located in Santa Maddalena in Rencio, caution must be exercised when arguing the case for a universal audience. The matter rests fundamentally on whether the laity, with middling literacy (Dal Prà 2003, 33) could enter sacrosanct areas in small parish churches, especially in the absence of a screen or other physical barrier. Santa Maria Maddalena was described at the beginning of this case study as a filial chapel of San Vigilio, and did not appear to have a resident priest to minister to the citizens of Cusiano until much later. As such, this may weight the argument towards free access to the presbytery and a fresco cycle that acted as both preaching tool and dramatic proxy for those in need of spiritual guidance.

Notes

[1] I am grateful to the Archivio Restauro of the Soprintendenza per i Beni Storico-artistici autonoma di Trento for allowing me access to the files on Santa Maria Maddalena, Cusiano. My thanks to the joint editors, Louise Bourdua and the anonymous reader for their valuable feedback when preparing this essay. Acknowledgement is also due to the Art and Humanities Research Council for their financial support of my doctoral research project from which it stems.
[2] The churches are found across the region and share the Magdalen dedication. Proximity to established travelling routes and the consistent increase in cycle lengths suggests awareness of rival cult *loci* and an element of one-upmanship.
[3] For a colour reproduction, see http://tethys.imareal.oeaw.ac.at/realonline/ (accessed July 2 2011). The cycle continues on the upper right wing with Mary Magdalen anointing the feet of Christ in the house of the Pharisee, then to the lower panel of the left wing with the *Noli me tangere*, concluding on the lower right with the elevation of the hirsute Magdalen by four angels in a landscape.
[4] Such sculpted altarpieces were likely found in the other Magdalen churches.
[5] Mareta is near to Vipiteno, a town famed for its theatrical productions. Correlations between religious drama and art in a Magdalen context are considered by Janssen (1961, 301) and particularly Wildenberg-De Kroon (1979).
[6] It may also have been part of the first phase of decoration (in the nave) of Santa Maddalena, Rencio (*c*.1300-10), which was contemporaneous to that of Vadena.
[7] Wildenberg-de Kroon challenged previous studies that argued for a clear relationship between stage and visual representations, both in terms of the direction of transfer (stage to art or art to stage) and the weakness of the examples they used. In her specific examination of the Magdalen legend in German drama and art she saw little evidence of this relationship concluding that each medium had its own

tradition. However, by keeping her focus on German paintings she did not include those from Cusiano, Rencio or the rest of this south Tyrolean, German-speaking region (Alto Adige), which were clearly influenced by the same, though now lost, plays.
[8] Not only are the surviving nave frescoes (dated to the mid-fourteenth century) interrupted by the later supporting pilasters, south-side door and window but the most recent restoration has found evidence of the supporting beams for the *quattrocento* wooden roof on either side of the triumphal arch. The beam heads, now covered in neutral mortar, are symmetrically placed above the heads of the Magdalen (left) and Anthony Abbot in Episcopal robes (right).
[9] The paintings are by a different hand and dated to the early sixteenth century. The Magdalen is portrayed on the wall behind the left altar, holding her unguent vase and a book. For the significance of the dual symbols, see Jansen (2000, 96-9).
[10] A few pages earlier in the same volume a second, and probably later, hand corrects the date to 1503, however this does not affect the proposed dating. Two painted consecration crosses are found on the walls of the presbytery.
[11] Due to the large number of inscriptions and their varying state of conservation I will curtail their reference to specific iconographical issues.
[12] Domenico Cavalca's account of Mary Magdalen in his popular and widely disseminated *Vita dei Santi Padri*, written in the Italian vernacular in *c.*1330, could have served as a primary source for the patron or the Baschenis workshop on account of its extensive treatment of the worldly Magdalen. However, with the pivotal role played by Martha in this text not being given primacy in the Cusiano cycle, as it is in Rencio, along with the fourteenth-century dating, I am sceptical as to its relevance.
[13] The scene of anointing is typically represented as occurring in the House of the Pharisee but the Latin speech text in the Cusiano scene specifies it as that of Simon the Leper, a conflation between the life of Mary Magdalen in *The Golden Legend* and the Gospel according to Matthew (26:6).
[14] Up until the investiture of the Italian bishop, Bernardo Cles in 1514, the diocese of Trent was administered by men of Germanic origins demonstrating the powerful stretch of the County of Tyrol under the Habsburgs and its cultural impact.
[15] See Rossano (2008, 40-3) for editions and precise verse citations.
[16] Matt. 19:21-the account of a man being encouraged to dispose of his worldly goods in order to achieve a higher spiritual life-becomes "a foundational text for the mendicant version of the *vita apostolica*." The only copy of Agostino's *Sermones dominicales et de Sanctis ad clerum* is held in the Biblioteca Angelica, Rome, MS 158. While a connection between Gospel text and Cusiano image is discernable, Jansen does not examine how and why the transfer took place on the walls of a small filial church high up in a Trentino valley. It is known that Agostino had been present at the court of King Robert of Naples from 1322 until his death six years later, a prime locus for the cult of the Magdalen, but the influence of his work in rural parishes in this northern region is not known. A parchment of 1463 records the presence of a Neapolitan priest, Guglielmo, in the parish of Ossana in 1442 but it is not enough to class him a conduit.

[17] Although the vernacular inscription does mention the donation of robes to the poor-"Como la Mad.na seguitava J. X° Martha e Lazzaro e altre compagne e depensavano le sue robe agli poveri per lo amere di Dio"- the act is not recorded in the painting.

[18] A further example of such altar decoration can be found in the church of S. Felice, Bono del Bleggio (Trentino) by Christoforo II Baschenis, 1496. It depicts Christ in the sepulchre, another meditative image (Vernaccini 1989, 50).

References

Anderson, J. W. 2012. "Mary Magdalen and her dear sister. Innovation in the mural cycle of Santa Maddalena in Rencio." In *Mary Magdalene: Iconographical studies from the late middle ages to the baroque.* Edited by M. A. Erhardt and A. Morris. Leiden: Brill.

—. 2009. *The narrative Magdalen fresco cycles of Trentino, Tyrol and the Swiss Grisons, c.1300–c.1500.* PhD diss., Univ. of Warwick.

Atti Visitali. Archivio Diocesano di Trento (ADT).

Baker, D. C., J. L. Murphy and L. B. Hall, Jr, eds. 1982. *The late medieval religious plays of Bodleian MSS Digby 133 and E Museo 160.* Oxford: Univ. Press.

Ben-Aryeh Debby, N. 2002. "Patrons, artists, preachers: The pulpit of Santa Maria Novella (1443-1448)." *Arte Cristiana.* 811: 261-72.

Bezzi, Q. 1970. Gliaffreschi di Giovanni e Battista Baschenis di Averaria nella chiesa di S. Maria Maddalena di Cusiano. *Studi Trentini Scienze Storiche.* Sezione 2. 49: 358-72.

Bronzino, B., D. Primevano, and P. Ventrini, eds. 1983. *Arte e devozione nelle chiese della Val di Sole.* Trent: Publilux.

Bynum C. W. 1987. *Holy feast and holy fast.The religious significence of food to medieval women.* Berkeley: Univ. of California Press.

Castagnetti, A. and G. M. Varanini, eds. 2004. *Storia del Trentino. L'età medievale,* vol. 3. Bologna: Il Mulino.

Cavalca, D.n.d. *Vita dei Santi Padri, colle Vite di Alcuni altri Santi.* Vol. 1. Edited by B. Sorio and A. Racheli. Milan: l'Ufficio Generale di Commissioni ed Annunzi.

Ciccolini, G. 1936. *Inventari e regesti degli archive parrochiali della Val di Sole.* Vol. 1. Trent: Rerum Tridentinarum fontes.

Codroico, R., M. L. Crosina, M. Grazioli, F. Martinelli, F. Odorizzi, M. Poian and R. Turrini, eds. 2000. *Ecclesiae: Le chiese nel Sommolago.* Arco: Il Sommolago.

Cristoforetti, G. 1989. *La visita pastorale del cardinale Bernardo Clesio alla diocesi di Trento 1537-38.* Bologna: EDB.

Curzel, E. 2004. "Le istituzioni ecclesiastiche." In *Storia del Trentino. L'età medievale*. Vol. 3. Edited by A. Castagnetti and G. M. Varanini. 539-77. Bologna: Il Mulino.

Dal Prà, L. 2003. "La cultura dell'immagine nel Trentino. Il Sacro." In *Le vie del Gotico. Il Trentino fra trecento e quattrocento*, 31-77. Trent: Provincia autonoma di Trento, Servizio Beni Culturali, Ufficio beni storico-artistici.

Erler, M. C. 1993. "Margery Kempe's white clothes." *Medium Ævum*. 72:78-83.

Garnier, F. 1982. *Le langage de l'image au moyenâge. Signification et symbolique*. Paris: "Le Léopard d'Or."

Jansen, K. L. 2000. *The making of the Magdalen. Preaching and popular devotion in the later middle ages*. Princeton (NJ): Univ. Press.

Janssen, M. 1962. *Maria Magdalena in der abendländischen Kunst. Ikonographie der Heiligen von den Anfängen bis ins 16. Jahrhundert*. PhD diss., Univ. of Freiburg.

Kaftal, G. 1952-78. *Iconography of the saints*. 4 vols. Florence: Sansoni.

Maffei, A., and M. Maffei s.a.s. 1996. *Relazione tecnica. Inerente al restauro degli affreschi della chiesa di Santa Maria Maddalena, Cusiano (TN)*. Archivio restauri, Soprintendenza per i Beni Storico-artistici autonoma di Trento.

Meech, S., B. Hope and E. Allen, eds. 1940. *The Book of Margery of Kempe*. London: Oxford Univ. Press

Nash, S. 2008. "Claus Sluter's 'Well of Moses' for the Chartreuse de Champmol reconsidered: part III." *The Burlington Magazine* 150: 724-41.

Piccolo Paci, S. 2003. *Le vesti del peccato. Eva, Salomè e Maria Maddalena nell'arte*. Milan: Àncora.

REALonline. Institute für mittelalterliche Realienkunde. http://www.imareal.oeaw.ac.at/

Rossano, B. 2008. Visualising the Magdalen. The depiction of Mary Magdalen in medieval literature. *Philologieim Nitz* 45:33-55. http://web.fu-berlin.de/phin/phin45/p45t3.htm (accessed July 2 2011)

Salih, S. 2002. "Staging conversion. The Digby saint plays and *The Book of Margery Kempe*." In *Gender and holiness. Men, women and saints in late medieval Europe*, edited by S. J. E. Riches and S. Salih, 121-34. London: Routledge.

Spada Pintarelli, S., ed. 1985. *Museo civico di Bolzano/Städtisches museum Bozen. Aquisti e restauri/Erwerbungen und Restaurierungen 1980-1984*. Bolzano: Museo Civico.

Vauchez, A. 2002. *The laity in the middle ages: Religious practices and experiences*. Edited by D. E. Bornstein. Translated by M. J. Schneider. Notre Dame (IN): University Press.

Vernaccini, S. 1989. *Baschenis de Averaria. Pittori itineranti nel Trentino*. Trent: Temi.

von Regensburg, Berthold, (1862-80) 1965. *Vollständige ausgabe seiner deutschen predigten*. Edited by F. Pfeiffer and J. Strobl. Berlin: Walter de Gruyter.

Voragine, J. 1993. *The golden legend. Readings on the saints*. Vol.1. Translated by W. Granger Ryan. Princeton (NJ): Univ. Press.

Wildenberg-De Kroon, C. E. C. M. van den. 1979. *Das Weitleben und die Bekehrung der Maria Magdalena im Deutschen Religiosen drama und in der bildenden Kunst des Mittelalters*. Amsterdam: Rodolpi.

Fig. 7-1. Plan and key of Magdalen Cycle, Santa Maria Maddalena, Cusiano Original drawing by author.

1. Worldly Life 2. Conversion through Preaching of Christ 3. Anointing in House of Simon 4. Raising of Lazarus 5. Act of Charity 6. Expulsion from Holy Land 7. Adrift at Sea 8. Taking Shelter Outside Marseilles 9. Challenge of Faith by Prince 10. Blessing the Pregnant Princess 11. City Keys 12. Birth of Son and Death of Princess at Sea 13. Princess and Son left on Rocky Island 14. Prince before St Peter in Rome 15. Prince and St Peter in Jerusalem 16. Miraculous Discovery of Princess and Son 17. Return to Marseilles 18. Blessing the Royal Family 19. Baptism in Marseilles 20. Baptism in Aix 21. Retreat to the Wilderness 22. Penance in the Wilderness 23. Elevation by Angels 24. Hermit as Witness 25. Destroyed 26. Destroyed 27. Destroyed 28. Entombment 29. Funeral 30. Partially Destroyed

Fig. 7-2. Giovanni and Battista Baschenis de Averaria (attrib.), *The Worldly Life of Mary Magdalen*, fresco, *c*.1490s. Cusiano, Santa Maria Maddalena. Photo: author. Reproduced by permission of the Arcidiocesi di Trento, Ufficio Arte Sacre e Tutela Beni Culturali Ecclesiastici.

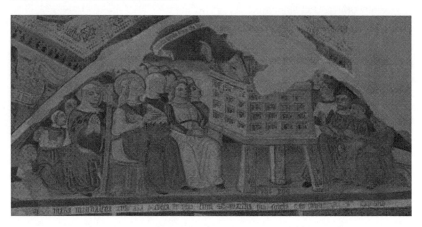

Fig. 7-3. Giovanni and Battista Baschenis de Averaria (attrib.), *The Conversion of Mary Magdalen through the Preaching of Christ*, fresco, *c*.1490s. Cusiano, Santa Maria Maddalena. Photo: author. Reproduced by permission of the Arcidiocesi di Trento, Ufficio Arte Sacre e Tutela Beni Culturali Ecclesiastici.

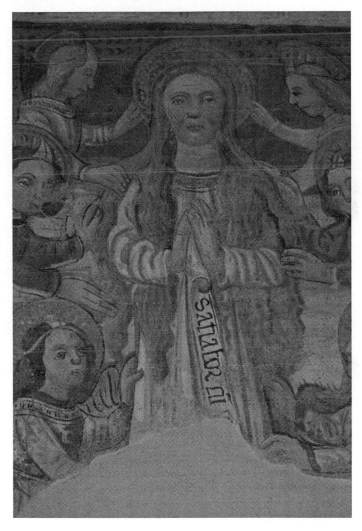

Fig. 7-4. Giovanni and Battista Baschenis de Averaria (attrib.), *The Elevation of Mary Magdalen by Angels* (detail), fresco, *c*.1490s. Cusiano, Santa Maria Maddalena. Photo: author. Reproduced by permission of the Arcidiocesi di Trento, Ufficio Arte Sacre e Tutela Beni Culturali Ecclesiastici.

Fig. 7-5. Giovanni and Battista Baschenis de Averaria (attrib.), *The Elevation of Mary Magdalen by Angels*, fresco, *c.*1490s. Former high altar decoration, Santa Maria Maddalena, Cusiano. Photo: author. Reproduced by permission of the Arcidiocesi di Trento, Ufficio Arte Sacre e Tutela Beni Culturali Ecclesiastici.

CHAPTER EIGHT

VENICE, THE SEA
AND THE CULT OF ST NICHOLAS

ANASTASIA KANELLOPOULOU

"Oh Felix Venetia et oh beata Venetia, quae beatum Marcum evangelistam, utpote leonem in bellis habes et Nicolaum patrem graecorum in navibus gubernatorem."
—Monachi Anonymi Litorensis, *Historia de Translatione* (Rigon 2001, 281).

Venice is one of the most representative examples of a maritime republic.[1] The dominion of the Adriatic and the Aegean seas was the most crucial factor in the increasing power and the progress that characterised Venice between the twelfth and the fourteenth centuries. The fundamental role of the sea was manifested eloquently in the eleventh century with the transfer of the relics of St Nicholas of Myra from Lycia to Venice (1096). This *translatio* marked and defined the political and diplomatic rapports between Venice, Bari, and the Adriatic, and St Nicholas became the second most important patron of the city after St Mark. Soon Venice was confronted with the problem of adopting the saint, and of defining his imagery as a new patron saint. In order to respond to the challenge the Venetians turned to the iconography of St. Nicholas developed within the Byzantine tradition.[2] My purpose here is twofold: to offer a brief account of the cult of St Nicholas in Venice, and to elucidate the strong connections with the painting of the Balkans, especially Thessaloniki, in the work of the major fourteenth century Venetian panel painter, Paolo Veneziano.

The religious foundations of St Nicholas

In Medieval Venice the active religious foundations dedicated to the saint were San Nicolo, on the island of Lido; San Nicolo dei Mendicoli, in the quarter of Dorsoduro; and San Nicolo della Lattuga, a minor chapel of secondary importance close to Santa Maria dei Frari.[3] Among these, doubtless the most important and influential was the Benedictine establishment of San Nicolo in Lido, situated on the north-eastern side of the island, facing the coast of St Mark. The monastery was founded by Doge Domenico Contarini, the Patriarch of Grado Domenico Marengo, and the Bishop of Castello Domenico Contarini in 1053, in a period of fervent reconstruction in the city (Corner 1990, 50-60; Guiotto 1948). It is well known that the Benedictines promoted the veneration of St Nicholas, although the Benedictines of Montecassino had at least six Nicolaian monastical settlements already by the tenth century. The cult of the saint in Venice was reinforced with the *translatio* of his relics in 1099, dated only some years after the Barese *translatio* in 1087 (Pertusi 1978; Cessi 1985). The rivalry between Venice and Bari for the acquisition of the saint's body should be seen within a broader historical and political frame.[4] The end of the eleventh century saw constant skirmishes between the Byzantine and the Venetian fleet against the Normans for the dominance of the Adriatic and, more importantly, in 1098 Venice, after joining the crusading fleet of Urban II, participated in the first crusade and the conquest of the *terra santa* to recapture Jerusalem from the Muslims.

Within this context, the *translatio* of St Nicholas acquired symbolical meaning and inaugurated the coming of age of Venice as maritime power. The Venetian version of the history of the *translation* justified and consecrated the *furta sacra* as part of the greater Venetian expedition to restore Jerusalem. The *translation* to Bari, written by a Benedictine monk was subsequently recorded by many authors.[5] Corner refers to Andrea Dandolo, Pietro Calo, Marin Sanudo, Pietro de Natali (Corner 1990, 50). The official version of the Translatio narrates the trip of the Venetian fleet to Lycia and this narration was adopted by most of the authors. However there are other texts that promote a different version. Martin da Canal in his chronicle, *Les estoires de Venise,* written in the late thirteenth century narrates that Venetians on their way back to Venice from the crusades stopped at Patras from where they brought the body of St Nicholas.[6] All the narrations make a reference to two more bodies that were found and transferred together with the body of St Nicholas that of St Nicholas the uncle and of St Theodore.

San Nicolo of Lido, the church that received St Nicholas relic, became the hub of the new noble mercantile society, as the place where the doge was elected and the scene of the sumptuous annual celebration of the *Sensa*, on the day of the Ascension.[7]

Finally, the Venetians established numerous churches with titular saint St Nicholas throughout the Byzantine Empire. Some of the most important were San Nicolo de Venetorum founded in 1159 by the prior Giovanni Rustico in Constantinople, and the churches of St Nicholas in Almiros, Corinth, Sparta, Thebes, and Abydos in the Troad.[8]

Born in the port city of Patara in Lycia and the saint of mariners, St Nicholas embodied the growing maritime economy of medieval Venice. The most important aspect was maritime trade, with the ship-building industry and the fish market also attested to in early documentation. The early origins of Venetian trade are well-documented (Morozzo della Rocca-Lombardo 1940). The ship-building industry, although limited to individual and private initiatives, existed at least as early as the twelfth century. Several *squeri*, small ship-making workshops, were active in various parts of the lagoon, and the first *Arsana Comunis,* the Arsenale, opened in 1206. An example can be found in a document of 1177 which records Romano da Mairano working in his *cantiere* in the area near to the monastery of San Zaccaria, constructing his own trading fleet (Concina 1984, 9). Finally, the *arte de pescatoribus,* the fishing guild, was vigorous in the north of the lagoon, dedicating its first statute in 1227 (Monticolo 1896, 59).

St Nicholas held particular importance to the fishermen. The aforementioned San Nicolo dei Mendicoli, or St Nicholas of the Poor, was the second most important religious foundation venerating St Nicholas, as titular saint and as the patron of the poor, orphans and people in need. In fact, the establishment gave the name to the whole quarter that extended on the north side of Dorsoduro along the Grand Canal. Although the church is an early medieval foundation dating to the eleventh century, its appearance was later altered by reconstructions.[9] The residents of the community, the so-called Nicolotti, were considerably less wealthy in comparison to other merchants and craftsmen in Venice but had special status. They could elect a separate *gastaldo*, the famous "doge of the poor" who participated in state ceremonies. This unusual privilege demonstrates the respect that the Venetian republic held towards the Nicolotti.[10] Furthermore, because membership in the guild and participation in the fish market were restricted to members of San Nicolo dei Mendicoli, an allegiance to the saint was required of all fishermen (Crouzet Pavan 2001, 183-231).

The Iconography of St Nicholas in Venetian Art
of the Trecento

As an important patron saint for the Venetians, St Nicholas soon acquired a place in the Venetian iconographic tradition. Representations of the saint are first known in Venetian art from the twelfth and the thirteenth centuries.

Not many works of the twelfth to early fourteenth centuries survive that show St Nicholas or his *vita*, mostly due to the dispersion of early Venetian panel painting during the Renaissance. However, there is a significant presence of the saint in the art commissioned by the official Venetian state. The oldest representation known, from the twelfth century, is a mosaic in the main apse of the Basilica of St Mark. The mosaic, displaying the four patron saints of Venice—St Mark, St Nicholas, St Peter, and St Hermagoras—asserts the function of the church as the ducal sanctuary.

The cult of the saint tended to be forefronted when the Venetian predominance of the sea was challenged. In 1340, the external rivalries of Venice culminated with a war against Genoa and in 1343 the Venetians allied with the pope Clement VI to put forward and to instigate a new Crusade against the Turks (Nicol 1988, 258-263).

It was mostly under Doge Andrea Dandolo (1343-1354) that the veneration of the saint was reinforced and the dissemination of his images flourished. The most powerful kings of the Middle Ages held a special veneration toward St Nicholas. It was Robert Guiscard, the French King of Bari who authorized the transfer of the relics of the saint to Bari, and King Louis VII who dedicated to St Nicholas his *saint chapelle* in Paris. Most of the Serbian Kings of the Nemanja dynasty established numerous chapels and donated icons of the saint as diplomatic gifts to their allies.[11]

Andrea Dandolo apparently developed a similar political dependency on the saint and incorporated the representation of St Nicholas into the majority of the works he undertook during his dogade (Pincus 1990, 191-205). St Nicholas occurs in the mosaics of the chapel of St Isidore, occupying a significant space, flanking the enthroned Madonna alongside St John the Baptist and participating in the eloquent narration of the *translatio* of St Isidore to Venice.[12] Likewise St Nicholas is reinserted among the major patrons and protectors of Venice in the *Pala Feriale*, the protective cover of the *Pala d'Oro*, signed by Paolo Veneziano and his sons in 1345. Here St Nicholas is represented in half bust flanking the Man of Sorrows alongside Theodore, Peter, the Virgin, John the Evangelist, and Mark, and is right above the panel that features the new burial of the St

Mark's relic; an arrangement that could possibly allude to the St Nicholas burial in Lido.[13]

The fifth panel of the second tier of the Pala, the maritime scene, constitutes an interesting case for further investigation (fig. 8-1). This scene narrates the episode of the transfer of St Mark's body from Alexandria to Venice, during which a terrible storm threatened to overturn the ship and drown the mariners, and St Mark intervened miraculously to save the ship and the navigators. The scene obviously is borrowed from the cycle of St Nicholas, more precisely from the episode that is called *praxis de nautis,* and narrates the intervention of St Nicholas to save mariners from a terrible tempest.[14] The Venetian republic and its people experienced extreme misfortunes between the years 1340-1345, especially under Doge Bartolomeo Gradenigo (1340-1343) including wars, plague, famine, and an earthquake that created a disastrous *acqua alta* threatening to drown the city.[15] Under these circumstances the recourse to the veneration of St Mark and St Nicholas is not surprising. This panel seems to be a tribute to their protection and their miraculous intervention. Here the two saints meet under the same iconographical and hagiographical context. As Edward Muir stresses, St Mark and St Nicholas constitute "a binomial mystery, a dual protectorship," and in a way the two saints supplement each other in the sphere of the saintly patronage (Muir 1981, 99). In the Venetian text for the *translatio* of St. Nicholas we read the name *Il Nocchiero*, in which some scholars see the combination of the two cults of St. Nicholas and St. Mark (Tramontin 1973, 805-806).

Another important work related with the iconography of St Nicholas is a polyptych painted by Paolo Veneziano assumed to be that commissioned by Andrea Dandolo in 1346 to decorate the chapel of the saint in the Ducal Palace.[16] The chapel clearly was of significance to the republic, as it was repeatedly altered, expanded, and reconstructed in the thirteenth and fourteenth centuries by multiple patrons.[17] Of the original polyptych only two panels survive, formerly in the Contini-Bonacossi collection in Florence.[18] One represents the saint's *Nativity* and the *Bath Miracle* and the other, the *Generosity of St Nicholas* (figs. 8-2, 8-3).[19]

Before trying to analyze their iconography we should explore the psychological and political motives behind these panels, especially the *Generosity of St Nicholas*. This specific panel constitutes a sophisticated reflection on the social service of the Venetian commune. According to the story, a noble man in Myra became so impoverished that he could neither support his daughters nor provide them with dowries and decided to hire them out as prostitutes. St Nicholas heard of the situation and, slipping out to the man's house one night, threw a bag of coins through the window.[20]

Although St Nicholas was generally patron saint of orphans and the poor, this story offers an eloquent allegory of the beneficial function of the Venetian state as a trustee and administrator of dowries, a practice that was also common in other Italian cities.[21] According to Venetian law, the dowry was to remain intact in order to support the widow in the death of her husband. The protection of women was achieved by depositing in the *procuratia* a sum equal to the estimated value of the dowry, which could be invested by the state in activities like trading and return profits to the families (Mueller 1971). The father, as head of the family, was responsible for providing the dowry. However, when patrician families could not afford a dowry, girls were sent to monasteries, or the state stepped in and provided the dowry.[22] In an annual ceremony established early in Venetian history, the doge and the commune sponsored weddings and dowries for twelve deserving but poor young girls in a ceremony conducted by the bishop in the cathedral of San Pietro in Castello.[23] Marriage ties became especially important for the patricians after the closing of their council, known as the *serrata*, in 1297. The nobility maintained their presence in the aristocratic government through the institution of marriage, where the wealthiest indirectly sponsored the marriages of daughters of poorer nobles, in order to ensure their hereditary aristocratic status (Chojnacki 1974, 179-180).

This unique practice of state-sponsored dowries may be connected to the episode where St Nicholas supports the young girls of an impoverished noble man. The garment of the man in the panel, the long tunic, *lucco*, and the distinctive hat, *cappuccino*, illustrate his noble origin.[24] That the crimson tunic was the official garment of patricians is clearly indicated in a Zaratine document of the middle fourteenth century:

"Ubi nunc eorum *palia muricis* coloris, uvi eorum indumenta variis suffulta cutibus".[25]

Decorating the seat of administrative authority, the *Generosity of St Nicholas* in the Ducal Palace becomes a suggestive allegory on the protective capacity of the Venetian state towards the poor noble families (Queller 1986, 30).

St Nicholas was generally popular in the fourteenth century in areas connected to the Venetian republic, often appearing among other saints in polyptychs or small retables from the workshop of Paolo Veneziano. Examples include the polyptych of Piran, another in the Cathedral of San Giusto in Trieste, and three works from Split: a panel with the Virgin and the Child surrounded by saints, an altarolo with the Virgin, the Child and the *Christo Passio*, and a triptych in the archaeological Museum.[26] Several

works from Venice itself have been lost. St Nicholas probably appeared in icons of the fourteenth century in the school of San Nicolo dei Carmini,[27] in San Nicolo in Lido, there is evidence for an elaborate ancona and for some panels from the iconostasis,[28] and finally in a partly preserved fresco from San Nicolo dei Mendicoli.[29]

Venice-Thessaloniki: The Byzantine models and their Venetian interpretation.

While developing their own cult and iconography for St Nicholas, the Venetians had to turn to the East for models. St Nicholas in the Byzantine tradition had a rich and well-developed imagery evidenced by the numerous *vita* icons and fresco cycles throughout the Byzantine Empire.[30] The Venetians absorbed this already established tradition, adding their own stylistic virtuosity and techniques.

The twelfth century mosaic of St Nicholas from the Basilica of St Mark is a clear example of how Byzantine elements were interpreted in a western composition. St Nicholas stands alongside Peter, Mark, and Hermagoras between the windows of the apse in the tier below the enthroned Christ (Demus 1984, 31-32). The representation of St Nicholas is otherwise Byzantine. He wears the typical Byzantine garments of an eastern hierarch: the *sticharion,* a long robe; the *phailonion,* a tunic; and the *omophorion,* a shoulder cover, decorated with crosses. He holds a book with his left hand while blessing with the right, unlike the South Italian tradition where he commonly wears a mitre and holds a crozier. This is the fundamentally Byzantine iconography of the saint. In fact in most of the eastern vita icons and wall paintings Christ offers him the gospel and the Virgin offers him an *omophorion*. This is the way he is also depicted in the panel of *pala feriale*. He is in frontal position, holding the gospel and wearing the *omophorion* which characteristically drops loosely around his neck. His hair and beard are undulating and his forehead accentuated. The work evokes a Sinai icon from the thirteenth century and numerous other representations of the saint in the Serbian art of the thirteenth and fourteenth centuries.[31]

The Venetian panel paintings representing St Nicholas are also firmly rooted in the Byzantine tradition. Most examples from the thirteenth century were Veneto-Crusader art produced in the Holy Land. Attributed to a painter of Venetian background is St Nicholas from the border frame of the Kykkotissa Icon and in the central panel of a Sinaite triptych (Folda 2005, 452, 461). Also two bust icons of St Nicholas are going back to Crusader and possibly Veneto crusader origin (Weitzmann 1963). These

early crusader works must have influenced Venetian panel painting of the Trecento, providing stylistic and iconographic antecedents for the depiction of the saint. A panel in the Museo Marciano painted in the northern Adriatic, perhaps in Venice itself, at the transition of the thirteenth and fourteenth centuries shows the Virgin and Child framed by saints, including Nicholas, in an essentially Byzantine style (Flores d'Arcais and Gentili 2002, 124).

In the Trecento, Venetian painting expresses both Byzantine and Gothic ideals. However, the works representing or alluding to St Nicholas show a closer affinity to the eastern tradition. A defining factor for the stylistic choice is without doubt the patronage of the works. Both the *Pala Feriale* and the St Nicholas panels are state commissions with special importance for the republic of Venice, which sought to establish itself as a new Byzantine Empire (Pincus 1992).

The closest counterpart to the maritime scene of Paolo Veneziano in terms of style and iconography comes from the Byzantine world, more precisely from the church of San Nicholas Orphanos in Thessaloniki. Here the *praxis de nautis* may refer to the capture of Thessaloniki by the Normans in 1185, while alluding to the recent invasion of the Catalans 1308 (fig. 8-4).[32] The fresco, part of a more extensive cycle of the life of St Nicholas over the eastern wall of the narthex, reflects more than the *Praxis de nautis,* the *Thauma of Artemide* and *the Praxis de navibus frumentaris.*[33] For that reason the composition is calmer, and diverges from the traditional sea story which is distinguished for its dramatic overtones such as devils flying on the mast, boat fighting with the waves, intense and desperate gestures of the crew. All these elements are absent. Instead the boat is floating an almost calm sea; St Nicholas is close to the mast, approaching the jar which, according to the myth, he will have to get rid of to cease the tempest and to pacify the sea.

The similarities between the panel of St Mark in Venice and the fresco of St Nicholas in Thessaloniki are obvious in the treatment of the sea, the usage of the jagged rocks, the type of the ship, more particularly the shape of the sail, fully inflated and adorned by a cross. The arrangement with the saint standing close to the mast over the people inside the boat is also similar. More striking is that the difference in subject between the two works is so elaborately bridged and translated in the same composition. The Byzantine connection is all the more striking given that the same subject appears in a very different, more typically Gothic mode on a rich in details and dramatic predella panel of the late fourteenth-century by the later painter Lorenzo Veneziano (Kustodieva 1977).

The maritime scene appears to have been more common in Byzantine art than in Italian, which might explain why Paolo borrowed an eastern model for his maritime scene of St Mark. On the other hand, the *Nativity* and the *Generosity of St Nicholas* are more consistent with popular Italian models. From a stylistic point of view, the two Venetian panels reveal influences from Bolognese painting, possibly reflecting the sojourn of Paolo in the Emilian city, and at the same time recent developments in Venetian painting of the middle of the Trecento, especially in respect to the architectonic settings and the clothing of the figures. The lavishly painted clothes reveal the love of the Venetian for textiles, while the representation of the buildings offers to us an unprecedented documentation of the late Gothic architecture in Venice. However, the panels still straddle the western and the Byzantine traditions.

The *Bath Miracle* in the Nativity is a scene met almost exclusively in Eastern art. Close counterparts are the relevant scenes in Staro Nagoricino[34] in Gracanica[35] and in Platsa[36], all of them dating to the first half of the fourteenth century, just about the same time as Paolo's panel. Interestingly enough all the Serbian cycles of St Nicholas start with the Nativity and the Bath Miracle. The more obvious similarity between the Serbian scenes and the panel of Paolo lies in the behavior of the child as he tries to stand on his feet without the help of the midwife.[37]

Both Staro Nagoricino and Gracanica paintings were executed by Michael Astrapas and Eutychios, two painters originating from Thessaloniki. In Staro Nagoricino an inscription has survived indicating the names of the two painters. In Gracanica, on the other hand, the attribution has been based on the similarities between the two churches Todic (1999, 331 & 320). It is possible that Michael Astrapas and Eutychios created a language that influenced broadly other contemporary artists.

Likewise, the panel of the *Generosity of St Nicholas* appears inspired by another Byzantine model attested in the church of St Nicholas Orphanos in Thessaloniki (fig. 8-5).[38] The latter fresco from Thessaloniki inaugurates a whole new conception of the scene in the eastern iconography and moves forward, even surpassing the inventiveness of the Roman painter in the Sancta Sanctorum (Romano 1995, 66). The father and daughters are enclosed in a separate room. In an innovative interplay between exterior and interior St Nicholas, on the far left, reaches up to a window from outside the building.[39] The affinities between the panel and the fresco in the construction of the space and in the behavior and posture of the saint are so great that can not be coincidental. Keeping in mind that this iconographic subject was extremely common to western art we are

inclined to believe that the painter of St Nicholas Orphanos had also borrowed models from the west, especially because after the first half of the fourteenth century the Byzantine composition becomes more conservative, the scene loses the partition of the walls and in consequence loses its perspective and the notion of space.

The two panels by Paolo coming from the administrative seat of the Doge were probably part of a greater assemblage. Their size indicates that there were more panels, now lost, with episodes from the life of St Nicholas. A later panel of Giovanni da Bologna from the Correr museum is indicative since it incorporates all the three scenes the 'Nativity' of the saint, the 'Story of the three maidens' and the episode where the saint saves three innocent soldiers from execution, known as *praxis de stratelatis* (Sevcenko 1983, 104-108). The *praxis de stratelatis* is the most ancient episode of the iconographic cycle of St Nicholas and the most common, therefore is very popular in the fourteenth century Serbian cycle of St Nicholas and can be seen in Staro Nagoricino and Decani, providing us with a third iconographic model from the life of St Nicholas that appears to have been adopted into the Venetian tradition.[40] As with the previous examples by Paolo, Giovanni da Bologna appears to have borrowed elements from the eastern iconography rather than contemporary Italian depictions of the scene. Again the resemblance with the *praxis de stratelatis* from Staro-Nagoricino is close especially in the posture of the three soldiers kneeling, with their eyes bandaged, ready to be executed and the way that St Nicholas intervenes to save them (Sevcenko 1983, 250, fig 21.9).

But how might the Venetians have become aware of the artistic developments taking place in Thessaloniki, Macedonia, and western Greece of the first half of the fourteenth century?

After the restoration of Constantinople in 1261 by Michael VIII the Palaiologue, Thessaloniki was set at the forefront of the artistic creativity of the Orthodox world and became the hub of the new Palaiologan art. In the thirteenth century there were flourishing workshops of mosaicists, goldsmiths, glassmakers, enamel makers, and a notable production of illuminated manuscripts (Bettini 1974, 66-68). This flourishing is partly due to the fact that Thessaloniki retained an important commercial role in the Balkans and in the Aegean sea, establishing new economic relationships with Italian cities like Venice and Genoa. This economic boom resulted in the emergence of a new powerful middle class of tradesmen and aristocrats who became the patrons of the new art. At the same time, and as the Byzantine Empire contracted, Thessaloniki became an autonomous city-state, a thoroughly cultured city which nurtured some

of the most pioneering intellectuals and humanists of the time.[41] Thessaloniki's development thus paralleled that of Venice under the dogade of Andrea Dandolo and his chancellor Benitendi da Ravegnani, itself an autonomous city and a burgeoning centre of humanistic studies.[42]

Therefore the iconographic and artistic relations between Venice and Thessaloniki might be expected, although the interaction of these two cities should be examined primarily within a commercial and political context.[43] Thessaloniki as a major centre exporting grain, appears already from the twelfth century as a destination and a transit station for Venetian merchants.[44] The first Venetian colony in the city should be dated at the end of that century;[45] however the first official documentation confirming the donation of a residential quarter to the Venetians of Thessaloniki dates to the following century in 1265.[46] That was placed under the jurisdiction of a Venetian consul who was appointed *per gratiam* by the *maggior consiglio* and whose presence is attested to in the city from the thirteenth century onwards.[47] Attempts to identify that residential area have proved fruitless; although considering the commercial activities of the Venetians we should probably place it within the Latin Quarter in the south-western part of the city, in the vicinity of the harbor. Unfortunately we do not have a firm knowledge of the urban characteristics of the Venetian settlement or specific establishments, but we do know that San Nicolo of Lido had also a dependency in the city around 1187.[48] The majority of the agreements between Venice and Thessaloniki can be classified as political or economical as they refer to the appointment of consuls and other magistrates or ambassadors in the city and to regulations for conducting trade (Giomo 1970, 81, 82, 106, 108, 121, 130, 237).

Moreover the King of Serbia Milutin, Stephan Uros II, making Thessaloniki his second home, played a great part in the distribution of the new ideas. His mother in law Irene transferred her residence to the city of Thessaloniki in 1303 and together with King Milutin set about restoring, establishing and endowing churches in the area of Thessaloniki and in the broad area of Macedonia.[49] St Nicholas Orphanos (1310-1320), therefore, has been considered an establishment of Milutin which partly explains the influx of various western elements in the church.[50] Milutin was also the founder of St George in Staro Nagoricino (1317-1318) and Gracanica (1315), offering an explanation for the artistic and iconographical exchange between Staro Nagoricino, Gracanica and the Venetian panel painting.[51]

In fact the presence of the Serbian element in Thessaloniki is recorded as early as the twelfth century. Contemporary historical documents indicate the existence of a Serbian population in the church of St.

Nicholas. Eustathios, Bishop of Thessaloniki, in his historic account of the capture of Thessaloniki by the Normans, narrates the efforts of the people to defend the city as follows:

> "They bore themselves bravely even though many of them were without weapons, included among them were the children of the "Myrovlitou" and some of the Serbians that were attached to his cult and showed no fear of the enemy." (Eustathios 1988, §76; Tafel 1839, 142)

In the fourteenth century however this Serbian presence was intensified first with King Milutin (1282-1321) who established power through his marriage to the daughter of Andronikus II, Simonis, in 1299, and promoted Byzantine influence on Serbian art. The second Serbian expansion came with Dusan, who became king of the Serbs and the Greeks between 1331-1346.

The Macedonian influence was exerted through the whole Greek territory to the southern part of Greece. The church of St Nicholas at Platsa in Mani, although it was established in the ninth century, had a major renovation between 1337-1348 (Mouriki 1975, 14-18). The patron of the new program, Constantine Spathis, known from the inscriptions in the interior of the church, was the administrative authority of the area and had Slavic origins with the Melings family, a Slavic tribe. The Bath Miracle from Platsa, part of an extensive cycle of the life of St. Nicholas, matches unexpectedly the model of Staro Nagoricino and is almost contemporary with Paolo's Bath Miracle. It is generally accepted that the painters of the south aisle of the church were coming from an important artistic centre in northern Greece (Mouriki 1975, 69-72).

A very close relationship was developed between the cult of St Nicholas and the Serbian rulers. This is apparent in the use of the saint's life cycle and cult in most of the endowments of the Serbian dynasty. Cycles of St Nicholas can be found in Sopocani, Arije, Pizren, Gracanica, Melnik, Episkope and Calendzixa. Venice, trying to integrate the cult of St Nicholas and to promulgate the political appeal of a rising empire, found in Macedonian art the appropriate language to express the new political dynamics. In fact, the influence of Macedonian art, a hybrid of Greek skills and Serbian patronage, on the Venetians is an important aspect of the study of Venetian painting, one which I have only begun to explore in this paper.

Moreover the exchange of artistic languages must have been an outcome of the activity of itinerant merchants and artisans between Venice, Thessaloniki and the Balkans. The cultural rapports between Venice and Thessaloniki were established both via direct contact between

the two cities as well as via the Macedonian art of the Serbian rulers that from an early stage penetrated the north-Italian region.[52]

To conclude, the old cult of St Nicholas was deeply rooted in maritime cities that were in direct connection with the water such as Bari, Thessaloniki, and Venice. It is noteworthy that the veneration towards the saint was reinforced in certain moments when the Venetian State was ravaged by internal disasters or external enemies. It is not accidental that two recognitions, *recognitio* of the body of St Nicholas took place, one just after the plague of 1347 and the other, two years later in 1349 (Tramontin 1965, 195-197).

Finally whatever the exact way the Venetian painters came in contact with the Byzantine iconography of St Nicholas, they apparently turned to contemporary Macedonian painting, from which they borrowed schemes that they adapted and developed in their own artistic language; a language that defined Venetian painting of the Trecento.

Notes

[1] This article was presented at the International Medieval Congress in Leeds in 2007, and constitutes a part of my thesis where I examine the Venetian panel painting of the first half of the 14th Century, conducted in the University of Glasgow, under the supervision of Professor Robert Gibbs and Dr John Richards. I am also indebted to Professor Julian Gardner who first advised me to undertake research into the cult of St Nicholas in Venice.

[2] St Nicholas and his cult has been the subject of numerous studies. The first important work is the hagiographic treatise of Anrich (1913). The most detailed study for the saint's iconographical cycle in the Eastern tradition is that of Sevcenko (1983). Moreover a very comprehensive study incorporating different aspects for his cult, his veneration and his iconography both in the West and in the East was the volume of Otranto (1987) while a more abbreviated recent version of his myth and the development of his iconography can be found in the recent work of Bacci (2009). Finally individual studies exist for the churches dedicated to St Nicholas while a thesis on the cult of St Nicholas in medieval Italy was recently completed by Sarah Burnett (2009).

[3] A later church dedicated to San Nicolo of Bari was founded in Venice in the 15th century, see Franzoi, (1976 , 511-514) . Moreover there were schools dedicated to St Nicholas dating between the 13th-16th century: Scuola di San Nicolo e San Niceto (1237), Scuola di San Nicolo dei Mercanti (1319), Scuola di San Nicolo di Bari (1398), Scuola di San Nicolo dei bastasi del Fontego dei tedeschi (1431), Scuola di San Nicolo dei Greci per I Greci residenti in Venezia (1498), Scuola di San Nicolo dell'arte dei Cimadori (1530)Scuola dei Marineri di San Nicolo di Castello (1573) see Gastone (2004).

[4] For a detailed account of the furta sacra in the Middle Ages see Geary (1978) and Tramontin (1973).

[5] The Venetian version was written at the end of the 12th century, just after the translatio under the title *Historia de translatione da un Monaco di un monastero del Lido*. For other, more famous, accounts of the *translatio* see Corsi (1987).

[6] *"li evesque Henric Contarins, que au retorner que il fist s'en ala il a Patras et osta d'ileuc le cors de monseignor saint Nicholas li Evesque et son oncle saint Nicholas et tiers saint, que l'en apele mesire saint N., et les condustrent en Venise."* Enrico Dandolo on his way back he stopped at Patras and he took the body of San Nicolo Bishop and San Nicolo zio and a third saint whose name was also Messer San N. and he brought them back to Venice. Da Canale (1972, 26)

[7] For more details on the election of doge Domenico Selvo in 1071 that took place in Lido in the church of St Nicholas see Cracco (1992, 947-950). For the cult of St Nicholas and the feast of the Sensa see Cracco (1967, 116-117).

[8] See Jadran (1992) and Morozzo della Rocca-Lombardo (1940, §88, §205, §137, §382).

[9] It has been suggested that the church was founded by the family Zancaruoli, in Corner we read *Zancarola*, one of the noble families in the quarter of Mendigola in Dorsoduro, see Corner (1990, 415-416) and Franzoi (1976, 190-191).

[10] For the special privileges held by the community of the Nicolotti and their gastaldo see also Scarpa (1975).

[11] Among them, one of the most precious gifts was the icon that the spouse of Uros I and daughter of Baldwin I, Helena d'Anjou offered to the Pope Nicholas IV, now in the Vatican treasury. The bottom of the icon has a very prestigious depiction of Helena being crowned by St Nicholas, for details about the painting, see Flores d'Arcais and Gentili (2002, 116-117).

[12] The formation of the chapel of St Isidore started in 1348 and finished by the Doge Giovanni Gradenigo in 1355. More about the decoration of the chapel see De Franceschi (2003).

[13] For a detailed discussion on the pala feriale and the politics connected with the work see Goffen (1996).

[14] For an account of the life and the miracles of St Nicholas see Cioffari (1987).

[15] For the commissions under the dogeship of Andrea Dandolo and the contemporary political conditions see Pincus (1990).

[16] *"Dedimus ducatus XX auri magistro Paulo pentore Sancti Lucae, pro pentura unius bone facte in ecclesia Sancti Nicolai de Palacio, Die XX mensi Julii:"* We bequested 20 golden ducats to master Paolo painter of the district of Santa Lucia, in order to produce a painting 'bone facte', virtuously crafted for the chapel of St Nicholas in the Ducal Palace, 20th day of the month July , see Lorenzi (1868, 33).

[17] The chapel was inaugurated by doge Pietro Ziani immediately after the end of the fourth crusade in 1204, although the intention for its construction was first expressed by Enrico Dandolo and Sebastiano Ziani. The chapel was reconstructed by doge Giovanni Soranzo who also repainted it with stories from the reconciliation of the Pope Alexander III and the Emperor Barbarossa. Between 1319 and 1346 the space was subjected to numerous alterations and improvements, see Zanotto (1853, 16).

[18] The panels of St Nicholas were first attributed to Paolo Veneziano by Sandberg-Vavala (1930), the attribution was reinforced later by Pallucchini who was the first to make the connection with the commission of the painting for the chapel of San Nicolo, see Palluchini (1964, 35). Muraro had second thoughts for the origin of the work, Muraro (1970, 36). For a cohesive account of the history of the attributions see Pedrocco (2003, 174).

[19] The representations of St. Nicholas were generally inspired by the *Vita* of Giovanni Diacono that was written in the 9th Century and was the source for all the later hagiographical sources such as 'the Legenda Aurea' of Jacopo da Voragine. However these particular episodes are included in all the famous *Vitae* of St Nicholas in the '*Vita per Metaphrasten*', '*Vita per Michaelem*' and '*Encomium Neophyti*'. From the area of the Veneto originates a codex from the 15th century (XII.F.25) that refers to all the major episodes from the life of St Nicholas and comes from the library of the convent of San Giovanni a Carbonara in Naples. See Cioffari (1987, 20-37).

[20] The story was very common in the Byzantine world see Sevcenko (1983, 86-90). However it became immediately very popular in the West. Dante in the purgatory he uses the model of St Nicholas to exemplify poverty (XX, 31-33) see Alighieri (1929, 473).

[21] For example in Florence the role of the safe guardian of the dowries was undertaken by the commune. In fact in 1425 a new institution was established the *Monte dei Doti* or *Monte delle fanciule* that insured the transmission of the patrimonial property, see Kirshner and Molho (1978).

[22] More about the institution of dowries and about the position of men and women in the Venetian commune see Chojnacki (1979; 2000, 135). A detailed account of the position of the woman in the Middle Ages can be found in an early study of Cecchetti (1886) and also in Guzzetti (2002, 2004).

[23] A chronicle composed at the end of the 15th century testifies that from the ancient times, on the 31st January of each year that is on the day of the transfer of St Mark a sumptuous ceremony took place, the *Festa della Marie*, during which the Doge was giving dowries to 12 impoverished daughters. For more details see Muir (1981, 135-154). Other chronicles place the feast on the 2nd of February day of the Purification of the Virgin and they describe a visit of the Doge in the parish church of Santa Maria Formosa where the feast took place. More on this celebration see Devaney (2008).

[24] Similar clothing we can see in the capitals of the columns in the Palazzo Ducale, sculpted around 1340 by Filippo Calendario, in particularly in the zodiac capitals, see Wolters (1972, 172-178). Moreover in a capital from the town hall in Ragusa we meet the same clothing in an allegory of the justice.

[25] *Palia muricis* is the purple colour in a literal translation but it is likely that they mean red with the use of the adjective *murex*, See G. Schwandtner, *Scriptores rerum hungaricarum, dalmaticarum, croaticarum, slavonicarum veteres ac genuine*, t.III, Vindobonae, 1748. I am indebted to the professor of the University of Budapest Neven Budak for this observation and for the provision of the Zaratine source.

[26] For the aforementioned works see Flores d'Arcais and Gentili (2002, 158-159), Muraro (1970, 150), Pedrocco (2003, 211), Il Trecento (2002, 170-171), Il Trecento (2002, 126-127).

[27] Testi in his early treatise about Venetian painting mentions an icon of St Nicholas from the school of San Nicolo dei Carmini that was dismantled in the 19th century, see Testi (1909, 150).

[28] An inventory of the sacristy from 1371 from San Nicolo in Lido refers to the existence of an ancona *cum imaginibus multum pulchra*, now lost, also there is evidence for a panel of St Nicholas surmounting the iconostasis of the church and flanked by the images of Nicolo Giustiniani and Anna Michiel, see Fabbiani (1989, 55) and Corner (1990, 66) : *cererum imagines tres ille sue Sanctique Nicolai posite, in ingressu Chori super Januam depicte, ut supra dicitur quas vidimus multi nostrum, ..ibi prope figuram Beatissime Marie Nicolai Giustiniani, eiusque uxoris Annae..*

[29] This is a Crucifixion of an anonymous painter, dated around 1320-1330 with dimensions, 155x170 cm, and comes from a first-storey attached room of the original foundation of San Nicolo dei Mendicoli, that served probably as the office of the church authority. The discovery took place recently and the mural was published and described by Merkel (1978). It can be stated with a great degree of probability that the space occupied by one of the two lost saints on the far left of the composition featured St Nicholas.

[30] For the cycles of St. Nicholas see Sevcenko (1983) and for the Vita Icons see Sevcenko (1999).

[31] For the Sinai Icon see Weitzmann (1963, 195).

[32] During the capture of the city by the Normans, St Nicholas had interfered to save the city see Eustachios (1988, 94): "Indeed the arrows that were fired from the Golden Gate on the west took wing and continued in their flight through the air as far as the shrine, so that the great Nicholaos the Myrovletes once awoke, and fell upon the tents of the barbarians, which were moved away at once".

[33] The fresco of St Nicholas Orphanos represents "the Praxis de navibus frumentaris". According to the episode *Praxis de navibus frumentariis in Mari* mentioned in various versions of St Nicholas life, once that Myra was in a severe situation of famine St Nicholas appeared to the captain of a grain ship and giving him gold ordered him to proceed and navigate directly to Myra with the cargo to nurture the city. The scene appears broadly in the decoration of several ecclesiastical monuments from Greece and Serbia. See Sevcenko (1983, 97).

[34] The *diakonikon* was separated from the *Naos* by a full wall. The cycles of St Nicholas appear in the side-chapels flanking the apse, in what we loosely call the *prothesis* and the *diakonikon*, we find that these rooms where totally walled off from the rest of the church and accessible only from the *bema*. A portrait of St Nicholas might occupy the conch or the apse. These chambers actually take on the aspect of distinct and separate chapels dedicated to St Nicholas while the church itself can be dedicated to another saint or feast. St Nicholas decoration can also be found in the *diakonikon* of Sopocani, Arije, Pizren, and in the *prothesis* (north *parekklesion*) in Gracanica, Prizren, Monemvasia, Melnik, Episkope, Calendzixa.

For the lateral chapels and their programs and the Serbian monumental painting see Babic (1969, 129-158).
[35] In Gracanica in the church of the Annunciation that was restored in 1315 by King Milutin , the frescocs can be found in the vault of the north *parekklission*. See Todic (1999, 330-337). This comes from the *diakonikon* (south *parekklession*) of the church. The church was established in 1312/1313 by King Milutin. Todic (1999, 320-325), Sevcenko (1983, 242, fig 21.1)
[36] For the frescoes of St Nicholas in the church of Platsa in Mani see Sevcenko (1983, 276, 28.1) and Mouriki (1975).
[37] The Bath Miracle is almost unknown to the Western art. In the 12th century the baby is still represented supported by the midwife. In Staro Nagoricino, Gracanica and Platsa the scene is clear and monumental. See Sevcenko (1983, 68-69).
[38] For San Nicholas Orphanos and its fresco cycle see Tsitouridou (1986), Xyngopoulos (1955), Mavropoulou Tsioumi (1986), Todic (1999, 347-350) and Velmans (1966).
[39] It is very interesting that in the sacramentary of St Mark, also commissioned during the dogade Andrea Dandolo we can find a miniature of St Nicholas providing a dowry to the three maidens with a similar treatment of the composition: sacramentary cat.no.20. Venice, BNM, cod.lat.cl.III, III(=2116), fol.132, see Katzenstein (1987, 109).
[40] The homicide with the strike of the knife, *percuciens gladio* as it is described in the *Praxis de Stratilatis,* was one of the most condemned acts in the Venetian law, See Margetic (1992).
[41] The author Thomas Magistros, the bishops and authors Neilos and Nicolaos Kavassilas and the monk Varlaam, all lived in Thessaloniki around 1330-1331 and inaugurated and promoted the humanistic and hellenistic studies, see Tafrali (1913, 149-151).
[42] Muraro (1972, 189). He quotes: "The most characteristic aspect of this phase was the return to the study, the spirit and the traditions of the ancient Hellenism."
[43] For the economical condition of the city and of the broader area of Macedonia see Laiou (1980-1981; 2000a; 2000b).
[44]Thessaloniki is often documented as a traffic station see Morozzo della Rocca, Lombardo (1940, §137, §235, §399, §400, §415)
[45] Pietrus Bono from the quarter of Santa Maria Formosa is mentioned as a resident of Thessaloniki in 1191: "*Qua propter ego quidem Pietrus Bono filius quondam Mathei Bono de Confinio Sancte Marie Formose nunc autem habitator in Saloniki.*" Morozzo della Rocca, Lombardi, (1940, 391). And in 1193 Pietro Syriano from Mazzorbo and Gherardo Marchesano are documented, living in Thessaloniki and being part of a trading boat called San Marco: "*Testificamur nos quidem Petrus Syriano de Maioribus et Girardus Markisano habitator in Saloniki quod nos eramus in nave in qua nauclerus ereat Paulus Desde in Saloniki...*" Morozzo della Rocca, Lombardi (1940, 417). For an extensive discussion on the trade between East and West see Jacoby (1994; 1997). For the Venetian case specifically see Borsari (1988) and Chrysostomidis (1970).
[46] For the treaty between Michael Paleiologus and Ranieri Zen in 1265 and the donation of the residential quarter see Tafel (1839, 81) "*Item dare sibi debeat*

Imperium meum in Salonichi extra castrum terram et locum ubi sibi placebit.pro faciendo sezium et mansionem. Item in partibus de Volero et de Eno".
[47] An interesting point is that around 1318, consul of the Venetian colony in Thessaloniki was Giuliano Zancarolo. See Thiriet (1953). The Zancarolo family on the other hand was the founder family of San Nicolo dei Mendicoli. The name of the family is also met often in Crete.
[48] For the presence of foreigners in Thessaloniki see Jacoby (2003), while for the Venetian presence see Jadran (1992) and Borsari (1988, 39) with particular reference to the foundation of Lido.
[49] For Irene and her connections with Thessaloniki through the Montferrat family and through her marriage with the byzantine emperor Andronikos II Paliologos see Nicol (1988).
[50]Tsitouridou recently established King Milutin as the probable founder of the church of St Nicholas Orphanos, see Tsitouridou (1986, 29). A source offering testimony that the king built a church of such a dedication in the second city of the Empire is the text of Archbishop Danilo II. King Milutin previously had founded the monastery of Chilandary, in Mount Athos. Moreover it is an established true that the Nemanja family held a specific devotion for St Nicholas.
[51] The occurrence of the saint of St George 'Ο Γοργός' both in St. Nicholas Orphanos and in Staro Nagoricino is the most conclusive element that led the scholars to argue in favor of the activity of the same artists in both churches.
[52]With the word Macedonia we define a broad geographical territory which contains Serbia, Bosnia, Kosovo, Scopja, and expands to Thessaloniki (including the hinterland of Constantinople and the Marmara sea, along the northern coast of the Aegean and as far as the Adriatic coast in the west).When talking about the Macedonian influence of the thirteenth century we mostly imply the central area of the Balkan peninsula, which extended between the rivers Sava and Danube and to the south almost to Skopja, known as Raska, which became the seat of the powerful dynasty of Nemanja. Moreover at the beginning of the fourteenth century and during the Palaiologan dynasty, the word Macedonia was connected with the area of Thessaloniki that became the new artistic hub. For more about geographical definition of Macedonia see Koder (2000).

References

Alighieri, Dante. 1929. *La Divina Commedia.* Edited by Giuseppe Vandelli. Milalo: Ulriko Hoepli
Anrich, Gustav. 1913. *Hagios Nikolaos: der Heilige Nikolaos in der Griechischen Kirche.* Leipzig, Berlin: B G Teubner.
Babic, Giordana. 1969. *Les chappelles anexes des eglises byzantines. Foction Liturgique et Programmes Iconographique.* Paris: Editions Klincksieck.
Bacci, Michele. 2009. San Nicola, *Il grande traumaturgo.* Bari: Editori Laterza

Bettini, Sergio.1974. *Venezia e Bisanzio*. Venezia: Electra Editirice.

Borsari, Silvano. 1988. *Venezia e Bisanzio nel XII secolo, I rapporti economici*. Venice: Deputazione editrice.

Burnett, Sarah. 2009. The Cult of St Nicholas in Medieval Italy, PhD diss., University of Warwick. http://wrap.warwick.ac.uk/3632/1/WRAP_THESIS_Burnett_2009.pdf

Cecchetti, Bartolomeo. 1886. "La donna nel medioevo". *Archivio Veneto* 31: 33-69, 307.

Cessi, Roberto. 1985. *Venezia del Duecento: Tra Oriente ed Occidente*. Venice: Deputazione editrice.

Chojnacki, Stanley. 1974. "Patrician Women in Early Renaissance Venice." *Studies in the Renaissance* 21:176-203.

—. 1979. "Dowries and Kinsmen in Early Renaissance Venice." *Journal of Interdisciplinary History* 5 (4): 571-600.

—. 2000. *Women and Men in Renaissance Venice*. Baltimore Md: The John Hopkins University Press.

Chrysostomidis, Julian. 1970. "Venetian Commercial privileges under the Paleologi.".*Studi Veneziani* 12:267-356.

Cioffari, Gherardo. 1987. 'La vita.' In *San Nicola di Bari e la sua Basilica, Culto, Arte, tradizione*, edited by Giorgio Otranto, 20-37. Milan: Electa.

Concina, Ennio. 1984. *L'arsenale della Repubblica di Venezia*. Milan: Electa.

Corner, Flaminio, ed. 1990. *Notizie delle chiese e monasteri di Venezia e di Torcello tratte dalle chiese veneziane e Torcellane*. Introduction by Ugo Stefanutti. Bologna: Arnaldo Forni.

Corsi, Pasquale. 1987. "La traslazione delle reliquia." In *San Nicola di Bari e la Sua Basilica, Culto, Arte, Tradizione*, edited by Giorgio Otranto, 37-49. Milan: Electa.

Cracco, Giorgio. 1967. *Societa e stato nel Medioevo veneziano*. Florence: Olschki.

—. 1992. "I Testi agiografici." In *Storia di Venezia dalle Origini alla Caduta della Serenisima*, 923-956. Rome: Istituto della Encyclopedia Italiana, Fondata da Giovanni Treccani.

Crouzet - Pavan, Elisabeth. 2001. *Torcello, Storia di una citta scomparsa*. Rome: Jouvene Societa Editoriale.

Da Canal, Martin. 1972. *Les estoires de Venice*. Edited by Alberto Limentani. Florence: Olschki.

De Franceschi, Enzo. 2003. "I mosaici della capella di Sant'Isidoro nella basilica di San Marco." *Arte Veneta* 60: 7-29.

Demus, Otto. 1984. *The mosaics of San Marco in Venice.* Vol 1, Chicago: University of Chicago Press.

Devaney, Thomas. 2008. "Competing spectacles in the Venetian Festa delle Marie." *Viator* 39 (1): 107-125.

Eustachios of Thessaloniki. 1988. *The Capture of Thessaloniki.* Translated by John R. Melville-Jones. Canberra: Australian Association for Byzantine Studies.

Fabbiani, Licia. 1989. *La fondazione monastica di San Nicolo di Lido (1053-1628).* Venice: Universita degli studi di Venezia.

Folda, Jaroslav. 2005. *Crusader Art in the Holy Land: from the third Crusade to the fall of Acre.* Cambridge: Cambridge Scholars Press.

Franzoi, Umberto, and Dina Di Stefano. 1976. *Le chiese di Venezia.* Venice: Alfieri.

Gallo, Andrea, and Stefania Mason. 1995. *San Nicolo dei Mendicoli.* Venice: Marsilio.

Gastone, Vio. 2004. *Le scuole piccole nella Venezia dei Dogi, Note d'archivio per la storia delle confraternite veneziane,* Costabissara (Vicenza): A. Colla.

Geary, Patrick J. 1978. *Furta Sacra. Thefts of Relics in the Central Middle Ages.* Princeton, N.J.: Princeton University Press.

Giomo, Giuseppe. 1970. *I Misti del Senato della Repubblica Veneta (1203-1331).* Amsterdam: Adolf M. Hakkert-Publisher.

Goffen, Rona. 1996. "Il palliotto della pala d'oro di Paolo Veneziano e la commitenza del doge Andrea Dandolo." In *San Marco, Aspetti Storici e agiografici, Atti del Convegno Internazionale di Studi. Venezia 26-29, Aprile, 1994,* cura di Antonio Niero, 313-333. Venice: Marsilio.

Guiotto, Maria. 1948. "L'antica chiesa di S. Nicolo nel Lido di Venezia." *Atti dell'Istituto Veneto di Scienze, Lettere ed Arti* 56 (2):175-193.

Guzzetti, Linda. 2002. "Dowries in 14th century Venice." *Renaissance Studies* 16 (4): 429-602.

—. 2004. "Le donne nello spazio urbano della Venezia." In *Donne a Venezia, Vicende Femminili fra Trecento e Settecento,* edited by Susanne Winter, 1-22. Rome: Edizioni di storia e letteratura; Venice: Centro tedesco di studi veneziani.

Flores d'Arcais, Francesca, 2002. *Il Trecento Adriatico: Paolo Veneziano e la pittura tra Oriente ed Occidente.* Milan: Silvana.

Jacoby, David. 1994. "Italian Privileges and Trade in Byzantium before the fourth Crusade: A Reconsideration." *Annuario des estudios medievales* 24:349-369.

—. 1997. "The Migration of Merchants and Craftsmen: a Mediterranean Perspective (12th-15th Century)." In *Trade, Commodities and Shipping in the Medieval Mediterranean*. 533-559. Aldershot: Ashgate, 1997.

—. 2001. "The Venetian Quarter of Constantinople from 1082 to 1261." In *Novum Millenium, Studies on Byzantine History and Culture dedicated to Paul Speck,* edited by Claudia Code and Sarolta Anna Takacs, 132-170. Aldershot: Ashgate.

—. 2003. "Foreigners and Foreignness and the urban economy in Thessaloniki ca, 1150-1450." *Dumbarton Oaks Papers* 57:85-132.

Jadran, Ferluga. 1992. "Veneziani fuori Venecia." In *Storia di Venezia dalle Origini alla Caduta della Serenissima*. 693-719. Rome: Istituto della Encyclopedia Italiana, Fondata da Giovanni Treccani.

Kaftal, George. 1978. *Iconography of the Saints in the Painting of North-East Italy*. Florence: Sansoni.

Katzenstein, Ranee A. 1987. *Three liturgical Manuscripts from San Marco: Art and Patronage in mid-Trecento Venice*. PhD diss., Harvard University.

Kirshner, Julius, and Antony Molho. 1978. "The Dowry Fund and the Marriage Market in Early Quattrocento Florence." *The Journal of Modern History* 50 (3):403-438.

Koder, Johannes. 2000. 'Macedonia in Byzantine Spatian Thinking.' In *Byzantine Macedonia, Identity, Image and History. Papers from the Melburne Conference, July 1995*, edited by John Burke and Roger Scott, 12-28. Perth: Australian Association of Byzantine Studies.

Kustodieva, Cristiana. 1977. "Due frammenti della pittura veneziana del Trecento." *Arte Veneta* 50: 7-11.

Laiou, Aggelliki. 1980-1981. "The Byzantine Economy in the Mediterranean Trade System, 13th-15th Centuries". *Dumbarton Oaks Papers* 34: 177-222.

—. 2000a. "The Economy of Byzantine Macedonia in the Paleologan Period." In *Byzantine Macedonia, Identity, Image and History. Papers from the Melburne Conference, July 1995*, edited by John Burke and Roger Scott, 199-212. Perth: Australian Association of Byzantine Studies.

—. 2000b. "Thessaloniki and Macedonia in the Byzantine period." In *Byzantine Macedonia, Identity, Image and History. Papers from the Melburne Conference, July 1995*, edited by John Burke and Roger Scott, 1-12. Perth: Australian Association of Byzantine Studies.

Lorenzi, Giambattista.1868. *Monumenti per Servire alla storia del Palazzo Ducale: Parte I*. Venice: Vicentini.

Margetic, Lujo. 1992 "Il diritto". In *Storia di Venezia dalle Origini alla Caduta della Serenissima*. 690-69. Rome: Istituto della Encyclopedia Italiana, Fondata da Giovanni Treccani.

Mavropoulou-Tsioumi, 1986. *The church of St Nicholas Orphanos, Thessaloniki,* Institute for Balkan Studies.

Merkel, Ettore. 1978. "I Maestri della Crocefissione della Chiesa di San Nicolo dei Mendicoli." *Quaderni della Sorpritendenza ai beni artistici e storici di Venezia* 7:77-78.

Monticolo, Giovanni. 1896. *I Capitolari delle arti Veneziane*. Rome: Forzani e C. Tipografi del Senato.

Morozzo della Rocca, Raimondo, and Agostino Lombardo. 1940. *Documenti del commercio veneziano nei secoli XI-XII*. Vol. 1. Rome.

Mouriki, Doula. 1975. *The frescoes of the church of St Nicholas at Platsa in the Mani*. Athens: Bank of Attica.

Mueller, C. Reynold. 1971. "The Procurators of San Marco in the 13th and 14th Centuries: A study of the office as a financial and trust institution." *Studi Veneziani* 13: 105-220.

Muir, Edward. 1981. *Civic Ritual in Renaissance Venice*. Princeton NJ: Princeton University Press.

Muraro, Michelangelo. 1970. *Paolo da Venezia*. London: University Park: The Pennsylvania state university press.

—. 1972. "Vari phasi di influenza bizantina a Venezia nel Trecento." *Thesaurismata* 9:180-201.

Newton, Stella Mary. 1980. *Fashion in the age of the Black Prince, A study of the years 1340-1365*. Rochester NY: Boydell & Brewer

Nicol, M. Donald. 1988. *Byzantium and Venice, A study in diplomatic and cultural relations*. Cambridge: Cambridge University Press.

Otranto, Giorgio, ed. 1987. *San Nicola di Bari e la sua Basilica, Culto, Arte, tradizione*. Milan: Electa.

Pallucchini, Rodolfo. 1964. *La pittura Veneziana del Trecento*. Venezia, Roma: Istituto per la Collaborazione Culturale.

Pedrocco, Filippo. 2003, *Paolo Veneziano*, Milan: Alberto Maioli Editore.

Pertusi, Agostino. 1978. "Ai confini tra religione e politica. La contesa per le reliquie di San Nicola tra Bari, Venezia e Genova." *Quaderni Medievali* 5:6-56.

Pincus, Debra. 1990. "Andrea Dandolo (1343-1354) and Visible History: The San Marco projects." In *Art and Politics in Late Medieval and Early Renaissance Italy, 1250-1500,* edited by Charles Rosenberg, 191-205. Notre Dame, IN: University of Notre Dame.

—. 1992. "Venice and the two Romes: Byzantium and Rome as a Double Heritage in Venetian Cultural Politics." *Artibus et Historiae* 13 (26):101-114.

Queller, Donald E. 1986. *The Venetian Patriciate: Reality versus myth.* Urbana: University of Ilinois Press.

Rigon, Antonio. 2001, "Devozioni di lungo corso: lo scalo veneziano in Genova." In *Genova, Venezia, il Levante nei secoli XII-XIV. Atti del Convegno internazionale di studio (Genova-Venezia, 10-14 marzo 2000),* edited by Gherardo Ortalli and Dino Puncuh, 394-412. Venice: Istituto Veneto di Scienze, Lettere ed Arti.

Romano, Serena. 1995. "Il sancta sanctorum: Gli affreschi," In *Sancta Sanctorum,* 38-123. Milan: Electa.

Runciman, Steven. 1970. *The last Byzantine Renaissance.* Cambridge: Cambridge University Press.

Sandberg Vavala, Evelyn. 1930. "Maestro Paolo." *The Burlington Magazine for Connoisseurs* 57 (331): 160-183.

Sevcenko, Nancy Peterson. 1983. *The life of St Nicholas in Byzantine Art.* Turin: Bottega d'Erasmo.

—. 1999. "The 'Vita' Icon and the Painter as Hagiographer." *Dumbarton Oaks Papers* 53:149-165

Scarpa, Roberto. 1975. *Notizie della Chiesa e Parrochia di San Nicolo dei Mendicoli. Dalle Origini al Restauro.* Venezia: Venice in Peril Fund.

Tafel, Gottlieb-Lucas-Friedrich. 1839. *De Thessalonica eiusque argo dissertatio geographica.* Berlin:GA Reimerum.

Tafrali, Oreste. 1913. *Thessalonique au quatorieme siecle.* Paris: P. Geuthner.

Testi, Laudedeo. 1909. *Storia della pittura veneziana.* Vol. 1, *Le origini.* Bergamo: Istituto italiano d'arti grafiche.

Thiriet, Freddy. 1953. Les Venitiens a Thessalonique dans la premier moitie du XIV siecle. *Byzantion* 22:23-332.

Todic, Branislav. 1999. *Serbian medieval painting, The age of King-Milutin.* Belgrade: Draganic.

Tramontin, Silvio. 1965. *Culto dei Santi a Venezia.* Venice: Edizioni Studium Cattolico Veneziano.

—. 1973. "Influsso Orientale nel culto dei Santi a Venezia fino al secolo XV." In *Venezia e il Levante fino al secolo XV,* vol. 1, edited by Agostino Pertusi, 801-820. Florence: L.S Olschki.

Tsitouridou, Anna. 1986. *Ho zographikos diakosmos tou Hagiou Nikolaou Orphanou ste Thessalonike, symbole ste melete tes palaiologeias zographikes kata ton proimo 14° aiona.* Thessalonike: Kentro Vyzantinon Ereunon.

Velmans, Tania. 1966. "Les fresques de Saint Nicholas Orphanos a Salonique et les rapports entre la peinture d'Icones et la decoration monumentale au XIV siecle." *Cahiers Archeologique* 16:145-176.

Weitzmann, Kurt. 1963. "Thirteenth century Crusader Icons on Mount Sinai." *The Art Bulletin* 45:179-203.

Wolters, Wolfgang. 1976. *La scultura gottica veneziana.* Venice: Alfieri.

Xyngopoulos, Andreas. 1955. *Thessalonique et la peinture macedoniene.* Athens: M. Myrtidis.

Zanotto, Francesco. 1853. *Palazzo Ducale.* Venice: G. Antonelli.

Fig. 8-1: Paolo Veneziano with his sons Luca and Giovanni, *Pala Feriale* (below) and detail of *St Mark saves the ship from a Tempest* (above), panel-painting, 1345, 56 x 42,5 cm (detail), Venice, Museum of St Mark. Photo: reproduced with the kind permission of the Procuratoria di San Marco, Venice.

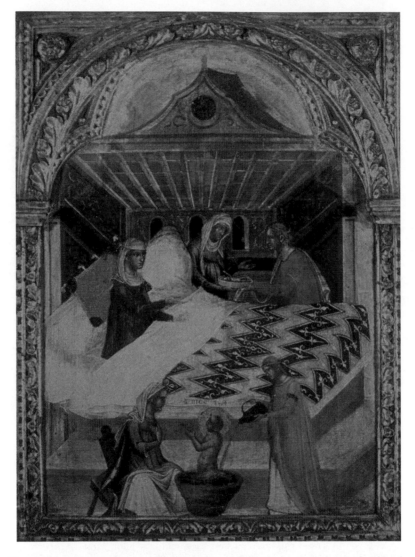

Fig. 8- 2: Paolo Veneziano, *The Nativity of St Nicholas and the Bath Miracle*, panel-painting, 1346, 74,5 x 54,5 cm, Inventory Contini Bonacossi, n.6, Florence, Uffizi. Photo: reproduced with the permission of the Uffizi.

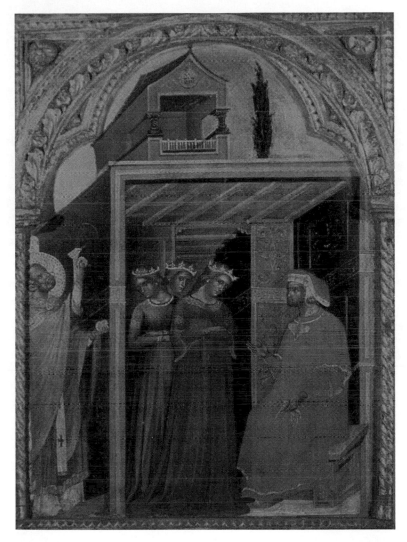

Fig. 8- 3: Paolo Veneziano, *The Generosity of St Nicholas*, panel-painting, 1346, 75 x 53 cm, Inventory Contini Bonacossi, n.7, Florence, Uffizi. Photo: reproduced with the permission of the Uffizi.

Fig. 8- 4: Anonymous artist, *Praxis de Nautis, (St Nicholas saves the ship from a tempest)*, fresco, c. 1320, Thessaloniki, St Nicholas Orphanos. Photo: the author, reproduced with the permission of the IX Ephorate of Byzantine Antiquities in Thessaloniki.

Fig. 8-5: Anonymous artist, *Praxis de Tribus filiabus, (The Generosity of St Nicholas)*, fresco, c. 1320, Thessaloniki, St Nicholas Orphanos. Photo: the author, reproduced with the permission of the IX Ephorate of Byzantine Antiquities in Thessaloniki.

CHAPTER NINE

THE MAN OF SORROWS AND THE SYMBOLS OF THE PASSION: ASPECTS OF THE IMAGE IN THE *PASSIONAL OF ABBESS CUNEGUND*

JENNIFER S. VLČEK SCHURR

"Weep, my eyes, and melt, my soul, in a fire of compassion for wounding this loveable Man whom you see in so much meekness, afflicted with so many sorrows." *Meditations on the Life of Christ* (Ragusa and Green 1961, LXXXV).

The medieval image of the Man of Sorrows sought to encapsulate all aspects and implications of the Crucifixion and Resurrection, whilst conjuring up feelings of sympathy, guilt and awe. It embodied the pathos of Christ's plight and his obedience to God's will. It suited the demands of medieval religious piety and, being supported by Church dogma, the Man of Sorrows became one of the most emotive European devotional images from the end of the thirteenth to the early sixteenth century. In Bohemian art, the earliest dateable example of the *Man of Sorrows and the Symbols of the Passion* (fig. 9-1) appears on fol. 10r of the *Passional of Abbess Cunegund* NKČR XIV.A.17, parchment, 1312-1314, National Library of the Czech Republic, Prague.[1]

The manuscript was commissioned by Cunegund (1265-1321) who from 1302 was abbess of the Benedictine Convent of St. George in the Prague citadel of Hradčany. She is illustrated on the dedication page of the *Passional*, accompanied by the nuns of her convent, receiving the work from its author (fig. 9-2). Not only was she abbess of the oldest and most prestigious convent in the Czech Lands,[2] she was also a Premyslide princess, the eldest daughter of Přemysl Otakar II (c.1233-1278), a dynastic King of the Czech Lands (1253-1278). This enabled her to become an important benefactress, endowing the convent with considerable

wealth.[3] The *Passional* is Abbess Cunegund's most important surviving legacy.

The *Passional* is a compilation of five essays/sermons, assembled between 1312 and 1314. The first treatise, which is dated 1312, and extends over ten pages, will be considered here.[4] The text elaborately entreats the nuns to seek salvation through the Instruments of the Passion that caused Christ's suffering. The author was a Dominican lector, Colda of Colditz, and the scribe, who is also illustrated to the far left of the dedication illustration, was called Beneš. The first treatise is the neatest section of the codex with lines ruled in red rather than the grey of the subsequent essays. This, together with the quality and quantity of the illustrations, identifies it as the principle work in the codex.

Colda establishes the work's theme in the introductory sentences of the dedication,

> "*Si vultis adversus Sathanam / victoriose confligere oportet ar/mis spiritualibus armare.*" (Fol. 2r, col. a, l. 26-28: If you want to fight Satan with victory, you must arm yourself with spiritual armour.)

This is further developed in a rubricated title on fol. 2v:

> "*Hic est clipeus arma et in/signia invictissimi militis qui / cognominatus est victor cum / quinque vulneribus, fultus lan/cea, decoratus que corona.*" (Fol. 2v, col. b, l. 18-24: Here is the shield, the weapons and symbols of the invincible knight whose title is Victor with five wounds, supported by a spear and decorated with a crown.)

The treatise is prefaced by a full page illustration of the *Arma Christi* (Weapons of Christ), fol. 3r (fig. 9-3), facing the title page. It presents a shield on which are depicted the Instruments of the Passion.[5] From the tenth to the thirteenth centuries the Instruments were frequently illustrated borne by angels attending Christ in Judgement, acting as an accompanying reminder of the Passion.[6] In the *Passional* illustration, fol. 3r, however, they fulfil a very different role: they are the subject, and each item is disposed to attract attention. The Cross of Calvary fills the shield, reaching from edge to edge, replicating the red cross on the shield of St. George, patron of the convent, at the top of fol. 1v and on the shield of Christ the knight, fol. 3v, (fig. 9-4). Displayed for viewing, on either side of the central upright on the *Arma Christi* shield, are various items associated with the Passion of Christ. Three unusual inclusions, certainly at the author's request as he examines them in the text, are a knife, the Mount of Olives and a circumscribed wound. All the items on the shield (with the

exception of the ladder and the dice, neither of which were directly touched by Christ) are conspicuously dotted with bright red minium, signifying that they were spattered with Christ's blood.[7] This is the first indication that the spilling of Christ's blood is at the heart, quite literally, of this work.

Turning the page, the introductory text takes the form of a parable, set out and illustrated on fol. 3v: a nobleman searching for and rescuing his abducted bride. On fol. 3v-6r, Colda explains the analogy, describing the marriage of the Son of God to his bride, the Soul of Man. This so-called *Brautmystik* (bridal mysticism) was a concept established by Bernard of Clairvaux (Barr 2010, 70). Colda likens the Fall of Man, through Eve's eating of the fruit of the Tree of Knowledge, to the abduction of Christ's bride. Redemption, the saving of Man's Soul, is achieved through Christ's suffering and sacrifice.

From fol. 6r to the close of the first treatise, Colda describes how the Instruments of the Passion are to be used as weapons to vanquish Evil and Death, enabling the Soul to be rescued and restored. The presence of the circumcision knife, which has no place in the Passion story, is explained in the text,

> "*Primum genus armorum cultrum…in circumcisionis misterio primo san/guinem suum fudit ut evidenter ostenderet peccati origiona/lis delendam maculam per succedens sacramentum ecclesiae.*" (Fol. 6r l. 9-12: The first type of weapon [instrument] the knife… he poured out his blood in the first mystery of the circumcision so that he might clearly show that the stain of original sin is to be destroyed through the subsequent holy sacrament.)

Colda expresses explicit Eucharistic implications for Christ's bloodshed which are exploited in the closing image of the treatise, on fol. 10r. This is another full page illustration, the companion-piece to the *Arma Christi*, and will be the main discussion point of this article: the *Man of Sorrows and the Symbols of Passion*. These remarkable paintings form the dramatic 'book-ends' of the treatise. Both are designed as a stimulus to meditative prayer, inviting the onlooker to pore over the Instruments that inflicted suffering on Christ. They are key images with the purpose of focusing the nuns' thoughts on Christ's sacrifice for Mankind.[8]

The *Man of Sorrows* does not dominate the composition for, just as in the *Arma Christi*, each element demands attention: the whole is designed to be scrutinised item by item. As on fol. 3r, the Instruments are bejewelled with dots of red representing Christ's blood. The Eucharistic inference is developed at the head of fol. 10r where the chalice [9] and the

Mandylion, the vernicle, are depicted, the latter without a cloth.[10] From the vernicle Christ's gaze confronts the observer; his attenuated features, particularly the nose, are carefully modelled in light and shade, and his face is surrounded by stylised, stranded hair. This handling of Christ's face, symmetrically placed within the crossed halo, draws on Eastern antecedents.[11] Most significantly this image of Christ's face takes the form of a circular Eucharist wafer: the host.

Christ's actual presence within the elements of Eucharist is overtly expressed in St. John's Gospel,

"I am that living bread which has come down from Heaven; if anyone eats this bread he shall live for ever." (John 6: 51, New English Bible).

"My flesh is real food; my blood is real drink. Whoever eats my flesh and drinks my blood dwells continually in me and I dwell in him." (John 6: 54-56, New English Bible).

Transubstantiation, the translation of bread and wine into the flesh and blood of Christ at the moment of consecration, was a focus for argument in the Medieval Christian Church (Rubin 1992, 14-35). However it was not until the Dominican Thomas Aquinas (1224-1274) set out the office for the festival of *Corpus Christi* that an established doctrine was created for the celebration of Christ's living body in the Eucharistic elements.[12] The feast day was established by Pope Urban IV in 1264, and was observed on the Thursday following Trinity Sunday. Its widespread popularity increased, however, when Pope Clement V reconfirmed the festival in Vienna, in 1311-1312; significantly just 200 miles from Prague and in the very year of the dedication of Cunegund's *Passional*. Not only does her personal breviary,[13] contain the offices for the mass of *Corpus Christi*, on fol. 132r-146r, but on the pages directly following, fol. 146v-151v, is the prayer/hymn known as *Kunhutina modlitba* (Cunegund's prayer).[14] It is in the vernacular rather than Latin and was probably intended either as a Eucharistic prayer or chant accompanying the *Corpus Christi* procession.[15] It includes the following lines 7-11, in verses 8 and 9, addressed directly to Christ and incorporating the tenets of transubstantiation, demonstrating Cunegund's personal fascination with the concept:

"chléb v své tělo proměňuješ,	Thou dost take the wine and wafer,
z vína svú krev učiňuješ.	Making them thy blood and body.
V chlebnéj tváři ty sě skrýváš	In the face of bread thou hidest,
božskú světlost tú pokrýváš	All thy godly brightness hidest;
cěle v oplatcě přebýváš	In the Host thou art all present"
(Matejka 1979, 10-17).	

The image of Christ's face appears imprinted on the host in the fol. 10r image, representing the embodiment of Christ within. This would seem to illustrate the line in the hymn, "In the face of bread thou hidest". Beside it the chalice of the Eucharist is highlighted in white and shaded in blue-grey, suggesting silver, and an attempt has been made to illustrate the wine within.

The host and the chalice are depicted at the top of the composition, in close proximity to one another, above and to each side of Christ. He appears below as the *Man of Sorrows*, having sacrificed his body and having shed his blood to provide the elements of Holy Communion. The literary origins of the image are the prophetic Fourth Canticle, Isa. 52:13, 53:12, describing the humiliation of the Suffering Servant, which Colda quotes in the text on fol. 6v l.20- fol. 7r l.2. The Byzantine image of *Akra Tapeinosis* (Utmost Humiliation), illustrated the *Imago Pietatis* (Man of Sorrows) on one side of a panel and the Virgin Mary as *Mater Dolorosa* (Lamenting Mother) on the other, and was an important part of the Eastern Orthodox Good Friday devotions (Belting 1980-81, 1-16).[16] After the Fourth Crusade and the capture of Constantinople in 1204, numerous religious images were imported to the West (Belting 1994, 312), and a Latin presence was maintained in Constantinople until their eventual expulsion in 1261. The earliest Western Man of Sorrows images[17] employed Byzantine iconography: a half-length Christ figure in a funerary position with crossed arms, or with arms down to his sides, and the closed eyes of *Christus Patiens*.[18] Since the Eastern devotional image of the Man of Sorrows appeared on free-standing, processional boards, they must have been among the easiest items of church furniture to export to the West, thus becoming widely available to be copied.

As the festival of *Corpus Christi* became established, with its complex rituals involving the host, so the Man of Sorrows image was provided with an apposite Western context. The Church required an image to represent their new religious focus; one that demonstrated both Christ's sacrifice and his enduring presence, and that could be associated with the mysteries of transubstantiation. The Eastern image of the Man of Sorrows seems to have been consciously adopted to fulfil this role, which would explain why surviving Western examples post-date 1264 and then become so numerous. The image of the Man of Sorrows fitted the purpose, concentrating on his sacrificed body and on his blood whilst capturing and conveying the pathos of the suffering Christ, already crucified yet upright in preparation for the Resurrection. It had the added advantage for this purpose that, unlike other Passion iconography, it was not related to any specific biblical event.

The development of the image and its juxtaposition with the instruments that wounded Christ's body (the bread) and caused Christ to bleed (the wine), served to enhance its Eucharistic message. The Man of Sorrows was often to be found on predella panels of altarpieces, directly before which the elements were prepared during mass.[19] As the image became popular and widespread, new iconography developed which is already demonstrated in the full-length, upright Christ on fol. 10r.[20] Christ appears to be held aloft before the cross, as if by divine forces; hovering between life and death. This impression is enhanced by the contrast between his limp, slumped and damaged body, and his open eyes, following the Romanesque *Christus Triumphans* tradition. The full-length figure of Christ, vertical and unsupported, exhibiting his wounds, developed into the standing Man of Sorrows particularly popular in Northern art.[21] Panofsky (1927, 293) referred to this image as *"mimschaktiven Standfigur"* (a figure apparently actively standing erect), which in the following centuries was to become particularly associated with the iconography of the mass of St. Gregory.[22]

The image of the Man of Sorrows is acknowledged as having been adopted from Eastern iconography and the political attention of Cunegund's brother, King Wenceslas II, was decisively orientated towards the East. In 1291 he sent Cunegund, then twenty-six, to marry Count Boleslav II of Mazovia as a manoeuvre to enhance Wenceslas' chances of winning the Polish crown, which he duly gained in 1300. Both Wenceslas and Cunegund had a deep personal link with the East through their mother Cunegund of Hungary (d.1285), who was the daughter of a Russian lord, Rastislav Michailovich Chernigovski, and the granddaughter of the King of Hungary (Stejskal 1975, 108). The Zbraslav chronicler, writing contemporaneously, recorded Wenceslas II's familiarity with Eastern Orthodox religious rites,

"*Vždyť jsme viděli, jak se k tomuto proslulému králi sbíhali řeholníci a také přemnozí duchovní světští nejen ze všech končin Italie, Francie a celého Německa, ale tu z Ruska, tu z Pruska, tu z Řecka a nejednou z nejzazších krajů uherských a přímořských... častěji sloužili před králem slavnostní mše podle svého obřadu v řeckém, někdy I v slovanském jazyce.*" (For we saw how very many monks and clerics flocked to this distinguished king not only from all corners of Italy, France and the whole of Germany, but also from Russia, and then Prussia and then from Greece and not infrequently from the furthest reaches of Hungary and coastal regions...frequently, before the king, they celebrated mass according to their own rites in Greek and sometimes in the Slavonic language). (*Kronika zbraslavská – Chronicon Aulae Regiae* 1952, 177).

It is interesting to compare the Bohemian *Man of Sorrows* from the *Passional* with Byzantine illustrations which appear on fol. 65v and 167v of the Karahissar Gospels, Codex Petropolitanus MS gr.105, c.1260-70, Public Library, St. Petersburg. This manuscript presents two Byzantine, half-length images of the Man of Sorrows, and in both images Christ is placed before the cross with his arms lowered. Together with the *Passional* image, they all share much of the typical early Man of Sorrows iconography: the limp posture of the upper body; the head tilted towards the right shoulder; the absence of the Crown of Thorns, which is replaced by a halo with a cross within it, indicating that it is Christ who is depicted, although in the *Passional* Christ's head is decorated with red strokes representing blood where the Crown of Thorns had been placed. Another parallel may exist between the illustration on fol. 10r and that on fol. 167v of the Codex Petropolitanus; for I suggest that the latter may be the earliest surviving example of the incorporation of items referencing the Passion into the iconography of the Man of Sorrows. Belting considers the objects to the right of the picture to be a representation of the tomb "as a domed building" (1980-1981, 7). It is difficult to decipher, however I interpret the 'dome' as a spice jar, beside which is the winding sheet[23] draped over the rectangular stone of the open tomb. If this is so, the objects' role here is to contextualise. The Symbols of the Passion accompanying the sacrificed Christ in the *Passional* image, on the other hand, serve to enhance the pathos of his plight. It is the agony, not the story, which is invoked.

The full-length Christ figure on fol. 10r also strongly suggests another Byzantine iconographic influence: the *Epitaphios*.[24] This painted or embroidered cloth representing Christ's shroud, was carried in the Great Entry Procession and then laid upon the altar; a liturgical practice in the Eastern Orthodox Church (Taft 1980-1981, 49). It depicted Christ's body, laid out upon the anointing stone,[25] and was a persuasively sacrificial image. Significantly in both this dead Christ of the *Epitaphios* and the early images of the Man of Sorrows, the absence of other protagonists, indeed their exclusion from the drama, is a defining factor, differentiating them from the iconography of the Deposition or the Lamentation. Christ as the Man of Sorrows on fol. 10r appears in utter isolation; caught between death and eternal life. The *Epitaphios* translated into the erect position.

Man's sins were believed to inflict further sufferings upon Christ, and so, in the fol. 10r image, Christ's limply gesturing right hand points to a banner bearing the motto, "*Sic homo sto pro te cum peccas desine pro me*" (Thus as a man I stand here for you; cease to sin for me).[26] In his left arm Christ holds the scourge and birch close to his chest in a manner repeated frequently throughout the centuries of the image's popularity. In the

context of the *Passional*, however, there maybe a more sinister aspect to this iconography, at least to our modern way of thinking: a reference to the practice of self-flagellation which combined punishment for sin with empathetic suffering with Christ.[27] In the *Passional* image, scourge wounds pock-mark Christ's body, depicted in bloody red. There is also a hectic cascade of red droplets from Christ's face, wrists and feet in the image of Christ kneeling, entitled *"In monte oliveti"* (On the Mount of Olives). The artist has combined two separate biblical occasions and locations: the Mount of Olives and the miracle of the rain of blood in the Agony in the Garden of Gethsemane:

> "and in anguish of spirit he prayed the more urgently; and his sweat was like clots of blood falling to the ground." (Luke 22:44, New English Bible).

The painting distinguishes between bead-like clotted blood, as on the instruments and in the image of the kneeling Christ, and wavy ribbons of fresh blood pouring from the gaping "five wounds" of Christ, referred to in the title on fol. 2v. Christ's blood was among the rarest and most precious relics of the Christian world, and blood flowing after death was proof that Christ's body was incorruptible. The Eastern doctrine of the Rite of Zion, which dictated the heating of the wine of Eucharist and the drinking of it warm from the chalice, had strong implications for transubstantiation. It expressed the belief that the Holy Ghost, present within Christ, allowed his blood to continue flowing even after his death. This quality held particular significance in the Czech Lands: the sanctity of their patron saint, St. Wenceslas, was evidenced by the miraculous failure of his blood to dry when he was killed in 929 (Havránek and Hrabal 1957, 56-57).

The veneration of Christ's wounds featured prominently in medieval piety, promulgated not only by the new orders but also by Benedictines. The famous Benedictine thinker, the Venerable Bede (672-735) wrote of Christ's wounds,

> "He does not discard them, in order to prove to the disciples that He has risen in the flesh; in order to be able to show them to the Father as intercessors and mediators for Mankind; for the sake of the dying, who may take comfort from the agony that He suffered; and finally, to show them to the Jews at the Last Judgement that they may see how much He suffered through them."[28] (Bede in Schiller 1972, 188).

In the *Passional* the five wounds of the *Man of Sorrows* are displayed; his feet, which are placed side by side to ensure that both wounds can be seen, and his hands expose dark circles where the nails had been withdrawn, each surrounded by rivulets of flowing blood.[29] The most important wound, however, is that in Christ's side. This was viewed as the very source of the communion wine.[30] John 19:34-35 is quoted and commented upon by Colda, in the text,

> "*Unde inquit / iohanes militum lancea latus eius aperuit et continuo exivit sanguis et aqua. Sanguis in pretium aqua in ablutionis a sordibus / sacramentum.*" (Fol. 7v l.18-21: "And so," said John, "the lance of the soldiers opened his side and blood and water flowed out continually." Blood used as a reward, water as a sacrament for the washing away of filth.)

Colda interprets Christ's blood as a gift to Man, and the water in the holy sacrament as spiritually cleansing and redemptive.

The side wound, according to tradition caused by the lance of the Roman soldier Longinius, created a direct opening to Christ's heart. For this reason it is mentioned specifically on fol. 2v, together with the five wounds, in the title of this section of the *Passional*. An illustration on fol. 7v (fig. 9-5) displays the lance prominently, its head daubed with blood, beside the figure of Christ, and referring back to the illustrations accompanying the Parable on fol. 3v, it is made graphically clear that the lance deals the final death blow to the personification of Evil, piercing through the neck of the rogue of the parable, who had deceived and stolen away the bride. The lance represents the ultimate, conquering weapon. It was venerated in Jerusalem from as early as the sixth century and special deference was offered to it throughout the Christian world, then having been brought to Europe it was numbered among the most precious relics of the Holy Roman Empire, the head of the lance being mounted within the hilt of Charlemagne's ceremonial sword (Schiller 1972, 189-190).

Christ's side wound is given special attention in the *Passional*. To ensure that it can be properly examined, the artist has painted an enlarged, vertical image towards which Christ gestures with his right hand.[31] It is positioned on the page 'at the right hand' of Christ: the position of greatest respect and honour. The wound is labelled "*haec est mensura*" (this is the measure) and was surely intended to be life-like as well as life-size. *Mensura* gave the stamp of authenticity to the image:[32] that it was measurable gave it definition, making it the more real.[33] Bury (2007, 129) states that there was widespread devotion to the *mensura vulneris* across Europe through the fifteenth and sixteenth century and that only recent

cvidence has shown it to have been a feature of fourteenth century piety. The *Passional* fol. 10r illustration provides a very early fourteenth century, titled and dateable example.

The function of this *mensura vulneris* was intercessory and redemptive, for encircling the image is an inscription, almost indecipherable today but which Dobner (1785, 332), studying the manuscript in the eighteenth century, recorded:

> "*Redemit pendens in cruce sancta ostendens vulnere...* [Illegible] *bus nos vulnere omnibus transeuntibus*" (He redeemed (us) by hanging on the holy cross, showing us his wound...with his wound for all us transgressors).

Dobner (1785, 332) goes on to comment that the wearing away of the inscription is likely to be the result "*crebis osculis*" (of frequent kisses), a devotional practice that escalated following the promise of seven years indulgence, instigated by Pope Innocent VI, for devotional kissing of the *mensura vulneris* (Rubin 1992, 304). Redemption was obtained by kissing, gazing on or touching Christ's wound, whilst contemplating his suffering. The Man of Sorrows image also became popularly employed as a devotional means of earning indulgences.[34] St. Anselm (1033/4-1109) had established the connection between Christ's suffering and Mankind's redemption in his treatise "*Cur Deus homo?*" (Why did God become Man?), completed after 1098 (Easton, 2006, 395). It is interesting that Cunegund's library contained two copies of the Prayer of St. Anselm which describes in close detail each moment of Christ's crucifixion (Vilikovský 1948, 27), presumably for purposes of visualisation.

It was part of medieval religious practice to use words and images to stimulate the imagination and to direct thoughts that might carry the subject towards an intensely spiritual experience. Spiritual exercises, such as repetitive recitations of prayers or, as in the *Passional* the concentrated contemplation of the Instruments of the Passion, were designed to invoke an interior knowledge of God (Petroff 1986, 6). A missing folio facing the image of the *Man of Sorrows* carried succinct prayers and supplications invoking the Instruments individually and recalling Christ's suffering, which obviously link directly to the opposing image.[35] The illustration on fol. 7v of the *Passional* portrays a Benedictine nun, with whom every nun in the convent could identify, kneeling in supplication at Christ's feet, gazing deeply into the wound in Christ's side, which appears as a crimson gash through his robe.[36] Colda's accompanying text is most elucidatory,

> "*Lancea latus aperi voluit ut amota per vulnus / carne hoc cor eius in tus positum aspiceretur.*" (Fol. 7v, l. 16-17: He wanted his side to be opened

by a spear so that, by this wound, the flesh would be moved away and his
heart could be seen within.)

The nuns are directly instructed that Christ's heart will be visible to
them through this wound.

The illustration on fol. 10r of the *Passional* attempts to realise this. An
unusual feature of the figure of Christ is an oval at the very centre of
Christ's chest. Remarkably this has passed unnoticed by previous authors
and therefore has never before been commented on or described. It is a
hole in the parchment. Unlike a flaw or a flay hole, it is perfectly
symmetrical and has been purposefully delineated. Close observation
shows that perforations were made around the perimeter to aid the cutting
out and removal of a small, oval portion of parchment. The resulting
aperture enabled the nuns directly to invoke Christ's wounded heart: the
object of intense adoration in the Medieval Church. It appears literally
opened up to receive the supplications of the faithful, that the nuns might
focus their devotions upon it and call for intercession. In the *Man of
Sorrows* on fol. 10r, the flesh over his heart has been literally 'moved
away'. It is possible that the wafer of the Eucharist may have been placed
directly behind this hole, being visible to the nuns through it, representing
and being venerated as the true Body of Christ, offering the promise of
eternal life.[37] The host 'became' Christ's body at the moment of
consecration and consecrated wafers were sometimes reserved in safe-
keeping for up to a week, for special occasions or for visiting the sick
(Rubin 1992, 43-46). At Easter three hosts were consecrated on Maundy
Thursday: one for the following communion, one for Good Friday and one
for the sepulchre (Duffy, 2005, 28). It is possible that such consecrated
wafers were placed behind the fol. 10r aperture, not only for safe keeping
but to allow the nuns prolonged, private access to gaze at the *Corpus
Christi*. Sight of the elevated host at the moment of transubstantiation, and
subsequently during the *Corpus Christi* rites, was considered to offer a
most holy experience, and the protection of Christ's body within the host
thereafter was an imperative. Duffy (2005, 30) writes of the later practice
of placing the host within a recess in the chest of images of Christ.
Devotion to relics, often required gazing on objects of veneration through
apertures; already a well established practice.[38] Indeed during the rites of
Corpus Christi, the host was often processed and presented to the
congregation in a monstrance.

At the base of fol. 10r, beneath the whips and pliers, is the shadow of a
title in large writing which is illegible today. Once again it is Dobner
(1785, 333) who provides the transcription: "*Contemplare in plagam*"
(Gaze into the wound). Even the figure of Christ himself is pictured

staring intently into the wound in his side. The nuns' desire was "to be incorporated into Christ's body through the side wound" (Bynum 2008, 181), and through that wound into Christ's heart. To achieve this they are specifically instructed to behold it; to concentrate on it whilst contemplating Christ's agony.

The counterpart to agony is ecstasy. Visions, spiritual experiences and miracles are documented attributes of female medieval religiosity. An image could become the route to an ecstatic religious experience.[39] The illustration on fol. 10r was designed to foster feelings of empathy, working as a catalyst to create a close and mystical bond with Christ. To be united with Christ was the aspiration of devout nuns who were, after all, considered to be the brides of Christ. *Brautmystik* expressed,

> "... a reciprocity of desire between God and the soul../..These spiritual trends, centred around an emotional identification with the humanity of Christ, elicited powerful responses from women." (Voaden 1999,14-15).

The Song of Songs became the vehicle for this mode of thought, the passionate sentiments of which were popular in the Middle Ages, and which are reflected in the opening parable of the *Passional*. Cunegund had been raised to a deep belief in Christ the bridegroom, for between the ages of twelve and twenty six (1277-1291) she had been under the care of the sisters of the Franciscan Convent of Poor Clares in Prague and the tutelage of her great-aunt, St. Agnes of Prague (1211-1282). Both foundress and abbess, Agnes had maintained a personal correspondence with St. Clare (1194-1253), four letters of which survive. All make repeated references to marriage with Christ (Stace 2001, 105-123) and Cunegund's education would have been structured around these letters. The first, dated before 11th June, 1234, tells Agnes,

> "... you are taking a spouse of more noble lineage, the Lord Jesus Christ, who will always keep your virginity unspotted and intact. When you love him, you remain chaste; when you touch him, you will become more pure; when you accept him, you are still a virgin." (Stace 2001, 109-110).

It appears to be conjugal love rather than purely spiritual love which is being referred to, and this motif becomes even more explicit in the fourth letter, dated to between February and the beginning of August 1253, where St. Clare quotes directly from the Song of Songs:

> "as you go on to contemplate his ineffable delights…as you sigh for them in the boundless desire and love of your heart, cry out; 'Draw me after you…heavenly spouse! I shall run and never weary…until your left hand

cradles my head and your right hand embraces me in happiness, and you
kiss me with the most happy kiss of your lips!'." (Stace 2001, 122).

There is an undeniable erotic element to a bride of Christ's desire to be
fully united with Christ. Vaginal analogies have been made in the context
of vertical representations of Christ's side wound[40], and Bynum (2007, 14)
acknowledges that in many medieval images the side wound of Christ was
"…offered for veneration as a gaping and often erotically charged
longitudinal slit". The shape of the wound on fol. 10r has lent itself,
however, to several other interpretations: Stejskal (1975, 78) suggests a
plantain leaf, a candle flame or an egg, preferring the latter. The candle
flame analogy would seem apposite, for the *Legenda aurea*, c.1255, had
established a comparison between Christ's body, soul and divinity,
describing them as the wax, wick and flame of a candle, and this became a
regular subject for Candlemas sermons (Duffy 2005, 22). There is nothing,
however, in the text and rubrics which accompany the *Passional* image of
the wound to suggest that it is illustrating anything but the wound. Then,
as it is today, interpretation was in the eye of the beholder.

It is certain, however, that the image was intended to inspire and guide
the nun's thoughts towards a spiritual blending with Christ, through prayer
and contemplation. The second of the remaining letters from St. Clare to
Agnes, dated between 1234 and 1239, reads,

> "Your spouse [Christ] is the most comely of the children of men, yet for
> your salvation he made himself the lowliest of men; he was despised,
> beaten, scourged many times over his whole body, then suffered the agony
> of the cross and died. Most noble queen, gaze upon him, consider him,
> contemplate him in your desire to imitate him." (Stace 2001, 114-115).

By gazing, considering and contemplating, the nuns could become more
Christ-like themselves; 'imitating' him. The image on fol. 10r provided
Cunegund and her nuns with the means.

Medieval piety was woven through with a deep fear of the Last
Judgement and everything was done to ameliorate the chances of
forgiveness and to win a place in heaven. Salvation lay in Christ, and the
image of the Man of Sorrows and the Symbols of the Passion, embodying
the mysteries of transubstantiation and *Corpus Christi*, acted as
intercessor. Immersing one's thoughts in Christ's suffering was believed to
be a means of attaining the highest possible spiritual protection. This is
sought by the supplicating nun on fol. 7v, as she implores, "*Fili Christe
dei ti misere me*" [Christ, Son of God, take pity on me]; likewise the
abbess and the nuns of the Convent of St. George, when they meditated

upon the poignant image of the *Man of Sorrows and the Symbols of the Passion* on fol. 10r of the *Passional*. The closing words of the first treatise in the *Passional of Abbess Cunegund* read,

> "Jesus, let us feast our hearts[41]
> On your bitter suffering
> For we shall never be satiated
> Contemplating its source.
> Let us serve you faithfully
> So that we may earn for ourselves
> The eternity of your heaven
> In place of this transience."[42]
> (Translated from German, MS XVI.E.12, fol. 23v-24r, National Library of the Czech Republic, Prague).

If, as I have suggested, a consecrated host was partially concealed on the page opposite this closing prayer, visible only through the aperture over Christ's heart, then this would provide the nuns with the opportunity to 'feast' not only their 'hearts' spiritually, but physically to consume Christ's heart: an ultimate act of consuming, rather than consummation, for a bride of Christ.

Notes

[1] Hereafter the work will be referred to as the *Passional* without further qualification. Similarly the illustrations contained within the codex will be referred to by their descriptive titles, for example, the *Man of Sorrows and the Symbols of the Passion*, with no further qualification. All translations from Latin which are included in this paper, and not otherwise referenced, are by my daughter Emily Schurr, B.A. Hons. Cantab., and from German by Jacqueline Taylor, B.A.. I thank them for their time and effort. I would also like to thank Professor Robert Gibbs, of the University of Glasgow, for giving me the confidence to return to the field of Art History and for supervising my research. I extend my gratitude to Dr. Veronika Procházková and Dr. Renata Modráková, of the National Library of the Czech Republic, in Prague, for their kind interest in my research, and for furnishing me with digital images of the illustrations of the *Passional* from which to work. I am also deeply grateful to my husband and children for their unfailing encouragement and infinite forbearance.

[2] The Convent of St. George was established in c.970 by Mlada; who was sister of Boleslav II (ruler of the Czech Lands 967-999). The establishment's strong ties with the ruling families of Bohemia reached back to the founding of the Basilica in the early 10th century by the then overlord, Vratislav (d.921). Cunegund's great-great aunt Agnes (d.1228), another Premyslide princess, had also been abbess of the Convent of St. George.

[3] For example, Tomek (1855, 444), records how Abbess Cunegund bought three villages, in 1320, and gave them all to the convent in order that the profits raised from them would afford yearly petitioning for her soul in perpetuity.

[4] Within the codex itself three references clearly date the presentation of the first treatise to 1312: fol. 2v col. 2 l. 12-14, fol. 31v l. 4-6 and l. 8-10. The first and last references state specifically 27th August, 1312. An apparently scratched out XIII on the fol. 2v reference led Ryněsova (1926, 13-35) to query the date. This may have been a straight forward scribal error or, perhaps might indicate that the dedication page and the image of the *Man of Sorrows* on fol. 10r which share a folio, were added the year after the manuscript was presented to Cunegund. Somewhat enigmatically the Czech National Library catalogue dates the entire codex "not before 1313 and not after 1321", and Hamburger (1998, 374) dates the fol. 10r image 1321, and on p. 408 dates the *Passional* c.1320.

[5] This image compares with a similar depiction of the Symbols and Wounds set within a shield: *Arma Christi* MS 288, fol. 15r, French Book of Hours, parchment, beginning of fourteenth century, Bibliotheque de l'Arsenal, Paris.

[6] For example, Nicholas Verdun *Judge of the World (enthroned)*, Klosterneuburg Altar, champlevé enamel, 1181, Monastery of Klosterneuburg, near Vienna.

[7] (Vlček Schurr 2012, 203) The white daubs on Christ's seamless robe appear to have been placed by the artist to provide a ground on which to apply minium, thus avoiding the red running in with the blue of the robe. The red, however, was never applied. Minium was the red ink used by scribes for important features of the text such as headings.

[8] A small group of nuns could have gathered around the *Passional* for meditative devotion. This would comply with the Rule of St. Benedict, chapter XLII (Monks of Glenstal Abbey 1994, 244) which encouraged shared study. I concur with the dimensions given by the National Library of the Czech Republic and Stejskal and Urbánková (1975, 19): 30 x 25cm. Matějček (1922, 6) and Toissant (2003, 13), however, both state the codex to measure 29.5 x 25cm.

[9] Schiller (1972, 193) interprets the chalice as representing the summation of Christ's suffering rather than a Eucharistic symbol.

[10] This can be compared with the remnant of a wall painting, dated to 1304-06, depicting *Christ's face* within a large, crossed halo, the Church of the Assumption of the Virgin, formerly a Benedictine monastery, Police nad Metují, Czech Republic. In this painting, however, Christ's left shoulder is depicted. See Dvořáková et al. (1964, 140 and Fig. 1).

[11] There are similarities between this image and the *Laon vernicle*. This was sent by the future Pope Urban IV in 1249 to his sister, abbess of Montreuil-les-Dames, a convent near Laon, and bears a cyrillic inscription and is of Slavonic origin: Serbia, Bulgaria or Russia (Kuryluk 1991, 115).

[12] It should be noted that Colda, the author of the treatise, was also a Domincan. Clearly an educated theologian, he may have been the abbess' confessor and spiritual guide, therefore influencing her set of beliefs.

[13] NKČR VII.G.17d, National Library of the Czech Republic, Prague.

[14] Rubin (1992, 191-195) discusses hymnody associated with the *Corpus Christi* liturgy.

[15] Rubin (1992, 156) describes "a veritable explosion of vernacular Eucharistic prayers".

[16] For example, *Akra Tapeinosis*, panel, second half of the 12th century, Byzantine Museum, Kastoria.

[17] For example, Border roundel with *Man of Sorrows, Supplicationes Variae*, Bibl.Laur.Ms.Plut.XXV.3, fol. 183v, Laurentian Library, Florence.

[18] This was standard Byzantine iconography of the Crucified Christ, since the 9th century.

[19] For example, Simone Martini, *St. Catherine's polyptych*, panel, 1319, Museo Civico, Pisa.

[20] Similar iconography appears in the *Man of Sorrows with Instruments of the Passion*, wall painting, c.1320, Church of the Birth of the Virgin Mary, Průhonice.

[21] For example *Man of Sorrows* from the Roudnice altarpiece, panel, c.1410, National Gallery, Prague.

[22] Christ appearing before St. Gregory at the altar is often portrayed, accompanied by the Symbols of his Passion, bleeding directly into the communion cup, for example *St. Gregory's mass, Les Grandes Heures* of Philip the Bold, parchment, Paris, 1376-79, MS3-1954 fol. 253v, Fitzwilliam Museum, Cambridge.

[23] Belting makes no allusion to this (1980-81, 7).

[24] For example *Epitaphios*, embroidery, c.1200, Museo Marciano, Venice.

[25] The porphyry slab on which Christ's body was reputed to have been placed following the Deposition (Freely 1998, 141).

[26] A similar entreaty recurs around the frame of a later Bohemian image of the *Man of Sorrows*, panel, c.1470, National Gallery, Prague.

[27] St. Katharina von Gueberschwihr, writing c.1320, described how during Advent and Lent "all the sisters would go to the chapter house or other suitable places after Matins and fall upon their bodies with various kinds of scourges, cruelly and ferociously lacerating their flesh even to the shedding of blood, so that the sound of whipping resounded throughout the monastery, rising more sweetly than any music to the ears of the Lord of Hosts, who is greatly pleased by such works of humility and devotion." (Newman 2008, 163).

[28] The Franciscans were to adopt Bede's sentiments almost verbatim in the *Meditations on the Life of Christ*, which was widely read in the Middle Ages (Ragusa and Green 1961, XCIII). The wounds bore the greater relevance for them: St. Francis of Assisi having received the stigmata in 1224.

[29] Bynum (2007, 135) suggests, "Italy is probably the origin of the famous motif of the bleeding Man of Sorrows". Opposing this hypothesis is the example of the Serbian illustration of the *Man of Sorrows* on fol. 65v of the Karahissar Gospels, Codex Petropolitanus MS gr.105, c.1260-70, Public Library, St. Petersburg, where streams of red and white flow from Christ's side wound. The bleeding *Passional Man of Sorrows* also presents itself as an early example in Central European art.

[30] For example, fol. 65v of the Karahissar Gospels, Codex Petropolitanus MS gr.105, c.1260-70, Public Library, St. Petersburg. The flow of blood and water was replicated in the mixing of wine and water for Holy Communion.

[31] The vertical depiction of Christ's side wound became an established, independent item among the Symbols of the Passion, for example *Arma Christi*

altarpiece panel, c.1340-1370, Cologne Master, Wallraf-Richartz Museum, Cologne.
[32] Duffy (2005, 244-245) describes how the measure of the wound offered indulgences and talismanic rewards.
[33] Included in the Instruments of the Passion on fol. 10r is another *mensura*. It is the Measure of Christ, labelled "*Hec linea sedecies ducta longitudinem demonstrat Christi*" (This 1/16 measure shows the height of Christ). Dobner (1785, 332) noted that this would make Christ of huge stature. The measure, rather than being a literal measure, represents another revered relic, the *mensura longitudinis corporis*, listed in early twelfth century catalogues, and one of c.1200, as one of the venerated Passion relics in Constantinople (Belting 1994, 526-7).
[34] Duffy (2005, 214) describes a popularly circulated fifteenth century wood-cut image of the *Man of Sorrows*, Bodleian Library, Oxford University, granting 32,755 years of pardon.
[35] The folio preceding fol. 10r has been torn out of the manuscript, however a 19th century German translation of the first treatise survives, complete with the missing folio which included the closing paragraphs on the recto and devotional prayers on the verso - MS XVI.E.12, fol. 20v-24r, National Library of the Czech Republic, Prague.
[36] Stejskal and Urbánková (1975, 27) suggest that Cunegund herself is portrayed here; however there is nothing to directly indicate this. See also Vlček Schurr.
[37] Fol. 10v was left unlined with no writing or painting, which supports this theory.
[38] For example a double-panelled reliquary (1260-1300) from the Convent of St. George, and now housed in Strahov Monastery, Prague. Fragmentary relics are to be observed through polished rock-crystal windows in the second panel.
[39] For example Gertrude "the Great" (1256-c.1302) whose mystical vision was stimulated by contemplating the painting of the crucifixion in her prayer book (Newman 2008, 160).
[40] See, for example, Lochrie (1997, 187-191) and Caviness (2001, 120 and 158).
[41] See Bynum (1988).
[42] See Toissant (2003, 193-196) for a transcription of the German translation. It is in rhyming couplets suggesting that the original Latin prayer was in verse.

References

Areford, D.S. 1998. "The Passion Measured: A Late-Medieval Diagram of the Body of Christ." In *The Broken Body – Passion Devotion in Late-Medieval Culture,* edited by A.A. MacDonald, H.N.B. Ridderbos and R.M.Schlusemann. 211-238. Groningen: Egbert Forsten.
Barr, J. 2010. *Willing to know God: Dreamers and visionaries in the later Middle Ages.* Columbus: Ohio State University Press.
Belting, H. 1980-81. "An image and its function in the liturgy: The Man of Sorrows in Byzantium." *Dumbarton Oaks Papers* 34-35:1-16.

—. 1994. *Likeness and presence: A history of the image before the Era of Art*, translated by E. Jephcott. Chicago: Chicago University Press.

Binski, P. and S. Panayotova, eds. 2005. *The Cambridge illuminations: Ten centuries of book production in the medieval West*. Exhibition catalogue. London: Harvey Miller Publishers.

Brooke, C. 2003. *The age of the cloister: The story of monastic life in the Middle Ages*. Stroud: Sutton.

Bury, M. 2007. "The measure of the Virgin's foot." In *Images of medieval sanctity – Essays in honour of Gary Dickson*, edited by D. Higgs Strickland. 121-134. Leiden: Brill.

Butler, Dom. C. 1924. *Benedictine Monachism*. London: Longmans.

Bynum, C.W. 1987. *Holy Feast and Holy Fast: the Religious Significance of Food to Medieval Women*. London: University of California Press.

—. 2007. *Wonderful Blood: Theology and Practice in late Medieval Northern Germany and Beyond*. Philadelphia: University of Pennsylvania.

—. 2008. "Foreword." In *Crown and veil: Female monasticism from the 5th to the fifteenth centuries*, edited by J. F. Hamburger and S. Marti. xiii-xviii. New York: Columbia University Press.

—. 2008. "Patterns of female piety in the later Middle Ages." In *Crown and veil: Female monasticism from the 5th to the fifteenth centuries*, edited by J. F. Hamburger and S. Marti. 172-190. New York: Columbia University Press.

Caviness, M. 2001. *Visualizing Women in the Middle Ages: Sight, Spectacle and Scopic Economy*. Philadelphia: University of Pennsylvania.

Cormack, R. 2000. *Oxford history of art: Byzantine art*. Oxford: Oxford University Press.

De Hamel, C. 1992. *Medieval craftsmen – scribes and illuminators*. London: British Museum Press.

—. 2004. *A History of Illuminated Manuscripts*. London: Phaidon.

Ditchburn, D., S. Maclean and A. Mackay, ed. 2007. *Atlas of medieval Europe*. Oxford: Routledge.

Dobner, J. G. 1785. *Monumenta historica Bohemiae*. Vol. 6. Prague: J.J. Clauser.

Dobrzeniecki, T. 1971. "Imago Pietatis: Its meaning and function." *Bulletin de Musée Nationale de Vasavie* 12 (61-62):4-27.

Duffy, E. 2005. *The stripping of the altars: Traditional religion in England c.1400 - c.1580*. London: Yale University Press.

Dvořáková, V., J. Krása, A. Merhautová and K. Stejskal. 1964. *Gothic mural painting in Bohemia and Moravia 1300 – 1378*. London: Oxford University Press.

Erben, K. J., ed. 1845. *Výbor z literatury české*. Vol. 1. Prague: Kommisse u Kronbergra i Řiwnáče.

Easton, M. 2006. "The wound of Christ, the mouth of hell: Appropriations and inversions of female anatomy in the later Middle Ages." In *Tributes to Jonathan J.G. Alexander: the Making and Meaning of Illuminated Medieval and Renaissance Manuscripts, Art and Architecture,* edited by S. L'Engle and G.B. Guest. 395-415. London: Harvey Miller.

Freely, J. 1998. *Istanbul: The Imperial City*. London: Penguin.

Fiala, Z. 1978. *Předhusitské čechy 1310-1419: Český stát pod vládou Lucemburků*. Prague: Svoboda.

Hamburger, J. 1998. *The visual and the visionary: Art and female spirituality in late medieval Germany*. New York: Zone Books.

Hanuš, I. J. 1865. "Kritické poznámky." *Krok* I:227-240.

Havránek, B. and J. Hrabák, eds. 1957. *Výbor z české literatury od počátků po dobu Husovu*. Prague: Československé akademie věd.

Kronika Zbraslavská – Chronicon Aulae Regiae. 1952, translated by František Heřmanský. Prague: Melantrich.

Kuryluk, E. 1991. *Veronica and her cloth: History, symbolism and structure of a 'true' image*. Oxford: Basil Blackwell.

Kutal, A. 1971. *Gothic art in Bohemia and Moravia*. London: Hamlyn.

Lawrence, C. H.. 1989. *Medieval monasticism*. London: Longman.

Lochrie, K. 1997. "Mystical Acts and Queer Tendencies." In *Constructing Medieval Sexuality,* edited by K. Lochrie, P. McCracken and J. Schulz. 180-191. Minneapolis: University of Minnesota Press.

Manuscriptorium: *Building Virtual Research Environment for the Sphere of Historical Resources* (www.manuscriptorium.cz) for colour digital images of the *Passional of Abbess Cunegund.* NKČR XIV.A.17. Licensed viewing only.

Martínková, D., ed. and trans. 1997. *Frater Colda ordinis praedicatorum: Tractus mystic,* Vol. 2. Prague: Fontes Latini Bohemorum.

Matějček, A. 1922. *Pasionál abatyše Kunhuty*. Prague: Jan Štenic.

—. 1924/25. "Iluminované rukopisy svatého Jiřího XIV a XV věk v universitní knihovně pražské," *Památky archaeologické* 34:15-16.

Matejka, L., ed. 1979. *Anthology of Czech poetry*. Michigan: Slavic Publications.

Merhautová, A. 1966. *Bazilika Svatého Jiří na Pražském hradě*. Prague: Akademie.

Millet, G. 1916. *Recherches sur l'iconographie de l'evangile. (Fascicule 109 de la Bibliothèque des écoles françaises d'Athènes et de Rome.)* Paris: Fontemoing et Cie.

Monks of Glenstal Abbey, trans. 1994. *The Rule of St. Benedict.* Dublin: Four Courts Press.

Nechutová, J. 2000. *Latinská literatura českého středověku do roku 1400.* Prague: Vyšehrad.

Newman, B. 2008. "The visionary texts and visual worlds of religious women." In *Crown and veil: Female monasticism from the 5th to the fifteenth centuries*, edited by J.F. Hamburger and S. Marti. 151-171. New York: Columbia University Press.

van Os, H. W. 1978. "The Discovery of an early Man of Sorrows on a Dominican Triptych." *Journal of the Warburg and Courtauld Institutes* 41:65-75.

Panofsky, E. 1927. "Imago pietatis: Ein Beitrag zur Typengeschichte des 'Schmerzensmanns' und der 'Maria Mediatrix'." In *Festschrift für Max J. Friedländer zum 60 Geburtstage*, edited by M. J. Friedländer. 261-308. Leipzig: E.A. Seemann.

Petroff, E. 1986. *Medieval women's visionary literature.* New York: Oxford University Press.

Ragusa, I. and R. B. Green, trans. 1961. *Meditations on the life of Christ: An illustrated manuscript of the fourteenth century.* Princeton: Princeton University Press.

Rubin, M. 1992. *Corpus Christi: the Eucharist in late Medieval Culture.* Cambridge: Cambridge University Press.

Rynešová, B. 1926. "Beneš kanovník svatojiřský a pasionál abatyše Kunhuty." *Časopis archivní školy*, 3:13-35.

Schiller, G. 1972. *Iconography of Christian art.* Vol. 2. London: Lund Humphries.

Stace, C. 2001. *St. Clare of Assisi: Her legend and selected writings.* London: Triangle.

Stejskal, K. and E. Urbánková. 1975. *Pasionál Přemyslovny Kunhuty: Passionale Abbatissae Cunegundis.* Prague: Odeon.

Stejskal, K. 1998. "Die Wundertätigen Bilder und Grabmäler in Böhmen zur Zeit der Luxemburger." In *King John of Luxembourg (1296-1346) and the art of his era. Proceedings of the Prague international conference Sept. 16-20, 1996,* edited K. Benešovská and K. Stejskal. 270-277. Prague: Koniasch Latin Press.

Taft, Rev. R. 1980-1981. "The liturgy of the Great Church: An initial synthesis of structure and interpretation on the eve of iconoclasm." *Dumbarton Oaks Papers* 34-35:45-75.

Tichý, F. 1939. "Frater Colda" O.P. *Časopis národního muzea* 113:81-88.

Toissant, G. 2003. *Das Passional der Kunigunde von Böhmen: Bildrhetorik und Spiritualität*. Paderborn: Schöningh.

Tomek, V. V. 1855. *Dějepis města Prahy*. Vol. I. Prague: Vetterlowské knihtiskárny (A. Renn).

Vilikovský, J. 1948. *Písemnictví českého dramatu*. Prague: Universum.

—. 1957. *Výboru z české literatury od počátků po dobu Husovu*. Prague.

Vlček Schurr, J. Forthcoming. "The dedication illustration of the Passional of Abbess Cunegund and questions of identity." In *Art and identity: Visual culture, politics and religion in the Middle Ages and Renaissance*, edited by S. Cardarelli and E. J. Anderson. Newcastle: Cambridge Scholars Publishing.

Voaden, R. 1999. *God's words, women's voices: the discernment of spirits in the writings of late Medieval women visionaries*. York: York Medieval Press.

Vocel, J. E. 1865. "Kritické poznámky." *Krok* 1:297-303.

van Zeller, Dom. H. 1958. *The Holy Rule: Notes on St. Benedict's legislation for monks*. London: Steed and Ward.

—. 1965. *Benedictine nun: Her story and aim*. Dublin: Helicon.

Žemlička, J. 1986. *Století posledních přemyslovců: Český stát a společnost ve 13. století*. Prague: Panorama.

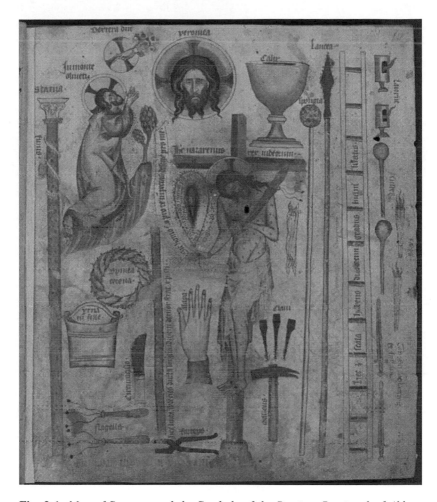

Fig. 9-1. *Man of Sorrows and the Symbols of the Passion, Passional of Abbess Cunegund,* NKČR XIV.A.17, fol. 10r, parchment, 1312, 30 x 25cm. National Library of the Czech Republic, Prague. Photo: reproduced courtesy of the National Library of the Czech Republic, Prague.

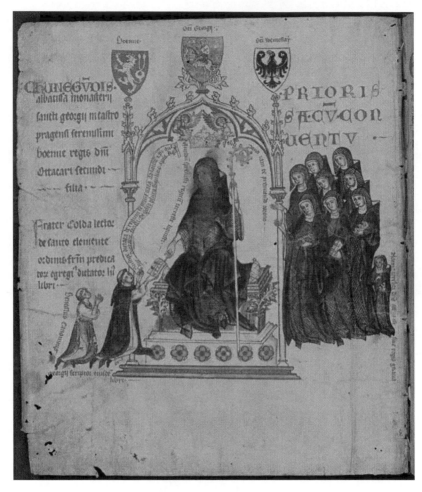

Fig. 9-2. *Dedication illustration, Passional of Abbess Cunegund,* NKČR XIV.A.17, fol. 1v, parchment, 1312, 30 x 25cm, National Library of the Czech Republic, Prague. Photo: reproduced courtesy of the National Library of the Czech Republic, Prague.

Fig. 9-3. *Arma Christi, Passional of Abbess Cunegund,* NKČR XIV.A.17, fol. 3r, parchment, 1312, 30 x 25cm, National Library of the Czech Republic, Prague. Photo: reproduced courtesy of the National Library of the Czech Republic, Prague.

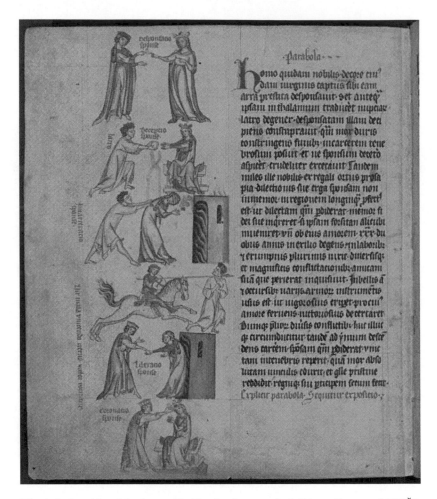

Fig. 9-4. *Parable of the Invincible Knight, Passional of Abbess Cunegund*, NKČR XIV.A.17, fol. 3v, parchment, 1312, 30 x 25cm, National Library of the Czech Republic, Prague. Photo: reproduced courtesy of the National Library of the Czech Republic, Prague.

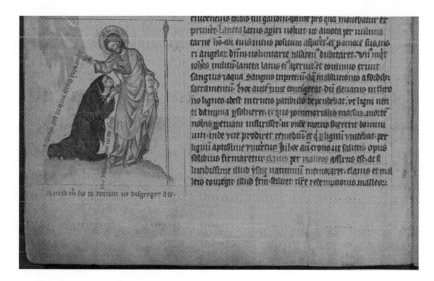

Fig. 9-5. *Christ with Lance and Supplicating Nun, Passional of Abbess Cunegund,* NKČR XIV.A.17, fol. 7v (detail), parchment, 1312, 30 x 25cm, National Library of the Czech Republic, Praguc. Photo: reproduced courtesy of the National Library of the Czech Republic, Prague.

SECTION IV

SPECTACLE, RITUAL AND REPUTE

CHAPTER TEN

LATE FIFTEENTH CENTURY ARCHITECTURAL MANIFESTATIONS OF DUCAL AUTHORITY IN THE VICINITY OF MUNICH

ANDREAS DAHLEM

Dukes Sigmund (1439-1501, reg. 1460-67) and Albrecht IV (1447-1508, reg. 1465-1508) of Bavaria-Munich ordered the renovation and extension of their predecessors' castles and palaces in the immediate surroundings of Munich, their principle ducal seat in the fifteenth century. Their patronage focussed mainly on the ducal estates to the South and the West of Munich (fig. 10-2). They commissioned the erection of churches and had all of these buildings decorated with distinctive heraldic schemes. This article examines the dukes' strategies and motivations for these architectural demonstrations of authority.

Duke Sigmund of Bavaria-Munich could look back on an almost three hundred year-old history of his dynasty's rule over the Duchy of Bavaria when he succeeded his father Albrecht III in 1460. Emperor Frederick Barbarossa had installed Count Otto V of Wittelsbach as Duke of Bavaria in 1180 (Spiegel 1988, 195; Stahleder 2005, 16). The Wittelsbach dukes strived to establish themselves as a local power and a political force in the Holy Roman Empire. These aspirations were thwarted by almost continuous inner-dynastic struggles, which became especially pronounced in the fourteenth and fifteenth centuries. Duke Louis IV (reg. 1302-47) who was crowned king of the Holy Roman Empire in 1314 and later became known as Emperor Louis the Bavarian left a vast territory. His heirs divided it and the dynasty broke up into four lines. The inner-dynastic disputes climaxed in the military conflicts of 1421-22 and 1439-43 between Duke Louis VII of Bavaria-Ingolstadt (reg. 1413-1447) and Dukes Ernst (reg. 1397-1438), William III (reg. 1397-1435) and Albrecht III (reg. 1438-60) of Bavaria-Munich as well as Duke Henry XVI of

Bavaria-Landshut (reg. 1393-1450) (Dittmar 1992, 60-4; Stahleder 2005, 243).

In the second half of the fifteenth century, the territory of the Duchy of Bavaria-Munich comprised the heartland of Upper Bavaria, which extended from the River Lech in the West to the River Inn in the East and from the lands north of Munich almost to Kufstein and the Alps in the South (fig. 10-1). The Dukes of Bavaria-Munich had inherited some of the Bavarian domains of the Bavaria-Straubing line when it had become extinct in 1425. These lands stretched approximately from Ingolstadt in the West to Bohemia in the East along both sides of the River Danube. They extended almost to Amberg in the North and bordered on the territories of the Dukes of Bavaria-Landshut in the South.

Sigmund and Albrecht IV set a new political tone. They curtailed the aristocracy's traditional privileges. The extinction or departure of established patrician families from Munich permitted the dukes to increase their authority over their principal ducal seat (Pfister 1999, 14, 16). For instance, the dukes disregarded civic jurisdiction and the customary autonomy of civic government by freeing a nobleman from the town hall's prison chamber in 1467 and by intervening the election of the inner council in 1479 (Stahleder 1992, 145; Stahleder 1995, 412-13, 476). In the 1480s, Albrecht IV imposed monastic reforms (i.e. stricter, more observant rules for the Augustinian order in 1481) against the will of Munich's burghers (Stahleder 1995, 472). Instead of requesting military support from the Estates, Albrecht IV levied the so-called Reisgeld in 1488 (Bastert 1993, 115). This tax raised money for funding professional military troops as the duke expected to go into war against the Swabian Confederation, which had been founded by Frederick III of Habsburg. Albrecht IV's act insulted the aristocracy and the landed gentry. They were consternated by the dissolution of this customary alliance that denoted a curtailment of their traditional privileges. Albrecht IV's choice of mercenaries instead of the support from aristocrats and the landed gentry illustrates their loss of autonomy and political weight.

Unlike Dukes Ernst and William III of Bavaria-Munich whose reign was beneficial for Munich's development but who mostly resided in the castles outside Munich (i.e. Dachau, Starnberg and Grünwald, fig. 10-2), their successor Albrecht III concentrated his government in Munich (Störmer 1999, 364; Ziegler 2003, 762). In comparison with Louis the Bavarian's architectural and artistic commissions in Munich, neither Ernst, William III nor Albrecht III initiated a major scheme of patronage that

visually manifested their government. This situation changed considerably during the reign of Sigmund and Albrecht IV.

The most important period for the cultural and political development of late medieval Munich began in 1460. Sigmund and Albrecht IV continued the social and religious commitment of their predecessors Ernst, William III and Albrecht III. The coalition of dukes and patricians guaranteed peace and benefitted Munich's economy as well as its cultural life (Bös 1992, 14; Warnke 2003, 38; Ziegler 2003, 761). These conditions attracted craftsmen, artists and master masons like Erasmus Grasser, Jan Polack and Jörg von Halspach. The swift completion of the Late Gothic building of the Church of Our Lady, initiated in 1468 and built almost completely within two decades, attests to the success of this alliance.

Innovations in architecture initially occurred in the dukes' urban building projects like the renovation of the Alte Hof, which remained the main ducal residence until the early sixteenth century when the dukes chose the Neuveste as their new residence because of its location at the town's perimeter. In the 1460s, Sigmund initiated construction work at the Alte Hof to create a splendid court residence that benefitted his status (Bastert 1993, 124; Burmeister 1999, 47-8, 116-7; Störmer 1999, 368).

A hall in the Alte Hof's western wing (Zwingerstock) was decorated with genealogical murals, which depicted a series of legendary and real ancestors. The fragments of this large genealogical cycle, showing only fourteen of the original sixty-one figures, were discovered on 5th August 1850 during renovation work in the Zwingerstock. They remained there until 1893 when they were transferred into the Bayerisches Nationalmuseum in Munich (Burmeister 1999, 48, 51). The fragments depict fourteen members of the Arnulfing, Carolingian and Agilolfing dynasties who were claimed to be ancestors of the Bavarian dukes in the fifteenth century. The complete series of sixty-one legendary and real ancestors as well as relatives of the Bavarian dukes in its original conception is documented on two manuscript scrolls (c. 1470/80) in the Cabinet des Estamps of the Bibliothèque Nationale in Paris.

The elegant Late Gothic oriel of the southern wing (Burgstock) was built in conjunction with the new roof frame (1463) and provided poly-focal views across the courtyard and the River Isar into the distant countryside. The facades of the southern wing and the gate tower were embellished with a white, grey and light yellow lozenge pattern. The lozenges alluded to the armorial bearing of the Dukes of Bavaria, whereas their colours made reference to the imperial colours of Emperor Louis the Bavarian. This evocative motif had already been employed as decoration of the town walls in 1419 as attested by the payments recorded in the

ledgers of the civic treasury (Stahleder 2005, 236). The southern wing's exterior was also decorated with armorial bearings, which for instance illustrated the recent conjugal bonds of the Dukes of Bavaria-Munich (i.e. Visconti, County of Gorizia and Duchy of Brunswick)[1] and thus identified the building precisely as a residence of the Bavaria-Munich branch of the Wittelsbach dynasty.

The painted heraldic decorative schemes of the southern wing's exterior were visible until the early twentieth century (Burmeister 1999, 47-8). However, the evaluation of their authenticity and the accuracy of their reconstruction are problematic because of the extensive undocumented renovation and construction work in the five centuries after their creation. The dismantling of the top half of the Burgstock's gate tower in 1813 and the demolition of the palace chapel of St Laurence in 1816 were two of the most severe incisions into the ensemble's fabric. Bombing during the Second World War did not damage the Burgstock unlike some of the Alte Hof's other wings. Nevertheless, renovation work was carried out from 1964 till 1968 to accommodate the Inland Revenue's offices. This construction project comprised the reconstruction of the gate tower according to the wooden model of Munich, built by Jakob Sandtner in 1570 for Duke Albrecht V of Bavaria and now in the Bayerisches Nationalmuseum in Munich. The artists Kleemann and Braun discovered the façade's original decoration and restored it. Their findings and subsequent restoration work also remained undocumented (Burmeister 1999, 47-8, 71-104). Hence it cannot be appraised to what extent the current heraldic programme reflects the original scheme as envisaged by its patron Duke Sigmund in the 1460s. However, the armorial bearings on the exterior of the Burgstock express similar concepts as the schemes found at the Chapel of Blutenburg Palace and St Wolfgang in Pipping, two later examples of Sigmund's patronage. For this reason, it may be assumed that most of the coats-of-arms on the exterior of the Burgstock's gate tower and the oriel echo Sigmund's original heraldic scheme and that they were reconstructed based on the traces of the facades' fifteenth-century embellishments that were discovered during the renovation work.

Sigmund retired from his active role in the ducal government on 3rd September 1467 and passed most of his powers over to Albrecht IV. He retained the ecclesiastic fiefs, the right of patronage and allocation of ecclesiastic sinecure. Sigmund received Blutenburg Palace and the estates in Menzing, the castles and palaces in Dachau, Grünwald, Nannhofen and Starnberg, the income from several ducal estates like Laufzorn as well as a princely allowance as compensation for his abdication in favour of

Albrecht IV (Altmann 1994, 2; Bastert 1993, 112; Sigmund von Bayern-München 1467; Stahleder 1995, 412, 416; fig. 10-2).

From the 1470s, Sigmund's patronage focused on these palaces and estates. Two contemporary beholders noted Sigmund's patronage in Blutenburg Palace. The chronicler Veit Arnpeck wrote that Sigmund

"liked Menzing [where Blutenburg Palace is located] very much, built it appropriately, and had the churches there decorated lavishly and beautifully" (Arnpeck 1915, 673).

Ulrich Füetrer stated in his *Chronicle of Bavaria* that Sigmund "built more than one church and embellished them in a manner appropriate for a prince" (Füetrer 1909, 261-2). These two quotes refer to Blutenburg Palace (fig. 10-5), St Wolfgang in Pipping (fig. 10-4), the Church of St Martin in Untermenzing (built from 1492), and the church in Aufkirchen (constructed from 1499) that is dedicated to the Assumption of the Virgin Mary (Loibl 1980, 16; von Riezler 1892, 284).

Blutenburg Palace became Sigmund's main residence and was transformed into one of the most magnificent late medieval palaces in the vicinity of Munich (Störmer 1987, 18). The pious duke laid the foundation stone of St Wolfgang in Pipping on 5^{th} May 1478 (Altmann 1980, 43). Pipping is situated along the pilgrimage route from Augsburg to St Wolfgang im Salzkammergut and in close proximity to Blutenburg Palace (Altmann 1996, 304), where the construction of a second chapel commenced in 1488 (Erichsen 1985a, 6; Erichsen 1995b, 36; Loibl 1980, 14).

Initially, Albrecht IV's patronage focused on Munich, where his government and administration were centred. On 12^{th} December 1485, Sigmund signed over Grünwald Castle to Albrecht IV (Sigmund von Bayern-München 1485). Subsequently, Albrecht IV initiated a prestigious construction project, because the castle was intended as Morgengabe[2] to his future wife Kunigunde of Austria, whom he was to marry on 2^{nd} January 1487. The scheme comprised among other things the erection of a new gatehouse and the decoration of the chambers of the duke and duchess with murals to create an appropriate and comfortable hunting lodge. Work began in January 1486 and was finished in October 1487 (Hartig 1926, 14; Loibl 1980, 10-2; Weithmann 1995, 151; Wild 1979, 11-4).

Ulrich Füetrer decorated the crowstep gable of Grünwald Castle's gatehouse with a hierarchical presentation of armorial bearings in 1486/87 (Bös 1992, 88; Hartig 1926, 14; Wild 1979, 14-5). The combined coat-of-

arms of the Dukes of Bavaria and the Counts Palatine of the Rhine, displayed at the gable's apex, boldly placed Albrecht IV as well as his dynasty at the zenith of this scheme (fig. 10-3). Below the House of Habsburg's heraldic shield represents Kunigunde of Austria. It is flanked by the coat-of-arms of the Portuguese House of Braganza that refers to Eleanor of Portugal, the wife of Emperor Frederick III and mother of Kunigunde. The armorial bearings of the Duchy of Brunswick, the House of Visconti, the County of Hainaut, the County of Gorizia, the Kingdom of (Naples and) Sicily, the Duchy of Cleves, the Kingdom of Poland and the Duchy of Jülich-Berg represent the wives of Albrecht IV's ancestors.[3]

The heraldic scheme on the crowstep gable of Grünwald Castle's gatehouse must have provided a glimpse of the armorial programme that awaited the ducal family, courtiers and visitors in the halls of the Dürnitzstock, the western wing of Grünwald Castle, where the living quarters of the duke and duchess were located. This wing is now lost. The slope on which Grünwald Castle is located was constantly eroded during floods of the River Isar. The diminishing stability of the western wings' foundations triggered the gradual destruction of the buildings with the ducal apartments from the end of the seventeenth century to prevent an uncontrolled collapse of the ruinous buildings (Wild 1979, 14-5, 24-5).

The heraldic embellishment of the halls in the Dürnitzstock is documented in the ledgers of the ducal treasurer Matthäus Prätzl, now kept in the Bavarian State Library in Munich (Hartig 1926, 16-7; Wild 1979, 14). According to Prätzl's records of 1486 and 1487, Ulrich Füetrer and master Heinrich decorated the rooms with murals. Heinrich embellished the room adjacent to the kitchen, the blue parlour (blaue Stube) as well as the entrance hall (Fletz), situated between the blue parlour and the large hall that faced toward the River Isar. Füetrer painted two sundials and a stove, decorated two rooms, created six coats-of-arms with shields and crests, eighty-nine armorial bearings of the knights who participated in tournaments, and eight history paintings (Hartig 1926, 16-7; Wild 1979, 14). Füetrer's works of art and armorial bearings may be imagined as a heraldic or genealogical programme for a knight's hall. The coats-of-arms may have complemented the history paintings by decorating a large room in a frieze-like manner.

The elevations of the choir of St Wolfgang in Pipping feature a painted tracery frieze below the roof line that incorporates the following coats-of-arms (fig. 10-4): (beginning with the heraldic programme on the choir's southern exterior wall and ending with the coats-of-arms on the northern side) a troika with the heraldic shields of the Duchy of Brunswick, the Palatinate of the Rhine and the House of Visconti; the County of Hainaut,

the Duchy of Bavaria, the County of Cleves; the imperial eagle of Emperor Frederick III,[4] the heraldic shield of the Duchy of Bavaria, the imperial eagle of Emperor Louis the Bavarian; the combined coat-of arms of the Dukes of Bavaria and the Counts Palatine of the Rhine, the armorial bearing of the House of Habsburg; the coats-of-arms of Friesland, Zeeland and Holland. This heraldic-genealogical scheme illustrates the matrimonial alliances of members of the Bavaria-Munich line, it emphasises the reign of Emperor Louis the Bavarian and the territorial gains (i.e. Friesland, Holland and Zeeland) that resulted from his marriage with Margaret of Holland, and it demonstrates Sigmund's affinity with Emperor Frederick III, which was appropriately presented on this building, because it was situated along a southbound route to the Habsburg's lands.

The northern and southern facades of the Chapel of Blutenburg Palace are also embellished with a tracery frieze below the roofline that includes armorial bearings. On the northern façade the combined coats-of-arms of the Bavarian dukes and the Counts Palatine of the Rhine are flanked by the heraldic shields of the Duchy of Brunswick (on the left side) and the Habsburg's armorial bearing (on the right side). These two coats-of-arms refer to Sigmund's mother Anna of Brunswick and Albrecht IV's wife Kunigunde of Austria. The southern façade features a series of heraldic shields that illustrate the matrimonial alliances of the ancestors of Sigmund and Albrecht IV (fig. 10-5). The coats-of-arms in the painted tracery frieze represent (from left to right) the conjugal bonds of Catherine of Gorizia and Duke John II, Elisabeth Visconti and Duke Ernst, Anna of Brunswick and Duke Albrecht III, Kunigunde of Austria and Albrecht IV, Margaret of Cleves and Duke William III.[5]

In addition to the presentation of the matrimonial alliances of the progenitors of Sigmund and Albrecht IV, the programme of the chapel's southern façade features a conspicuous imperial theme. Louis the Bavarian's imperial coat-of-arms is prominently placed in the centre of the painted tracery frieze between the other armorial escutcheons. Unlike the other coats-of-arms, which are incorporated into the grouped trefoil motifs, the imperial eagle of Louis the Bavarian is elevated from the painted tracery frieze by placing it on a blue rectangle with a red border. Another depiction of the imperial eagle is situated above the chapel's portal. Heraldic shields with the standing lion (the heraldic animal of the Counts Palatine of the Rhine) and the white-and-blue lozenge pattern of the Bavarian dukes flank the imperial eagle.

These heraldic schemes' specific genealogical references on the facades of the Chapel of Blutenburg Palace, St Wolfgang in Pipping and

Grünwald Castle demarcate them specifically as residences of the Dukes of Bavaria-Munich.

Louis Morsak observed that in the fifteenth century most subjects were familiar with the Bavarian dukes' coat-of-arms as a symbol of the Wittelsbach dukes' sovereignty over the Duchy of Bavaria (Morsak 1984, 145). It can be assumed that the majority of contemporary beholders could decipher the conceptual connotations of these heraldic-genealogical programmes and they would correctly identify all three buildings as residences of the Dukes of Bavaria-Munich.

The heraldic programme of the Chapel of Blutenburg Palace is the most brilliant scheme because of its intelligibility. The complexity of the heraldic programme on the northern façade takes the wide range of its beholders into account. Even those people who did not gain access to the courtyard would be able to view the chapel's northern façade. Its heraldic scheme only comprises the armorial bearings of the building's patron, his mother and sister-in-law. Yet the southern courtyard-facing exterior illustrates the conjugal bonds of Sigmund's ancestors and celebrates the reign of Louis the Bavarian (fig. 10-5). Even though this programme incorporates a wider range of coats-of-arms, all of them relate to the Bavaria-Munich branch of the Wittelsbach dynasty.

This notion becomes even more apparent when comparing these programmes with the heraldic and genealogical decorations of the buildings interiors. The interior of the Chapel of Blutenburg Palace, the "knight's hall" in Grünwald Castle and a hall in the Alte Hof's Zwingerstock featured more complex genealogical programmes that reflected the political agenda of the Dukes of Bavaria-Munich, who desired to reunite the Wittelsbach dynasty (Störmer 1999, 367-71). This intention was expressed with armorial bearings in the Chapel of Blutenburg Palace, whereas the halls in the Alte Hof and probably in Grünwald Castle featured genealogical murals or so-called history paintings. A fragment of the Alte Hof's mural, depicting a series of the dukes' legendary and real ancestors, is now exhibited in the Bayerisches Nationalmuseum in Munich. Füetrer's armorial bearings and history paintings for a hall in Grünwald Castle are only known, because they are documented in the ledgers of the ducal treasurer Matthäus Prätzl (Hartig 1926, 16-7; Wild 1979, 14). These schemes on the buildings' exteriors and in their interiors demonstrate a differentiation of audiences as they addressed specific groups of beholders. The interiors' programmes required a better knowledge of the Wittelsbach dynasty's history to interpret them as statements of the political agenda of Sigmund and

Albrecht IV. Whereas the exteriors' armorial bearings mostly functioned as means to identify the buildings as residences of the Dukes of Bavaria-Munich.

The findings of Kilian Heck's study *Genealogie als Argument. Der Beitrag dynastischer Wappen zur politischen Raumbildung der Neuzeit* (Heck 2002) can be adapted to explain the Dukes of Bavaria-Munich's objectives that underlie the heraldic embellishments of their ecclesiastic foundations and residences. Heck examined coats-of-arms as genealogical symbols and their function in providing a social group with an identity or for defining a territory. He described this process as the construction of reality through the symbolic connotations of these armorial bearings. From the late twelfth century, coats-of-arms served as means of identification in tournaments and battles. Subsequently, their original function gradually diminished, because they increasingly became visual representations of dynasties. This development is reflected in the heraldic shields' decreasing size. (Heck 2002, 17, 19)

From the fifteenth century, an aristocratic house's identity was not exclusively linked to its ancestors, it also stemmed from geographic entities. In the Late Middle Ages, aristocratic houses in the Holy Roman Empire intended to noticeably demarcate their territories by differentiating them from the other dynasties' territories with the application of characteristic armorial bearings and heraldic programmes on buildings in their princely seats and peripheral locations (Heck 2002, 81-2). Heck also stated that analogous to Jurij M. Lotman's concept of the "semio-sphere" in literary studies, coats-of-arms and heraldic schemes were intended to introduce order into an unstructured, peripheral space by serving as impressive visual representations of a dynasty and by expressing its authority over a territory (Heck 2002, 18). Therefore, coats-of-arms not only represented a dynasty and its members, they also stood for the dynasty's territories and its authority over these realms.

The extension of the framework for the demonstration of the princely government with armorial bearings, ducal residences and ecclesiastic foundations to the vicinity of Munich coincided with the novel conceptual argument in late fifteenth-century Bavarian historiography like Ulrich Füetrer's *Chronicle of Bavaria* (Füetrer 1909). These works were intended to conceptually associate the Wittelsbach dynasty with their territory, the Duchy of Bavaria, and vice versa. Jean-Marie Moeglin referred to this notion as the "genealogical" strategy, which established a succession of rulers from the territory's foundation to the contemporary generation of princes, the patrons of these historiographic works, who are related by blood. Thereby, the dynasty's genealogy was at once linked to their

territory and to a continuous bloodline of Bavarian rulers (Spiegel 1988, 196).

The requirement to demonstrate the ducal authority in rural or peripheral spheres was particularly important, because in the fifteenth century the majority of aristocrats and noblemen lived in the countryside rather than in the princely seats. This social topography of the Duchy of Bavaria was described by Johannes Aventinus, who stated that the Bavarian

> "aristocrats lived in the country outside the towns, [they] spent their time with hunting and stalking; they did not ride to the court except for those who worked for and were paid by the court" (Bastert 1993, 132).

Furthermore, Munich's patricians acquired estates in the vicinity of Munich. By 1469, almost all of the established patrician families except for the Rudolf owned estates in the country around Munich. Successful merchants like the Barth, Gollier, Pötschner, Ridler, Schrenck, Sendlinger and Tulbeck joined the landed class with the acquisition of rural Hofmarken (manors or minor regional centres) and thus obtained a status that is comparable to that of the gentry or aristocrats. Thereby, these patricians fulfilled a condition that allowed them to serve in the ducal administration (Pfister 1999, 14; Stahleder 1992, 133-9; Steiner 2004, 19).

The patricians' departure from Munich to their bucolic estates demonstrates that the attributes of the aristocratic status and claim to power had changed significantly in the Duchy of Bavaria from the middle of the fifteenth century. The aristocrats' rank and sovereignty were increasingly based on territorial possessions rather than personal qualities. The notion of property as a criterion of the aristocratic status is illustrated by an administrative phenomenon of the late fifteenth century. Alongside the minor jurisdiction over a Hofmark and an appropriate chivalric lifestyle, members of the nobility had to own estates. This requirement is reflected in the Landtafeln of circa 1465, 1485 and 1490 (Bastert 1993, 222). These property registers list the Upper and Lower Bavarian noblemen and their estates.

Sigmund and Albrecht IV pursued a dual strategy to legitimise their status as rulers of the Duchy of Bavaria-Munich. They presented their distinguished genealogy and kinship to other eminent aristocratic houses. At the same time, they demarcated their territory with castles, palaces and churches, which were decorated with distinct armorial bearings. These heraldic escutcheons assigned the territory unmistakably to the Dukes of Bavaria-Munich.

The ducal commissions, which occurred after the reunification of the duchy in 1505, further substantiate the notion of coats-of-arms, residences and ecclesiastic foundations as demarcations of the dukes' territory. In the first half of the 1510s, the Bavarian dukes commissioned Hans Leinberger to produce a new high altarpiece (finished in 1514) for the parish church of St Kastulus in Moosburg.[6] The exterior panel of the predella's left wing, painted by Hans Wertinger, shows Dukes Wolfgang, William IV and Louis X as the altarpiece's donors. The wing's panel is flanked by the magnificent combined coats-of-arms of Bavaria and the Palatinate of the Rhine on the left side. Moosburg had belonged to the Duchy of Bavaria-Landshut before the Landshut War of Inheritance. It constituted a new domain of the Dukes of Bavaria-Munich's territory in the 1510s and they intended to convey their reign to their "new" subjects with this visual demonstration of authority. Similar considerations must have prompted the ducal commission of a stained glass window (1511) for the Heilig-Geist-Kirche in Landshut, which shows the armorial bearing of the Dukes of Bavaria and Counts Palatine of the Rhine.[7]

The heraldic decorations did not represent an illusory ideal that did not correspond to reality. Sigmund and Albrecht IV's strategies of manifesting their sovereignty throughout the Duchy of Bavaria-Munich could only be realised by rulers and aristocrats who had the actual power to do so. For example, the ducal order for the preservation of forests and game only became possible when the authority of the Dukes of Bavaria-Munich enabled its enforcement and execution (Loibl 1980, 10). These decrees and the ducal patronage in the country around Munich accompanied the increasing consolidation of the Dukes of Bavaria-Munich's territorial sovereignty in the second half of the fifteenth century. Next to the Electorate of Saxony the Duchy of Bavaria was the most consolidated and developed early modern territorial state in the Holy Roman Empire in the late fifteenth century (Lange 1998, 153).

This strengthening of the central ducal government is reflected in the administrative structures that created a "cultural landscape" for instance in the region southwest of Munich along the River Würm. The Hofmarken were planned from the beginning as country estates or local centres of the ducal administration as well as regional courts of justice (Schober 2005, 8). The Wittelsbach dukes established the centralised regional administration for the development of these regions and the execution as well as enforcement of their government on a local level. The judges of these regions were paid by the court and thus acted according to the intentions of the Dukes of Bavaria-Munich (Altmann 1980, 6). Hence most of the estates along the River Würm and around the Würmsee (now

Starnberger See) belonged to members of the ducal household or their court officials. For instance, Albrecht IV conferred the Königswiesen Estate near Gauting and the forests of Weyerbuchet, Holzen as well as Schachen on loan to Hans Weiler and in 1502 to Erhard Perfaller for Perfaller's son Benedikt (fig. 10-2). In 1507, Duke Wolfgang, the younger brother of Sigmund and Albrecht IV, acquired the Königswiesen Estate to build a hunting lodge or palace there (Schober 2005, 56-8).

The Dukes of Bavaria-Munich established these "suburban" residences with the objective of creating rural spheres that were suitable for their princely pursuits like hunting and that distinguished them from other aristocrats and the landed gentry. In the second half of the fifteenth century, Blutenburg Palace, Grünwald Castle and Starnberg Palace functioned as temporary residences or hunting lodges (Störmer 1987, 17), where the Bavarian dukes and members of their court only stayed for a limited period before returning to their main residence in Munich, where the ducal administration was permanently located, or before moving on to one of their other rural palaces like Dachau and Nannhofen (Loibl 1980, 13, 15-6). From the 1480s or 1490s, Albrecht IV, Kunigunde of Austria and the court began to temporarily reside in Starnberg Palace for a couple of weeks each summer. Albrecht IV carried out his government business from this interim residence. Albrecht IV, Sigmund and Wolfgang used Starnberg Palace as a basis for hunting and their pilgrimages to Andechs, where their father Albrecht III and older brother John IV are buried. Sources indicate that there were several boat houses near the castle and that the dukes' boats lay at anchor there (Schober 2005, 229-30). The boats were used for the hunting of birds like herons.

Rural residences like Blutenburg Palace, Grünwald Castle and Starnberg Palace were expressions of the Dukes of Bavaria-Munich's superiority over their peers, the gentry and the patricians, who could not afford to maintain several stately houses with deer parks and menageries. Especially deer parks, menageries and pleasances as documented in Blutenburg Palace and Grünwald Castle served exactly this purpose (Arnpeck 1995, 673; Sigmund von Bayern-München 1485; Wild 1979, 11). Only the wealthiest patrons could afford them.

In summary, the characteristic heraldic programmes of the Dukes of Bavaria-Munich's residences and ecclesiastic foundations in the vicinity of Munich precisely identified them with their patrons. They demarcated the territories of Sigmund and Albrecht IV, demonstrated their authority and thus visually represented actual political developments. The dukes became

conceptually associated with their territory. They provided the Duchy of Bavaria-Munich with a distinct history and identity that derived from the bloodline of rulers, who shaped the duchy's development. At once, the Wittelsbach dynasty obtained its identity from their territory. By the late fifteenth century, territorial possessions became an essential requirement for aristocrats and patricians, who aspired to serve the ducal court. The exquisite, princely lifestyle, which was realised at and represented by the impressive castles, palaces and ecclesiastic foundations allowed Sigmund and Albrecht IV to distinguish themselves from peers, lesser aristocrats and patricians.

Notes

[1] Duke John II (reg. 1375-97), the great-grandfather of Sigmund and Albrecht IV, married Catherine of Gorizia; Duke Ernst, their grandfather, wedded Elisabeth Visconti; and Anna of Brunswick was Duke Albrecht III's second wife.

[2] Morgengabe describes the gift given to a bride by her husband after the wedding night.

[3] Anna of Brunswick, the mother of Albrecht IV and daughter of Duke Erik I of Brunswick, married Duke Albrecht III of Bavaria-Munich in 1437. Duke Ernst of Bavaria-Munich (the grandfather of Albrecht IV) wedded Elisabeth Visconti in 1396. The coat-of-arms of the County of Hainaut stands for the marriage of Emperor Louis the Bavarian with Margaret of Holland in 1324, which bestowed the Wittelsbach dynasty with the territories of Hainaut, Holland, Zeeland and Friesland. Duke John II of Bavaria-Munich married Catherine of Gorizia-Tyrol in 1372. Duke Stephen II of Lower-Bavaria wedded Elisabeth of Sicily in 1328. Duke William III of Bavaria-Munich married Margaret of Cleves in 1433. Duke Louis VI of Upper-Bavaria wedded the Polish princess Kunigunde, the daughter of King Casimir III of Poland, in 1352. Elisabeth, the daughter of Duke Ernst of Bavaria-Munich and aunt of Albrecht IV, married Duke Adolf of Jülich-Berg in 1430.

[4] Sigmund's affinity for Emperor Frederick III and his stay at the imperial court in Vienna during his youth are reflected in Sigmund's choice of his clothes' colours: black, red and white. These are the colours of Emperor Frederick III and the Habsburg dynasty. Moreover Sigmund sought support from the imperial court in Vienna during the struggles with Albrecht IV, when his younger brother demanded participation in government. In 1474 Sigmund also received the relics of St Ursula from Frederick III for the Church of Our Lady. (Arnpeck 1915, 673; Burger 1978, 7; Stahleder 1995, 442-3.)

[5] Duke John II is Sigmund and Albrecht IV's great-grandfather, who became the first ruler of the Duchy of Bavaria-Munich after the partition of 1392. Duke Ernst is the grandfather of Sigmund and Albrecht IV. Duke Albrecht III is the father of Sigmund and Albrecht IV. Duke William III is the brother of Duke Ernst, and the great-uncle of Sigmund as well as Albrecht IV.

[6] For reproductions refer to Niehoff 2007, 18, 20, 28.

[7] For reproductions refer to Niehoff 2007, 268-9.

References

Altmann, Lothar. 1980. *Kirchen entlang der Würm.* Edited by H. Schnell and P. Mai. 2nd ed. Vol. 77, *Grosse Kunstführer.* Munich: Schnell & Steiner.

—. 1994. "Die spätgotische Bauphase der Frauenkirche 1468-1525. Eine Bestandsaufnahme und Interpretation bekannter Daten und Fakten." In *Monachium Sacrum. Festschrift zur 500-Jahr-Feier der Metropolitankirche Zu Unserer Lieben Frau in München,* edited by H. Ramisch, 1-20. Munich: Deutscher Kunstverlag.

—. 1996. "St. Wolfgang in Pipping, eine Pilgerkirche?" *Amperland. Heimatkundliche Vierteljahresschrift für die Kreise Dachau, Freising und Fürstenfeldbruck* 32: 302-08.

Arnpeck, Veit. 1915. *Sämtliche Chroniken.* Edited by G. Leidinger. Munich: M. Riegersche Universitäts-Buchhandlung.

Bastert, Bernd. 1993. *Der Münchner Hof und Fuetrers 'Buch der Abenteuer'. Literarische Kontinuität im Spätmittelalter.* Edited by W. Harms. Vol. 33, *Mikrokosmos. Beiträge zur Literaturwissenschaft und Bedeutungsforschung.* Frankfurt am Main: Peter Lang.

Bös, Werner. 1992. *Gotik in Oberbayern.* Munich: Süddeutscher Verlag.

Burger, Susanne. 1978. *Die Schloßkapelle zu Blutenburg bei München. Struktur eines spätgotischen Raums.* Edited by K. Bosl and M. Schattenhofer, *Miscellanea Bavarica Monacensia. Dissertationen zur Bayerischen Landes- und Münchner Stadtgeschichte.* Munich: Kommissionsbuchhandlung R. Wölfle.

Burmeister, Enno. 1999. *Die baugeschichtliche Entwicklung des Alten Hofes in München.* Munich: Buchendorfer Verlag.

Dittmar, Christian. 1992. "Kriegerische Auseinandersetzungen bis 1505 als Folge der Landesteilung." In *Bayern-Ingolstadt Bayern-Landshut 1392-1506. Glanz und Elend einer Teilung,* edited by B. Ettelt, 60-77. Ingolstadt: Stadtarchiv Ingolstadt.

Erichsen, Johannes. 1985a. "Umrisse Blutenburger Geschichte." In *Blutenburg. Beiträge zur Geschichte von Schloß und Hofmark Menzing,* edited by J. Erichsen. 28-52. Munich: Haus der Bayerischen Geschichte.

—. ed. 1985b. *Blutenburg. Beiträge zur Geschichte von Schloß und Hofmark Menzing.* Munich: Haus der Bayerischen Geschichte.

Füetrer, Ulrich. 1909. *Bayerische Chronik.* Edited by R. Spiller. Munich: M. Riegersche Universitäts-Buchhandlung.

Hartig, Otto. 1926. *Münchner Künstler und Kunstsachen. 1: Vom Beginne des 14. Jahrhunderts bis zum Tode Erasmus Grassers (1518) und Jan Polacks (1519).* 4 vols. Vol. 1. Munich: Verlag Georg D.W. Callwey.

Heck, Kilian. 2002. *Genealogie als Argument. Der Beitrag dynastischer Wappen zur politischen Raumbildung der Neuzeit.* Munich & Berlin: Deutscher Kunstverlag.

Lange, Hans. 1998. "Gasse, Gang und Galerie - Wegenetz und Inszenierung des Piano nobile in der Stadtresidenz." *Die Landshuter Stadtresidenz. Architektur und Ausstattung*, edited by I. Lauterbach, K. Endemann and C. L. Frommel, 151-162. Munich: Zentralinstitut für Kunstgeschichte.

Loibl, W. 1980. "Wittelsbacher Jagdschlösser um München." *Das Bayerland* 82 (2): 2-64.

Morsak, Louis C. 1984. *Zur Rechts- und Sakralkultur Bayerischer Pfalzkapellen und Hofkirchen.* Edited by L. Carlen. Vol. 21, *Freiburger Veröffentlichungen aus dem Gebiete von Kirche und Staat.* Freiburg, Switzerland: Universitätsverlag.

Niehoff, Franz, ed. 2007. *Um Leinberger. Schüler und Zeitgenossen.* 2nd ed. Landshut: Museen der Stadt Landshut.

Nöhbauer, Hans F. 2003. *München.* 2nd ed. Munich: Hirmer.

Pfister, Peter. 1999. "Città Nobelissima - München im 15. Jahrhundert." In *Münchner Gotik im Freisinger Diözesanmuseum*, edited by P. B. Steiner, 11-24. Regensburg: Schnell & Steiner.

Schober, Gerhard. 2005. *Schlösser im Fünfseenland. Bayerische Adelssitze rund um den Starnberger See und den Ammersee.* Waakirchen: Oreos-Verlag.

Sigmund von Bayern-München. 1467. "Hausurkunde 665": Bayerisches Hauptstaatsarchiv Munich - Geheimes Hausarchiv.

—. 1485. "Hausurkunde 681": Bayerisches Hauptstaatsarchiv Munich - Geheimes Hausarchiv.

Spiegel, Gabrielle M. 1988. Review of Jean-Marie Moeglin, *Les ancêtes du prince: Propagande politique et naissance d'une histoire nationale en Bavière au moyen âge (1180-1500). Speculum* 63 (1): 195-99.

Stahleder, Helmuth. 1992. "Konsolidierung und Ausbau der bürgerlichen Stadt - München im 15. Jahrhundert." In *Geschichte der Stadt München*, edited by R. Bauer, 120-47. Munich: C.H. Beck.

—. 1995. *Chronik der Stadt München. Herzogs- und Bürgerstadt. Die Jahre 1157-1505.* Edited by R. Bauer. 3 vols. Vol. 1. Munich: Hugendubel.

—. 2005. *Chronik der Stadt München. Die Jahre 1157-1505.* Edited by R. Bauer. 3 vols. Vol. 1. Munich & Berlin: Dölling und Galitz Verlag.

Steiner, Peter B. 2004. "Jan Polack - Werk, Werkstatt und Publikum." In *Jan Polack. Von der Zeichnung zum Bild. Malerei und Maltechnik in München um 1500*, edited by P. B. Steiner and C. Grimm, 15-26. Munich & Freising: Diözesanmuseum Freising:.

Störmer, Wilhelm. 1987. "Die oberbayerischen Residenzen der Herzöge von Bayern unter besonderer Berücksichtigung von München." *Blätter für deutsche Landesgeschichte* 123: 1-24.

—. 1999. "Hof und Hofordnung in Bayern-München (15. und frühes 16. Jahrhundert)." In *Höfe und Hofordnungen 1200-1600. 5. Symposium der Akademie der Wissenschaften in Göttingen*, edited by H. Kruse and W. Paravicini, 361-81. Sigmaringen: Jan Thorbecke Verlag.

von Riezler, Sigmund. 1892. "Sigmund, Herzog von Baiern-München." In *Allgemeine Deutsche Biographie*, 282-84. Wissenschaften. Leipzig: Duncker & Humblot.

Warnke, Martin. 2003. *Geschichte der deutschen Kunst. Band 2: Spätmittelalter und Frühe Neuzeit 1400-1750*. Edited by H. Klotz and M. Warnke. Vol. 2, *Geschichte der deutschen Kunst*. Munich: C.H. Beck Verlag.

Weithmann, Michael W. 1995. *Inventar der Burgen Oberbayerns*. 3rd ed. München: Bezirk Oberbayern.

Wild, Joachim. 1979. *Prähistorische Staatssammlung. Museum für Vor- und Frühgeschichte. Führer durch die Geschichte der Burg Grünwald*. Munich: Süddeutscher Verlag.

Ziegler, Walter. 2003. "Bayern." *Höfe und Residenzen im spätmittelalterlichen Reich. Teilband 1: Dynastien und Höfe*, edited by W. Paravicini, J. Hirschbiegel and J. Wettlaufer, 752-64. Ostfildern: Jan Thorbecke Verlag.

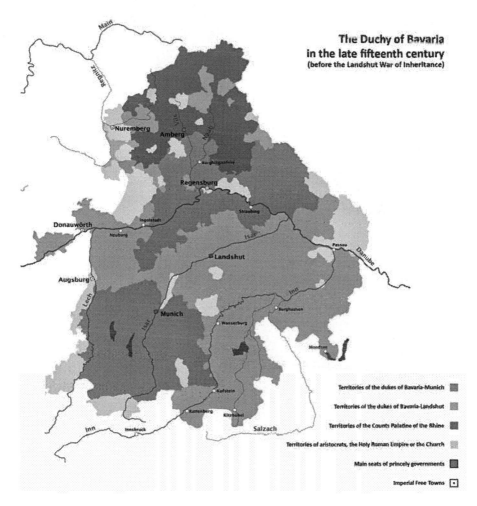

Fig. 10-1. The Duchy of Bavaria in the fifteenth century. Source: author.

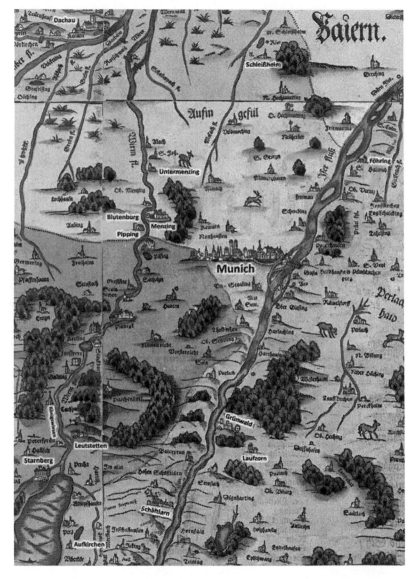

Fig. 10-2. Detail from Philipp Apian, *Bairische Landtaflen* (collage of plate 13, 14, 17, 18), woodcuts by Jost Amman, 1568. Photo: Bayerische Staatsbibliothek München (Shelfmark: Hbks F 15 b).

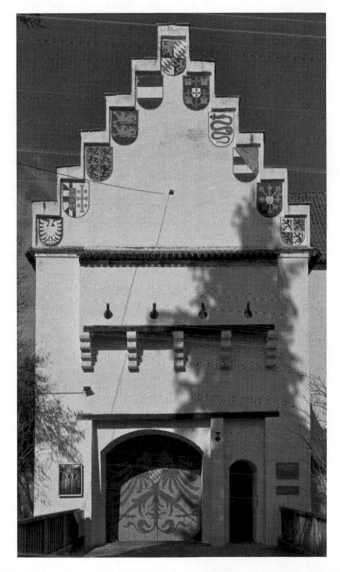

Fig. 10-3. The gatehouse of Grünwald Castle from the East. Grünwald, Bavaria. Photo: author.

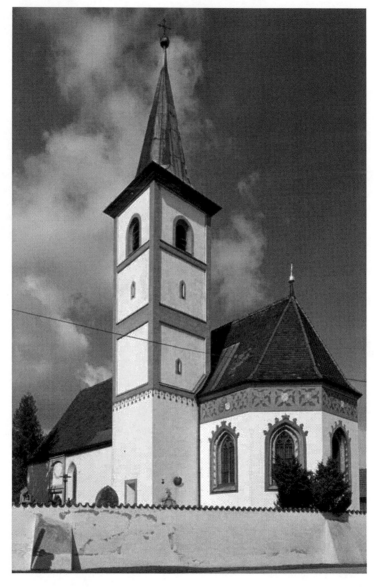

Fig. 10-4. St Wolfgang in Pipping from the South-East. Pipping, Bavaria. Photo: author.

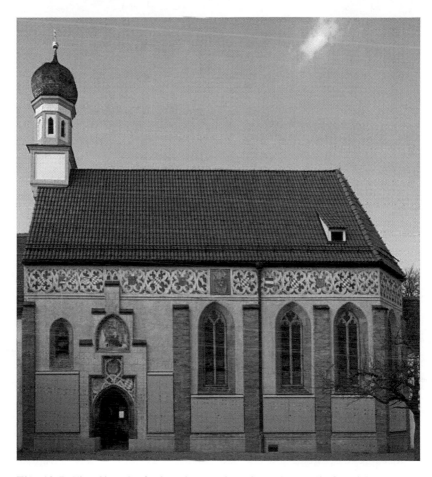

Fig. 10-5. The Chapel of Blutenburg Palace from the South. Munich, Bavaria. Photo: author.

CHAPTER ELEVEN

ROYAL ENTRIES IN FIFTEENTH CENTURY FRANCE: LOUIS XI'S NORTHERN PROGRESS OF 1463-64

NEIL MURPHY

In 1619 the French jurist and antiquarian Théodore Godefroy published *Le Cérémonial de France* (Godefroy, 1619). An enlarged version was reprinted by his son, Denis, in 1649 under the title *Le Cérémonial français*, with the young Louis XIV receiving the first copy from the printing press (Godefroy, 1649).[1] In this important work, still used by historians today, Godefroy printed a large number of documents relating to the rituals and ceremonies of the medieval and Renaissance French monarchy. The ceremonial entrances made by French kings into their *bonnes villes* figure prominently in the sources reproduced, and in many ways Godefroy's work set the tone for subsequent studies of royal entries.

Godefroy was primarily concerned with entries made into Paris, and the history and development of the Parisian entry has been studied more intensively that of any other French town.[2] This is unsurprising as the Parisian entry formed one of the elements of the French coronation ceremony. From at least the reign of Louis VIII, French kings left Reims shortly after receiving the *sacre* in order to make their entry into the capital (Petit-Dutaillis 1894, 222). While historians have focused on Paris, Parisian entries did not in themselves provide a model for the civic receptions of regional cities. Rather than examining the development of the royal entry in Paris, this paper will focus on the royal progress made by Louis XI to towns lying on northeastern frontier of the kingdom in 1463-64, which followed his repurchase of the Somme towns.[3]

The provisions of the treaty of Arras in 1435, which brought peace between Philip and Charles VII, had formally granted the Somme towns as possessions of the duke of Burgundy. A clause of the treaty stated that these territories could be bought back by the French crown for 400,000

écus, and Louis XI redeemed them from Philip the Good in 1463. The repurchase of the Somme towns formed a key part of Louis's drive to extend the borders of the kingdom and strengthen the power of the monarchy. It was a mark of prestige for Louis that only two years into his reign he had succeeded where his father, Charles VII, had failed and that expansion into this region had been achieved without the use of force, a feat which contemporaries commented on with admiration (Vaughan 2002, 355). When Louis made his entry into Amiens, the largest and most important of the Somme towns, in 1464, he remarked to Alberta Maleta, the Venetian ambassador then riding in his entourage, that Amiens alone was worth the payment (Mandrot 1919, 1:181).[4]

The Somme towns had been Burgundian for almost thirty years, and Louis needed to establish contact with the urban elites in order to encourage their loyalty. Louis also used this progress as an opportunity to make a tour of other towns in the region, such as Tournai, which by the mid-fifteenth century formed a French enclave deep into Burgundian territory. Louis's visit was the first made to the town since Charles VI had entered in 1382 and during these eighty years Tournai often had cause to feel separated from the rest of the kingdom. Indeed, in 1456 the town council described their town as "isolated and distanced from the other towns of France" (Small 2000, 156).

Royal entries in later medieval France provided a moment of dialogue between the king and urban elites (Guenée and Lehoux 1968, 2), which was especially important to the populations living on the frontiers of the kingdom.[5] If the campaigns of Charles VII to drive the English out France had led to a return of peace and stability across most of the kingdom, the north-east, which lay at the intersection of French and Burgundian power, remained a zone of intense military activity throughout the fifteenth century. This region was key to the foreign policy of Louis XI and he was well aware of the importance of royal entries in forming relations with the elites of these towns. When Louis had to delay his planned visit to Amiens in January 1464, he sent his wife, Charlotte of Savoy, and his father-in-law, Louis, duke of Savoy, in his place, asking the town to welcome them as they would the king (AMA BB9/124v). This worked to foster links with the civic elite of the town, which were consolidated when he entered in June that year.

The initial instruction to hold a royal reception inevitably emanated from outside the city walls. It was in the interests of the king to inform town councils of his intention to enter as early as possible, as it gave urban groups time to produce a magnificent entry, rather than a hastily prepared welcome. Town councils were not passive in organising these spectacles,

however. They engaged the services of other individuals to inform them of the location of a royal entourage, and whether or not royals intended to visit the town. In January 1464, Tournai's town council were unsure when the king intended to visit the city, so some of its notable members went to Arras, where the king had arrived on the night of 21 January, to ask on what day they could expect him to arrive, so that they could prepare the reception, sumptuous entertainments and make the best welcome that they could (Grange 1885, 51-52).[6] At a meeting of Amiens's town council held on 30 September 1463, the *échevinage* decided to send one of its own members, Philippe de Morvilliers, to meet the Chancellor of France at Hesdin (AMA BB9/115v). The Chancellor, Pierre de Morvilliers, was Philippe's cousin, and Philippe asked him when the king expected to visit the city, what road he planned to take, how he wished to be received, and what privileges the town could expect to obtain. It was, of course, important to know when the king intended to come. In 1469, Dijon went to considerable trouble and expense to welcome Charles the Bold. The town council hired master painters, glassmakers and basket makers to construct the decorations for the entry, and they even employed the services of the famous sculptor Antoine Le Moiturier, who was working on John the Fearless's tomb at Champmol. All this came to nothing, however, as Charles remained in Holland that year. When he eventually did come to Dijon in 1474, these expensive decorations were taken out of storage but many were unusable as they had rotted from damp (Quarré 1969, 328-31). It was also desirable to know what road the king planned to take, so that the town council could prepare the necessary gate and decorate the processional route leading from it. When Charles the Bad, king of Navarre and count of Evreux, entered Tournai in 1353 he approached by the road leading to the Coquerel gate, though the town had prepared the Bourdel gate for his arrival. As a result, two civic deputies had to lead Charles round the walls to the correct gate so that he could enter the city (Grange 1885, 22).

The town councillors of Amiens had hoped to exploit family connections in order to avoid such complications, and to allow them to produce the best spectacle possible. Unfortunately, the Chancellor's reply benefited the city little. On 10 October, Philippe appeared before the town council and told the gathered *échevins* that while his cousin had remembered who he was, Pierre had been too busy with the great affairs of state to give him a lengthy audience. The Chancellor told Philippe that he did not know when the king intended to visit the city, or if he even intended to do so. When asked what road Louis would take if he did come, Philippe was told that the king would take whatever road he wanted to.

He made no mention of any privileges that the town could hope to obtain, but he did tell Philippe that the king should be received in the way that the town usually welcomed monarchs, though it should not be too grand an entry (AMA BB9/119v). The town council chose to ignore the only bit of advice given by the Chancellor and prepared to stage the most sumptuous civic reception provided in Amiens for any dignitary up to that date.

Municipal councils across France competed to outdo each other in the splendour of their entries, in the expectation that an especially magnificent reception would create a favourable relationship with the king and lead to the obtaining of news right and liberties from the king. Competition between towns was present in the north-east, with Amiens and Tournai sending observers to watch entries in the neighbouring towns of Abbeville and Arras. When preparing Duke Charles the Bold of Burgundy's entry in 1466, Amiens' town council also wrote to the *échevins* of Abbeville to ask what presents they had given to the duke, what plays were performed and what proposals they made to Charles when he entered their town (AMA BB10/96v), though we do not know if the *échevins* of Abbeville sent a reply.[7]

The civic elite established personal contact with the king from the very outset of the ceremonial proceedings. The town councillors and other wealthy burgesses met the king outside the walls in order to escort him into the city. In Amiens, the town council ordered the greeting to be made in the fields beyond the town (AMA BB9/115v). It is not stated in documents how far they were go out of the gate, but generally the distance reflected the dignity of the visitor, and kings were greeted the furthest from the town. At Tournai, the greeting party was to meet king a league outside the town. This was on the extreme of the *banlieue*, which was as far as the town's jurisdiction extended (Grange 1885, 44). The expression of formal greeting was the main purpose of any ceremonial entry and the speaker was the focal point of this welcome. Given the expectations placed on the speaker to make a good greeting, it was not always a favoured position. On 22 August 1558, Amiens's town council met to discuss Henry II's proposed entry. During this meeting, an argument broke out among the *échevins* as to who would make the welcoming speech. The first *échevin* approached refused, the second *échevin* refused as he had not been asked first, while the third and fourth refused on the basis that it was not their duty to make the speech. Eventually, after several more refusals, a provost was appointed to make the welcome (AMA BB31/123v). The speaker had to follow a strict procedure, both in gesture and in words, in order to make the appropriate greeting and endear the town to the king. For Louis's entry into Tournai in 1463, the town council instructed the

speaker to get down off his horse, when the king approached, and make a brief greeting on foot, as the deliberations tell us that it was more humble and respectful to make the welcome in this way (Grange 1885, 44-45).[8] In a further sign of deference to the king, Tournai's *échevins* ordered the keys to the city to be presented to Louis while the welcoming speech was being made. These keys were brought to the king in box fashioned into the shape of a castle and attached on the back a white horse. Louis, however, refused to take possession of the keys and, by the same token, the town. Instead he asked the council to retain them, declaring that the city had always remained loyal and obedient to the crown (Grange 1885, 53). This highly unusual refusal of ceremonial submission was a highly charged symbolic expression of the relationship that existed between the crown and Tournai in the latter half of the fifteenth century.

It was at this point in the ceremony that the king could return the banished to the town and release those imprisoned in the civic jails. The pardoning of prisoners was generally the prerogative of the king, and the town did not accord this privilege lightly to others. When Philip the Good, a royal cousin, had attempted to pardon prisoners in 1439, the civic council refused him permission to do so (Grange 1893, 373). Attempts by John II in the fourteenth century to consolidate the right of pardon into the hands of the monarchy were reversed during the late fourteenth and early fifteenth centuries (Legoux 1865, 9). During this period, French princes sought to exploit the weakness of the French crown by asserting their right to pardon prisoners at the entries they made into towns outside their domains. In 1436, René, duke of Anjou, king of Sicily and titular king of Jerusalem, arrived at the edge of the *banlieue* of Tournai with a large number of the banished, whom he hoped to readmit to urban society. The town council moved to block his claims to issue pardons, informing René that neither he nor his successors had the right to perform this act at Tournai. After a lengthy deliberation, during which René was kept waiting in the fields outside the town, the councillors agreed to let him admit some of the banished, but only on their own terms. The *échevins* decided which people René could return to the body of the town, and they made it clear that this right was only being granted to him on this single occasion, and was not to be seen by him nor his successors as a customary right (Grange 1885, 38-39). When Louis came to Tournai in 1463, it was expected that, as king of France, he would pardon prisoners when he entered the town. Such an act could pose a threat to the internal security of the town and in the days before the entry the council sent some representatives to the king with the town registers containing the names of the banished. The *échevins* instructed these deputies to encourage the king not to admit those people

back into the town that the council did not want readmitted. They were to do this by highlighting the potential dangers of readmitting these excluded persons to urban society, and by demonstrating to Louis that previous French kings had listened to the advice of the town in this matter (Grange 1885, 42). Tournai had remained loyal to the French crown throughout the challenges of the fourteenth and fifteenth centuries and Louis worked with the town council to ensure that those guilty of serious crimes, such as rape or murder, were exempt from receiving his pardon at the entry.

When Louis entered Arras in January 1464, the issue of the pardoning of criminals was more contentious. The liberties of Arras stated that prisoners guilty of serious crimes were not receive pardon during a ceremonial entry. Up to 1463, the counts of Artois and Flanders, and the dukes of Burgundy had respected this right. However, the pro-Burgundian citizens of Arras had a fractious relationship with Louis XI and they were not certain that the French king would honour the town's liberties regarding the banished when he entered in January 1464. As soon as they received word that numerous criminals were gathering at the edge of the town's jurisdiction in anticipation of receiving grace at his entry, the municipal council petitioned the king not to pardon these criminals. Louis delayed in making his reply and only on the morning of his entry did the king inform the apprehensive town council that he would respect their liberties on this occasion (Proyert 1861, 102; Lecesne 1880, 398). By means of his entry into the Arras, Louis could demonstrate to the townspeople that, while they may be in the territories of the duke of Burgundy, he was their king and that their rights and liberties were dependent on his good favour. The consequences of opposing him were demonstrated when the people of Arras rose against his rule. After taking the town by siege, he made a triumphal entry through the hole that his artillery had created in the walls, before going to execute one of the leaders of the revolt and imposing a fine of 400,000 *écus* on the population (Molinet 1935, 1:189; Champion 1927, 2:270).

At the initial meeting and at all other encounters between the king and the civic council, an image of unity and cohesion among the municipal elite was paramount to the town. To this end, clothing was successfully used as a clear means of identification. In the municipal deliberations that devised the schema for Louis XI's entry into Tournai, the council strictly ordered the particular garments to be worn by the various civic groups included in the official welcoming ceremony. These groups include the civic officers, the guilds, the militia, burgesses, as well as groups of children. In pre-modern societies, clothes were the principal external marker of class and status. Clothing was part of a semiotic system, acting

as a visual language defining the position of the wearer in the social hierarchy. When John II entered the city in 1355, he asked all those who wore the cloths and arms of the town to dine with him; namely, the town council (Grange 1885, 28). The dress and appearance of those instructed to participate in the welcoming delegation had to be perfect, as the presence of a large body of well-groomed and well-attired merchants implied prosperity and thus made the town more appealing to the king and other visitors. Rituals, ceremonies and public appearances all served important purposes in projecting an image of elite unity to their fellow citizens and to the crown. In Tournai the three hundred heads of the wealthiest households comprised the most representative of the city's administrative bodies, and along with the town council they formed the welcoming delegation at royal entries. The image of cohesion among the elite was so important that for Louis's entry into Tournai the *échevins* ordered that all members of this three hundred who were old or ill were still to visibly participate in the ceremony (Grange 1885, 44). This was an occasion when the urban elite publicly presented themselves at their finest. As the king processed through the streets, ladies lined the galleries of houses along the parade route. The sons and daughters of the elite were also required to participate in the entry. In Tournai, groups of children were placed at important points along the parade route, including the gate into the town. They were dressed in the town colours, and when prompted by a council-appointed deputy they called out 'Noel' as the king passed by (Grange 1885, 44, 53). While municipal councils across France expected that the members of the wealthiest families would participate in a ceremonial entry, many did not wish to do so due to the expense of purchase of new clothing for the occasion.[9] We do not find any cases of resistance to participation from townspeople in the entries by made Louis XI into the towns of the north-east during this progress. It had been decades since a French monarch had visited this region and the urban elites of this region were keen to establish personal contact with their king.

After the greeting, the next phase of the entry was the intra-mural procession. Before the king made his entry through the gate, a canopy was raised above him, in much the same way that it covered the host during Corpus Christi processions. This was a privilege exclusively reserved for the king during ceremonial entries during the fifteenth century. Elite townsmen carried the canopy above the king until he reached the door of the cathedral. At his entries into Amiens and Abbeville, those who carried the canopy came from wealthy mercantile families, whose male members consistently filled the top places in the council during the later Middle Ages (AMA BB9/132v; Ledieu 1902, 106).[10] As the entry ceremony was a

public display of power, urban architecture gave a physical structure to civic identity, and the streets of the town provided the ritual space for the performance of the ceremony. The buildings and their adornments were themselves integral to the rite, and were designed to encourage the success of the ritualised performance of the civic reception. The space of the gate was one of the most symbolically important, and it was ornately decorated. When Louis entered Tournai through the Ste-Fontaine gate, a young woman descended from on high in a small, wooden castle, by means of a pulley system. She held in her hands a heart, which opened and revealed a fleur-de-lis, which was a symbol of the city's loyalty to crown (Grange 1885, 53-54). Tournai had not been separated from the French crown since being granted its charter by Philip Augustus in 1188, a fact that the citizens were fiercely proud of. We should not see the use of the fleur-de-lis in this way as simply the submission of the commune to royal authority, but rather as a symbol of intense civic pride. The Tournaisians took a royal emblem and used it as a badge of civic identity, and we find the fleur-de-lis appearing in the council chambers, on banners and on municipal clothing during the fifteenth century.

Town councils ordered townspeople who lived in residences along the processional route to decorate the facades of their houses with fine cloths and cover the streets with grass and other greenery (AMA BB9/115v; Grange 1885, 47). This is in reference to the palm leaves laid on the road before Christ as he entered Jerusalem. We might have expected straw to be used, as it is easier to come by, but in the eyes of spectators straw was associated with tournaments and public executions. At John II's entry into Tournai in 1355, jousts were staged on the main square. A clear visual distinction was made between the grass strewn across the processional route, which the king paraded down as Christ entering a New Jerusalem, and the straw that demarcated the space used for combat. At Tournai, the magistrates in charge of policing the quarters of the city were ordered to make sure that the streets were cleaned in time for the king's arrival, and that the waste collected was to be disposed in the fields outside of the town. Failure to do so was to result in punishment (Grange 1885, 47). On the day of the entry, council-appointed deputies lined the streets. These deputies were instructed to police the event, keep the crowd under control and to lead the people in making the necessary acclamations to the king at the correct time. The public space of the processional route was cordoned off. On one hand, this was a crowd-control measure. However, it was also to ensure the king followed the ceremony through to its conclusion and when Louis entered Abbeville in 1463 the actual processional route had been boarded off so that the king did not have anywhere else to go (Basin

1972, 3: 287).

Stages were erected at several points along the processional route, on which plays were performed. At Abbeville these performances began at the gate on entry and continued right through until the king reached his lodgings (Ledieu 1902, 106-7). Amiens was one of the first towns in France to stage a mystery play, and for Louis's entry the town council paid the guilds to produce short pageants, derived from biblical episodes such as Jonah and the whale.[11] At Tournai, the themes of the plays performed to Louis were more historical and episodes from the lives of Clovis, Charlemagne and St. Louis were played to the king as he passed by (Grange 1885, 46). Tournai hired the services of a rhetorician to conceive, order and direct the plays for the entry (Grange 1885, 66-67); whereas Amiens employed one Pierre Martin, procurator of the court of Amiens to design the plays performed (AMA BB10/74). In both towns, the town council approved the content of the pageants, to which no changes whatsoever could be made (Runnalls 2003, 231; Calonne 1899, 1:317; Grange 1885, 46-47). The lines were only to be delivered by approved members of the guild. Deputies were appointed by the council to oversee each guild's production of their play, and guild-members were under threat of public punishment to make sure that there was no deviation from the official script. It could be extremely important for town councils to monitor the text and content of civic plays. In 1447, the content of a farce staged by guildsmen in Dijon almost proved disastrous for city as the text of the play had been changed to slur the King, his son and their supporters (Small 2005, 140). These plays could be very realistic indeed. When Emperor Charles V entered Tournai in 1531 accompanied by his young son, Philip, the play of Judith and Holophernes was staged. To give added realism, a criminal under the sentence of death played the role of the unfortunate Holophernes and had his head severed from his body as the Emperor rode past impassive (Rolland 1956, 194).

Entries were often made at dusk and as such lighting was a crucial part of the urban decorations. The civic council paid for torches at Amiens, but at Tournai the responsibility and expense for providing these illuminations was put on the residents of those houses lining the processional route. Lights were kept burning across the city for the duration of the Louis's visit, and each resident had to place a candle or lantern in their window at night. At Amiens, one thousand torches and lanterns were bought for this purpose, and bonfires were made at crossroads and other open spaces (Dubois 1868, 18). On the one hand, illuminations served the practical purpose of providing extra security at night, but they were also very symbolically important. The Book of Revelation tells us that in the New

Jerusalem 'there will be no night' (Revelation, 21:26), and so it was during a royal entry. Through transforming the urban space, by means of decorations, lighting, and the staging of plays, the city sought to present an image of itself as a New Jerusalem, to both king and townspeople.[12]

Elite urban groups also made use of particular sounds to represent and reinforce their civic authority. Bell towers were particularly pertinent in this respect. During entries the presence of the belfry was highlighted through the use of lighting, and plays were frequently performed in the space in front of it. When Charles VI entered Tournai in 1382, a tightrope walker performed acrobatic feats on a cable tied to the belfry, drawing the king's attention to this potent symbol of urban liberties (Grange 1885, 33). Belfries were frequently attached to the town hall and the right to use it was granted in the town's charter. When a commune was abolished, the right to ring the communal bell, even in times of fire, was lost too (Petit-Dutaillis 1978, 112). Bell towers' stature made them a focal point in the city, and we find the ringing of bells acting as the call for collective action, including urban ceremony. In Tournai, those riding in the extramural delegation were instructed to assemble at a designated point upon hearing the sound of the municipal bell.[13] The main town bells were only sounded on important public occasions and unsanctioned bell ringing could be punished by death (Haemers 2005, 73). During royal receptions bells were used to great effect and were central to aural urban identity, acting as a counterweight to the sound produced by the king's trumpeters.[14] The specific meanings of bells were often only intelligible to the residents of the town in which they were sounded (Marín 2002, 58-59). Some bells were used for expelling the banished and for executing prisoners; others during times of danger or for the call to revolt. The main bells of the town were only rung during a major public event and they acted as cohesive agents in the formation of a collective identity, and were important in lending solemnity to a civic reception.[15]

The presentation of the gift to the king came at the conclusion of the ceremony. As Louis's entries in 1463-64 were inaugural entries, they differed from subsequent civic receptions in terms of the political oaths taken and the cultural and financial value of the gifts given. In inaugural entries the ceremonies and rites were transitional rites (Turner 1995, 94-130; Hurlbut 2001 155-86). First, there is a separation. This occurs when the previous king dies, or in the case of Amiens, when the town passed from Burgundian to French control. Before the new monarch made his entry there was a period of instability when the bond between king and town was broken. As such, in theory, the town could not be sure that new king would renew the city's rights and liberties, and the king had not been

formally granted the support and loyalty of the town. Before Louis came into sight of the walls of Tournai, the council had sent representatives to the king with a copy of the rights accorded to the town by French monarchs. These representatives asked the king to maintain Tournai in its liberties, and Louis assured them that he would do so. Nevertheless, the civic council paid local nobles to speak favourably to the king on behalf of the town prior to his entry. The town council also decided that the *échevins* were to encourage the king to grant further liberties when they made the gift presentation (Grange 1885, 48-49).

In any visit made by the monarch to one of his towns, the king could expect gifts of food and wine, but when he entered a town for the first time he could expect more valuable gifts, which he received in return for confirming urban liberties. When deciding upon which presents to make, Amiens's town council looked through their civic archives to determine what was customarily given (AMA BB9/153v). On 2 January 1464, Amiens' town council gave Louis's wife, Charlotte of Savoy, a silver dish and two spoons, with Abbeville's town council gifting similar gifts to the queen at her entry (Ledieu 1902, 102). Pierre Latargie, a goldsmith and resident of Amiens, was paid 206 l for making the spoons and plates and for engraving the arms of the town onto them (AMA BB9/132v).[16] At Tournai, the *échevins* ordered that a silver cup, which had been given to the bishop of Tournai, to use at the meal following his ceremonial entry, be taken from its resting place in the city's treasury and given to Louis. Before it was given to the king, it was gilded and decorated with the arms of the city (Grange 1885, 62-63). In return for the gifts, the king was expected to confirm the rights, liberties and privileges of the town. At Amiens the liberties granted by Louis XI were so considerable that right through to the reign of Henry II, the civic council appealed to the crown to confirm the rights that Louis had granted to them (AMA AA5/250). Gifts were given not only to the king or queen, but also to those men and women travelling in the entourage of the royal visitor who were seen to have influence at court. The intent of the council was that by means of these gifts the recipient would remember the town. Wives of dignitaries were also given gifts. The town council of Tournai gave two silver pots to the chancellor's wife, then accompanying her husband in Louis's retinue, in thanks for his actions in working to preserve the rights and liberties of the town (Grange 1885, 64).

I have hoped to demonstrate that ceremony and ritual played a crucial role in communication between the king and his towns during this period. While the form of the entries staged to welcome Louis XI at his towns in

the north-east was similar to those found across the kingdom, the function of a royal entry in establishing links between town and crown was especially crucial in frontier regions, such as the north-east, where political authority was contested between rival powers.[17] The town council could use the ceremony to gain access to the king and seek to obtain the confirmation of urban privileges, while the king made use of the entry to strengthen his authority over the towns. Following Louis's entry into Abbeville, which had many prominent Burgundian supporters, he had the population of the town and the local nobility swear public oaths of loyalty to him. While he removed many key Burgundian officials from power, such as the lord of Saveuses, who held the captaincy of Amiens, he made no changes to the composition of the municipal councils (Continuator of Monstrelet 1810, 10:135). If he hoped to establish and maintain power in the north-east, he needed the urban elites to act on his behalf once he had left the region.

The ability of urban elites to design and produce impressive civic receptions reflects the increasingly important role that they were playing in the life of the realm during the fifteenth and sixteenth centuries.[17] It was not in the best interests of the monarch to try and weaken the power of urban oligarchies; both groups benefited from mutual support (Ladurie 1994, 12; Chevalier 1971, 267-70). For Bernard Chevalier, urban elites entered into an *entente cordiale* with the French monarchy between the reigns of Charles VII and Henry II (Chevalier 1982, 274). This new sense of urban identity and symbiosis with the crown was manifested in the ceremonial welcomes provided for royals, where town and crown came together. In order for the state to function effectively during the fifteenth century, the crown had to work with local elites, not against them. Entries have often been seen as royal power being imposed over urban populations in a ceremony designed to visually demonstrate the theoretical good ordering of society around a quasi-sacral king. However, royal entries were not spectacles where urban populations stood speechless in awe of the majesty of French royalty, but occasions when French townspeople participated in a dialogue with the monarch. Sir Richard Southern observed that, "The success of familiar collaboration with the right people was the secret of French government" (Southern 1970, 179). In this case, it holds as true for the fifteenth century as it did for the twelfth.

Notes

[1] In the preface to this volume Théodore is described as 'Conseiller du Royen ses Conseils', and Denis is described as 'Advocat en Parlement, & Historiographe du Roy', Godefroy (1619, 2).

[2] In the 1619 version, every entry ceremony is Parisian. In the considerably expanded *Le cérémonial françois*, accounts are given of entries made into towns such as Rouen, Bordeaux and Lyon, but the focus is still firmly on Parisian entries. Lawrence Bryant's study of Parisian entries (1986) remains the standard published text on the French royal entry ceremony.

[3] These were: Abbeville, Amiens, Saint-Quentin, Doullens, Montreuil, Rue, Saint-Valéry, Le Crotoy, Crèvecour-en-Cambraisis and Mortagne.

[4] "Non vi pare che questa cità sola vaglia molto meglio che li quatrocento milia scuti che ho pagato a mon de Bergogna?"

[5] For royal entries into towns which lay at the centre of royal power in the second half of the fifteenth century see: Rivaud (2007, 215-25).

[6] "Aulcuns notables d'entre eulx pour savoir la journée que son plaisir seroit de faire sa dite entrée en ladite cité, affin qu'ilz se peussent préparer pour le reçevoir, festoyer et onnourer, comme tenulz estoient, et que bien faire le désiroient".

[7] On 5 May 1466 Amiens's town council wrote to the *échevins* of Abbeville to know "quel jour et à quele heure Mons. de Charolais entra ladite ville d'Abbeville, quels mistères luy ont esté fais, quels présens il a eu, quels propositions ont esté faites à sa venue".

[8] "Et le parlant descendront à pié pour faire la proposicion qu'il seroit plus-révérend et plus-grant humilité que de demourer et parler à cheval."

[9] See, for example, Henry II's entry into Rouen in 1550 where the town council had to compel wealthy families with threats of punishment in order have their children participate in the entry (AMA Rouen A17/fol. 23).

[10] At Amiens these men were: Philippe de Morvilier, Hue de Courcheles, Jean Lenormant, Jacque Clabault, Jean Legris, Aubert fauval and Jean de St-Fussien. Gille de Laon was to take Philippe's place if he was not able to carry the canopy (AMA BB9/132v). Jacque Clabault came from one of the great families of Amiens. For his career see Janvier (1889, 67-82).

[11] A Passion play was first performed in Amiens in 1413: Runnalls (2003, 229). The carters were paid 12 s. for staging the play of Jonah and the Whale during Louis's entry in June 1464 (AMA BB10/8v).

[12] As Gordon Kipling as demonstrated, during the Middle Ages urban populations specifically acted to transform the streets of the town into a New Jerusalem in order to receive the king: Kipling (1998). The emphasis on the theme of the New Jerusalem persisted into the sixteenth century, despite the shift from biblical allegory to one based on inspiration from ancient Greek and Roman texts: Wintroub (2006, 15-20).

[13] For the entry of Eleanor of Portugal, sister to the Emperor Charles V, into Tournai the town council ordered "Que tous ceulx de la loy soyent prestement montéz à cheval, et les doyens, bourgois, manans et des sermens de ceste ville et cité qui furent le jour d'hier audevant de l'Empereur, nostre souverain seigneur, se

trouvent pareillement prestement en la halle de ceste dicte ville, au son de la cloche de Wigneron, à tout leurs robes de parures, sans flambeaulx, pour aller au devnat de la Reyne Régente, soer de l'Empereur, nostredict seigneur, et luy faire révérence ad ce deue et appartenante": Grange (1885, 88).

[14] For the use of trumpeters in the entries made by the dukes of Burgundy see Clouzot (2000, 615-28). The town could also employ its own trumpeters, though the use of trumpets is not recorded at Louis XI's entries into Amiens or Tournai. However, civic trumpeters were used in other entries. When John II entered Tournai in 1355, the town council commissioned its trumpeters to perform from the belfry (Grange 1885, 27). Civic trumpeters could also be hired by a prince for ceremonial occasions including entries. Philip the Good and Charles the Bold hired city trumpeters from Ghent to perform at ducal festivities. (Wegman 1994, 35).

[15] For bells also see Corbin (1998).

[16] By the time Charlotte left Amiens for Chartres on 3 February, the gifts were still not finished. On 20 February, the town council instructed Jean Lenormant, provost, Jean Le Rendu and Aubert Fauvel, both *échevins*, to take the gifts to the queen then at Nogent-le-Roi and to give Charlotte a letter from the council. On 5 March the delegation returned and made their report to the *échevins*. A letter from the queen, in which she expressed thanks and gratitude to the council for the entry and gifts, was then read aloud in the council chambers. After this, the assembled *échevins* said a short prayer for the life and health of the queen (AMA BB9/138).

[17] For the wider development of the form of the ceremonial entry across France during this period see Murphy (2009), which also provides a comprehensive bibliography of material relating to the French royal entry ceremony.

References

Manuscript Sources

Archives municipales, Amiens (AMA)
 AA 5: Municipal charters (1115-1571)
 BB 9, 10, 31: Registers of municipal deliberations (1460-1558)
Archives municipales, Rouen (AMR)
 A 16 : Register of municipal deliberations (1548-1554)
 A 17: Register of municipal deliberations (1555-1559)

Printed Works

Basin, Thomas. 1972. *Histoire de Louis XI*, edited by Charles Samaran. Vol. 3. Paris:Renouard.
Bonenfant, Paul. 1996. 'Du Meutre de Montereau au traité de Troyes'. In *Philippe le Bon: sa politique, son action. Études présentées par A. M.*

Bonenfant-Feytmans. Edited by A. M. Bonenfant-Feytmans, 105-336. Paris:De Boeck Université.

Boynton, Susan, Jean Dumoulin and Jacques Pycke. 1992. "La grande procession, une réalité religieuse." In *La Grande Procession de Tournai (1090-1992): une réalité religieuse, urbaine, diocesaine, sociale, économique et artistique.* Edited by Jean Dumoulin and Jacques Pycke. Tournai: Fabrique de l'église cathédrale.

Bryant, Lawrence. 1986. *The King and the City in the Parisian Royal Entry Ceremony: Politics, Ritual, and Art in the Renaissance.* Geneva: Librairie Droz.

Calonne, Albéric de. 1899. *Histoire de la ville d'Amiens.* Amiens: Piteux frères.

Champion, Pierre. 1927. *Louis XI.* Paris, Champion.

Chevalier, Bernard. 1971. "The Policy of Louis XI towards the Bonnes Villes: The Case of Tours." In *The Recovery of France in the Fifteenth Century,* edited by Peter Lewis, 265-93. London: Macmillan.

—. 1982. *Les bonnes villes de France: du XIVe au XVIe siècle.* Paris: Aubier Montaigne.

Clouzot, Martine. "Le son et le pouvoir en Bourgogne au XVe siècle." *Revue historique* 302:615-28.

'Continuator of Monstrelet'. 1980. *The chronicles of Enguerrand de Monstrelet.* Edited by Thomas Johnes. Vols. 7-12. London, Longman.

Corbin, Alain. 1998. *Village Bells: Sound and Meaning in the Nineteenth-Century French Countryside.* Translated by Martin Thom. New York: Columbia University Press.

Dubois, Alexis. 1868. *Entrées royales et princières dans Amiens pendant les quinzième et seizième siècles.* Amiens: Lambert-Caron.

Godefroy, Théodore. 1619. *Le cérémonial de France.* Paris: Abraham Pacard.

—. 1649. *Le cérémonial françois.* Paris: S&G Cramoisy.

Grange, A. de la, ed. 1885. "Les entrées des souverains à Tournai." *Mémoires de la Société historique et litteraire de Tournai* 19:1-321.

—. 1893. "Extraits analytiques des registres des consaulx et de ceux aux publications, 1431-1476". *Mémoires de la société historique et litteraire de Tournai* 23:1-396.

Guenée, Bernard, and Lehoux, Françoise. 1968. *Les entrées royales françaises e 1328 à 1515.* Paris, CNRS.

Haemers, Jelle. 2005. "A Moody Community? Emotion and Ritual in Late Medieval Urban Revolts." In *Emotions in the Heart of the City (14th-16th Century).* Edited by Elodie Lecuppre-Desjardin and Anne-Laure Van Bruaene, 66-81. Turnhout: Brepols.

Hurlbut, Jesse D. 2001. "The Duke's First Entry: Burgundian Inauguration and Gift". In *Moving Subjects: Processional Performance in the Middle Ages and the Renaissance*. Edited by K. Ashley and W. Hüsken, 155-86. Amsterdam: Rodopi.

Janvier, A. 1889. *Les Clabault, famille municipale amiénoise, 1349-1539*. Amiens: Hecquet-Decobert.

Kipling, Gordon. 1998. *Enter the King: Theater, Liturgy, and Ritual in the Medieval Civic Triumph*. Oxford: Clarendon Press.

Ladurie, Emmanuel Le Roy. 1994. *The Royal French State, 1460-1610*. Translated by Juliet Vale. Oxford: Oxford University Press.

Lecesne, E. 1880. *Histoire d'Arras depuis les temps plus recules jusqu'en 1789*. Arras.

Ledieu, A. 1902. *Inventaire sommaire des archives municipals antérieures à 1790*. Abbeville.

Legoux, Emile. 1865. *Du droit de grâce en France comparé avec les législations étrangères commenté par les lois, ordonnances, décrets, lettres patentes depuis 1349 jusqu'en 1865*. Paris.

Mandrot, Bernard de, ed. 1919. *Dépêches des ambassadeurs Milanais en France sous Louis XI et François Sforza*. Vol.1. Paris: Renouard.

Marín, Miguel Ángel. 2002. "Sound and urban life in a small Spanish town during the *ancien regime*." *Urban History* 29:48-59.

Molinet, Jean. 1937. *Chroniques*. Edited by Georges Doutrepont and Omer Jodogne. Vols. 1 and 2. Brussels.

Murphy, Neil. 2009. 'Receiving Royals in Later Medieval and Renaissance France: Ceremonial Entries into Northern French Towns, c.1350-1570', Ph.D. thesis. University of Glasgow.

Petit-Dutaillis, Charles. 1894. *Étude sur la vie et le règne de Louis VIII (1187-1226)*. Paris: Émile Bouillon.

—.1978. *The French Communes in the Middle Ages*. Translated by Joan Vickers. Oxford: North Holland.

Proyart, M. 1861. "Louis XI à Arras." *Mémoires de l'académie des sciences, lettres et arts d'Arras* 34:101-18.

Quarré, Pierre. 1969. "La 'joyeuse entrée' de Charles le Téméraire à Dijon en 1474." *Académie royale de Belgique. Bulletin de la classe de Beaux Arts* 51:326-40.

Rivaud, David. 2007. *Les villes et le roi: Les municipalities de Bourges, Poitiers et Tours et l'émergence de l'Etat moderne (v.1440-v.1560)*. Rennes: Presses Universitaires de Rennes.

Rolland, Paul. 1956. *Histoire de Tournai*. Tournai: Comité national pour le relèvement de Tournai.

Runnalls, Graham A. 2003. "La passion d'Amiens de 1500. " In *Les mystères dans les provinces françaises: en Savoie et en Poitou à Amiens et à Reims*. Edited by Graham A. Runnalls, 227-63. Paris: Champion.

Small, Graeme. 2000. "Centre and Periphery: Tournai, 1384-1477". In *War, Government and Power in Late Medieval France*. Edited by Christopher Allmand, 145-74. Liverpool: Liverpool University Press.

—. 2005. "When *Indiciaires* Meet *Rederijkers*: A Contribution to the History of the Burgundian 'Theatre State'." In *Stad van koopmanschap en vrede. Literatuurs in Brugge tussen Middeleeuwen en Rederijkerstijd*. Edited by Johan Oosterman, 133-61. Leuven: Peeters.

Southern, R. W. 1970. "The Place of England in the Twelfth Century Renaissance." In *Medieval Humanism, and Other Studies*. Edited by R. W. Southern, 158-80. Oxford: Blackwell.

Turner, Victor. 1995. *The Ritual Process: Structure and Anti-Structure*. Hawthrone: Aldine de Gruyter.

Vaughan, Richard. 2002. *Philip the Good*. Woodbridge, Boydell.

Wegman, Rob C. 1994. *Born for the Muses: The Life and Masses of Jacob Obrecht*. Oxford: Oxford University Press.

Wintroub, Michael. 2006. *A Savage Mirror: Power, Identity, and Knowledge in Early Modern France*. Stanford: Stanford University Press

CHAPTER TWELVE

RENAISSANCE ENLIGHTENMENT: ERWIN PANOFSKY'S HUMANISM

DAN KEENAN

It is now commonly acknowledged that the development of English-language renaissance scholarship was predicated upon the work of German historians forced into exile in the United States from Nazi Germany (Trinkaus 1976, 679; Muir 1994, 1108; Mohlo 1998, 270). Although there were, of course, notable differences in the individual approaches of figures such as Ernst Cassirer, Erwin Panofsky, Hans Baron and Paul Oskar Kristeller, together these émigré humanist scholars made a concerted effort to address the very notion and periodicity of 'The Renaissance'.[1] Indeed, so comprehensive were these efforts that this group of scholars set the standards and established the parameters of research and inquiry in the field for the greater part of the twentieth century.

In terms of the history of art, Erwin Panofsky is certainly the major figure of this generation. Pre-eminent among the émigré art historians credited with the formation of the discipline in America, Panofsky's analysis of the renaissance question, and his ultimate defence of 'The Renaissance' from the point of view of the art historian has taken on canonical status (Panofsky 1960); to the extent that this work, although issued over fifty years ago, remains today an important point of reference, for art historians and historians alike.[2]

In spite (or perhaps because) of his enduring 'fame' however, Panofsky's work is, in recent discourse, more likely to be the subject of a concerted critical revisionism. Indeed, Panofsky is now often positioned as the figurehead of an older, 'retrograde' tradition of humanistic scholarship which is taken to task for its basic approach to history and historical interpretation.[3] Keith Moxey, for example, considers Panofsky the prime representative of an "objectivist and quasi-scientific tradition of art-historical writing" (2004, 757-8); and, emboldened by the post-modern mantra that no interpretation can be 'theory-neutral', Moxey, in a series of

essays, takes the émigré scholar to task for his "suppression of the authorial agenda" and the fact that in Panofsky's work, "political and emotional beliefs were repressed in favour of 'disinterestedness'" (1995, 395).[4]

For some commentators Panofsky's resistance to the issue of his own subjectivity as an author is considered indicative of a problematic attitude towards his 'Jewish identity'. Donald Kuspit, for example, suggests that Panofsky's "idealizing fantasy of humanism" was born of "a refusal to deal with his own Jewishness"; and he adds, with no-little unease, "I find this amazing—an extraordinary feat of repression" (1996, 9). Similarly, Catherine Soussloff (again, using Panofsky as a figurehead for the history of art as a humanistic discipline) equates the author's "resistance to the exploration of issues of subjectivity" with a "suppression" or "repression" of his Jewishness (1999, 5). Indeed, Soussloff suggests that this "repression" is manifest even in Panofsky's choice to study "the most Christian of periods in the history of art, the Renaissance" (1999, 9).

As far as I understand it, this argument suggests that by propagating some naive and critically weak notion of 'scholarly objectivity'—that "humanist myth of disinterested historical representation" (Parker 1997, 321)—Panofsky was guilty of denying, or at least of eliding from his work issues related to his own ethnicity and heritage; and he is criticised, therefore, for being either unable or unwilling to adequately address the momentous political forces that were actively and forcibly shaping his life.[5]

Such attempts to uncover and apportion a 'Jewish' element in Panofsky's work may be, to some extent, understandable.[6] However, they run the risk of projecting contemporary concerns onto a figure from the past. The danger is that by using their own 'subjectivity' as the basis for historical interpretation (and historical judgement), the historiographer then fails to do justice to the 'object' of their study on its own terms. It seems rather facile for example, to this author at least, to suggest that a scholar as sophisticated and self-aware as Panofsky would be either naively inattentive to the 'subjectivity' of his own interpretations, or entirely unresponsive to the social and political environment into which his work was issued. Such assertions not only fail to do justice to Panofsky as a thinker and as a practicing historian, they limit our understanding of the scope and substance of his scholarship itself.

Panofsky's Jewish background is, of course, an important contextualising factor in terms of understanding his life and work; but I would suggest that a more detached and 'historical' analysis of this background can actually help shed light on the manner in which

Panofsky's humanist scholarship—his methodology and his very conception of 'The Renaissance'—was, in fact, a quite self-conscious response to the historical predicament in which he found himself; firstly, as a Jewish-German art historian in Weimar Germany, and secondly, as an exiled scholar in the United States of America.

To properly situate the relationship between Panofsky's 'Jewishness' and his conception of humanistic scholarship we must begin by looking back to the cosmopolitan educational ideals of the German Enlightenment (*Aufklärung*); the period in which the ideological and political roots of Jewish emancipation were first formed in Germany. Inspired by the egalitarian ideals of the French revolution, German intellectuals such as Kant, Goethe and Wilhelm von Humboldt laid particular emphasis in their writing upon the freedom and autonomy of the human individual. To Kant, for example, writing in 1784, *Aufklärung* itself was a process whereby the individual achieved autonomy through the free application of their own reason; that is, without adherence to any higher authority, whether political prescription or religious dogma.[7] For Kant the enlightened individual was primarily the scholar[8] and, in deference to the ultimate reality—that man is neither omnipotent nor infallible— he maintained that the scholar must endeavour to retain a detached and critical perspective towards all aspects of his knowledge creation, including his own presuppositions. The individual must make the effort to think objectively, or, as in Kant's motto of Enlightenment, "*Sapere aude!* 'Have courage to use your own reason!'" (Kant 1963, 3). In an essay of 1798 Kant suggested that the university itself be characterised by this spirit of free, rational and critical inquiry (Kant 1979); and in this conception of *Wissenschaft*, 'disinterested' research and scholarship were considered fundamental to the progress of knowledge and enlightenment.

Kant believed scholarship to be the ultimate vocation of man in society, and education the basis of human progress. His philosophy is representative therefore, of that optimistic faith in the redemptive power of knowledge and education that so characterised *Aufklärung* thought (Nisbet 1982, 81). If ignorance be the root of all evil then the utilisation of reason and the process of education would themselves make the individual virtuous; and the individual's contribution to science and learning would, in turn, have an ameliorating effect upon society.

The concept of *Bildung* was central to this idea of human progress and 'enlightenment' achieved through education and learning. Found in the work of writers such as Herder, Goethe and Schiller, the term *Bildung* goes beyond the meaning carried by the English word 'education' to

encompass ideas of self-cultivation, self-formation and moral edification (Bruford 1975). At its core was a belief in the inalienable right (the responsibility even) of the individual to develop and grow according to their own inherent potential; tempered by an understanding of, and a faith in, a common humanity.

The individual's self-cultivation was to be brought about primarily through an intense engagement with culture, and above all classical culture. The resulting development of aesthetic taste and sensibility was considered the means with which to bridge the gulf between the development of the rational mind and the informing of the moral will, engendering spiritual as well as intellectual development (Guess 1996, 161; Nisbet 1982, 82).

The individual's approach to their classical sources was considered indicative of the process of *Bildung* (Ringer 1969, 86), involving not just a study of, but a deep personal involvement with, and understanding of the cultural source material. This understanding (*Verstehen*) of the sources was only possible through the individual's re-experiencing (*Erleben*) of them. They had to be 'brought to life,' as it were, in a process of empathetic understanding enacted by the individual interpreting subject. It was only through this personal re-experiencing that the sources held any real 'meaning.' This was no wanton abandonment to the vagaries and sensations of a purely subjective aesthetic experience however. Instead, it was the individual's responsibility to attempt a disciplined and rationalised understanding of such 'objective' aesthetic qualities as balance, proportion and harmony. This 'classical' aesthetic spoke to human reason, and a deep engagement with such qualities was thought to have a saturation effect on the individual, improving them in a 'universal' sense.[9] As Herder himself would describe the process of *Bildung*,

> "Man must grow like a plant toward the unfolding of his personality until he becomes an harmonious, autonomous individual exemplifying both the continuing quest for knowledge and the moral imperative." (Mosse 1985, 3)

This liberal philosophy of self-development provided the means through which an emerging German middle class of the mid to late-eighteenth century forged a salient identity. The status of this *Bildungsbürgertum* was based primarily upon their 'cultivation'. Linked as it was with notions of moral edification and moral improvement, this was a meritorious identity that transcended the traditional societal values of birth, wealth and privilege. Common recognition and affirmation of the

importance of education and cultivation allowed the *Bildungsbürgertum* to distinguish themselves from the German aristocracy.

George Mosse has demonstrated how the cosmopolitan philosophy of *Bildung* also provided "an ideal ready-made for Jewish assimilation" (1985, 3). As a process of self-formation, an educational philosophy of *becoming* based on the universal value of reason and rationality, a faith in a shared humanity and the corresponding postulates of responsibility and tolerance, the ideals of *Bildung* were held as a means to transcend differences of race and religion through the unfolding of the individual personality. In many German states the emancipation of the Jews became conditional on their subscribing to the process of *Bildung* (Sorkin 1987, 29-30), and an increasingly wealthy Jewish middle class eagerly embraced this educational philosophy, endeavouring to realise the status and societal standing of the *Bildungsbürgertum* through their cultural pursuits and educational self-development.

Vital to this process of 'cultural' assimilation were Wilhelm von Humboldt's efforts to institutionalise the precepts of *Bildung* through a restructuring of the German educational system (Sorkin 1983).[10] As head of the Section for Religion and Education in the Prussian Ministry of the Interior (from February 1809 through June 1810) Humboldt first gave renewed prominence and prestige to the Gymnasium school, making the *Abitur* the sole requirement for entry into the university. Students at the Gymnasium were to receive a thorough humanistic education, with a particular emphasis given to history and the classical languages. Taught by qualified, active scholars, students were to be imbued with the values of western culture, first and foremost through a personal engagement with the primary sources. The student was to be given an insight into the process of individual scholarship, and they were to be considered mature when they had learned enough to learn by themselves.

The influx of well-informed, independent learners then allowed Humboldt to conceive of the university as an institution devoted purely to research and the advancement of knowledge. Although funded by the state, the university was to be entirely free from restriction or prescription in its pursuit of knowledge. As in Kant's conception of the university, the emphasis was upon free, 'disinterested' *Wissenschaft*; with the sciences and the humanities envisaged, in a holistic sense, as a means for a progressive, developmental understanding of the natural world, and of man's place within it. Students were given huge freedom in (and responsibility for) the development of their own course of studies,[11] and they were, in essence, to be considered, alongside the professors, as active, individual participants in the research process. This was a cosmopolitan

vision of 'education as enlightenment' then, in which the university was to provide the intellectual space in which a community of responsible, autonomous individuals could communicate and contribute to a rationalised body of knowledge and understanding.

With the barriers of exclusion removed by Humboldt at the beginning of the nineteenth century, affluent Jewish families began to substantiate their position within the *Bildungsbürgertum* by enrolling their children in the German school system (Pickus 1999).[12] As opposed to receiving what had been, up until then, an exclusively Jewish, religious schooling, young German Jews were instead inculcated with the secular values of western humanistic culture; and through university-level study they could consider themselves participants in and contributors to that educational 'community of reason'.

It is important to point out that not all those who embraced the educational ideals of *Bildung* simply ceased to 'be Jewish'. This approach to assimilation did not necessarily entail a complete rejection (or a "repression") of Jewish identity, as has so often been asserted in retrospect. There *were* many German Jews who took a further step towards assimilation through baptism; but there were also those who maintained their Jewish traditions, considering them wholly compatible with the ideals of *Bildung* (Meyer 1990, 19). For others again, identification with the educational ideals of the Enlightenment signalled a move away from Judaism, but not necessarily towards Christianity. This goes to show that any discussion of an individual's 'German-Jewish identity' is necessarily multifaceted and complex. The point to be made here though, is that for many German Jews (just as for many non-Jewish German liberals), the humanistic, educational ideals of *Bildung* were held in themselves as an article of faith. Religious orientation could remain a matter of individual volition, whereas commitment to a life of 'disinterested' scholarship offered a means to transcend the particularising boundaries of religion, race and nationality.

Born in 1892, Panofsky was the son of a well-to-do Jewish rentier who had made his fortune in the mining communities of Silesia. Though he was certainly *au fait* with his Jewish ancestry[13] I have found no evidence in Panofsky's personal correspondence that he observed Jewish ritual or custom himself. He was though, often quite eager to point out the significance of his early education at the *Joachimschalthsches Gymnasium* in Berlin, and its importance for his future life as a scholar.[14] I would suggest that Panofsky's choice to devote his life to a career in the humanities should be understood as a quite self-conscious commitment to

the humanist ideals of the Enlightenment. And in the context of Weimar Germany this commitment had a quite particular significance.

As has been well-documented, over the course of the nineteenth century, the cosmopolitan ideals of the *Aufklärung* were increasingly supplanted in German intellectual thought in the wake of a growing nationalist sentiment (Iggers 1983, 40). Through such developments the concept of *Bildung* began to lose its more universal and 'humanistic' dimension, as 'culture' itself became an important tool in the creation of an exclusively 'German' identity.[15]

Scholarship played an integral role in the growth of this nationalist *Weltanschauung*, as German professors—the revered spokesmen, as it were, for the *Bildungsbürgertum*—put their considerable influence to use propagating the idea of a unified (and eulogised) German 'cultural' state. From Johann Gottlieb Fichte's assertion of the uniqueness of German cultural and pedagogical traditions in his *Addresses to the German Nation* (delivered in French-occupied Berlin in 1808), to the advocacy of the *Kleindeutsche* solution to the 'German problem', and the justification of the German *Sonderweg* in the work of Heinrich von Treitschke and the Prussian School of historians; the ideals of 'disinterested *Wissenschaft*' within the German university increasingly bowed to the self-serving interests of contemporary politics.[16] With Germany's cultural superiority commonly cited among German professors as justification for the First World War (as expressed in 'The Ideas of 1914'), the cosmopolitan and humanistic dimension of scholarship had been almost completely eradicated, and a narrow, chauvinist nationalism naturalised within German academia.[17]

This remained very much the case in Weimar Germany. Following the war there were no major changes in terms of those figures occupying chairs within the German universities, and the majority of these academics experienced Germany's defeat as a sharp shock. Their subsequent rejection of the Versailles Treaty and of the new democracy itself meant that the political atmosphere within the German university shifted even further to the right (Iggers 1967, 391-3). The historical professions in particular remained overwhelmingly conservative, illiberal and decidedly opposed to the cosmopolitan, humanistic ethos of the Weimar Republic. German historians in the nationalist tradition either hankered after the glorious days of Bismarck and the *Kaiserreich*, or (perhaps even more especially in the case of art historians) looked to the past to engender a romanticised, *Völkisch* idea of 'German-ness'—a national identity often based upon exclusive racial principles.

It is against this background that we must evaluate Panofsky's insistence upon the value of humanistic scholarship and the importance of 'scholarly objectivity'. Panofsky had been made professor at the University of Hamburg; a new institution, born of the egalitarian Republic and largely untainted by the deep-seated nationalistic traditions and the anti-Semitic prejudices that characterised the more established German universities. In Hamburg Panofsky worked alongside the Jewish philosopher Ernst Cassirer and in collaboration with the liberal intellectuals of the *Kulturwissenschaftliche Bibliothek Warburg* (many of whom were also from Jewish backgrounds). There can be no doubt that these figures were made well aware of their 'Jewish' status in the politically charged environment of Weimar scholarship; but this was a racist definition which they refused to countenance in their work. Instead, they considered themselves, first and foremost, as humanist scholars, and their 'humanism' should be understood as a quite self-conscious alternative to the chauvinist and increasingly racist nationalism that characterised the work of many of their contemporaries.

The deliberate partisanship evident in much German historical writing was considered by those involved with the *KBW* as a fundamental abuse of scholarship itself, and of its potential for 'enlightenment'. Panofsky, for example, memorably referred to the nationalist art historian Wilhelm Pinder as, "unreliable and subjective in a rather disagreeable way: he writes either with foam on his mouth, or with tears in his eyes." (Wuttke 2003, 39). The idea that the academic would exploit his position to appeal to the emotions and passions of a particular group was absolutely anathema to Panofsky. He was equally critical of those art historians who would conjure the idea of some timeless (and irrational) *Völkisch* 'spirit', only to pass harsh judgement upon those German artists who had failed to live up to these exclusive ideals.[18] This conflation of historical horizons, with its quite conspicuous contemporary 'significance', was regarded by Panofsky as an irresponsible and potentially dangerous misuse of history.

Looking to the cosmopolitan educational principles of the Enlightenment, Panofsky and his associates at the *KBW* promoted humanistic scholarship as a means to transcend the narrow-minded biases of nationalist (or racialist) perspectives. Holding man's capacity for cultural creation to be a defining human characteristic, they believed that the historical study of man's cultural or 'symbolic' forms afforded the means to understand mankind in a more holistic and universal sense.[19] This was humanistic study as *Kulturwissenschaft*; with *Wissenschaft* envisaged as a sphere for rational communication and mutual understanding between different individuals, different 'perspectives'.[20]

It is in this sense that Panofsky and his colleagues at the *KBW* would insist upon 'disinterestedness' and 'objectivity' as methodological principles.[21] They believed it was the primary duty of the scholar to think critically and 'objectively', in an *attempt* to rise above the freaks and prejudices that were naturally inherent in their own particular 'point of view'. This was the *discipline* required of the historical process. The responsible scholar had to first realise their own latent subjectivity and then, accordingly, make the *effort* to understand their object of study, as much as was possible, on its own terms.

Such an approach was an integral part of that deep-seated belief in the moral, didactic purpose of history and of humanistic scholarship; where the self-consciously 'objective' understanding (*Verstehen*) of historical and cultural 'difference' was held as the means for the individual to enrich and cultivate their own individuality. This was a conception of humanistic scholarship then, which affirmed the autonomy of the individual, at the same time as it encouraged and fostered an understanding and respect for cultural, historical, and human difference.

In this understanding, Panofsky's 'humanism' and his insistence upon 'scholarly objectivity' should not be understood as a denial or "repression" of his 'Jewishness'. This was no naive effacement of self, nor an "idealising fantasy of humanism" (Kuspit 1996, 9) constructed in an attempt to avoid the reality of social prejudice and political intolerance. In an environment in which 'Jewishness' and 'cosmopolitanism' were increasingly equated in an insidious anti-Semitic rhetoric, Panofsky was well aware of what was at stake in his choice to be a 'humanist' scholar.[22] But this choice was just that—a self-conscious affirmation of the individual's right to autonomy and self-determination, and a concomitant insistence upon the need for tolerance and understanding of human individuality, human diversity.

These were, of course, precisely those values that were, ultimately, forcefully suppressed in the totalitarian regime of National Socialism. It was the Nazis who would decide what constituted 'Jewishness'; and it seems somewhat wrongheaded now to suggest that Panofsky should actually have countenanced this racist demarcation by becoming somehow more 'Jewish' in his work after 1933.[23] Indeed, it seems eminently understandable that when forced into exile in America Panofsky would choose to reaffirm his identity as a humanist scholar, and to emphasise the importance of a 'humanistic' approach to scholarship.

Furthermore, as an exiled scholar in the United States, Panofsky encountered what was a markedly different academic and intellectual

environment. In the early decades of the twentieth century the American university was dominated by the positivistic ethos of the natural sciences. Christine McCorkel has shown how in this academic climate,

> "Empirical observation of data and testable conclusions—'science'— became a criterion of validity—a theme in popular epistemology—that affected all disciplines....The idea that knowledge was a matter of factual, repeatable observation included the assumption of its accessibility and relevance to a mass audience." (1975, 38-9)

As McCorkel suggests, this widely accepted equation of 'scientific objectivity' with a 'democratic' approach to knowledge and learning meant that the historical disciplines in America were also characterised by their 'positivism'. The American historian concerned themselves primarily with 'facts', and the manipulation of these 'facts' was often considered an end in itself. There was little or no attention paid to the theoretical nature of historical knowledge, and the role that the individual historian played in the creation of this knowledge.[24] McCorkel goes on to demonstrate that in their efforts to lift the study of art away from its associations with elitist notions of 'appreciationism', American art scholars at the beginning of the twentieth century most often looked to the criterion of 'science' for their disciplinary validation. Thus, although American scholarship was far less politically 'charged' than had been the case in Weimar Germany, in exile Panofsky found himself in an environment in which he felt the need to once again emphasise the importance of a 'humanistic' approach to art history, and to historical scholarship in general.

It is in this context that Panofsky's essay, *The History of Art as a Humanistic Discipline* should be understood (1938). In this scholarly manifesto the émigré art historian made a comprehensive effort to codify the rationale and the methodological principles of 'humanistic scholarship' for his new English-speaking audience.

Panofsky begins the essay by describing 'humanism' as,

> "not so much a movement as an attitude which can be defined as the conviction of the dignity of man, based on both the insistence on human values (rationality and freedom) and the acceptance of human limitations (fallibility and frailty): from this two postulates result—responsibility and tolerance." (1938, 92)

The significance of this definition, coined by a German Jewish exile, would have been more than evident to Panofsky's readers in 1938. And in citing Pico, Erasmus and Kant as individuals who had exemplified this

liberal, cosmopolitan attitude in their work (1938, 91-93), Panofsky was creating an intellectual lineage, from the renaissance to the enlightenment, with which he implicitly, though quite obviously identifies himself.

Panofsky then makes the point that the humanist is, "fundamentally, an historian" (1938, 96). Interested in the nature of mankind and the human experience, the humanist, according to Panofsky, attempts an understanding through recourse to man's cultural products. Having the quality of "emerging from the stream of time" (1938, 96) these human records are the humanist's primary objects of study. The humanities are defined therefore, as the systematic attempt "to transform the chaotic variety of human records into a cosmos of culture"; and they are distinguished from the sciences, which endeavour to "transform the chaotic variety of natural phenomena into what may be called a cosmos of nature" (1938, 96).

Panofsky is here demarcating what he would have understood as the sphere of *Wissenschaft*; that holistic body of knowledge encompassing all human attempts to understand the world, and our place within it. Mindful of the American academic climate however, Panofsky takes great care not to invoke the narrow positivistic connotations that result from the translation of *Wissenschaft* as 'science'. Instead, Panofsky highlights the wider methodological problems that both the humanist *and* the scientist face in terms of establishing relationships between their 'facts' and their 'theories'; and he makes the point that the *responsible* (*wissenschaftliche*) scholar—scientist or humanist—is aware of the contingencies and relativity involved in *any* creation of 'knowledge' (1938, 96-101).

It is only then that Panofsky reaches the crux of his essay, and the particular distinction of the humanist as a historian:

> "The scientist, dealing as he does with natural phenomena, can at once proceed to analyse them. The humanist, dealing as he does with human actions and creations, has to engage in a mental process of a synthetic and subjective character: he has mentally to re-enact the actions and to re-create the creations. It is in fact by this process that the real objects of the humanities come into being." (1938, 105)

For Panofsky, the humanist recognises, at a fundamental level, the extent to which they partake in the creation of their own object of study. Each individual's re-creative experience (*erleben*) of a work of art, a piece of literature etc, depends necessarily upon their own "*cultural equipment*" (1938, 108). What distinguishes the humanist as a historian is that he is conscious of this situation. The 'humanist' is self-conscious in regards to his own subjectivity, his own particular situated-ness, and the fact that "his cultural equipment, such as it is, would not be in harmony with that of

people in another land and of a different period" (1938, 108). As a *responsible* scholar then, the humanist makes the effort, through recourse to wider historical documentation and contextualisation, to understand their object of study, as much as is possible, on its own terms. It is in this sense that the humanist 'objectifies' their cultural source material. At the same time as they attempt that empathetic engagement with their object of study the humanist must remain cognisant of, indeed they must insist upon that intellectualised historical distance which separates them. As we have seen, for Panofsky this was the rational *discipline* required of the historical process—that recognition of self in relation to one's object of study—and it was this critical, historical self-consciousness that he held to be the defining characteristic of the humanist as a historian.

This insistence upon the importance of historical consciousness would also play an integral part in Panofsky's contribution to English-language renaissance scholarship. Responding to those 'revolting medievalists' who sought either to downplay the unique character of the renaissance (Haskins 1927), or to deny its importance altogether (Sarton 1929; Thorndike 1929), Panofsky entered the discussion with his own attempts to demarcate the nature and the significance of 'The Renaissance' as a 'period' (1944; 1960).

In contrast to the often polemical posturing of his opponents, Panofsky provided an even-handed and judicious appraisal of the different medieval 'revivals'. It was the ultimate distinction of the 'Renaissance' however, Panofsky concluded, to have insisted upon the historical distance separating it from Antiquity. Indeed, it was in this sense, Panofsky noted, that the very concept of a 'middle ages' or 'medieval period' could arise at all (1960, 8). Whereas the men of the Carolingian 'renascence', for example, would approach Antiquity "with the feeling of legitimate heirs who had neglected or even forgotten their property for a time," it was, in Panofsky's eyes, the achievement of the 'Renaissance proper' to have consciously circumscribed and objectified the classical past as a distinct 'period' that had ended. It was this insistence upon the sense of historical distance that allowed Antiquity to be understood, for the first time, on its own terms. For Panofsky, the new 'historical consciousness' of the Renaissance meant that the pagan nature of the classical past ultimately ceased to be a cause for psychological apprehension and ambiguity. Instead, the paganism of the classical past lost its 'reality' and its 'power' as Antiquity became conceived of as an object of historical recreation,

"The 'distance' created by the Italian, or main, Renaissance deprived Antiquity of (its) reality. The classical world ceased to be both a possession

and a menace...In sum, the Italian Renaissance looked upon classical Antiquity from a historical distance; therefore, for the first time, as upon a totality removed from the present; and therefore, for the first time, as upon an ideal to be longed for instead of a reality to be both utilised and feared." (1944, 227-8)

For Panofsky, this new, rationalised understanding of history was an integral part of the birth of that modern consciousness, summed up in Burckhardt's classic description of the Renaissance as, "The Discovery of the World and of Man" ([1860] 1944). In a very real sense then, he saw in the Renaissance the beginnings of his own conception of history as a discipline (Panofsky 1960, 108); that critical, 'objective' understanding of the past which provides orientation for man in the present.

Notes

[1] Perhaps most notable in this context are the contributions of Cassirer (1943), Baron (1943) and Kristeller (1943) to a symposium dedicated to the renaissance question, published in *The Journal of the History of Ideas*. Panofsky's essay 'Renaissance and Renascences' (1944) was conceived of by the author as an art-historical contribution to this same discussion.

[2] Norman Cantor, for example, refers to Panofsky's work as "the most subtle analysis ever made of the great Renaissance issue." (1991, 183).

[3] Taking account of these trends, Willibald Sauerländer has noted that, by the 1990s, Panofsky had come to be regarded as "the burdensome father figure from a bygone period of humanistic scholarship. The admiration for his unsurpassed erudition, his brilliance, and his wit gave way to a vehement reaction against his approach to the problems of interpretation, a reaction taking sometimes a vociferous violence which has been...denounced as 'Panofsky-bashing.'" (1995, 385).

[4] See also, Moxey (1986; 1990; 1994; 1995b).

[5] In her analysis of those German Jewish émigré art historians who insisted on 'scholarly objectivity', Soussloff writes, "this move prevented them from speaking as fully situated cultural subjects. Silent about their identity, these historians could locate neither themselves nor the discipline they helped to found in the historical moment, or predicament, they actually experienced." (1999, 12).

[6] Soussloff writes, for example, "I can acknowledge my motivation briefly by confessing my desire to understand my own Jewish identity and its role in my choice of profession and field. I found in art history, both past and present, many others who, like myself—or like my father, whose model I followed—had repressed or suppressed their Jewishness in their professional lives and writing." (1999, 9).

[7] "Enlightenment is man's release from self-incurred tutelage. Tutelage is man's inability to make use of his understanding without direction from another. Self-

incurred is this tutelage when its cause lies not in lack of reason but in lack of resolution and courage to use it without direction from another." (Kant 1963, 3).

[8] "By the public use of one's reason I understand the use which a person makes of it as a scholar before the reading public." (Kant 1963, p5).

[9] As late as 1928 the German encyclopaedia *Der grosse Brockhaus* gave the following definition of the term *Bildung*: "The fundamental concept of pedagogy since Pestalozzi, Bildung means forming the soul by means of the cultural environment. Bildung requires: (a) an individuality which, as the unique starting point, is to be developed into a formed or value saturated personality; (b) a certain universality, meaning richness of mind and person, which is attained through the empathetic understanding and experiencing of the objective cultural values; (c) totality, meaning inner unity and firmness of character" (Quoted in Ringer 1969, 86).

[10] The following excursus on Humboldt's educational reforms relies upon Sorkin's informative analysis (1983). It is important to note here too, that although Humboldt's reforms were based upon the Prussian educational system, and the University of Berlin in particular, they were so influential that they provided the standard model for the development of schools throughout the various German states.

[11] In terms of the regulation of a student's studies, the German educationalist Friedrich Paulsen writes, "...the individual has almost unlimited freedom: the arrangement and sequence of studies, as well as the choice of subjects, lectures, and exercises, and finally and especially the use of the offered instruction, are all really left to individual choice. The university demands merely that a student shall register for at least one academic course in each semester, not that he shall attend." (1906, 280).

[12] Even despite the fact that remaining anti-Semitic prejudices meant many official careers would not be open to Jewish university graduates, it is significant that Jewish families still sent proportionately many more of their children into the German institutions of higher learning in the nineteenth century than did their Protestant or Catholic counterparts (Ringer 1969, 136; Pickus 1999, 31).

[13] In a letter to his son Wolfgang, of 25th March 1950, for example, Panofsky recalled with some pride that his own grandfather had been both "an industrialist and a great Talmud scholar." (Wuttke 2006, 17).

[14] In a letter to his fellow émigré Stefan Hirsch, written on June 6, 1956, Panofsky would admit, "It is my honest belief that whatever value there may be in what I have written and attempted to teach is essentially based on the fact that I received a decent humanistic education before entering the university." (Wuttke 2006, 989-992).

[15] As George Mosse has noted, "The link between *Bildung* and the Enlightenment had been destroyed; instead *Bildung* was linked to racism and nationalism. National Socialism was merely the climax of a long development during which the *Bildung* of Humboldt, Lessing and Goethe had become an ever narrower vision." (1985, 73-4).

[16] George Iggers provides the still-fundamental analysis of the links between the rise of the German historical professions and the developing conception of a German nation-state (1983).

[17] This is not to say, of course, that support for the war among academics was exceptional in Germany. I only wish to point out that the chauvinism prevalent among German professors was, in large part, based upon their self-serving notion of 'cultural' superiority.

[18] In an essay that sought to put into 'proper' historical context Dürer's relationship with Italy, and with the Antique, Panofsky writes, "It is not for the historian to decide whether Dürer, in thus reforming German art, 'poisoned its roots'. He who deplores the fact that Dürer imbued Northern art with his *antikische Art*, or that Rubens was influenced by Michelangelo and Titian, is just as naïve and dogmatic—only with an inverted sign—as those rationalistic critics of old who could not forgive Rembrandt for *not going to Italy*." (1922, 325).

[19] Perhaps the best expression of this belief is Ernst Cassirer's *Philosophy of Symbolic Forms* (1923-1929).

[20] In a letter to Erich M. Warburg, 3rd June 1936, Gertrud Bing, a colleague of Panofsky at the *KBW*, described the Library as "a place where in the field of science and learning a genuine international collaboration may be done which...leads to the mutual understanding between different nationalities. This...would mean the practical realisation of that humanism and enlightenment which is the purpose of true learning." (Wuttke 2001, 904).

[21] Karen Michels notes, "The demand for unconditional objectivity and neutrality is one of the most important themes in the diaries of the Kulturwissenschaftliche Bibliothek Warburg." (1999, 176).

[22] Panofsky's awareness of the political implications involved in his approach to scholarship are clear from a letter to the American Margaret Barr, sent from Hamburg on May 7th 1932, in which he joked darkly, "I am lecturing on French art of the 17th and 18th centuries before about 120 people without having been attacked for treason against the country, and almost all the new students studying art-history as a 'Hauptfach' who have appeared at Hamburg...are runaways from Munich, the main stronghold of nationalism in art-history." (Wuttke 2001, 495).

[23] Karen Michels, for example, writes of Panofsky and his fellow émigrés, "Persecution and expulsion did not, as could have been expected, lead to any recognisable process of radicalisation, politicisation, or solidarity in the group of art historians who immigrated to America. The art historians did not respond to the policy of genocide with a new group identity based on their common interests or common origins...Their relationship to Judaism remained ambivalent and was frequently marked by a certain distance. It is difficult to evaluate this response." (1999, 170).

[24] In a jointly penned essay, the historians Charles Beard and Alfred Vagts noted, "American historians have no philosophy of history; they want none; they distrust it...few of our universities, it seems, offer courses in the history of historiography or pay much attention to what the historian thinks he is doing when he is taking mountains of notes and selecting and arranging his 'facts'." (1937, 464).

References

Baron, Hans. 1943. "Towards a More Positive Evaluation of the Fifteenth-Century Renaissance." *The Journal of the History of Ideas* 4 (1): 21-49.

Beard, Charles, Alfred Vagts. 1937. "Currents of Thought in Historiography." *The American Historical Review* 42 (3): 460-483.

Bruford, Walter Horace. 1975. *The German Tradition of Self-Cultivation: 'Bildung', From Humboldt to Thomas Mann.* London: Cambridge University Press.

Burckhardt, Jacob. [1860] 1944. *The Civilisation of the Renaissance in Italy.* Translated by S.C.G. Middlemore. Repr. London: Allen & Unwin.

Butler, Eliza M. 1935. *The Tyranny of Greece Over Germany: A Study of the Influence Exercised by the Greek Art and Poetry over the Great German Writers of the Eighteenth, Nineteenth and Twentieth Centuries.* London: Cambridge University Press.

Cantor, Norman F. 1991. *Inventing the Middle Ages: The Lives, Works, and Ideas of the Great Medievalists of the Twentieth Century.* New York: Murrow.

Cassirer, Ernst. 1923-1929. *Philosophie der Symbolischen Formen.* 3 vols. Berlin: B. Cassirer.

—. 1943. "Some Remarks on the Question of the Originality of the Renaissance." *The Journal of the History of Ideas* 4 (1): 49-56.

Gay, Peter. 1969. *Weimar Culture: The Outsider as Insider.* London: Secker and Warburg.

Guess, Raymond. 1996. "Kultur, Bildung, Geist." *History and Theory* 35, no. 2, (May): 151-164.

Haskins, Charles Homer. 1927. *The Renaissance of the Twelfth Century.* Cambridge, Mass.: Harvard University Press.

Iggers, Georg G. 1967. "The Decline of the Classical National Tradition of German Historiography." *History and Theory* 6 (3): 382-412.

—. 1983. *The German Conception of History: The National Tradition of Thought from Herder to the Present.* Rev. Ed. Middletown Conn.: Wesleyan University Press.

Kant, Immanuel. 1963. "What Is Enlightenment?" Translated by Lewis White Beck in *On History*, edited by L.W. Beck, 3-10. Indianapolis: Bobbs-Merrill.

—. 1979. "The Conflict of the Faculties." Translated by Mary J. Gregor. New York: Abaris Books.

Kristeller, Paul Oskar. 1943. "The Place of Classical Humanism in Renaissance Thought." *The Journal of the History of Ideas* 4 (1): 59-63.

Kuspit, Donald. 1996. "Taking Refuge in Humanism: Troubling Views of Erwin Panofsky, the Great German-Born Art Historian." *Forward* 100 (August): 9.

McCorkel, Christine. 1975. "Sense and Sensibility: An Epistemological Approach to the Philosophy of Art." *The Journal of Aesthetics and Art Criticism* 34 (1): 35-50.

Meyer, Michael A. 1990. *Jewish Identity in the Modern World.* London: University of Washington Press.

Michels, Karen. 1999. "Art History, German Jewish Identity, and the Emigration of Iconology." In *Jewish Identity in Modern Art History*, edited by Catherine Soussloff, 167-179. London: University of California Press.

Mohlo, Anthony. 1998. "The Italian Renaissance: Made in the USA." In *Imagined Histories: American Historians Interpret the Past*, edited by Anthony Mohlo and Gordon S. Wood, 263-294. Princeton N.J.: Princeton University Press.

Mosse, George. 1985. *German Jews Beyond Judaism.* Cincinnati: Hebrew Union College Press.

Moxey, Keith. 1986. "Panofsky's Concept of 'Iconology' and the Problem of Interpretation in the History of Art." *New Literary History* 17 (1): 265-274.

—. 1990. "The Politics of Iconology." In *Iconography at the Crossroads: Papers from the Colloquium Sponsored by the Index of Christian Art, Princeton University*, edited by Brendan Cassidy, 27-31. Princeton N.J.: Princeton University Press.

—. 1994. "Panofsky's Melancolia." In *The Practice of Theory: Poststructuralism, Cultural Politics and Art History*, Keith Moxey, 65-78. London: Cornell University Press.

—. 1995. "Motivating History." *The Art Bulletin* 77 (3): 392-401.

—. 1995b. "Perspective, Panofsky and the Philosophy of History." *New Literary History* 26 (3): 775-786.

—. 2004. "Impossible Distance: Past and Present in the Study of Dürer and Grünewald." *The Art Bulletin* 86 (1): 750-763.

Muir, Edward. 1994. "The Italian Renaissance in America." *The American Historical Review* 100 (4): 1095-1118.

Nisbet, H.B. 1982. "'Was Ist Aufklärung?': The Concept of Enlightenment in Eighteenth-Century Germany." *Journal of European Studies* 12 (2): 77-95.

Panofsky, Erwin. 1922. "Dürer's Stellung zur Antike". Translated by the author as "Albrecht Dürer and Classical Antiquity." In *Meaning in the Visual Arts: Papers in and on Art History*, 1955, 277-329. New York: Doubleday.

—. 1938. "The History of Art as a Humanistic Discipline." In *The Meaning of the Humanities*, edited by T. M. Greene, 89-118. Princeton NJ: Princeton University Press.

—. 1944. "Renaissance and Renascences." *The Kenyon Review* 6 (2): 201-236.

—. 1960. *Renaissance and Renascences in Western Art*. Repr., London: Paladin, 1970.

Parker, Kevin. 1997. "Art History and Exile: Richard Krautheimer and Erwin Panofsky." In *Exiles and Emigres: The Flight of European Artists From Hitler*, edited by Stephanie Barron with Sabine Eckmann, 317-325. New York: H. N. Abrams.

Paulsen, Friedrich. 1906. *The German Universities and University Study*. Translation by Frank Thilly and William W. Elwang. London: Longmans, Green, and Co.

Pickus, Keith H. 1999. *Constructing Modern Identities: Jewish University Students in Germany, 1815-1914*. Detroit: Wayne State University Press.

Ringer, Fritz K. 1969. *The Decline of the German Mandarins: The German Academic Community, 1890-1933*. London: Wesleyan University Press.

Sarton, George. 1929. "Science in the Renaissance." In *The Civilisation of the Renaissance*, by James Westfall Thompson, George Rowley, Ferdinand Schevill and George Sarton, 75-95. Chicago: University of Chicago Press.

Sauerländer, Willibald. 1995. "Struggling With a Deconstructed Panofsky." In *Meaning in the Visual Arts: Views From the Outside: A Centennial Commemoration of Erwin Panofsky (1892-1968)*, edited by Irving Lavin, 385-396. Princeton NJ: Institute for Advanced Study.

Schmidt, James. 1989. "The Question of Enlightenment: Kant, Mendelssohn, and the *Mittwochsgesellschaft*." *Journal of the History of Ideas* 50 (2): 269-291.

Sorkin, David. 1983. "Wilhelm Von Humboldt: The Theory and Practice of Self-Formation (*Bildung*), 1791-1810." *Journal of the History of Ideas* 44 (1): 55-73.

—. 1987. *The Transformation of German Jewry, 1780-1840*. Oxford: Oxford University Press.

Soussloff, Catherine. 1999. "Introducing Jewish Identity to Art History." In *Jewish Identity in Modern Art History*, edited by C. Soussloff, 1-16. London: University of California Press.

Thorndike, Lynn. 1929. *A History of Magic and Experimental Science.* New York: Macmillan Co.

Trinkaus, Charles. 1976. "Humanism, Religion, Society: Concepts and Motivations of Some Recent Studies." *Renaissance Quarterly* 29, no. 4, (Winter): 676-713.

Wuttke, Dieter, ed. 2001. *Erwin Panofsky Korrespondenz 1910 bis 1936.* Wiesbaden: Harrassowitz Verlag.

—. 2003. *Erwin Panofsky Korrespondenz 1937 bis 1949.* Wiesbaden: Harrassowitz Verlag.

—. 2006. *Erwin Panofsky Korrespondenz 1950 bis 1956.* Wiesbaden: Harrassowitz Verlag.

CONTRIBUTORS

Emily Jane Anderson

Emily Jane Anderson is completing her PhD in the Department of History of Art at the University of Glasgow funded by the AHRC. Her thesis is entitled "Vitale da Bologna and his Followers: the Eastern European *Vitaleschi*." She previously graduated with an MPhil by research and First Class MA with Honours in History of Art at the University of Glasgow, where she has been teaching assistant since 2004. She was the recipient of several bursaries and grants from the University of Glasgow, the Clark (Mile End) Trust, and the James McNeil Whistler and Beatrix Whistler Scholarship. She presented papers at several national and international conferences including the Society of Italian Studies Postgraduate Colloquium, Pembroke College, Cambridge (2005), *Moving Forward*, College of Arts and Social Sciences Postgraduate Conference, University of Aberdeen (2006), International Medieval Congress, University of Leeds (2007), *Communication and Exchange in the Art and Architecture of the Middle Ages*, Courtauld Institute of Art (2008), *Location: the Museum, the Academy and the Studio*, 34th Association of Art Historians Annual Conference, Tate Britain and Tate Modern (2008). She organised the Gloss Postgraduate Conference, Current Research on Medieval and Renaissance Art and Culture, University of Glasgow (2007) and co-organised *Art and Identity*, University of Aberdeen (2008). She was session convenor for "Images of Corporal Mortification and Corruption, Martyrdom and Mercy: 1250-1550" at the 36th AAH annual conference that took place at the University of Glasgow in 2010. She has published on the Bolognese *trecento* and on Egyptian New Kingdom statuary.

Joanne Anderson

Dr Joanne Anderson is a visiting lecturer at the History of Art Department, University of Warwick and administrative assistant of *The Art Bulletin*. She completed her doctorate in the History of Art at Warwick in 2009, under the supervision of Dr Louise Bourdua, focusing on the narrative Magdalen fresco cycles in Trentino, Tyrol and the Swiss Grisons, c.1300-1500. A recipient of an AHRC doctoral fellowship and two awards from the School of Divinity, History and Philosophy, University of Aberdeen (prior to transfer), she has also been an Early Career Fellow at the Institute

of Advanced Study, Warwick. She is a graduate of the Courtauld Institute of Art (MA, 2003) and the University of Aberdeen (MA, 2001). Joanne is interested in the visual culture of Mary Magdalen, iconography, modes of female patronage and itinerant artistic workshops during the late Middle Ages to early Renaissance in Italy and the pre-Alps. She has begun to publish her research in edited volumes and is currently preparing further journal articles and a monographic study.

Flavio Boggi
Flavio Boggi is Senior Lecturer and Head of the History of Art in University College Cork, Ireland. Educated both in Italy and Scotland, he completed an MA and PhD at the University of Glasgow in 1991 and 1997 respectively. He teaches and writes about Italian art and architecture of the Middle Ages and the Renaissance, and his research interests are primarily focused upon the artistic culture of fourteenth- and early fifteenth-century Tuscany—the city states of Lucca and Pistoia above all. He has published essays and reviews in such scholarly journals as *Arte Cristiana*, the *Burlington Magazine, Mitteilungen des Kunsthistorischen Institutes in Florenz*, and *Renaissance Studies*. Together with Robert Gibbs he is co-author of *The Life and Career of Lippo di Dalmasio, A Bolognese Painter of the Late Fourteenth Century*, which was published in 2010 to coincide with the sixth centenary of the artist's death.

Sandra Cardarelli
Dr Sandra Cardarelli holds a PhD in history of art from the University of Aberdeen (2011) funded by the AHRC. Her thesis entitled: "Siena and its *Contado*: Art, Iconography and Patronage in the Diocese of Grosseto from c. 1380 to c. 1480" investigates the relationship between the commune of Siena and the territories under its control, and how this reflected on the artistic output of the diocese of Grosseto, in Southern Tuscany. It also explores the dynamics of patronage in this area. Sandra previously completed an MLitt with Distinction also in history of art also from the University of Aberdeen, and a BA (Hons) from Turin, Italy. Her MLitt thesis was shortlisted for the AAH dissertation prize 2006. She has presented papers at academic conferences at the universities of Aberdeen, Glasgow, Leeds, and St Andrews, the AAH annual conference in London (2008 and 2012), and the RSA Annual Meeting in Venice (2010). She co-organized the "Art & Identity" postgraduate conference at the University of Aberdeen in June 2008 that has led to the publication of a volume entitled: "Art and Identity: Visual culture, Politics and Religion in the Middle Ages and the Renaissance" for Cambridge Scholars Publishing

(2012). Part of the research for her PhD is included in an edited volume: "Matteo di Giovanni nella Diocesi di Grosseto: Nuove Ipotesi e Spunti di Riflessione" in *Contributi per l'Arte in Maremma: Arte e Storia nella Maremma Antica*, vol. 1, ed. O. Bruschettini, (2009), pp. 187-202.

Andreas Dahlem
Andreas Dahlem studied History of Art, Medieval and Modern History, as well as Film and Television Studies at the University of Glasgow, where he received his Master of Arts in 2002. In 2009, he completed his PhD thesis on *The Wittelsbach Court in Munich: History and Authority in the Visual Arts (1460-1508)* under the supervision of Professor Robert Gibbs and Dr John Richards of the Department of History of Art at the University of Glasgow. He is currently working at the Bavarian State Library in Munich, where he was involved in a digitisation project and an internet publication platform on Bavarian history. Andreas Dahlem's research interest focuses on art, architecture and literature at the Wittelsbach Court in Munich in the Late Gothic, Renaissance and Baroque periods. An article on Nymphenburg Palace was published in Büttner, Frank, Eckhard Hollmann, Stephan Hoppe, and Meinrad von Engelberg, eds. 2008. *Geschichte der bildenden Kunst in Deutschland. Barock und Rokoko*. Munich: Prestel. He is planning a research project on Bishop Wilhelm von Reichenau of Eichstätt and digital humanities applications for research in architectural history.

Jill Farquhar
Dr Jill Farquhar is a specialist in the art of Trecento Marche and Romagna and, more recently, undertakes research into the place of women in medieval and Renaissance visual culture. She completed her PhD on Riminese painting at Warwick University in 2005 under the supervision of Professor Julian Gardner. She held the post of lecturer in Art History at Queen's University Belfast between 2002 and 2009 and was Head of the History of Art Department at Queen's from 2006 until 2009. She has also worked for the Open University in Ireland. Jill is currently an independent art historian.

Robert Gibbs
Robert Gibbs is Emeritus Professor of Pre-Humanist Art History and
Codicology at the University of Glasgow. He was born in London and
studied at the Courtauld Institute before taking up a post in Glasgow,
where he remained until retiring in September 2011. Robert's major
research area has been Bolognese painting between 1200 and 1425, the
subject of numerous articles and conference papers and of his current work
on catalogues of the illuminated law manuscripts of the Vatican library.
He has recently published, with Flavio Boggi, *The Life and Career of
Lippo di Dalmasio, a Bolognese Painter of the Late Fourteenth Century*
(Lampeter & Lewiston NY, 2010) and has written two books on Tomaso
da Modena (*L'Occhio di Tomaso*, Treviso 1981 & *Tomaso da Modena:
Painting in Emilia and the March of Treviso, 1340-80*, Cambridge 1989)
and, with Susan L'Engle, *Illuminating the Law: Medieval Legal
Manuscripts in Cambridge Collections* (London, 2001), relating to an
exhibition at the Fitzwilliam Museum in Cambridge, 5 November-16
December 2001.

Anastasia Kanellopoulou
Anastasia Kanellopoulou (born in Athens in 1977), is a final year Ph.D
student in the History of Art Department in the University of Glasgow.
Her research undertaken under the supervision of Professor Robert Gibbs
and Dr John Richards focuses on Venetian panel painting of the first half
of the 14th century. In 2001, she graduated from the University of Athens
with a degree in History and Archaeology and specialization in
Archaeology and History of Art. In 2003, funded by the Greek Institute of
Statal Scholarships (I.K.Y), she pursued her master's degree in the
University of Warwick, writing her dissertation under the supervision of
Professor Julian Gardner on the iconography of the posthumous life of the
Virgin in the Veneto. In 2005 she started her Ph.D in the University of
Glasgow and since then has been moving between Glasgow, Venice, and
Athens, her permanent residence. In the span of these years she has
worked pursuing voluntary or paid jobs in various museums and galleries,
taught History of Art in various vocational training institutes in Greece
and written articles for archaeological magazines. She speaks Greek,
English, and Italian fluently and reads French and German. After winning
a six-month scholarship, she is currently undertaking a period of study in
the Fondazione Giorgio Cini in Venice, helping to catalogue the
photographical archive of Pericles Papachatzidakis. This is her first
English publication.

Dan Keenan
Daniel Keenan is a PhD candidate, in his final year, in the Department of History of Art at Glasgow University. His previous MPhil dissertation provided a historiographical reconsideration of the life and work of Erwin Panofsky in the years immediately following his migration from Germany to America in 1933. His doctoral research expands upon this work, analysing Panofsky's entire American career and how the process of acculturation mediated his efforts to translate and transcribe his own conception of humanistic scholarship for his American audience.
Other research interests include the history of Renaissance scholarship and the history of the discipline of Art History. He also provides lectures on the art and theory of the Early Renaissance and on the Historiography of Art History at Glasgow University.

Neil Murphy
Dr. Neil Murphy is a lecturer in early modern European history at the University of Winchester. He was awarded his Ph.D in 2009 at the University of Glasgow for his thesis on the development of the ceremonial entry in France from 1350 to 1570. He is currently writing a monograph on this subject.

Pippa Salonius
Pippa Salonius has taught Art History to university students in Italy and North America. She completed her *laurea* in art history under the supervision of Professor Luciano Bellosi at the University of Siena in Italy and her PhD with Professor Julian Gardner at Warwick University in England. Her practical knowledge of museums has been acquired from periods of work in galleries such as the Museo dell'Opera in Siena, Italy and the National Gallery of Art in Washington DC, USA. She specializes in the art and architectural history of the Italian cathedral and the patronage of the papal court, with particular reference to the transmission and circulation of ideas within and beyond the Italian peninsula. She has published "Façade Reliefs Orvieto Cathedral", "Tabernacle of Orsanmichele", "Vecchietta: (Lorenzo di Pietro)," in *Encyclopedia of Sculpture,* ed. Antonia Böstrom (New York: Fitzroy Dearborn, 2004) and is currently co-editing with Andrea Worm *The Tree. Symbol, Allegory and Structural Device in Medieval Art and Thought* (Turnhout and New York: Brepols, 2013). Apart from her essay "The Cathedral Façade: Papal Politics and Religious Propaganda in Medieval Orvieto" in this current volume, she is also publishing the article "Heresy at the Door: Possible Cathar elements in early fourteenth-century encyclopaedic pictorial

programmes" in a forthcoming volume of *Digital Philology: A Journal of Medieval Cultures* entitled *Devotion and Emotion in the Middle Ages.*

John Richards
Dr John Richards is Senior Lecturer in History of Art and Head of Subject at the University of Glasgow, where he teaches both undergraduate and postgraduate courses on aspects of Medieval and Renaissance Art. He is also Deputy Director of the Institute of Art History, and fulfils a number of academic and administrative duties. He has published widely on *Trecento* Italian art, particularly on Padua and Verona, as well as on the influence of Humanist thought on Italian art. He was convenor of the AAH Annual Conference that was held in Glasgow in April 2010, and he has presented papers at national and international conferences and seminars, including most recently, The Edinburgh Seminar in Medieval and Renaissance Studies.

Jenny Vlček Schurr
Jennifer Vlček Schurr graduated from the University of Glasgow in 1982 with MA Hons (First Class) in Czech and History of Art. Whilst raising a family and working as a Specialist Lymphoedema Physiotherapist in the NHS, she maintained an interest in medieval Bohemian art. In 2007 she returned to her studies and in 2009, gained an MPhil (Research) at the University of Glasgow, under the supervision of Professor Robert Gibbs. She is now studying for a PhD (Research). Other areas of special interest include the iconography of the Man of Sorrows, the Chapel of the Holy Cross, Karlštejn and the manuscripts of Václav [Wenceslas] IV. Publication: 2012. 'The dedication illustration of the Passional of Abbess Cunegund and questions of identity.' In *Art and Identity: Visual culture, politics and religion in the Middle Ages and Renaissance*, edited by S. Cardarelli and E. J. Anderson. 193-218. Newcastle: Cambridge Scholars Publishing.

Katherine Wilson
Katherine Wilson is a Lecturer in Medieval History at the University of Chester. She works on the social history of the Low Countries in the later Middle Ages and is particularly interested in the material culture of this region. She has published several articles on the merchants who supplied tapestries to the Burgundian court and on the urban consumers of tapestry and is currently working on a monograph, 'Courtly and Urban Tapestries of the Burgundian Dominions' which will be published by Brepols.

INDEX

UNIVERSITY
OF
GLASGOW
LIBRARY

WITHDRAWN